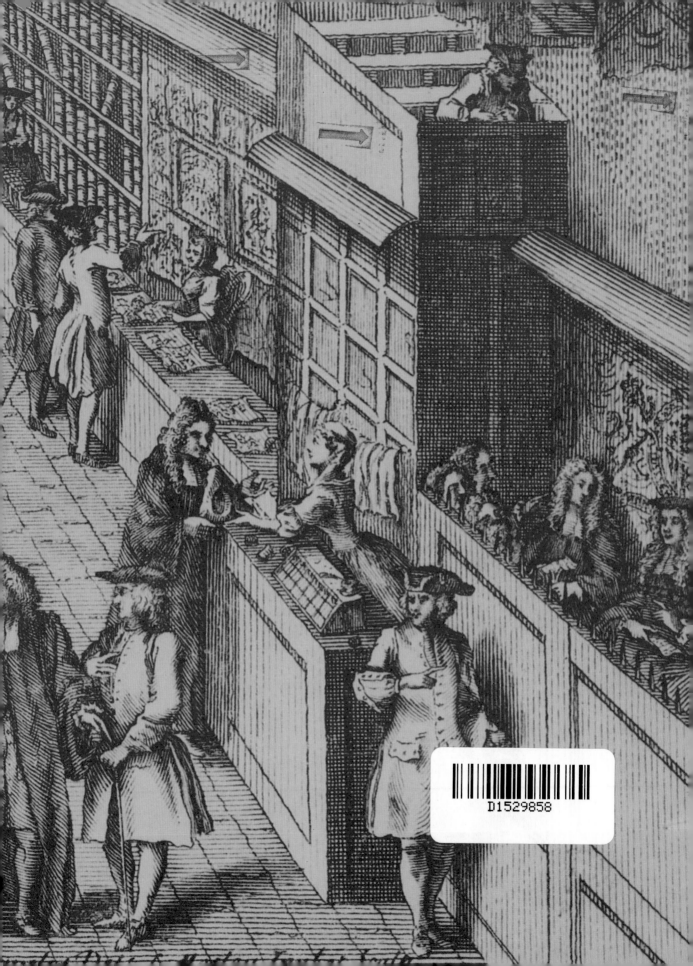

THE SPECTACLE OF DIFFERENCE

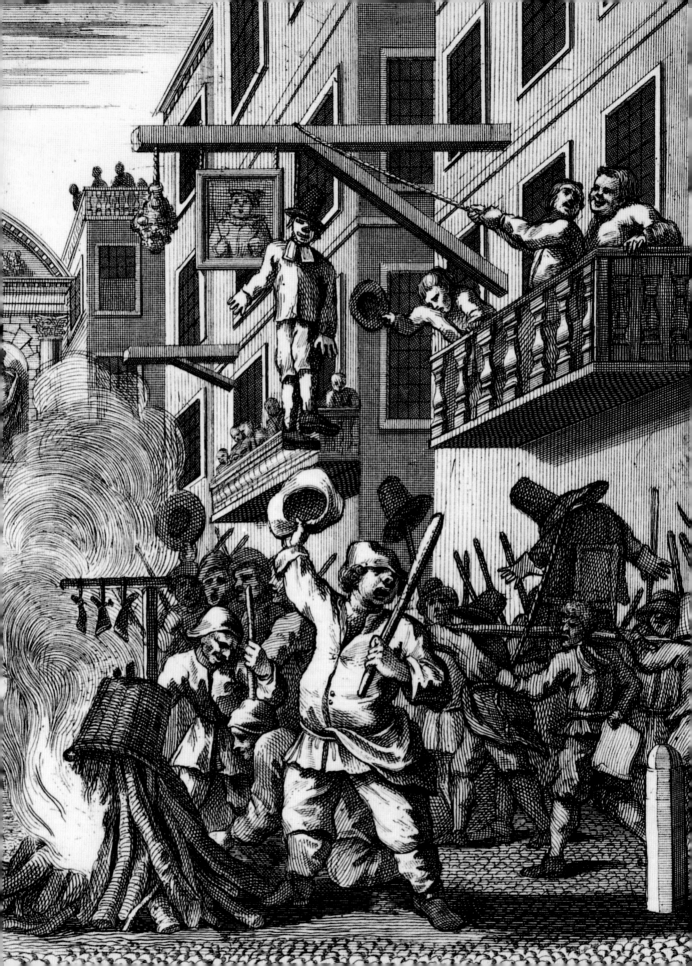

THE SPECTACLE OF DIFFERENCE

Graphic Satire in the Age of Hogarth

MARK HALLETT

Published for
THE PAUL MELLON CENTRE
FOR STUDIES IN BRITISH ART
by
YALE UNIVERSITY PRESS
NEW HAVEN & LONDON

Designed by Gillian Malpass

Printed in Hong Kong

Library of Congress Cataloging-in-Publication Data

Hallett, Mark. 1965–
The spectacle of difference: graphic satire in the age of Hogarth / Mark Hallett.
p. cm.
Includes bibliographical references and index.
ISBN 0-300-07778-5 (cloth: alk. paper)
1. English wit and humor, Pictorial. 2. Caricature – England – History – 18th century –
Themes, motives.
I. Title.
NC1473.H36 1999
769.942 – dc21
98-47309
CIP

A catalogue record for this book is available from
The British Library

ILLUSTRATIONS: Unless otherwise indicated, all illustrations are of prints.
'BM' numbers in parentheses refer to the catalogue number of the print in the
Catalogue of Prints and Drawings in the British Museum, Division 1: Political and Personal Satires,
ed. F. G. Stephens, E. Hawkins, M. D. George, 1870–1954.

ENDPAPERS: (*front*) detail from Charles Mosley after Hubert-François Gravelot,
The First Day of Term, 1738;
(*back*) detail from George Bickham junior, *The Champion, or Evening Advertiser*,
1740 (BM 2452).

FRONTISPIECE: Detail from William Hogarth, *Burning the Rumps at Temple Bar*,
1726 (BM 514).

To my family

Contents

Preface ix

Introduction Two Satires 1

One Pictures of Malice 27

Two Translations 57

Three Re-Reading *A Harlot's Progress* 93

Four Satire, Politics and Party 131

Five Satire and the Street: *The Beaux Disaster* 169

Six The Spectacle of Difference 197

Conclusion 235

Notes 237

Select Bibliography 246

Index 254

facing page Detail from fig. 98

Organ of *Vision*. By M. De St. *Yves*, Surgeon Oculist of the Company of *Paris*. Together with the Author's Answer to M. *Mouchard*. Translated from the Original French.

By J. STOCKTON, M.D.

Printed for T. Osborne, in Gray's-Inn; and M. Cooper, in Paternoster-Row.

Where may be had,

An Enquiry into the Exility of the Vessels in a Human Body, wherein Animal Identity is explained, and shewn incommunicable to any Individual throughout the whole Species. By *Clifton Wintringham*, jun. Fellow of the Royal Society. Price 1 s.

This Day are published,

The following PRINTS,

1. THE *Break-Neck Fox-Chase*, particular Persons, Price 1 s. 6 d.

2. *Great-Britain and Ireland's Yawn*, from the Yawn in the last Dunciad, 1 s.

3. *The Yellow-sash'd Confectioner*, setting forth the H——n Desert. Price 6 d.

Publish'd by G. Bickham in May's Buildings, Covent-Garden.

Where may be had,

1. The first Principles of Geometry explain'd by Description and Figures, 17 Pages, Price 1 s.

2. M'Pherson the Highland Soldier shot, and the Piper, the Originals, 6 d. each.

3. Brown the Valiant Dragoon, a Yorkshireman, who retook our Standard, 6 d.

4. The Head of Thamas Kouli Kan, at War with the Turk, 6 d.

As also the Pictures on Horseback of Col. Mentzel, and Baron Trenck, Colonel of the Pandours, and one of the King of France's Houshold Troopers, with the Colours we took at the Battle.

This Day is publish'd, in 8vo. Price 5 s. bound,

Containing near 200 Experiments, fully demonstrating the several Parts of Natural Philosophy;

The Second Edition, *of*

A COURSE of LECTURES.

By the late RICHARD HELSHAM, *M.D.*

Professor of Physick and Natural Philosophy in the University of Dublin.

Published by BRYAN ROBINSON, *M.D.*

To which are added, by way of Appendix, several Problems, by the Editor.

Printed for J. Nourse, at the Lamb without Temple-Bar.

Where may be had, (Lately publish'd,) Price 6 s. sew'd in Quarto.

1. Essays on several curious and useful Subjects in speculative and mix'd Mathematicks.

2. The Doctrine of Annuities and Reversions, deduced from general and evident Principles: with useful Tables. To which is added,

Preface

This book was being written during a year in which, exactly three centuries after his birth, the life and work of William Hogarth were being celebrated in numerous galleries and museums, conferences and symposiums, biographies and catalogues. In 1997 a flurry of publications and exhibitions dealt with the artist, all of which have helped us appreciate anew Hogarth's distinctive output. This book makes a contribution to this art-historical commemoration, but it does so in a highly specific way. I shall indeed be concentrating on Hogarth's graphic practice in some of the chapters that follow, but I shall be relating that practice to the wider workings of graphic satire in eighteenth-century London. This book is not so much interested in historically resurrecting Hogarth as an individual artist as with historically resurrecting the early eighteenth-century satirical engraving as an art form, and demonstrating that it was an ambitious, experimental and multi-faceted branch of graphic culture produced by numerous artists living and working in the English capital, of whom Hogarth was only one.

While I have of course been indebted to the existing scholarship on early eighteenth-century graphic satire in writing this book, it seems clear to me that it is time for new approaches to be taken towards the subject. In the past, graphic satire has too often been approached as an adjunct to literary satire, which has led to the problematic assumption that satiric images are little more than pictorial equivalents of, or bastardised derivations from, the kinds of work produced by writers like Alexander Pope, Jonathan Swift and Henry Fielding. Equally problematically, the graphic satire has also been frequently exploited as a form of historical illustration, used by countless writers to brighten up academic and popular accounts of Georgian England, but given little individual attention in its own right. When the early eighteenth-century satire has been taken seriously as a pictorial format in recent decades, its study has tended to forgo art-historical analysis in favour of a focus on the satire's engagement with the political debates of the period. The title of M. Dorothy George's pioneering work on the subject – *English Political Caricature to 1792: A Study of Opinion and Propaganda*, 1959 – offers a succinct indication of such preoccupations. Herbert Atherton, following on from George in his *Political Prints in the Age of Hogarth: A Study in the Ideographic Representation of Politics*, 1974, produced a detailed study of Georgian political satire which argued that such images should be understood primarily as vehicles of political controversy and public opinion, rather than as pictorial products with any claims to artistic or aesthetic interest.

The study of the graphic satire of this period has also been hampered, it seems to me, by the long-standing promotion of William Hogarth as an artist whose involvement in the genre temporarily rescued it from a deserved obscurity. It is telling that the influential, often brilliant, and always stimulating writings of Ronald Paulson, which afford us an exhaustive investigation of Hogarth's activity as an engraver, make little attempt to situate his work within the wider context of graphic satire, or to look at the satires produced alongside Hogarth's in Georgian London. In his three-volume critical biography, *Hogarth* (1991–3), which sums up his career-long interest in the artist, we find few reproductions of contemporary satirical prints by other artists, and correspondingly little discussion of their impact on, and engagement with, Hogarth's own practice. While this shortfall is understandable, given Hogarth's own range, skill and ambition, there is always the danger that he and his work will become misleadingly understood as standing alone in an artistic and cultural vacuum, rather than being seen as participating in a broader context of pictorial practice.

This book shall seek instead to interpret a wider range of satires and satirists, and to concentrate on the graphic satire's primary status as an artistic product circulating in London's print market. Most importantly, I will study satirical prints as pictorial as well as textual sites of cultural production which both manipulated a wide range of graphic conventions and engaged with fundamental urban desires and anxieties. In doing so, I shall be echoing the preoccupations of two other scholars who have recently been working on eighteenth-century graphic satire, and whose writings I found invaluable as I completed this study. Diana Donald, in her important book on graphic satire in the second half of the eighteenth century, *The Age of Caricature: The Satiric Print in the Reign of George III*, 1996, has also argued that graphic satires need to be understood as complex pictorial artefacts, and has demonstrated their nature and scope in the years after 1760. Meanwhile, I have been informed and encouraged by Eirwen Nicholson's work on the historiography of English graphic satire, and on the new methodological approaches that the form necessitates. Her 1994 thesis at the University of Edinburgh, entitled 'English Political Prints and Pictorial Political Argument c. 1640–c. 1832: A Study in Historiography and Methodology', encompasses both a caustic summary of the failings of scholarship in this field, and a refreshing call for a greater historical attention to the pictorial and textual language of the prints themselves.

My greatest scholarly debt, however, as for all the researchers in this field, is to the work of Frederick Stephens, the Victorian critic and scholar who wrote the entries for the early eighteenth-century prints described in the British Museum's comprehensive catalogue of engraved satires. Not always exact in their dates or attributions, his descriptions of the hundreds of satires of the period collected at the Museum's print room have none the less been absolutely essential for my work, providing exceptionally helpful, generous and thought-provoking comments on each and every catalogued image. The 'BM' numbers in the captions refer to the print numbers in this catalogue. If Stephens's work has helped make sense of the graphic satire of the period, it also points to the sheer diversity and scale of the satirical material that is available to study. How, then, could this material be discussed in a relatively economical and concentrated way? In this book, I have

decided to focus in detail on a limited number of satirical engravings that I have found both compelling as independent works of graphic art and representative of the genre as a whole. Yes, this approach means that hundreds of satires produced in the period will escape discussion, and yes, it might imply an undue concentration on the more elaborate and sophisticated images produced in the period. But through such a method, I have been able to give due attention to the complexity of the satirical print as a visual artefact while simultaneously narrating a broader history – selective and partial no doubt – of graphic satire in the first half of the eighteenth century.

A great number of individuals have given me support and stimulus in this undertaking. Most importantly of all, my parents and brothers have provided a constant source of encouragement and enlightenment, and I dedicate this book to them, and to the increasingly extended family of which I am a part. My other great debts are to the three scholars who have been central in bringing this project to fruition. David Solkin supervised the thesis out of which this book has grown, and has been a most attentive, thoughtful and positive critic of all my work. I am particularly grateful to him. John Brewer, as well as offering hospitality and friendship in a variety of venues across Europe, provided detailed and much-needed comments on an earlier draft of the manuscript. Brian Allen, meanwhile, has placed his faith in this study from the start, and has been a tremendous source of advice and reassurance. I would also like to thank a host of other friends and colleagues whose conversations and criticisms have stimulated my research and writing, and made the whole process of becoming an art historian an interesting one: namely David Alexander, Andrea Ashworth, Malcolm Baker, Rosemary Baker, John Barrell, David Bindman, Phillipe Bordes, Timothy Clayton, David Peters Corbett, Geoff Cubitt, Gregory Dart, Diana Donald, Nicholas Flynn, Mark Jenner, Ludmilla Jordanova, Amanda Lillie, Richard Marks, Susanne Märtens, Tim Marlow, Christopher Norton, Steve O'Connor, Frédéric Ogée, Mike Palmer, Marcia Pointon, Adrian Randolph, Angela Rosenthal, Katie Scott, John Styles, and Marcel Theroux.

A number of institutions have also helped me investigate the eighteenth-century graphic satire. The first year of my research was financed by an Andrew W. Mellon Fellowship at the Yale Center for British Art, and I will always remain grateful to Duncan Robinson and the staff at the Center for helping make my time at Yale so exciting. During the same year, I was also lucky enough to visit the Lewis Walpole Library in Farmington, Connecticut, where I was given a warm welcome by the librarians, Joan Sussler and Anna Malicka. In London, the Paul Mellon Centre for Studies in British Art has been a constant source of information, expertise and good company, and I would like to thank Kasha Jenkinson in particular for all her help. The late Michael Kitson, Director at the Centre when I began my research, typified the combination of friendliness and know-how that continues to characterise the staff in Bedford Square. I would also like to thank Antony Griffiths and the staff at the British Museum's Department of Prints and Drawings, who have been endlessly patient and knowledgeable in the face of all my queries and requests. In particular, Andrew Clary, Sheila O'Connell, Jennifer Ramkalowon, Chantal Serhan and Kim Sloan all assisted me a great deal. Thanks, too, to the staff at the British

Preface

Library, where I have spent too many hours. Since moving to the University of York, I have been lucky to work with a highly collaborative and enthusiastic group of art-historians, and with extremely supportive colleagues from the English and History departments. I would especially like to thank Alastair Minnis and Allen Warren for their help as Heads of these departments. This book was completed in the same year that the new Centre for Eighteenth-Century Studies was officially opened at the University, and I hope the following pages will pass muster within this already thriving intellectual community. I have also been fortunate to work with some of the editors and designers at Yale University Press, and I would like to express my gratitude to Gillian Malpass, Katharine Ridler and Abby Waldman for making the whole process of transforming a rather ragged manuscript into a finished book so smoooth and pleasurable. I would also like to note the support I have been given by the editors of *Art History* and *tate* magazine, where parts of chapters 1 and 6 have already been published in revised form.

Finally, I would like to thank Lynda Murphy for making the last few years such a good time for writing and living. She has proved the best satirist of all.

Introduction

Two Satires

This book offers a new history of the English satirical print in the first fifty years or so of the eighteenth century. This was the period in which William Hogarth, one of England's most well-known pictorial satirists, produced such famous works as *A Harlot's Progress*, *Gin Lane* and *Beer Street*, each of which I shall be analysing in depth.[1] But this was also the period in which numerous other artists, far less well known to modern readers, designed and engraved a wide variety of fascinating satiric images, packed with biting comment and elaborate pictorial detail. In this book, I shall be looking at these men's output alongside that of their more celebrated counterpart, and arguing that both they and Hogarth need to be understood as participating in a shared, collective artistic enterprise – that of graphic satire.[2] As we shall see, graphic satire was a branch of art with its own pictorial and textual traditions and conventions, with its own, highly distinct cultural identity and with its own attractions for the contemporary viewer and consumer. Like many other kinds of printed image, the graphic satire was also highly visible. Distributed to overflowing print shops and boisterous coffee houses, pinned up in cluttered street windows, scattered across crowded shop counters and coffee tables, and then passed from hand to hand, or hung and framed in glass, or pasted in folios bulging with other graphic images – the satiric print was a dynamic and mobile component of English graphic art, and a ubiquitous feature of contemporary urban life. In particular, graphic satire was associated with London – with the scores of engravers and print publishers who lived and worked in the centre of the great city; with the hundreds and thousands of Londoners who formed the primary audience for satiric prints; and with the anxieties and preoccupations, both political and social, that characterised the English capital in the early eighteenth century. In the chapters of this book, the graphic satire will be seen to emerge not only from the minds and hands of individual engravers, but also from a dynamic, highly contested metropolitan culture.

I

The pages that follow will not only offer a broad narrative of graphic satire's history in late Stuart and early Georgian London; they will also make a series of inter-weaving arguments about what I see as the form's primary characteristics and

contexts. These arguments can be summarised as follows. Firstly, I shall suggest that early eighteenth-century pictorial satire was an artistic hybrid, combining acidic and witty commentary on a range of political and social issues with an eclectic, multi-referential form of pictorial and textual dialogue. Satire, alongside its polemical bite, was distinguished by its wide-ranging engagement with, and adaptation of, a variety of representational materials, both high and low.[3] Secondly, I shall argue that graphic satire enjoyed a crucial but ambivalent relationship with the narratives and representations of 'politeness', which recent scholars have so rightly seen as central to the cultural make-up of urban society in this period.[4] Thirdly, this book seeks to demonstrate that the engraved satire was powerfully responsive to developments within the print market in England's capital city, and that satire and the satirist always defined themselves in relation to this market. Fourthly and finally, I shall argue that satiric art actively participated in the world of entertainment and consumerism in contemporary London, and that to understand satire's attractions we need to relate the form to a range of other cultural products and events – pamphlets and plays, tracts and exhibitions – that were being manufactured and staged in the English capital.

As they stand, these four propositions remain rather abstract and skeletal. Before embarking on our larger history, we need to flesh them out a little, and to clothe them with some crucial historical detail. To do this, I propose that we bring them to bear on two exemplary graphic satires from the period: George Bickham's *The late P–m–r M–n–r* (*fig. 1*) and William Hogarth's *Morning* (*fig. 2*). The first print was published by Bickham, an engraver and entrepreneur working in central London, in October 1743, and then re-issued in December of the same year.[5] His engraving savagely attacks the recently deposed prime minister of Great Britain, Sir Robert Walpole, and is a striking example of political satire – that is, of an image that rudely focuses on a subject taken from contemporary political life. His work transforms the fallen minister's head into a fatty, rounded emblem of complacency and failure. Walpole's tilted face, pulled into close-up, its lips seeming to press against the picture plane from the inside, is depicted as an indecorous and shocking composite of exposed features, dominated by a yawning mouth. His tongue, teeth and gums are laid bare to view, as are his upturned nostrils and half-closed, squinting eyes. Framing his face are the undulating forms of a wig and a neckcloth. Cumulatively, all these details add up to a politicised, grotesque metaphor of Walpole's exhausted leadership, which Bickham has conveyed with particular relish.

The second image was published some five and a half years earlier, in the spring of 1738. Hogarth's work is an ambitious social satire, interested in exposing the hypocrisies of city life. One of a quartet of images that tied different areas of London to the four times of day, the print is dominated by the figure of a spinster walking to an early-morning service at St Paul's church in Covent Garden.[6] A closer look at the woman suggests that her air of worthiness is not as convincing as it might at first seem. Her ostentatious dress and loaded make-up are dramatically out of keeping with the modesty expected of a Christian lady. She is, we quickly realise, an elderly fashion victim, desperately clinging to a manufactured ideal of youth, elegance and beauty. More surreptitiously, her stare at the group of figures

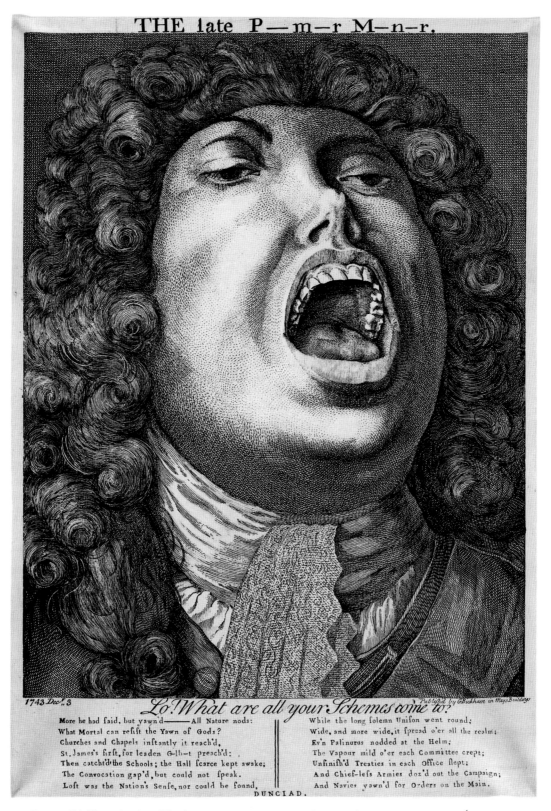

1 George Bickham junior, *The late P–m–r M–n–r*, 1743 (BM 2607). Engraving, 12 × 9½ in. Courtesy of the British Museum.

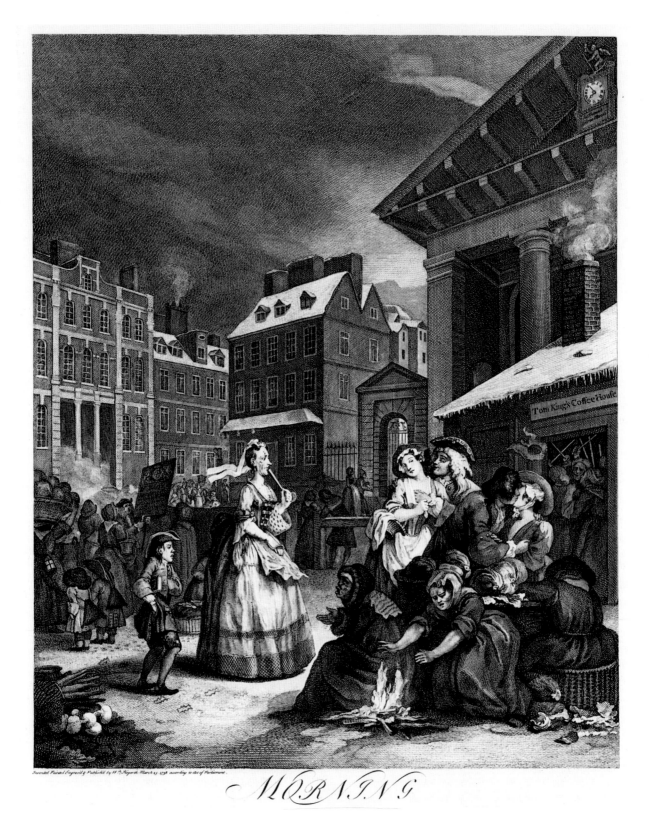

MORNING

2 William Hogarth, *Morning*, 1738 (BM 2357). Engraving, 19⅛ × 15¾in. Courtesy of the British Museum.

on the right suggests a salacious fascination with the activities taking place in front of her eyes, where a couple of rakes, stumbling out of the riotous environment of Tom King's coffee house, grope and kiss two young market girls. Alongside this comic embodiment of self-delusion and hypocrisy, Hogarth depicts a multiplicity of other figures, stories and encounters, including the figure of a frozen, hunch-backed servant boy, carrying the old lady's bible across the square.

Having briefly described these two images, we can now think about the ways in which they relate to the satiric characteristics and contexts I have outlined. To what extent do the two prints suggest not only satire's concern with exposing social and political deviance but also the genre's self-conscious heterogenerity of form and content? How do *The late P–m–r M–n–r* and *Morning* respond to the imagery and ideals of politeness that were being produced and promoted in the period? Where did such images fit in the contemporary print market? And how did they compete with, and fit alongside, the other kinds of cultural goods being manufactured and sold in the city: what was their artistic and commercial identity in urban society, and to whom did they appeal? Answering these questions will introduce us to some of the broader narratives of graphic satire in early eighteenth-century England, and open up the central themes and preoccupations of this book.

<div align="center">II</div>

By the early eighteenth-century, the word 'satire' enjoyed a number of connotations, which included being defined as a biting, frequently humorous form of critical commentary, and being understood as a miscellaneous assemblage of different materials. Satire maintained its traditional meaning as a literary form that, in the Oxford English Dictionary's words, was characterised by its employment of 'sarcasm, irony, ridicule, etc. in exposing, denouncing, deriding or ridiculing vice, folly, indecorum, abuses and evils of any kind'. *Cocker's English Dictionary* of 1704 focused on its aggressiveness, and declared that 'Anything sharp or severe is called a Satyr', while Oliver Goldsmith, half a century later, suggested that 'however virtuous the present age, there may still be growing employment for ridicule, or reproof, for persuasion, or satire.'[7] At the same time, the word's perceived links to the Latin term for a full, varied or mixed platter, *satura*, encouraged the writer Charles Gildon to point in 1721 to 'the variety or medley of subjects' that satire traditionally exhibited and encompassed, and to declare that the form's 'biting quality' was 'but one part of the whole.'[8] While such writers tended to have literary texts in mind when they sought to define satire's generic characteristics, prints such as those of Bickham and Hogarth worked to translate the features they described – particularly those described by Gildon – into graphic form.

Thus, looking more closely at Bickham's vitriolic attack on Walpole, we quickly find that *The late P–m–r M–n–r* is itself a pictorial medley, appropriating and gesturing to a variety of materials, both written and engraved. The engraving's caption, for example, is a revised extract from Alexander Pope's recently rewritten and re-issued poem, the *Dunciad*. Pope's poem, which linked Walpole's Whig party to the fictional reign of Queen Dullness over the nation, is here tied explicitly to

the figure of the 'late' Prime Minister himself, who occupies the Queen's former
position. Walpole's drowsy yawn, it is suggested, ripples imperiously and infec-
tiously across the country: 'More he had said, but yawn'd – All Nature nods:/
What mortal can resist the Yawn of Gods?'[9] At the same time,
the print's viewers would have appreciated the ways in which *The late P–m–r
M–n–r* echoed contemporary texts which caricatured Walpole's head as a gross,
gargoyle-like monstrosity. To give just one example, a 1740 issue of the opposition
periodical *The Champion* included a satirical proposal for 'a course of lectures on
the "Elements of Prime Ministry"', illustrated by a performing, mechanical head
which jerked successively into a 'very particular broad Grin', 'a stare which
surprizes and confounds', and a demonstration of 'the art of lie-looking'.[10] Looking
again at *The late P–m–r M–n–r*, we can now suggest that the reference to Pope's
yawning Goddess of Dullness is satirically supplemented, in the depicted face, by
the invocation of an alternative register of grotesque political portraiture being
developed in the city's periodicals.

Alongside this multiple engagement with literary and journalistic satire,
Bickham's print flaunts its exchanges with, and correspondences to, a variety of
pictorial representations. The open-mouthed, yawning portrait had become a stock
subgenre of modern pictorial satire, and Bickham's image related Walpole to the
ridiculed targets of prints like *Yae-ough* (*fig. 3*), issued by Thomas Bakewell in 1737.
Bakewell's satire humorously depicts a man who is unable to maintain a dignified
pose for his portrait, and whose yawn is recorded rather than ignored by the artist.
Even more strikingly, *The late P–m–r M–n–r* appropriated and resituated the details
of a printed sheet of physiognomic studies by the seventeenth-century Spanish
artist Jusepe de Ribera (*fig. 4*).[11] Ribera's reproduced drawings represented a
compendium of facial distortions and protubrances which focused as much on the
sprouting warts of a nose or chin as on the trio of yawning mouths arranged across
the page.[12] Bickham, in raiding so blatantly from this distinguished imagery of the
vulgarised face, and combining this reference with a more modern language of
satiric portraiture, thus dramatises his print as a graphic composite, one that fuses
the functions of political criticism with an elaborate programme of adaptation and
juxtaposition.

Hogarth's *Morning* offers a similar exchange with a multiplicity of textual and
pictorial discourses. Here, for economy, we shall concentrate on the central figure
of the strolling spinster, whose sartorial extravagance, as we have noted, is tied to
broader patterns of deceit and illusion – to fraudulent religious conformity and to
the doomed attempt to stave off the signs of age. This combination of targets was
already a staple of literary satire. In *The London Spy*, a comic tour of London
that was frequently republished in the years before *Morning's* appearance, Ned
Ward had described walking into Covent Garden, and noting with scorn an
'abundance of Religious Lady-birds, Arm'd against the assaults of Satan with
Bible and Common Prayer-Book, marching with all good speed to Covent-Garden
Church.' Visiting the church, it quickly becomes apparent that the women's
main aim 'was only to make Assignations; and the chief of their Prayers . . . [is]
that Providence will favour their intrigues.'[13] Another popular satirical writer in the
early eighteenth century, Tom Brown, had also attacked the 'old maid' who desires

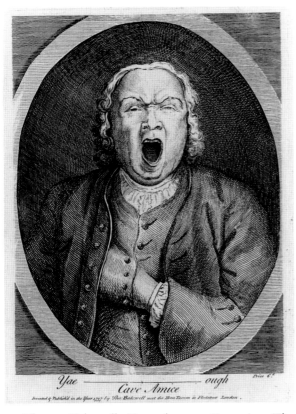

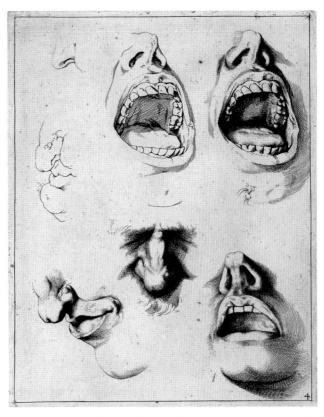

3 Thomas Bakewell, *Yae-ough*, 1737. Engraving. The Lewis Walpole Library.

4 Jusepe de Ribera (after), physiognomic studies, early seventeenth century. Engraving, $8\frac{3}{8} \times 5\frac{3}{8}$ in. Courtesy of the British Museum.

to 'be cherish'd like a girl of fifteen, in hopes that Paint, patches, and the religious Ogle, may get her a husband at last; believing that others cannot discover the Age, Ugliness, and Ill-Nature, under the double-disguise of body and soul, *saint* and *hypocrite*'.[14]

If, in his depiction of a 'Religious Lady-bird', Hogarth translates a standard trope of written satire, he, like Bickham, simultaneously engages with a number of pictorial vocabularies. In particular, *Morning* reworks an older, emblematic imagery which explicitly tied the narratives of cosmetics and clothing to religious hypocrisy. Hogarth's print reproduces the components of an engraving (*fig. 5*) found in a book entitled *Choice Emblems, Divine and Moral, Antient and Modern*, first published in 1684 and reissued in 1732.[15] Entitled 'Bella in Vista, Dentro Trista', the engraving shows another old woman sauntering across a city square, dressed to the nines and holding a fan in one hand and a youthful mask in the other. The accompanying verses elucidate the engraving's meaning: 'Look well, I pray, upon this Beldame here,/ For, in her habit, tho' she gay appear/ You thro' her youthful vizard may espy/ She's of an old edition by her Eye.' This critique of feminine dissimulation pierces the disguises of cosmetics, fashion and Christian respectability: 'I hate a painted Brow; I much dislike/ A maiden-blush draw'd on a furrow'd cheek . . ./

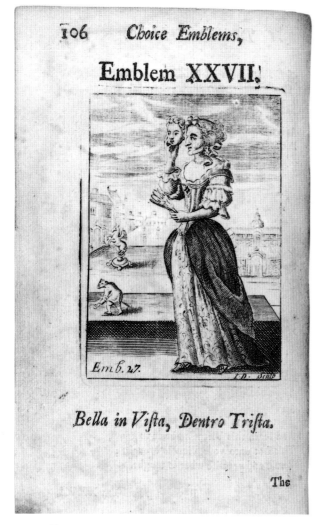

5 'Bella in Vista, Dentro Trista', from *Choice Emblems, Divine and Moral, Ancient and Modern*, London, 1732. Engraving, $3\frac{5}{16} \times 2\frac{5}{16}$ in. Courtesy of the British Library.

6 Elisha Kirkall, *Covent Garden*, from Tom Brown, *The Works of Tom Brown, Serious and Comical*, vol. 1, 1730. $4\frac{3}{4} \times 2\frac{7}{8}$ in. Courtesy of the British Library.

But more (yea most of all) my soul despiseth/ A heart that in Religious Forms disguiseth/ Prophane Intentions, and arrays in white/ The coal-black intentions of a Hypocrite.'[16] Noticing the formal and narrative correlations between the two images, it is clear that *Morning* offers a dialogue with an older tradition of emblematic representation. At the same time, Hogarth's print also responds to another kind of image: satirical illustrations of Covent Garden itself, which in the years immediately before the appearance of *Morning* were already castigating the square as a space of sexual assignation and intrigue (*fig. 6*).[17]

What we have begun recovering in this first return to Bickham and Hogarth's prints is the extent to which the graphic satires of the period were critical hybrids that reworked a wide range of literary and pictorial materials circulating in contem-

porary London, and played them off against each other. The prints we shall be looking at thus need to be understood as active repertories of signs that offered and foreclosed a variety of readings. They are objects whose meanings were generated as much by their engagement with other images and texts as by their self-sufficiency as individual works of art. In graphic satire, it is important to stress, these kinds of exchange were not something to be hidden away or denied. They were an intrinsic part of a satirical engraving's cultural and commercial appeal. For the contemporary viewer, graphic satire was appreciated both for the force and wit of its attacks on the figures and fixtures of political and social life, and also for its forms of representational dialogue, appropriation and play. So far, however, we have tended to concentrate on the satiric print's relationship to a broadly compatible and complementary network of materials, made up of other poetic and graphic satires, moralised emblems, and images of the grotesque. This remained only part of the genre's inter-referentiality. What we now need to suggest is graphic satire's charged relationship with other, more polite forms of representation.

<div style="text-align:center">

III

</div>

In the first half of the eighteenth century, the satirical engraving consistently engaged with the texts and images that were formulating an ideal of polite culture in London. These 'polite' modes of literary and artistic practice, frequently adapted from aristocratic models, were being deployed to provide a legitimate form of identity and community for the affluent members of commercial, urban society, and worked to disseminate the values of personal civility, benevolence, moderation and aesthetic discrimination on a collective basis. In recent years cultural historians such as John Brewer have usefully explored the impact of politeness on the society and art of eighteenth-century London.[18] In his book, *The Pleasures of the Imagination* (1997), Brewer offers a succinct formulation of the aim of politeness: this was 'to reach an accommodation with the complexities of modern life and to replace political zeal and religious bigotry with mutual tolerance and understanding. The means of achieving this was a manner of conversing and dealing with people which, by teaching one to regulate one's passions and to cultivate good taste, would enable a person to realize what was in the public interest and the general good. It involved both learning a technique of self-discipline and adopting the values of a refined, moderate sociability.'[19] In exploring the rise and impact of such values, Brewer focuses on specific kinds of social organisation and cultural practice, and in particular on the new clubs and journals that emerged in the early eighteenth-century capital. He highlights the importance of institutions like the Kit-Cat club in promoting an ideal of urbane sociability, one that was reinforced by the portraits of the club's members painted by the artist Sir Godfrey Kneller, and later reproduced as prints by John Faber in 1733. He also calls attention to the influence of publications like *The Spectator*, which disseminated the rules of polite taste and identity to an even larger public, both in London and elsewhere.

Satire's relationship to the institutions, the values and the materials of politeness was a dialectical one. On the one hand, thanks to its focus on the grotesque,

excessive and deviant aspects of urban politics and society, the satiric engraving offered a perspective on London life that clearly contradicted the characteristic forms and subjects of politeness. Satire introduced into visual representation the narratives of delinquency and abjection that were being screened out of the polite ideal of the modern city, and it aestheticised them. The satire made a spectacle of difference. Not only that, it also relentlessly parodied and poked fun at 'polite' artistic products, and by doing so called into question the values of such works. On the other hand, graphic satire, in its exposure of vice and its denunciation of political and social corruption, can also be seen to have worked in tandem with politeness. The satiric format stigmatised the aberrent bodies and spaces that were to be denied access to the polite public sphere, and reinforced the values of gentility through its deployment of the pictorial negative. Furthermore, satire's customarily ironic reworking of polite art can be understood to have confirmed that art's growing centrality in urban culture: the force of the satiric engraving's rhetoric of parody, trespass and dissent was always dependent, we can suggest, on the residual power of the forms of polite culture it was responding to and differing from.

This dialectical exchange with the codes of polite representation will become more evident if we return to our two satires. *The late P–m–r M–n–r*, in this light, can be re-read as a critical response to the kinds of elevated poetry and portraiture that offered men like Walpole a far more distinguished identity in contemporary culture. Thus, the acidic caption to Bickham's print can be usefully compared to an effusive poem published in the *Gentleman's Magazine* of October 1739, entitled 'On seeing a painting of Sir Robert Walpole': '*Britons*! When this *great character* ye view/ (*Great*, as e'er poet sung, or pencil drew;)/ Think each *illustrious Virtue* ye behold/ Which in her *patriots Rome* ador'd of old:/ And while ye praise the *limner's outward art*,/ Let *Walpole's* worth pierce ev'ry *Briton's* heart.'[20] The kind of image the *Gentleman's Magazine's* poet was writing about can soon be called to mind – indeed, it would have looked something like the portrait of Walpole painted by Kneller for the Kit-Cat club's rooms, again reproduced by John Faber in 1733 (*fig. 7*). John Cooper's mezzotint of Walpole (*fig. 8*), meanwhile, is another good example of the polite portrait prints of the prime minister being sold in the capital, here including a captioned list of the politician's offices and titles.[21]

Having looked at these two images, it quickly becomes clear that Bickham's satire offers a strident alternative to such portraits, and gained part of its polemical bite from its brutal revision of their details. In *The late P–m–r M–n–r*, the placidly idealised and distanced head that we see in Faber and Cooper's mezzotints is transformed. It is brought into claustrophobic proximity, ruptured by the gaping orifice of the mouth, and twisted outwards and upwards. The wig and neckcloth which, in the mezzotints, function as the elegant accessories of political office, are redrawn as the ill-gotten paraphernalia of power. Underneath, the calligraphic rhetoric of political distinction is replaced by the verses of a mocking poem. In all these ways, the satire punctures the pretensions of the polite portrait and breaks its rules. Yet we can also argue that Bickham's iconoclastic print concurrently works to empower, through its strategy of invocation and excess, precisely the kinds of representation that it seems to subvert. If the official portrait is called to mind as the

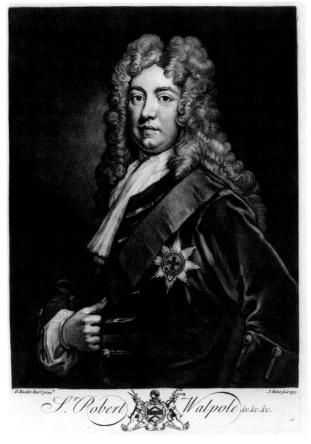

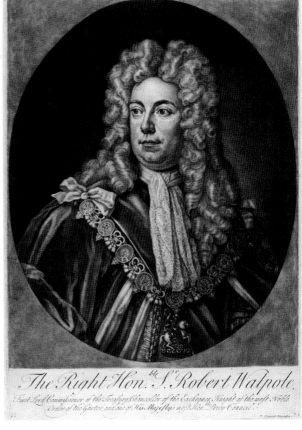

7 John Faber, after Sir Godfrey Kneller, *Sir Robert Walpole*, 1733. Mezzotint, $12\frac{1}{2} \times 9\frac{7}{8}$ in. Courtesy of the British Museum.

8 *The Right Hon.ble Sr. Robert Walpole*, c. 1735, mezzotint issued by John Cooper, $12\frac{1}{4} \times 10$ in. Courtesy of the British Museum.

pictorial template that is being vandalised, it is also dramatised as the hegemonic, regulative, model upon which the satiric image depends for its own coherence. Thus, even as *The late P–m–r M–n–r* denies Walpole's personal legitimacy as an honourable member of political culture, and instigates a policy of representational vandalism in order to do so, it simultaneously reinforces the legitimacy of that pictorial order – high portraiture – from which it seems to be dissenting. The deliberately mangled syntax of Bickham's print becomes as much a sign of a melancholy falling away from the polite pictorial grammar of public portraiture and from the political ideals associated with it, as it is a critique of that grammar and of the purposes to which it was being put by images like Faber's and Cooper's.

Graphic satire and what we might call, for want of a better phrase, polite art are shown in this process to have been bound up in a contradictory, antagonistic but mutually reinforcing relationship, the one helping to provide a form of cultural regulation and comparison for the other. We can recover an equivalent dialectics in *Morning's* relationship to competing depictions of Covent Garden, both literary

and pictorial. In the years before the appearance of Hogarth's print, polite texts had habitually represented the Garden either as a picturesque conglomeration of wooden stalls, private houses and public buildings, populated by an attractive array of fruit and vegetable traders, itinerant entertainers and local and foreign visitors, or else as a historic example of the urban square distinguished by its architectural grandeur. Remembering our earlier discussion of politeness, it is interesting to note that a 1712 issue of *The Spectator* offers a good example of the former point of view: the narrator declares that 'I could not believe any place more entertaining than Covent-Garden; where I strolled from one fruit shop to another, with crowds of agreeable young Women around me, who were purchasing Fruit for their respective Families.'[22] Meanwhile, a 1730 guide book for foreign and provincial travellers focused on the square's architectural merits: Covent Garden is described as 'a large pleasant square, and the most noted market in London for fine fruits, roots and physical herbs. In the middle is a Column with a sun dial, and on the east and north sides are noble pillars, with fine houses over them. The Church there is reckoned a masterpiece; it was built by the famous Inigo Jones, and is much admired, as being the only piece of Architecture that the Moderns have produced that can equal the Ancients.'[23]

In the same years, these mythologies of the Garden were being pictorially expressed by numerous artists, including Pieter Angellis, whose *Covent Garden Market* of 1726 (*fig. 9*) offers a particularly suggestive counterpoint to Hogarth's *Morning*.[24] Looking at Angellis's canvas, we can see that it is dominated by a trio of beautiful, elegantly dressed young women depicted at the centre of a series of looks, both male and female, that circle round their bodies. The three women are an urbanised version of the Three Graces, their profiles progressively swivelling around to allow us a fuller look at their faces and the contours of their dress and necks. One of them looks out at the spectator, half-smiling. Meanwhile, a flamboyantly dressed market trader, clutching a basket to his body, offers an illuminated register of visual and sexual interest in the three central shoppers that functions in a surrogate relation to that of the imagined male viewer of the painting. Here the market is defined not only as a colourful site of commercial bounty and entertaining spectacle, but also as an erotic territory opened up for the male gaze. If such details reinforce the *Spectator's* focus on the 'agreeable young women' shopping in Covent Garden, other parts of the painting depict the bountiful, picturesque market itself, and concentrate on precisely those architectural details listed in the guide book we noted.

Hogarth's image, we can now suggest, functioned as a powerful satirical counterpoint to such works. *Morning's* focus on the codes of contemporary fashion, on the market women, on anecdotal detail, on the narratives of erotic interest, and, most obviously, on the architectural details of a specific setting, suggest a highly self-conscious response to a specific category of contemporary painting. Here, however, this painting's habitual contents become subjected to a sustained process of pictorial parody and dislocation. The central figure of the overdressed spinster in *Morning* can now be read as a grotesque substitute for the fashionable urban females found in paintings like *Covent Garden Market*. The market women are no longer cheerful stall-holders or idealised cyphers, but are transformed into the victims of

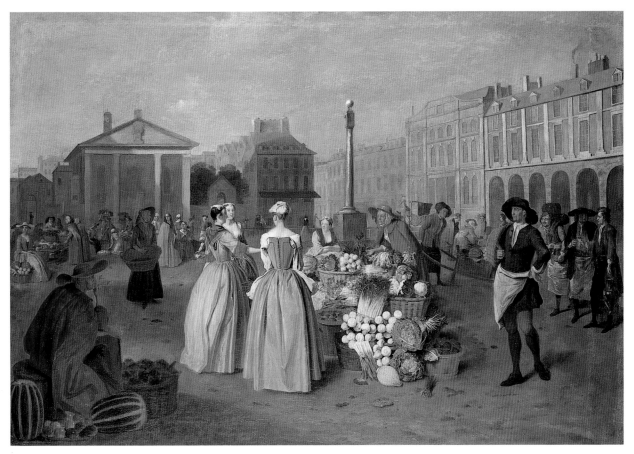

9 Pieter Angellis, *Covent Garden Market*, 1726. Oil on canvas, 30 × 49 in. The Marquess of Tavistock and the Trustees of the Bedford Estates.

poverty, of cold and of a drunken sexual assault. The fruit and vegetable market becomes a feeble repository of rotting plants and leaning placards, rather than an overflowing place of commercial surplus. Meanwhile, the view of St Paul's church is blocked by the dislocated, ramshackle structure of Tom King's, pulled from its actual position on the south side of the square. The Garden is cloaked in a miserable half-light, rather than being bathed by the rays of the sun. In all these ways, *Morning* powerfully contradicts the polite pictorial myths of Covent Garden being fabricated in contemporary visual culture.

Yet we can also suggest that, in so carefully delineating a pictorial catalogue of difference, social satires like *Morning* simultaneously dramatised the iconography of urban politeness as a positive counterpart to their own imagery of lasciviousness, squalor and hypocrisy, one that offered a model of social organisation and space with which the spectator could more easily and acceptably identify. Social satire, even as it provided a voyeuristic entrance into the disreputable but fascinating narratives of urban culture, kept in play a normative, more respectable, ideal of the city, one that the print's viewer could understand as his or her own, and return to. Recognising this, it becomes clear that *Morning* contradicts *and* confirms the more

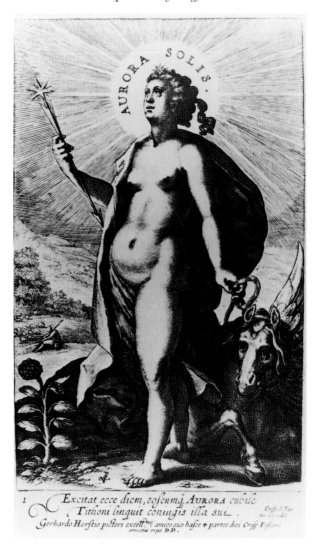

10 Crispijn de Passe the
Elder, *Aurora*. Engraving, 8 ×
4¼ in. Rijksmuseum.

genteel and desirable pictorial language of Angellis's prospect, and of others like it.
We can go on to note that *Morning*'s engagement with more conventionally
respectable images does not end here: as Sean Shesgreen has usefully demonstrated,
Hogarth's print also playfully evoked the venerable allegorical iconography of
Morning found in older 'Four Times of Day' engravings, and in this process linked
the decrepit, overdressed spinster to the traditional figure of Aurora, the goddess of
Dawn (*fig. 10*).[25] Again, Hogarth's reference is double-edged: on the one hand, his
comic modernisation of such images works to parody the older Four Times of Day
tradition; on the other hand, by making such a reference in the first place, Hogarth
aesthetically elevates his own project, and aligns it with a number of prestigious
graphic predecessors.

 What we have been uncovering here is satire's two-way relationship with the
literary and pictorial materials of politeness. We shall see that this was not only a

feature of Bickham and Hogarth's prints; rather, graphic satire as a whole was constantly involved in a complex process of cultural push and pull, in which the genre both asserted its own critical independence of polite forms of representation and also acknowledged its own complicity with and involvement in the workings of polite culture. This book will suggest, however, that this relationship became increasingly one-sided as the century progressed, and as politeness became more central and coherent as an urban ideology. Increasingly, satire was pushed into a more dependent, more responsive, and more conciliatory relationship with politeness. Yet even as this process gathered speed, graphic satires continued to emerge that maintained, or indeed accentuated, their own difference from the pictorial rhetoric of polite art. In so doing, they helped ensure that the genre maintained its distinct, iconoclastic identity within what was, as we can now explore, a crowded and highly competitive commercial environment.

IV

The primary commercial context for images like *The late P–m–r M–n–r* and *Morning* was the contemporary print market.[26] In the first half of the eighteenth century, London's print market was made up of a densely populated network of publishers, print sellers, artists and consumers, whose activities spread across a variety of urban sites, ranging from print warehouses to coffee houses. From the 1720s onwards, this grid of people and spaces was commercially dominated by the activities of two major print publishing businesses, those of the Bowles and Overton families. The Bowles concern, set up by Thomas Bowles in 1703, and carried on separately from the 1720s by his two sons, Thomas and John, gradually became the biggest print publishers in London. Simultaneously, the Overton firm, supervised after 1707 by another pair of brothers, Philip and Henry, became almost as large an enterprise. These two families of dealers sold thousands of prints on a wholesale and on an individual basis, many of which they advertised in ever-expanding catalogues.[27]

These catalogues – John Bowles's grew from thirty-six pages in 1728 to eighty-four in 1749 – are consistently packed with notices for maps, topographic prints, religious images and historical portraits, the venerable staples of the city's print trade. Increasingly, however, fine art engravings, ranging from reproductions of Italian Old Masters to prints after Dutch genre pieces, are also included and described in detail. This suggests that a traditional role for the printed image as an affordable piece of graphic furniture, and as a repository of useful information, whether civic, religious or historical, was gradually supplemented by the need to cater to a marked growth in the exercise of print connoisseurship in the city. In adding new prints to their stock, and in modifying their catalogues accordingly, the major print sellers were not only registering their own contribution to this shift in urban taste. The Bowles and Overton brothers were also responding to the commercial impact of other distinct but overlapping sectors of the print market – those made up of the print auctions, the print shops, and the engraver entrepreneurs of the city. All demand to be looked at in turn.

The print auction – and, in particular, the coffee house print auction – became a crucial event in London's graphic culture in the first half of the eighteenth century.[28] Such auctions were already regular occasions early in the period, widely promoted in the capital's newspapers. *The Daily Courant* of 18 February 1706, for example, announced that, 'at the Temple Change Coffee House in Fleet Street near Temple Bar, will be sold by auction a collection of extraordinary Italian, French and other prints, well preserved, and many of them at first printing. Beginning at 5 o'clock in the afternoon, and will be continued daily at the same place and hour till all are sold.'[29] The advertisement notes that the prints 'may be viewed at any time on the day before and after the [first] day of sale', and that catalogues are available at 'Olivers Coffee-house in Whitehall Gate, Mrs Sheffields Coffee House in Fleet Street [and] at the London Coffee-house in Threadneedle Street.'[30] Over the next few decades, this kind of print sale developed into an even more familiar occurrence, one in which the display of artistic appreciation and consumption fused with the other rituals of urban relaxation, conversation and business linked to the coffee house. At the same time, other kinds of establishment – the more salubrious types of tavern, the auction houses clustered around Covent Garden, the private houses of recently deceased or bankrupted collectors and artists – held similar sorts of sale. Like the coffee house auctions, they tended to take place in the early evening, and were normally preceded by the distribution of a catalogue and by the opportunity to inspect the hundreds, more often the thousands, of goods on display. Thus, in one of the newspapers advertising *The late P–m–r M–n–r* in the winter of 1743, we find an advertisement for a forthcoming print sale at Cock's Auction House in Covent Garden, which includes portfolios of prints after Watteau and Carracci alongside 'prints and drawings by RAPHAEL, GUIDO, POUSSIN, M. ANTONIO, P. VERONESE, TITIAN, TINTORET, J. ROMANO, CORREGIO, P. DA CORTONA, ANN. CARRACCI, REMBRANDT, HOLLAR, RUBENS, VANDYCK. And several others of the most eminent Masters. The said collection will be exhibited to publick View till the Time of Sale, which will begin each Evening at Five o'Clock precisely. Catalogues of which may be had at Mr COCK's.'[31] Auctions like these catered to, and helped foster, a highly sophisticated form of pictorial literacy in the city. They introduced a miscellany of engraved and etched images, largely foreign but also domestic, to an affluent constituency of urbanites. Thanks to the print auction, people in London became used to the spectacle of different prints being physically jostled and juxtaposed, and became experienced in comparing and contrasting their form and content.

A similar form of visual consumerism was encouraged by an adjoining site of graphic culture in this period, the print shop.[32] Graphic art was not only available at the major print seller's houses and the diverse sites of auction, but was also disseminated across a network of small retail outlets snaking along the central artery of the city, running from the recently completed St Paul's Cathedral in the east, along Fleet Street and the Strand, through the labyrinth of lanes and alleys around Covent Garden, and down to Charing Cross. Within this topographically confined space, numerous shops sold prints, and while there were only a few large concerns, far greater numbers operated on a more modest scale, run as family businesses, and frequently selling a range of other artistic commodities. Thus in *The Daily Courant*

of 23 April 1730, we find an advertisement for 'James Regnier at the Golden Ball in Newport Street, near Long Acre', who 'Sells all sorts of PRINTS, Italian, French, Dutch and others.' They include images of 'Statues, Vases, Fountains, Gardens, Buildings, Landscapes, Prospects, Sea-Pieces, Beasts, Birds', and are supplemented in Regnier's stock by 'Coloured Pieces for Japan Work, the finest Watercolours, Pastels, Black lead and hair pencils, Red, Black and White Chalk, Indian Ink, Gold and Silver Shells and Paper for Drawing.'[33] This miscellany of images and materials usefully suggests the variety of goods sold in such establishments. The engravings available in them ranged from the most distinguished fine art prints to those pornographic sheets noted by Ned Ward in *The London Spy*: 'In our loitering perambulation around the outside of St Paul's, we came to a Picture Seller's Shop, where as many smutty prints were staring the Church in the Face, as a learned Debauchee ever found in Aretine's Postures. I observ'd there were more People gazing at these loose fancies of some Leacherous Graver, than I could see reading of Sermons at the stalls of all the neighbouring Booksellers.'[34] However exaggerated, Ward's caustic comedy demonstrates how print shops had become fluid centres of visual culture in the city, selling both high and low forms of graphic art. As their numbers increased, and as the passage of prints across their counters became ever more hurried, they emerged as ubiquitous, bustling and highly visible centres of the print trade. Engravings would not only crowd the interior of such shops, and be put on display in their windows, but frequently would also spill haphazardly into the street itself, pinned to the door or window frame, and hung on boards standing outside.

A final – and for this study the most crucial – sector of the print market demanding to be noted here was that constituted by the engraver entrepreneurs of the city, who included artists like Bickham and Hogarth. This kind of individual – a trained artist who set up business as an independent producer and retailer of engraved goods – was part of a small but resilient community of engravers in London. George Vertue, an engraver himself, and the most fastidious chronicler of this group of artists, listed thirty-two master engravers working in London in 1713 and fifty-four in 1744.[35] These were men – in this period, professional engravers were exclusively men – who normally needed to harness their careers to the dominant organisations of graphic culture if they were to find steady work. Their commercial survival crucially depended on the patronage of commercial bodies within or closely linked to the print trade. They relied on being given a chance to execute reproductive engravings or portraits for the major dealers, and on being asked to produce illustrations and title pages for the London booksellers. In a similar vein, London engravers were available to design and cut prints for the owners of the smaller print shops, and to provide trade cards and other kinds of graphic ephemera for the city's shopkeepers. In carrying out these kinds of jobs, however, the engraver was customarily assigned a rather modest cultural and commercial status. As had traditionally been the case, he was regarded as a skilled but subordinate craftsman, dutifully responding to the demands of the more powerful institutions of the print market.

Over the course of the first half of the century the community of engravers in London attempted to challenge this subordination and, in doing so, dramatised

their growing alienation from, and discomfort within, the existing structures of the print market. Vertue's diaries are a powerful testament to this alienation, frequently lashing out at the print publishers that he perceived as his greatest enemies: 'they squeeze and screw, trick and abuse the representations of engravers', and 'raise their own future by devouring that of the sculpture-engravers, griping in every way possible.'[36] In order to carve out a new, distinct commercial identity for themselves, engravers increasingly turned themselves into entrepreneurs. Most had some kind of retail base in the city, even if this were only a rented room of a coffee house. More frequently, they operated from addresses that were part workroom, part shop, and which took their place in the constellation of print outlets in the centre of the city. From these premises, engravers increasingly resorted to promoting large-scale graphic schemes of their own, often financed by subscription. These frequently reproduced sets of Continental and Old Master paintings, such as Raphael's Cartoons. But engravers also executed and published single prints, both reproductive and original, which would be put on display at their own shops and in those of sympathetic print sellers.

Complementing this growing entrepreneurial independence, engravers also sought to assert their claims as liberal, creative artists. Here, it is worth reiterating that the paradigm for the ambitious engraver in London had long been that of a skilled copyist, someone who was valued for his ability to translate the painted model into a desirable graphic product. This form of artistic identity continued to be important in the eighteenth century. As we have seen, both the print entrepreneurs, and the London engravers themselves, frequently defined the graphic artist's proper role as that of reproducing an extant image. At the same time, however, we find that certain engravers were increasingly designing, engraving and publishing images of their own, and using this monopolisation of the different stages of the graphic process to claim a newer identity for themselves as inventive practitioners of the arts. Appropriating a critical discourse first articulated in the attempt to promote a contemporary school of British painting, most notably by Jonathan Richardson in his *An Essay on the Theory of Painting* of 1715, engravers began to define themselves as men whose worth depended on their ability to conceptualise and execute original works of art, rather than merely on their skill in graphic translation.[37]

Having surveyed the range of institutions and professions involved in London's print market, we can now suggest that the pictorial satire's history in this period was undoubtedly responsive to the broader commercial narratives of graphic culture. Thus, the engraved satire was a product that publishers like the Bowles and Overton brothers occasionally commissioned, sometimes purchased and frequently plagiarised. Looking through their catalogues at mid-century, we find a number of references to satirical prints, including ones executed by, and copied after, Bickham and Hogarth. The satire was also linked to the other major sites of print sale. The genre's self-conscious stategy of combining urban polemic with pictorial play was nicely complemented by the overlap between metropolitan debate and print connoisseurship found in the contemporary coffee house, where men were regularly acting out the kinds of interpretative practices demanded by the satiric engraving itself. The satiric print was also a product sponsored and sold by a wide

range of print sellers in the city, who utilised its scurrilous humour, entertainment value and pictorial variety in order to draw customers through their doors. Reading through the newspapers of the period, we find numerous advertisements announcing the publication of satirical prints by the capital's smaller print concerns: in March 1742, to give just one example, Thomas Cooper used the *Champion* to announce the sale of a print entitled *The Political Vomit for the Ease of Britain* (a title wryly described as 'sufficiently expressive without explanation'), at his print shop in Paternoster Row.[38] Most importantly of all, however, the graphic satire was associated with the engraver-entrepreneurs of the city. From the earliest years of the eighteenth century, numerous professional engravers produced graphic satires, both for the print publishers and print shop owners of the capital, and also for themselves. If the former role maintained their habitual position as subordinates within a commerical project financed and supervised from elsewhere, the latter offered new possibilities and opportunities for the individual engraver. Graphic satire's concentration on the urban and the modern, and its preoccupation with pictorial invention and play, allowed individual engravers to market themselves as modern artists in their own right, producing original work that focused not on the received subject matter of high art, but on the narratives of the contemporary city.

Nevertheless, it is also clear that the early eighteenth-century graphic satire was also perceived as a somewhat problematic and dubious commodity within graphic culture, difficult to reconcile with the notions of connoisseurship, use and decoration that underpinned the appeal of the individual engraving in the print market. The satire's relentless focus on the degraded and the scandalous meant that it existed on the fringes of aesthetic decorum throughout the period under study, and remained a risky product to commission, promote or execute as a desirable pictorial object. This was particularly true for the major players in London's graphic culture, who enjoyed easy access to those foreign fine art engravings that were almost universally accepted as the most refined and respectable kinds of graphic image to buy, and that were guaranteed by their Continental provenance to have avoided the taint of the provincial and the primitive that still clung to locally produced works like satires. From this elevated perspective, satiric engravings were stigmatised rather than praised for their typical forms of pictorial play and for their entertaining focus on contemporary subject matter. Ambitious engraving, it was widely understood, was predicated upon a deferential negotiation of the works of tradition, rather than the creation of iconoclastic and topical works of art. At the same time, satire's sophistication as a pictorial genre precluded any easy subordination of the genre into the realms of low art. Its self-consciously learned engagement with a variety of pictorial and literary codes distinguished it from the kinds of crude, lascivious prints attacked by Ward and, perhaps more importantly, from the cheaper, more popular formats of the ballad and broadsheet, which habitually carried a boldly drawn woodcut, and which were available for a penny from the street hawkers and the petty print shops of the city. Thanks to these differences, the satiric prints of the period, however thoroughly implicated in the wider workings of the print market, were inevitably marked out as recalcitrant, non-conformist images which maintained a certain distance from the other kinds

of graphic art, both high and low, being sold in the city, and which resisted the paradigms of refined and vulgar taste being fostered within graphic culture as a whole.

We can now see more clearly that prints like *The late P–m–r M–n–r* and *Morning* occupied an ambivalent position in graphic culture. On the one hand, images like these sought to appeal as legitimate and ambitious forms of graphic art, and be accepted as such within the wider framework of the contemporary print market; on the other, they cultivated a distinctly iconoclastic and antagonistic identity as images that refused to conform to the aesthetic and artistic norms being cultivated in this market. Rather than seeing this as an insurmountable problem, however, engraver entrepreneurs like Bickham and Hogarth, I suggest, exploited satire's ambivalent position to define a distinctly dualised commercial identity for both graphic satire and themselves. Here we can note again that Bickham's print, alongside its grotesque, debased focus on Walpole's gaping mouth, crammed with tongue and teeth, also flaunts its refinement as a pictorial commodity. Look at the exquisitely delineated whorls of the wig, the densely stippled depiction of the neckcloth and the circular pattern of dots that tracks across the politician's cheek – these are details that reinforce the print and its maker's aspirations to artistic sophistication and subtlety, even as these same details are harnessed to a distinctly scabrous political imagery. Thanks to such a mixture of seemingly contradictory qualities, visiting Bickham's shop near Covent Garden to see images like *The late P–m–r M–n–r* became a chance to indulge in refined connoisseurship *and* scurrilous humour.

Similarly, *Morning's* display of artistic inventiveness, reference and wit, its loyalty to Hogarth's painted original, and its undoubted technical brilliance, all helped ensure that the engraving would appeal to a knowledgeable and affluent audience of print buyers in the capital as an independent and ambitious work of art.[39] At the same time, Hogarth's satire is an image that, as we have seen, carefully defined itself as a shocking, witty and deliberately insubordinate alternative to more decorous images of Covent Garden being sold in the marketplace, which included, besides paintings like Angellis's, contemporary topographic prints of the square (*fig. 11*).[40] Looking at *Morning* as it hung alongside its painted and engraved companions – *Noon, Evening* and *Night* – in the artist's showroom in Leicester Fields, the prospective consumer could enjoy the ways in which Hogarth and his satire, just like Bickham and *The late P–m–r M–n–r*, were deliberately playing on the commercial as well as the pictorial borders between respectability and impoliteness.

V

Graphic satire's identity was not only conditioned by the workings of the contemporary print market but was also framed by the broader marketplace for printed products and urban entertainments. This is strikingly illustrated by glancing at two newspaper pages which advertised *The late P–m–r M–n–r* and *Morning* in the days surrounding their publication (*figs 12 and 13*). The first is the back page of *The*

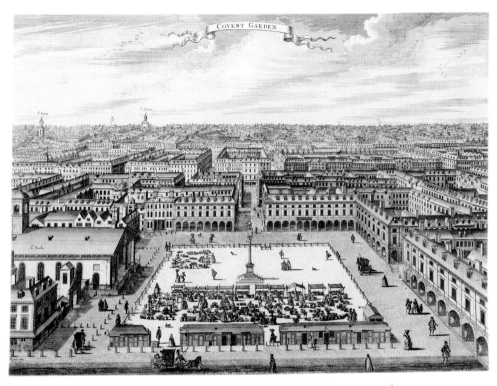

11 Sutton Nicholls, *Covent Garden*, from *London Described*, 1731, 13 × 17⅜ in. Courtesy of the British Museum.

London Daily Post and General Advertiser of 29 October 1743.[41] In the middle column, just above the centre, we find Bickham announcing the publication of three new satires, including *Great Britain and Ireland's Yawn*, which was the title given to the first published version of *The late P–m–r M–n–r*. This is advertised with other products from the engraver's commercial premises, including an introduction to geometry and a series of prints dealing with recent military affairs. More broadly, the notice for the first edition of Bickham's satirical portrait takes its place on the page beside an eclectic range of advertisements for other pictorial and literary publications, and for different urban events and entertainments. Sweeping across the different blocks of text, our eyes quickly notice an advertisement by Hogarth – for the *Marriage A-la-Mode* prints that he eventually published in 1745 – and a notice for Pope's revised *Dunciad*. The exhibition of an African hermaphrodite is also announced, juxtaposed with the details of a newly published tailor's biography, two dictionaries, a court report, a medical treatise and a number of other books and pamphlets. At the end of the page we find an example of the medical advertisements that were so ubiquitous in the period's newspapers, here offering 'An infallible cure for Barrenness in Women, and Impotency in Men, by Superlative Enlivening Drops.'

The second advertisement page is taken from an issue of the same paper from 9 February 1738, in which we find, in the upper left corner, a notice declaring that *Morning* and its companions – which included a fifth print entitled *Strolling Actresses*

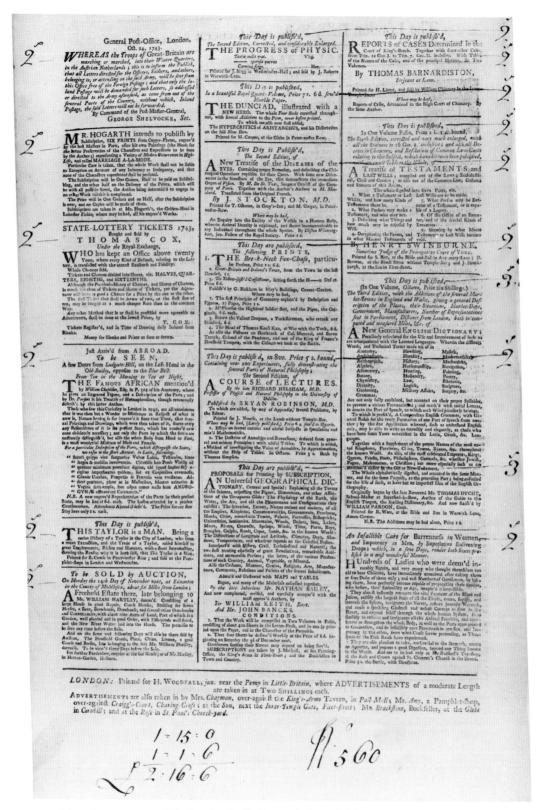

12 Advertisement page, *The London Daily Post and General Advertiser*, 29 October 1743. Courtesy of the British Library.

13 Advertisement page, *The London Daily Post and General Advertiser*, 9 February 1738. Courtesy of the British Library.

in a Barn – are 'in great forwardness.'[42] Across the rest of the page, we can see advertisements for a beerseller and an apothecary, for book auctions and bookshops, and for a smelling bottle that 'instantly relieves Persons in the most dismal fainting or swooning Fits.' Most prominently of all, a cluster of new literary publications are announced – the score of a 'burlesque opera', a geographical dictionary, a book promising to provide *The Rudiments of Genteel Behaviour*, a legal guide for women, a translation of Torquato Tasso's *Jerusalem*, an epitaph for Queen Caroline, a *Roman History*, two religious tracts and a literary satire entitled *The Tears of the Muses*. The page also carries a short advertisement for an anonymous *Enquiry into the Merits of Assassination,* a publication that used an account of Caesar's assassination to make the scandalous and only thinly veiled suggestion that the same fate should befall Walpole. It will be no surprise, perhaps, to find out that the author of this piece was none other than George Bickham junior.

A whole book could be written about such pages and the narratives they hold. For our purposes, they not only provide a vivid indication of the wider world of goods within which engravings like *Great Britain and Ireland's Yawn* – or, in its subsequent manifestation, *The late P–m–r M–n–r* – and *Morning* circulated, but also a useful introduction into the publication methods, the prices and the promotional languages of graphic satire in early eighteenth-century London.[43] It can be seen from his advertisement, for instance, that Bickham's satirical engravings tended to be published and sold individually, and normally cost sixpence, which was the most common price for graphic satire during this period. In this respect, the anti-Walpole satire we have been looking at was relatively expensive at a shilling. Turning to the advertisements for Hogarth's products found on both pages, we quickly notice that his images, by contrast, are sold as sets by subscription and are even more expensive. In the earlier notice, Hogarth announces that when the subscription is over and when *Morning* and its companions become available as single prints, they will cost five shillings each. If we compare these characteristics with those found elsewhere on the advertisement pages, we see that *Great Britain and Ireland's Yawn*'s status as an independent publication matches that of a range of printed goods, including a literary satire like *The Tears of the Muses*, and its price is the same as that of the medical tract listed immediately above Bickham's own notice. The subscription publication of *Morning*, meanwhile, echoes that of *The Rudiments of Genteel Behaviour,* while its price matches the musical score advertised nearby. Graphic satire's publication methods and prices, it is clear, were entirely comparable to, and competitive with, those of the other printed goods being promoted alongside them in the daily newspapers.

The very presence of Bickham and Hogarth's advertisements on such pages, moreover, confirms that satire was a highly visible and heavily marketed product in this period, something that is accentuated by the detail of the advertisements themselves, by their concentration on print publication as an event, and by their clear invitations to the consumer to come and inspect the goods in the artist's shop or showroom. Here, indeed, the exhibition and display of graphic satire is turned into something approaching pictorial theatre, with its own rhetoric of spectatorship and interpretation. In visiting Bickham's shop, the potential buyer would have been encouraged to appreciate a print like *Great Britain and Ireland's Yawn* as one of a

succession of such images produced by the engraver. Looking through Bickham's folios of anti-Walpole engravings, or scanning across the same images as they hung in the shop, the viewer was provided with an absorbing visual drama, in which Walpole's head and body were grotesquely transmuted from print to print. Meanwhile, the visitor to Hogarth's showroom could enjoy *Morning* as the first scene of an unfolding pictorial tour across London, in which the viewer, moving across to look at the paintings and prints of *Noon, Evening,* and *Night* that hung nearby – successively depicting Soho, Sadler's Wells, and Charing Cross – was offered a vicarious, theatrical encounter with the different spaces of the city. We can now see that Bickham and Hogarth's advertisements, housed in the same newspapers that carried announcements of nightly performances at the London playhouses and notices for a host of other performances and events, encouraged the reader to think of the publication and display of graphic satire in similar terms, as something that provided not only the opportunity to appreciate the individual image, but also the chance to indulge in a dramatic form of urban entertainment.

The two artist's advertisements are usefully representative of the variety of means by which graphic satire was being commercially packaged outside the engraver's workroom and the print shop. They not only help us understand how the eighteenth-century newspaper reader would have found out what was on offer within such environments, but also help us imagine why such a reader, after pausing for a moment, might have decided to go and look at what was on display. Who was such a reader likely to be?[44] While the evidence for, and scholarship on, graphic satire's audiences remains too thin for any detailed or steadfast answers to this question, I would like to suggest that *The London Daily Post's* advertisement pages also help us make some initial suggestions on this issue. For such pages both respond to and construct a specific audience, one that in this case is defined as resolutely metropolitan, relatively literate, moderately affluent, and eclectic in its tastes. It is interested in a wide range of urban pleasures, seeks instruction in a variety of disciplines, is willing to subscribe to books and prints, and can afford the prices being asked to do all these things. Recovering this imagined audience allows us to suggest that graphic satire, which in its own nature duplicated and exaggerated the eclecticism found on the advertisement page, appealed to what we can loosely call a 'middling' sector of urban society, whose social core was neither aristocratic nor plebian, but which comfortably absorbed individuals from both communities into its ambits. Even though more exquisite and expensive examples of the satiric genre – particularly those produced by Hogarth – were undoubtedly perused and purchased by an urban patriciate, and even though petty craftworkers and their social peers would also have appreciated some satirical prints, I argue that graphic satire was more generally aimed at the commercial and professional classes of London and Westminster, at shopkeepers and lawyers, coffee house owners and journalists, painters and publishers, clerks and doctors. These were men – and satire's primary audience seems to have been dominated by men – who were well read even if they were not always well educated, highly politicised even if they were not always part of the established political process, and visually literate even if they could not always afford to amass substantial collections of paintings or prints. Graphic satire's eclectic range of cultural references, its acidic forms of political and

social polemic, and its widespread use of pictorial appropriation and play all offered a kind of artistic practice that conformed to these men's own diverse tastes, skills, desires and anxieties, and that chimed in with the other kinds of cultural experience they were enjoying in the metropolis.

It was to this imagined and actual urban public, which certainly included aristocrats and apprentices, but which was dominated by tradespeople and professionals, that satirical engravings tended to appeal, and to which the efforts of artists like Bickham and Hogarth – even as they intermittently cultivated more elite audiences – were normally geared. Here, however, we need to stress that this public's status as a coherent 'public' had not yet, at the beginning of the eighteenth century, been fully fixed or recognised. Instead, we get a sense of an urban grouping bereft of any established system of identifications, aspirations and social bonds, whose collective identity was only just in the process of being forged. It was for this reason, we can now conclude, that satiric as well as polite forms of cultural practice developed in this period, together providing this loose assemblage of people with a dialectical range of representations and commodities that – in their contradiction and opposition – correlated to the bewildering vicissitudes and polarised experiences of urban life, and that – in their ultimate agreement and harmony – helped to provide a stable ideological basis upon which individual and collective identity could be defined. This book, among other things, is about graphic satire's own history within this broader process of urban cultural formation.

Using *The last P–m–r M–n–r* and *Morning* as pictorial exemplars has allowed us to begin recovering a number of graphic satire's most striking features, and to start considering a range of related issues that appear critical to an art-historical understanding of the genre's cultural status in the early eighteenth century. Now, however, we can begin telling a broader history, one that will deal not only with the constantly shifting role of graphic satire in the crowded and highly contested visual culture of the period, but also with the form's continuing dialogue with a multiplicity of urban preoccupations, ranging from alcoholism to fashion, from prostitution to politics, and from freemasonry to high finance. In looking at the satirical prints that negotiated these issues, we shall thus be engaging with some of the most pressing contemporary debates relating to life in the city, and be forced to think again about the ways in which the printed image variously resisted, amplified, ignored and confronted these debates. Doing this will help us redefine the graphic satire of eighteenth-century London as a highly responsive pictorial form, one that registered the central needs and demands of urban society, and that simultaneously signalled that society's deepest fissures and contradictions.

Chapter One

Pictures of Malice

A seven-headed dragon spits out daggers, swords, guns and whips; a peasant defecates next to the self-portrait of a painter; three winged allegorical figures fly across the English landscape, carrying an unfurled portrait of a cleric: when we begin looking at the earliest eighteenth-century graphic satires, we enter a strange, almost surreal visual world, swarming with grotesque monsters and serene angels, scheming villains and unruffled heroes. How did this world of discordant, disturbing and unfamiliar representations emerge, and how can we best make sense of it? To begin answering these questions, we shall in this chapter look in some detail at a variety of graphic satires produced between 1706 and 1711, ranging from political and religious engravings attacking the clergyman Henry Sacheverell and the writer Daniel Defoe to more enigmatic satirical prints which juxtapose kings and insects, soldiers and clowns, playing cards and obituary notices. In doing so, we shall be recovering the intimate links between graphic satire and political debate in London, and unearthing the striking continuities between early eighteenth-century satires and those produced in the final decades of the previous century. We shall also be discovering the ways in which graphic satire could be promoted as an ambitious form of visual art in this period, demanding a high degree of artistic sophistication and experimentation on the part of the engraver, and encouraging both the most stringent and the most playful kinds of interpretation on the part of the viewer.

I

We can begin by noting that the engraved satire was already a well-established category of the graphic arts at the beginning of the century. From the time of the Civil War onwards, the print entrepreneurs of London had commissioned and published satirical engravings that fused pictorial representation with religious and political critique. In the later seventeenth century, for instance, print sellers such as Peter Stent and John Overton recognised the particular appeal of such images during periods of urban controversy, and their publications in this line gave London's print buyers the chance to enjoy individual engravings as both works of art and as vehicles of metropolitan commentary.[1] Even though some of these images were executed by the most distinguished graphic artists working in the city,

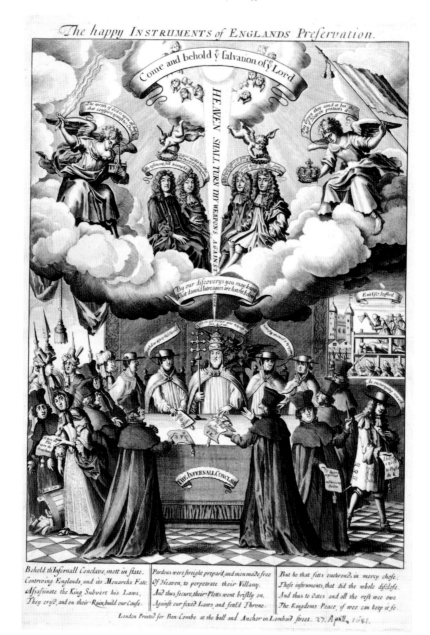

14 Francis Barlow,
*The Happy Instruments
of England's Preserva-
tion*, 1680 (BM 1114).
Engraving, $13\frac{7}{8} \times$
$10\frac{1}{4}$ in. Courtesy of
the British Museum.

including Francis Barlow and Wenceslaus Hollar, they have tended to be dismissed, like many later satires, as 'lowly . . . ephemerae'.[2] Yet, as a glance at a Barlow engraving of 1680 confirms (*fig. 14*), the political prints of pre-Georgian England were often highly detailed and inventive composites of visual and verbal signs, assuming a visually literate and educated readership. Functioning simultaneously as a specialised commodity within the print market, and as pictorial interventions in the realms of public debate, they constituted an important part of the capital's visual culture.[3]

In the first decade of the eighteenth century, the graphic satire maintained this long-standing artistic status, and remained remarkably loyal to the kinds of subject and iconography found in earlier prints.[4] To recognise this, and to start recovering the continuities and disruptions of the political satire in the years before the accession of George I in 1714, we can usefully look at the satirical engravings which responded to the first great ecclesiastical and political crisis of eighteenth-century London. On 5 November 1709, Dr Henry Sacheverell, chaplain of St Saviour's church in Southwark, gave a sermon at St Paul's Cathedral that sparked off a turbulent winter and spring of controversy and riot in the capital. For an hour and a half, the visiting cleric mounted a scathing attack on both the secular and ecclesiastical governments of the country, claiming that they were riven with traitors, 'monsters and vipers in our bosom', who colluded with each other to undermine the traditional tenets of the Church of England and to allow the establishment of a new ruling alliance of Whigs and Dissenters.[5] Exploiting a growing popular disillusion with the current Whig ministry, Sacheverell declared that the political leaders of the country were encouraging foreign immigrants to pursue their own, alien, religious practices in the capital, and aiding a native population of Dissenters, 'clamorous, insatiable and Church-devouring malignants', in their attempts to destroy the structures of the English Church.[6]

The ferocity of the sermon provoked a rapid response from the government. After a parliamentary majority had impeached Sacheverell for high crimes and misdemeanours against the state, the rebel chaplain was temporarily placed in custody and in February 1710 brought to trial. These events generated extraordinary public interest. Driving to court each day, Sacheverell's coach was swamped by huge, supportive crowds who sustained his contemporary cult status as a victim of political machination and religious betrayal, and who flooded into Westminster Hall, where the trial took place, to watch the proceedings. The relative lenience of the eventual verdict – Sacheverell was barred from preaching for three years, and his most inflamatory sermons ordered to be burnt by the public hangman – was greeted by large sections of the London populace as a moral victory, and the widespread celebrations that followed rapidly took on the roving form of a riotous, night-time assault on Dissenting meeting-houses. Six were sacked during these disturbances, which not only involved the disenfranchised poor – stigmatised as the conventional representatives of the mob – but also lawyers, bankers, physicians, shopkeepers and perriwig-makers, men who made up the nascent urban constituency of radical Toryism that Nicholas Rogers has so convincingly situated as the centre of metropolitan opposition to early eighteenth-century Whig government.[7] Despite a temporary, militarised calm, and the uneasiness with which the political nation regarded such outbursts of civic unrest, the events of February and March 1710 drained the government of political credibility, and in the parliamentary elections later in the year, a Tory ministry came to office.[8]

Taking place within an urban environment that was highly politicised and crowded with publishing outlets, the controversy spawned a huge body of texts, amounting to some 600 pamphlets, broadsides and sermons. Simultaneously, the crisis offered a temporary and lucrative focus for the capital's print entrepreneurs and engravers. Publishers rushed to issue the cleric's likeness, while denouncing

rival, independently published versions of Sacheverell's portrait as feeble imitations of their own products. In the *Evening Post* of 25 February 1710, for example, Philip Overton advertised 'the only true portrait of the effigie of Dr Henry Sacheverell. curiously perform'd in mezzotint, done from a painting of Mr Gibson, price 1 shilling 3d.' Overton includes a specific warning against cheaper plagiaries, 'all being imperfect copies, and not taken from the painting.' Two months later, the *Daily Courant* carried a similar advertisement, announcing a portrait of Sacheverell 'taken from the life, and very curiously engrav'd upon a copper plate by J. Nutting, and worked off upon a superfine paper. Price 3d. Beware of counterfeits, this will easily be distinguish'd by its goodness.'[9] Meanwhile, other engravers like George Bickham senior and George Vertue also produced portrait engravings of the cleric, and Thomas Gibson's painting of Sacheverell was even reproduced by Peter Schenk, a mezzotinter working in Amsterdam, and resold on the London market (*fig. 15*).

The ubiquity of the chaplain's portrait in the city, unsurprising in the light of this concentrated pattern of artistic activity, was noted by the writer William Bisset in his critique of Sacheverell's plebeian appeal: 'nine parts in ten of the public houses, whether taverns, ale-houses or bawdy-shops, are staunch conformists; and most of them have the Doctor's picture in their chief dining rooms, and some, I have seen, his sign at their doors.'[10] Clearly, Sacheverell's image had temporarily acquired the status of an urban icon. Furthermore, it was a commercialised 'effigie' that was concurrently being transplanted onto the material accessories of metropolitan life: carved on tobacco stoppers, imprinted on seals for letters, and even cut into coat buttons. In this process, the reproduced portrait became a key instrument within a culture of political celebrity that could redefine the most quotidian practices and performances in the city – unbuttoning a coat, smoking a pipe or having a drink – as displays of religious allegiance and political identity.

Sacheverell's portrait was also fixed to the inside of chamber pots in this period, which quickly alerts us to the fact that the promotion of a cult of personality and hero-worship was accompanied by the production of numerous texts, images and, in this case, household objects, that articulated a satiric counter-identity for the cleric. A slew of pamphlets and broadsides defined him in relation to the grossest narratives and languages of the city. Daniel Defoe, for instance, described Sacheverell's vocabulary as a 'kind of street-dialect, fitter for the kennel than the Church, and better suited to Billingsgate and the Bear-Garden than the Cathedral.'[11] The author of a pamphlet called *The Priest turn'd Poet* declared that Sacheverell had 'exhausted all the topics of Ill-Nature and Billingsgate, to patch up his discourse. There are so many new coin'd phrases adapted to scolding in it, that I fancy he has bankrupt all the Oyster-women, Porters, Watermen, Coachmen and Carriers in town, to make up his collection.'[12] At the same time, Sacheverell was linked to the extravagancies and influence of the Catholic Church, and to the maleficent counsel of the devil: 'Who do we fight against?' asks a soldier in a contemporary farce, as he quells a pro-Sacheverell riot, and is answered 'The Pope and the Devil'.[13] Similarly, Defoe wrote a pamphlet in 1710 called *Instructions from Rome*, which purported to be a letter from the Pope naming Sacheverell as his son.[14]

T. Gibson Pinx: *P. Schenk Fec: et Exc: Amst: C.P. 1710*

Henricus Sacheverell S.T.P.

15 Pieter Schenk, after
Thomas Gibson,
Henricus Sacheverell, 1710.
Mezzotint, 10$\frac{1}{2}$ ×
8$\frac{1}{2}$ in. Courtesy of the
British Museum.

The High Church Champion and his two seconds (fig. 16), an anonymous satirical
engraving issued in the months after Sacheverell's sermon, is an image that main-
tains this second framework of critique. The print shows the doctor writing in
his study, guided by the twin muses of the Devil and the Pope. Turning to the
representation of Sacheverell in this satire, it is immediately apparent that it
recycles, fairly precisely, the idealised portraiture being circulated so actively in the
print shops of the city. At the picture's centre, the cleric's bewigged head offers
a striking, reversed, parallel to Schenk's mezzotint, even down to the details of
Sacheverell's plump cheeks and heavy eyelids. Yet while the satire reproduces the
conventions of the celebrity portrait, it simultaneously subverts those conventions
through an additive strategy of pictorial and textual juxtaposition that invites a
wholly antagonistic set of readings. The gleaming surfaces of Sacheverell's wig, skin
and clerical robe are newly supplemented by an imagery of grotesque corporeality
and Catholic ritual: the freakish, floating devil is satirically balanced by the image

THE
High Church Champion
and his two seconds.

1709

'Tis these False Brethren, plague ye Church & State,
Princes dethrone, and CIVIL WAR create,
And the just power, of Parliaments debate,
Such pamper'd Priests, plead ye Pretenders cause,
Support his Faction and dispise the Laws,
And cry High Church, is ruin'd and undone,
If Persecution, don't through Britain run.

What tho: this EMBLEM, may have little in't,
Yet since you bought ye Sermon, buy ye Print.

1709

16 *The High Church Champion and his two seconds*, 1710 (BM 1498). Engraving, 5½ × 6½ in. Courtesy of the British Museum.

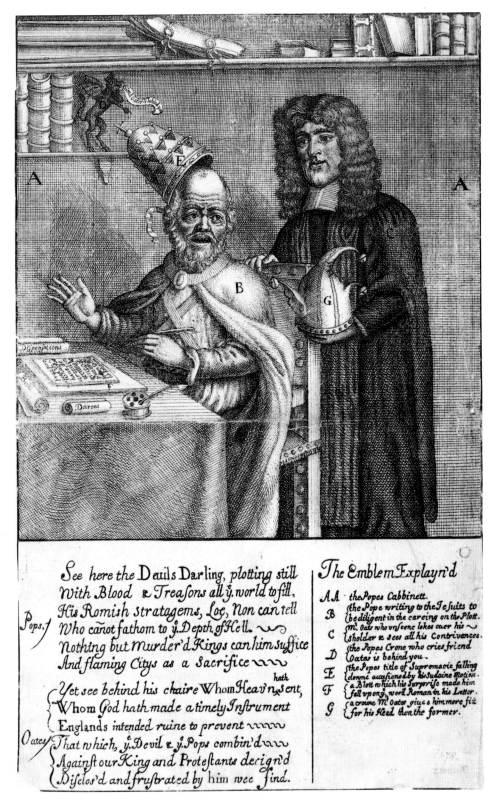

17 *The Devil, Titus Oates, and the Pope,* c. 1678 (BM 1068). Engraving, $6\frac{1}{4} \times 5\frac{3}{4}$ in. Courtesy of the British Museum.

of the Pope giving benediction. The studiously minimalist transcription of pictorial space in Schenk's image, and its single strip of text, are replaced by an expanded inventory of space, figures and poetry. Here, the satire announces its status as an image that both contributes to a contemporary process of pictorial commodification and celebrity, and that also undermines the pictorial construction of personal and public identity developed by that process.

This parodic engagement with a modern phenomenon of the print market is complemented by the engraving's broader appeal as both a scandalous, excessive vehicle of political attack and an elegant graphic object that competed with the other goods being advertised and displayed in the print shops and print auctions of the city. Alongside its scurrilous pictorial slander, the print flaunts its aesthetic and formal credentials. The delicately patterned gown and hat of the Pope, and the fastidiously delineated textures of the tablecloth, not only helped secure satirical narratives of ostentation and vanity but also propped up the commercial appeal of the engraving as a refined decorative object. This appeal is reinforced by the internal frame and the calligraphic support to the image. Framed, the restless mobility of a reproduced urban icon is reconfigured in terms of the static, vertical closure of the individual, collectible work of art. Outside this frame, the undulating forms of a penman's writing endow political and religious polemic with a supplementary value as calligraphic embellishment.

At the same time as it asserts its engagement with the contemporary workings of graphic and political culture, *The High Church Champion* indicates the early eighteenth-century satire's continuing dependence on iconographic and symbolic tropes established in print culture during the previous century. More specifically, the print clearly adapts the narrative, figural and spatial organisation of *The Devil, Titus Oates and the Pope* (*fig. 17*), a satire released sometime during the 'Popish plot' scare of the late 1670s and early 1680s, which had been sparked off by the fraudulent announcement of a renegade cleric, Titus Oates, that he had discovered a Catholic scheme to invade Britain and kill the king.[15] The earlier print's protagonists are depicted in the Pope's study, or 'cabbinett', where the figure of Oates is shown surprising his adversary at work, and offering him a fool's cap to replace his tumbling hat. A devil is squeezed onto the book-lined shelves, and warns the Pope of Oates's presence. While, in *The High Church Champion*, Sacheverell is the focus of attack, and is not heroised as Oates is in the earlier print, the two satires display a near-identical triumvirate of figures, with the one cleric replacing the other. Both images are set in a private study, and are cluttered with the same kinds of material objects – a writing desk, bookshelves, an inkpot. Both invite the viewer's eye to move along similar compositional and narrative routes, which pass across the fingers resting on the back of a chair, and spread to the outstretched hands, the quill and the fragment of text lying on the tablecloth.

Comparing *The High Church Champion* with *The Devil, Titus Oates and the Pope* in this way also helps us to appreciate the ways in which early eighteenth-century religious and political satire maintained a long-standing emblematic tradition; indeed, it is striking that both images use the term 'Emblem' to define themselves.[16] In doing so, they were situating themselves in a venerable graphic format that invited a mode of viewing which moved comfortably between the reproduced

image and the printed word, and that expected the one to inform the other. If, in later satire, the pictorial took a greater precedent over the textual, the format never entirely lost this emblematic interplay between word and image. In the *High Church Champion* the interplay is explicitly extended outwards, beyond the print's edges. The satire not only depicts Sacheverell writing his infamous text, but also offers itself as a subversive pictorial complement to the Doctor's sermon, one designed to accompany the published version of Sacheverell's address circulating in the capital: 'since you bought ye Sermon, buy ye print.' The political potency of this satirical alignment is indicated by the author of *The Picture of Malice*, a pamphlet of 1710, who declared that prints like *The High Church Champion* had 'been the chief machine which his enemies employ'd against the Doctor; they have exposed him in the same piece with the pope and the devil . . . what admirer can now be so blind as not to see his cloven foot?'[17]

Far from being an isolated pictorial phenomenon, *The High Church Champion* was a satiric commodity that competed with a variety of other graphic products issued at the time of the Sacheverell affair. Perhaps the best indication of the claustrophobically intimate dialogues of pictorial polemic in the period is provided by a print produced in direct response to the anti-Sacheverell satire we have just been examining. In all probability engraved by George Bickham senior, *To the Unknown Author of the High Church Champion and his Two Seconds* (*fig. 18*) maintains *The High Church Champion's* basic structure, but transforms its contents and meanings.[18] Comparing the two images, as we are expected to do, we quickly see that Bickham has metaphorically peeled Sacheverell's image away from the earlier satire and taken it elsewhere. The Doctor's displaced, unrolled portrait is held by two angels, and the trumpeting figure of Fame flies overhead. This flattened, pyramidal group hovers above the shadowed figures of Malice and Discord sprawling across the foreground, and is superimposed over an idealised English arcadia far from the city, dotted with the landmarks of a classical temple, a church and a farmhouse, and populated only by a fisherman and a walker. Through these strategies, the engraving articulates a process of pictorial withdrawal for its subject, as Sacheverell's public identity is reconstituted in terms of an iconic mask, a representation within a representation, further framed and protected by a classicised vocabulary of feminine allegory and rural harmony. The generalised, laundered iconography of the engraving not only offers an internal opposition to the grotesque imagery of the earlier artist – here invoked by describing the prone figures in the foreground as 'thy two Emblems' – but also helps seal Sacheverell off from the accusation that his renown depended on a prostituted exchange with the grossest urban subcultures; rather, it is suggested, he occupies a chaste, ruralised realm of retreat.

Looking at prints like these helps us interpret and contextualise the ways in which the political and religious satire worked in the early years of the eighteenth century.[19] Clearly, the Sacheverell engravings need to be situated in relation to a tradition of satirical representation stretching back into the previous century. But they should also be understood as intervening in the contemporary patterns of artistic and political commodification in the city. *The High Church Champion*, as we have seen, mimicked the iconography of political celebrity, while overwriting that iconography with new, subversive meanings. It deferred to, and intervened

To the
unknown AUTHOR of the
HIGH CHURCH CHAMPION.
and his two seconds.

See, Spightfull Numskul of Fanatick brood,
Once in thy Life thy Qualities do good.
See whom thou striv'st to tarnish shine more bright;
So innocent a Thing is Foolish Spight.
See him ascend with Fame and Angels round,
Whilst thy two Emblems grovel on the ground.
But if thou say'st "Those Emblems are not mine,
Then take the Devil for the Devil's thine.

I own Shallow fool that your Emblem in print
Is brim full of Wit, or the Devil is in't.

1709

18 George Bickham senior(?), *To the Unknown Author of the High Church Champion*,
1710 (BM 1501). Engraving, $6\frac{1}{4} \times 7$ in. Courtesy of the British Museum.

in, the political discourses of the day, while asserting its status as an aestheticised site of visual appreciation operating outside those discourses. It also competed with the other refined graphic products being promoted in the modern print market, while announcing its ironic distance from them. In generating this representational dialectics, the print was part of a satirical agenda that self-consciously merged a variety of pictorial and textual materials, and that was being refashioned in response to the new political narratives and artistic conditions of an expanding, urban public sphere. The political satire was enjoying a critical resurgence as a pictorial product that confronted those narratives and conditions, and that was starting, if somewhat conservatively, to claim a specific, distinctively modern identity in graphic culture.

II

The first decade of the century saw another, more ambiguous, kind of satirical art being developed in London, that of the medley print.[20] To understand its identity and appeal, we can turn first to the figure of the engraver entrepreneur John Sturt. Sturt's business, in a shop and studio in Golden Lyon Court just to the east of St Paul's, typified the diversity expected of the contemporary London engraver. One of Sturt's identities was that of a 'penman' – a draughtsman whose calligraphic and pictorial skills were employed not only in commercial engraving but also in producing 'penbooks' full of elegant calligraphy and in running a drawing school. Alongside such projects, Sturt produced elaborately illustrated books. In 1707, for instance, he published an adaptation of Andrea Pozzo's *Rules and Examples of Perspective*, 'engraven on 105 ample folio plates, and adorn'd with 200 initial letters to Explanatory Discourses: Printed from copper plates on ye best paper.' He went on to revise and copy Claude Perrault's *Treatise on the Five Orders of Columns in Architecture*, and produced a *Complete History of the Holy Bible* that was 'adorned with above 250 cuts.'[21] In Sturt's output, these pictorial translations of the most elevated blueprints of Continental learning and religious narrative were accompanied by a variety of less ambitious, expensive and time-consuming projects. He engraved trade cards and also accepted commissions for the graphic paraphernalia that so ubiquitously framed the text in early eighteenth-century publications: frontispieces, illustrations, title pages, decorative borders and tail-pieces.

Sturt's workshop also generated a more unusual kind of image, the medley print. In an advertisement of 1717, the engraver described a medley he had first published in 1706 and which, for clarity, we can call *The May Day Country Mirth* (*fig. 19*):

A Miscellaneous piece of art on a broadside, in imitation of ye manner of engraving of the following masters, vis King Henry VIII and a Blackmoor Woman's head, after Mr Hollar, one after the noble Callot. A title-page dedicated to the Duke of Burgundy, after M. le Clerc. A Page in Red and Black in imitation of the Letter Press. A Drawing in Red Chalk, another in Indian ink, on blue paper. A piece of old Manuscript writing in red and black. A ballad

entitled May Day Country Mirth: wherein the woodcuts and letter-press are imitated. A map of Great-Britain and Ireland, after Mr Clerc, engraver. A knave of clubs after the cardmasters way of painting and colouring. Also several insects and butterflies in miniature. The whole thing being a Deceptio Visus; for at a small distance, they appear like so many single pieces promiscuously thrown one upon another. Price 5 shillings.[22]

Sturt's engraving fuses the mechanics of trompe l'oeil with a sustained programme of representational juxtaposition and overlap. Through an almost microscopically exact process of pictorial imitation, the engraver attempts to persuade us, however momentarily, that we are gazing at a scattering of printed and drawn objects, thrown together in front of our eyes. The recycled images of great seventeenth-century and contemporary engravers – Wenceslaus Hollar, Jacques Callot, Sebastien le Clerc – are laid next to anonymous tokens of pictorial and calligraphic practice – a tract entitled *The Frenchman and the Spaniard*, an upturned playing card, a popular ballad, an unfinished drawing, a fragment of Latin text. A fly, two butterflies and a beetle stroll across this assembly of goods, their hovering, transparent wings reinforcing *The May Day Country Mirth*'s powerful if temporary claims to three dimensionality.

How best can we explain this print? We might begin by suggesting that it was aimed at exploiting and inviting the pleasures of visual deception. This is something celebrated not only in Sturt's advertisement, but also by the tiny roundel that lies above Callot's cannon-men in his print, written in the miniscule lettering that was a conventional badge of the Penman's prowess. The roundel bears a quote from Dryden: 'HEARING excites the mind by slow degrees; the man is warmed at once by what he SEES.' Here, we are directed to the thrill of 'seeing at once', when the viewer in fact mistakes the print for something that it is not. Contemporary texts on the arts dramatised the significance of this deceitful first impression. Dryden's introduction to the 1695 translation of du Fresnoy's *The Art of Painting* summarised the French writer's argument that 'the chief end of Painting is to please the eyes . . . the means of this pleasure is by Deceipt.'[23] Similarly, Roger de Piles, whose criticism was being translated into English in this period, declared that 'the essence of painting consists not only in pleasing the eye but in deceiving it'.[24] Although the writings I have cited focus on painting, they offer a highly suggestive critical context for the workings of the medley. In the case of the *May Day Country Mirth*, too, the viewer is supposed to appreciate the visual trap laid by the engraver, and regard the image's self-conscious artifice as a gauge of skill.

At the same time, Sturt's medley functioned as a wide-ranging form of commercial display. *The May Day Country Mirth* not only indicated Sturt's own versatility and expertise, but quite literally exhibited the kinds of goods available at his shop, and the kinds of skills he helped disseminate. The print is packed with examples of the penmanship that was Sturt's stock in trade, and crowded with images that demonstrate his connoisseurial appreciation of a wide range of graphic products, and that flaunt his entrepreneurial status as someone operating at the centre of a crowded urban nexus of graphic commodities. *The May Day Country Mirth's* exchange with the patterns of modern pictorial commodification is

19 John Sturt, *The May Day Country Mirth*, 1706. Engraving, 13¼ × 10 in. Courtesy of the British Museum.

accentuated, we can suggest, by its deliberate mimicry of the visual codes of the auction and the printshop. The print's composition and appearance – the facsimile it offers of a scattered array of different graphic products on display – would inevitably have invoked the spaces within which the graphic image was displayed and sold in the capital. Moreover, the medley's variety echoed the catholic patterns of private purchase and viewing advocated by Roger de Piles in his contemporary writing on engraving: 'Every particular man may chuse those subjects that are most proper to him, that may either refresh his memory or strengthen his judgement, in which he should be directed by the Inclination he has for things of his own Gout and Profession.' While some 'collect their prints by the Gravers, without respect to Painters', others choose 'by other fashions, and, indeed, tis reasonable that everyone shou'd have liberty to do in this what seems to him to be useful and agreeable.'[25]

Having outlined a number of interpretative contexts for Sturt's medley, however, there still remains something to be explained. If we spend any time looking at his engraving, we become increasingly disposed to puzzle out quite what Sturt was up to, in pulling *these* images and texts together, in *this* arrangement. In doing so, it becomes apparent that the engraver has offered us the possibility of moving beyond the criteria of illusion, style, skill and advertising into a more elusive, and more uncertain, zone of interpretation, one where we are encouraged to recover surreptitious links between the seemingly disconnected objects on display. In order to begin to understand this carefully orchestrated, and highly circumscribed, form of intepretative allowance, it is helpful to move away from Sturt's image for a moment, and turn to other kinds of trompe l'oeils being crafted in the period. In particular, we can usefully look at the work of Edwaert Collyer, a Dutch artist who settled in London, and who rose to fashion in metropolitan society at the turn of the seventeenth and eighteenth centuries.[26]

Collyer's letter racks (*fig. 20*) were pictures that mapped the associations and components of the still-life vanitas image onto the flattened planes of the politicised trompe l'oeil. In them, the subdued emblematics of temporal passage and corporeal frailty – the *memento mori* portrait, the hanging watch, the curling corner of a page – are juxtaposed with the discursive regimes of urban politics and social commentary, which are distributed across the tattered, folded and shielded ephemera of commercial publishing. These images dramatised aesthetic appreciation not only in terms of a successful pictorial deceit, but as a process of decoding, the magnifying glass and quill the visual keys to an allegorical deconstruction of the apparently haphazard collection of objects that crowd the depicted letter rack. Several of Collier's images include published House of Commons speeches alongside portraits of Charles I, which must have suggested the dynastic and constitutional conflicts of the past; other examples of the letter rack genre incorporate documents relating to the recent Union with Scotland, tracts attacking popery and philosophical pamphlets concerning 'Memorie'. Part of the interest of these paintings thus lay in the contemporary viewer's ability to uncover the half-hidden political, moral and historical narratives being suggested across the image, and to enjoy the picture's invocation of the public discourses of parliamentary debate and royal proclamation

20 Edwart Collyer, *Letter Rack*, c. 1700. Oil on canvas. Hunterian Museum and Art Gallery.

on the one hand, and the more private, contemplative exchange of the vanitas on the other.[27]

The letter rack image provided a powerful model for the working of the medley print. Sturt's engraving, like Collyer's pictures, combines representational verisimilitude with the potential for meditative forms of supplementary reading. *The May Day Country Mirth*, as we can now more clearly recognise, is an image that also overlays the minutely realised bits and pieces of contemporary graphic culture with the migratory symbols of the vanitas. The flies and insects depicted in Sturt's print function not only as catalysts of visual illusion, but also as recurrent emblems of mortality. The inverted playing card is a detail that could be read in terms of the vagaries of chance and the dangerous lure of luxury, while the frayed paper edges are more discreet liminal signifiers of temporal wastage. The obituary notice lying at the bottom of the pile of objects – we can just see the word 'Died' jutting out next to the playing card – offers another gesture to the emblematics of death. If the print operated as a celebratory form of modern montage, it thus also seems to have borne more melancholic narratives, ones that partially duplicate those found in the letter rack painting.

More importantly for our purposes, we can also suggest that the various details

of the print add up to something approaching satire. Perusing Sturt's engraving at length, we find that its disparate components together suggest a variously ironic, acidic and humorous commentary on social and political power, one that is articulated through precisely that playful assemblage of graphic materials that I have defined as a crucial feature of the satirical genre. Here we can briefly focus on the central, skewed image of Henry VIII, who is framed not by the elevated imagery of allegory or by the traditional symbols of royal power, as we might expect from a normal portrait, but by the profiles of two grotesque heads (taken from the famous caricatures by Leonardo), by the bodies of three wandering insects, by the upturned image of a knave, and by the figures of laughing peasants, whose pleasures are pointedly described as something 'to be priz'd before Courtly pomp and pastime'. Thus, even as his portrait head dominates the engraving, and seems to assert his authority, the king's iconic identity is disturbed by a series of distracting and dissonant images and texts. If this invites one kind of satirical reading, others are indicated by the profusion of references, humorous and otherwise, to the French and by the print's witty disruption of cultural hierarchies, whereby a caricature and an official portrait, a popular broadside and a Latin manuscript are all jostled up alongside each other.[28]

It remains clear, however, that Sturt's image precludes any real form of inter-pretative closure, satiric or otherwise. Narrative here operates according to a code of frustrated pictorial shorthand, dominated as much by the ambiguous areas left between seemingly related objects as by the implied connections traced across the objects themselves. The image remains a pictorially fragmented and syntactically uncertain work of art. In Sturt's medley, the pleasures of deception and the rhetoric of commodification are succeeded by a more complicated, baffling and only partially satisfied exchange with the spectator, one which involves transparency *and* concealment, interpretation *and* illegibility. Recognising this, we can go on to suggest that *The May Day Country Mirth's* semiotic open-endedness and uncertainty allowed Sturt to articulate an alternative, supplementary artistic identity to that suggested by his skill in imitation, one that fitted into a more modern notion of the engraver as a liberal practitioner of the arts, an individual who invented rather than copied and whose prestige was dependent on his intellectual credentials rather than his mechanical skills. In this light, the intepretative complexities demonstrated by an image like Sturt's can be seen to have asserted the engraver's ambitions as a distinguished member of the city's artistic community. Through the subversive play with pictorial hierarchy, through the kaleidoscopic multiplicity of signs, and through the strategies of disconnection and ambiguity, *The May Day Country Mirth* becomes overlaid by an unstable and unresolved set of meanings that is both generated and withheld by the engraver himself. Here, the artist becomes an editor as much as an author, playfully manipulating a range of graphic ready-mades in order to produce a heterogeneous, fractured, satirical assemblage of his own making. It is thus telling as well as convenient that an anonymous journalist chose the word 'Medley' as a name for a short-lived newspaper in 1710:

> since according to the true intent and meaning of the word, I can properly make
> use of any matter whatsoever . . . the more various the subject is, or the more

different sorts there are of it, the more likely will it be to make what we mean by a medley . . . the name and nature of my paper are such, that connection would be a vice in it. I have declared against form and order, and at first assum'd a liberty to ramble as I pleased.'[29]

Through an equivalent graphic format, the engraver could define himself as an independent artist staking an ambitious claim to aesthetic status through the combination of breathtaking technical skill with an innovative programme of pictorial dislocation, satirical overlap and narrative elusiveness.

Other medley prints executed in the period maintained these characteristics. George Bickham senior, who had been one of Sturt's most brilliant pupils, produced *Sot's Paradise* in 1707 (*fig. 21*).[30] The print clearly announces its debts to *The May Day Country Mirth*. Bickham's print, like his old master's, is dominated by a single portrait head, and a woman's face is placed as a precise mirror-substitute for Sturt's 'Blackmoor'. Another playing card and another pair of grotesque profiles echo those we found earlier. More broadly, we can recognise a similar series of textual and pictorial juxtapositions that yoke together different categories of representation. Bickham's image engages even more explicitly with a Continental fine art tradition: at the centre of his medley, there is a copy of an engraved self-portrait of Philippe de Champaigne, a Brussels-born painter who had risen to fame in seventeenth-century France. Moving across the image, we again find examples of le Clerc and Callot's graphic work, supplemented by examples of a modern category of French art, the *commedia dell'arte* print, that was rapidly becoming fashionable on both sides of the channel. This dense assemblage is accompanied by more local remnants of published texts and images: Francis Barlow's seventeenth-century prints of animals, the elaborate heraldic stencil signifying the recent Union, a sheet from a writing manual, a letter of receipt and the title page of Ned Ward's *Sot's Paradise*, a particularly crude poetic satire on urban drunkenness – to give a taste: 'I turned to the left, and did amongst them squeeze, and heard some belch, some fart, and some sneeze.'[31]

At one level, *Sot's Paradise* functions as an elevated repository of connoisseurial trophies which links the modern engraver's own practice to a series of distinguished precedents, and at another the print offers a playful and satirical assault on the rules and personalities of high art. Most obviously, Bickham's engraving engages ironically at a number of levels with Gerard Edelink's engraved image of Philippe de Champaigne, produced late in the previous century. Even as the portrait's and the subject's refined status is confirmed by their centrality within *Sot's Paradise*, this status is undermined by the series of overlapping pictorial and textual signs which cut across, and interfere with, the idealised form of identity constituted by the painter's face. In *Sot's Paradise*, Edelink's engraving (*fig. 22*), which remained loyal to the painter's depiction of himself in a depopulated, tranquil landscape, is not only radically truncated, but infringed by a mass of discordant iconographies and discourses. Champaigne's head is overlaid by bits of paper, and he is surrounded by the comic, gaping faces of clowns, by the smiling profile of a knave and by the competing glance of a beautiful woman. Rather than the arcadian environs of the self-portrait, the landscapes that cluster immediately around the painter are those of

21 George Bickham senior, *Sot's Paradise*, 1707. Engraving, 11¾ × 9 in. Courtesy of the British Museum.

22 Gerard Edelink, after Philippe de Champaigne, *Self-Portrait*. Engraving, seventeenth century. Courtesy of the British Museum.

war, defecation and theatre. Thus, if *Sot's Paradise* might seem to invoke and celebrate the work of a Continental painter and engraver, the image also introduces pictorial conjunctions and contrasts that relentlessly destabilise this form of tribute.

This kind of graphic performance, we can now conclude, contributed to a distinct kind of satirical art, one signalled in *Sot's Paradise* by Bickham's inclusion of the partly hidden word SATYR in a prominent position. That the word is only partly visible, however, and that it is clearly linked to a pre-existing text, is also a nice indication of the medley print's differences from those satirical prints which followed during the Sacheverell crisis of a few years later. The medley's satire is deliberately ambiguous rather than polemically strident, and it is far more self-conscious than the Sacheverell engravings in its ironic and sophisticated reliance on existing graphic materials. Because of these features, the medley print's satirical status, although clear upon close examination, is not in fact self-evident or immediately obvious. As we have discovered, the satirical preoccupations of these images have to be slowly teased out, rather than being quickly visible as in the case of the *High Church Champion and his Two Seconds*. In the years that followed, however, largely thanks to the impact of the Sacheverell affair on graphic culture, Bickham was to offer a dramatic fusion of satiric practices that invoked both the medley print and the Sacheverell engravings. It is to this process that the rest of this chapter will be devoted.

III

Sometime in 1711, Bickham executed and published *The Whig's Medly (fig. 23)*. As in the case of the medley prints we have just looked at, our initial response is conditioned by the mechanics of the trompe l'oeil. A series of printed objects – playing cards, short poems, miniature portraits, fragments of calligraphy – are shown as if they were distinct entities scattered about by a casual hand, lying on top of each other and distributed across a partially obscured engraving entitled 'The Three False Brethren'. This illusionism is again generated by a microscopically exact process of reproduction, in which Bickham's burin, cutting into a single copper plate, mimics a broad range of graphic vocabularies, both high and low. Yet unlike the earlier medleys, *The Whig's Medly* is distinguished by its pictorial, textual and polemic coherence. This is clear even in the way the print is formally organised. Its layout is studiously decorous in comparison with the earlier engravings; each component is made clearly visible and legible, and not hidden away or obscured. This ease of spectatorial access to the assorted graphic objects complements a new narrative intimacy between them. Rather than being defined by an overall schema of cryptic, frustrated and incomplete reading, the relationships between the different products on display are designed to be rapidly deciphered.

And what we quickly find out is that the print engages in a brutal form of satirical polemic, which focuses on the author and activist Daniel Defoe. The different images and texts contained in *The Whig's Medly* articulate a carefully co-ordinated form of political critique, revolving around the central depiction of Defoe as a bewigged, stylishly dressed and self-satisfied figure being advised by the Pope and the Devil. This satirical portrait is supplemented by an alternative, juxtaposed image of the writer's head caught in a pillory, 'with blobber Lips, & Lockram Jaws,/Warts, Wrinkles, Wens, & other Flaws.' Nearby, the portrait roundel of Cromwell, suggestively placed next to the courtly symbolism of a playing card, invokes the reviled figure of an anti-monarchical usurper as a historical precedessor to Defoe. At the same time, the description of 'A Whig and Tory a Wrestling' links the writer's ideological allegiances to a broader pattern of party political conflict, while the card in the lower left-hand corner refers to a treasonous form of festive commemoration, in which a calf's head had become a bestial symbol of Charles I's decapitation in the previous century.

In making this attack, Bickham's print trades on Defoe's contemporary prominence. Defoe had first come to notoriety as a political journalist and writer in 1702, when he had written *The Shortest Way with Dissenters*. This tract represented a sophisticated piece of parody on Defoe's part, in which he adopted a strident, fevered High Church authorial voice and pretended to advocate the mass extermination of Dissenters. The support the *Shortest Way* received from the most extreme High Churchmen, who took it to be genuine, and the shock provoked by the revelation that the text was a particularly convincing piece of literary impersonation, were followed by Defoe's arrest on a charge of seditious libel. He was punished with imprisonment and a three-day visit to the pillory. In response, Defoe composed *A Hymn to the Pillory*, which included an early attack on Sacheverell, and

23 George Bickham senior, *The Whig's Medly*, 1711 (BM 1571). Engraving, 15 × 10³⁄₄ in. Courtesy of the British Museum.

which was sold on the streets as he stood through his punishment. This event become famous for the support the author received from sections of the London populace, who garlanded him with flowers rather than pelting him with stones or stinking fruit. Soon afterwards, Defoe began the *Review*, a journal that combined a Whig agenda of political commentary with consistent criticism of the High Church party and its chief adherents. During Sacheverell's trial the *Review* maintained this attack, personalising it in terms of Defoe's own experiences: he calls Sacheverell the 'Foundation of my Destruction', and declares that the doctor's arraignment has belatedly vindicated 'the Reasonableness, and the Seasonableness of those fatal Observations I made on this Man's Preaching and his Party's Practice, for which . . . I suffer'd the Overthrow of my Fortune and my Family, and under the Weight of which I remain as a banish'd Man to this Day.'[32]

Recognising this persistent pattern of belligerence and self-comparison, we can more clearly understand why Defoe became a satirical target in the immediate aftermath of the Sacheverell affair. And looking more closely at *The Whig's Medly*, we also see that Bickham reinforces this connection by appropriating the graphic vocabulary of the pro- and anti-Sacheverell satires released the previous year. Most obviously, Defoe, like his clerical antagonist in *The High Church Champion and his Two Seconds*, is shown being advised by the figures of the Pope and the Devil in a book-lined room, sitting in front of a draped curtain, and touching a text: here, one apocryphally entitled 'Resistance Lawful', which reinforces the writer's satiric identity as a mouthpiece of treason.[33] If we think about Bickham's earlier response to *The High Church Champion*, in which he depicted Sacheverell locked into an allegorical surround, hovering above the English countryside, we can also suggest that *The Whig's Medly* offers a related, but satirically revised, form of internal pictorial support for his new protagonist's portrait, one that substitutes a corrupted ring of masculine heads and bodies for the floating, feminine personifications of virtue. Finally, Bickham's attack on Defoe maintains the forms of critique found in prints that had combined their focus on Sacheverell with an attack on Defoe himself. A number of pro-Sacheverell satires pictured Defoe as an embittered, treasonous creature of Whiggism, whose criticism of the cleric was only part of a broader programme to undermine the authority of the Church and the Crown. In *Faction Display'd* (*fig. 24*), for instance, the journalist's portrait, captioned with the name of the *Review*, is made to look suspiciously like that of Oliver Cromwell, and is grafted onto the body of a multi-headed mutant that is part-dragon, part-cannon and that expels a cluster of weapons in the direction of Sacheverell.[34] The fact that *The Whig's Medly* also incorporates the figures of the Pope, the Devil and Cromwell further dramatises Bickham's engagement with an established, and recently active, repertoire of satiric signs.

We can now see that *The Whig's Medly* brought two independent systems of satiric representation – the medley print and the political and religious satire – into productive contact.[35] What kind of image emerges out of this ambitious strategy of integration? Here it is noteworthy that both the Sacheverell satires and the medley print had been characterised by their preoccupation with the portrait. In *The Whig's Medly* portraiture again dominates the workings of the image, and encourages closer analysis of all the different heads that are scattered across the engraving. We can

FACTION DISPLAY'D

The Whore of Babylon

If e'er I did project a usefull print, — — — — —
I've hit it now, or els the De'el is in't. — — — —
Was e'er a finer peice brought from the mint.
Here's Pop'ry plac'd Infalibly ith' middle, — — —
And Six Scismaticks Danceing to the Fiddle: —
But who they represent, You'l say's, a Riddle;
Yet veiw them near, and You, without a glass, — —
May by the ears of one, see he's an Ass; — — — —
And, by the others Fiz, t'appears as plain, — — —
What they intend, and that they've all one aime: — —

But truth's its own best Sheild, and Innocence, — — —
Without a Barrier, is its own Defence; — — — — —
Nor can Fanatick Cannons drive it hence; — — — —
Tho Pr———s Load it deep with powder, — —
And In———s Ramm, to Bounce the Louder; — —
Nay, tho' the An———s, with chaine-Shot, — — —
Do over-load it, while the Cole's kept hot, — — —
By the Fanatick Champion at Its tayle, — — — —
Not they, nor all their Black-Guard, shall prevail:—
But if they'll Try th'experiment e'en let 'em, — — —
The Cannon fir'd, will Burst, and so o'er-set 'em.—

24 *Faction Display'd*, 1710 (BM 1508). Engraving, $3\frac{3}{4} \times 8$ in. Courtesy of the British Museum.

begin at the print's centre, where the representation of Defoe himself was clearly designed to be read in relation to an already established graphic identity for the writer, circulated across the frontispieces of his various published works. A good example of what I mean is the elegant portrait engraved by Michael Vandergucht, which appeared in the 1706 edition of Defoe's *Jure Divino* (*fig. 25*).[36] Bickham's print serves satirically to undermine the public persona constructed by engravings like this, which promoted Defoe as a dignified gentleman of letters. In Vandergucht's image, the writer is dressed in a gushing, extravagant wig, wrapped in a silk scarf and fine clothes, and enclosed by an elaborate internal frame that incorporates a coat of arms and stands on a pediment inscribed with a Latin quote. In *The Whig's Medly* these pictorial props are systematically travestied, and over-loaded with dissonant detail. The central portrait of Defoe, rather than existing in decorous isolation, is integrated into a crowded pictorial infrastructure of bodies and texts, which not only situates the writer in relation to the deviant figures of the

25 Michael Vandergucht,
Daniel Defoe, frontispiece to
Defoe's *Jure Divino*, 1706.
Engraving, 10½ × 7 in.
Courtesy of the British
Library.

Pope and the Devil, but also subjects him to an invasive flurry of pictorial and
textual fragments from outside.

The most blatant of all these forms of trespass is that effected by the overlapping
image of Cromwell. Bickham's representation of the Protector duplicates the details
of Robert Walker's portrait of Cromwell, which was frequently used as the basis
for later engravings. In *The Whig's Medly*, Cromwell's portrait is not only offered
as a notorious point of reference but, I would like to argue, is also suggested as a
kind of mask for Defoe, one that could be mentally slid across the picture surface
by the viewer, and superimposed *over* the modern journalist's face. This kind of
pictorial masquerade, encouraged by the proximity of Cromwell's portrait to the
centre, and by the impression we are given of its supposed mobility and manoeu-
vrability across 'The Three False Brethren', gives Bickham's satire a particularly
theatrical quality, one that also demands a specific kind of performance and play
on our part. In *The Whig's Medly*, the mental reshuffling of the depicted images

expected of the viewer means that Defoe is successively assigned a series of different identities, made up from the various pictorial masks scattered across the picture space, which can be metaphorically laid over the bewigged head at the engraving's pictorial and narrative centre. The two knaves' heads shown in the playing cards on either side of the image seem to extend this satiric masquerade. They function not only as pointers to the central protagonist's knavery but also as schematized doubles of the Pope's and the Devil's profiles nearby.

The lines underneath Cromwell's portrait in *The Whig's Medly* supplement this process of reading by explicitly invoking the ancient art of metoposcopy, which involves, in the Oxford English Dictionary's words, 'judging a person's character, or telling his fortune, from his forehead and face.' Here, it is implied, the idealising conventions of high portraiture are insufficiently stringent to prevent the 'thoughtfull, resolute & sly' character of Cromwell from seeping out of the image, and being recognised by the attentive viewer. Significantly, Bickham has appropriated this caption from an art theory text published in 1700 by John Elsum and entitled *Epigrams upon the Paintings of the Most Eminent Masters, Antient and Modern*.[37] Elsum's lines, which offered an independent ekphrastic commentary on Walker's painting, used the discursive framework of face-reading in order to elide the vocabulary of historical critique with that of art appreciation. In Bickham's print, his verses, coupled with a reproduction of the same image, help reinforce the broader preoccupation of *The Whig's Medly* with reading portraiture as a format that could be broken down into different party and historical narratives on the one hand, and into different generic and art critical preoccupations on the other. This duality is confirmed when we realise that Elsum's *Epigrams* had also included the verse on an anonymous 'Deformed Head' which Bickham has adapted as a caption to the alternative image of Defoe at the top of *The Whig's Medly*, where he is shown stuck in the pillory.[38]

In this second portrait of the writer and activist, Bickham engages with a far more explicitly grotesque and popular iconography of portraiture than in his revision of Vandergucht's and Walker's pictorial formulae. In particular, the distorted and comic invocation of Defoe's public punishment in *The Whig's Medly* corresponds to the woodcut of Defoe that was affixed to a chapbook in the period (*fig. 26*).[39] Through this invocation of the indecorous and historically resonant iconography of the pillory, Bickham loads his image with yet another set of pictorial and political associations, drawn from the most unflattering and strident categories of contemporary graphic portraiture, and from the street-level narratives of public punishment and terror that the pillory symbolised. Defoe's popular canonisation during his confinement, and the aesthetics of the floral garlands with which he had been decorated, are here deliberately overwritten by a rhetoric of ugliness and ridicule. In this section of *The Whig's Medly*, his face functions as a kind of caricatured composite of his bewigged double in the centre of the engraving and the unwigged image of Cromwell. His eyes become crossed, his nose is extended, his lips are made bulbous, and his skin is twisted, pocked and wrinkled: he is 'cadaverous, black, blue and green / Not fit in publick to be seen.' Finally, this severed head – cut off at the neck, and given a circular frame – can also be read, like Cromwell's, as gravitating towards the body at the image's centre, and

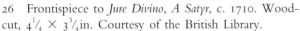

26 Frontispiece to *Jure Divino, A Satyr*, c. 1710. Wood-cut, 4¼ × 3¾in. Courtesy of the British Library.

27 Frontispiece to Edward Ward's *The Secret History of the Calve's Head Club*, 1709 (BM 1517). Engraving, 6¼ × 3¾in. Courtesy of the British Library.

can be mentally slotted into the shadowed arc of drapery that surrounds Defoe's head in 'The Three False Brethren'.

 This elision of the aesthetics of portraiture with those of pictorial decapitation – in which a radically truncated head is clearly cut off from the body, even as it seems to return to that body – is maintained as a calligraphic and textual trace, and given a more pointed meaning, in the lower left-hand corner of the image. Here we see a card which details the treasonous activities of the Calves Head Club, a 'secret' society that had aquired a widespread notoriety for its annual celebration of King Charles I's execution, and for its extravagantly anti-royalist sympathies. In *The Secret History of the Calves Head Club*, published in 1709, Ned Ward described the

society's annual meeting, held 'in a blind alley about Moorfields, where an axe hung up in the club room, and was reverenced as a principal symbol in this diabolical Sacrament. Their bill of fare, was a large dish of Calves Heads dressed several ways; a large pike with a small one in his mouth, as an emblem of tyranny; a large cod's head, by which they pretended to represent the person of the king singly, as by the calve's head before they had done him, together with all them that had suffered in his cause.'[40]

In the frontispiece to Ward's text (*fig. 27*), the fleshy components of this symbolically cannibalistic ritual are laid out under the hanging axe. *The Whig's Medly*, which refuses such an explicit focus, translates this symbolism into a more decorous combination of verse and calligraphic embellishment. The card declares that 'Fanatics base, a Calves Head Feast still hold/ In scorn of Charles, a pious king and bold', and supplements this poetry with a pair of delineated calves' heads that are seamlessly integrated into the decorative surround. However much the potency of the club's rituals is muted by such devices, the card is clearly meant to introduce an explicit metaphor of decapitation and of grotesque portraiture into Bickham's satire; it is linked to the portraits of Defoe and Cromwell, Charles I's executioner, at the level of political narrative, and related to the deformed head of Defoe, in addition, at the level of pictorial analogy. For not only does the 'Calves Head' card invoke the shocking rituals of regicide, but it also takes its place alongside Defoe's pillory portrait as another ruptured and repulsive emblem of treason.

Here, however, we must be careful not to take such references too sombrely, and lose our sense of the playful, humorous strategies of Bickham's engraving. If we carry on reading the 'Calves Head' card, for instance, we find that it calls for the participants of the feast to be cuckolded: 'may Cuckoldom be all their fates/ And horns of Calves heads still adorn their Pates.' In this instance, the narratives of political treason are tempered by those of sexual comedy. In the larger card of 'A Whig & Tory a Wrestling' lying nearby, in which Defoe is shown like a puppet being bustled to the ground by an opponent, the violent narratives of political in-fighting are similarly tempered by the comic vocabulary of a wrestling match. Poems like 'A Whig & Tory a Wrestling' were popular tokens of political allegiance in early eighteenth-century London, enjoyed in public places like the tavern and the coffee house as well as at home, and occasionally attaining the status of urban folk songs. A collection of such songs, conveniently entitled *The Whig and the Tory*, and published in 1712, was described by its author as being designed to 'suit every Temper and Capacity; here are some things solid, some burlesque; some more lofty, others in an humbler skein . . . they are now in their prime, when every person may understand what is allegorical.'[41] This description may remind us of the diversity of the objects collected in the medleys of the day. More specifically, it helps us to understand the ways in which *The Whig's Medly*, by including one such poem, was self-consciously aligning itself with the characteristics of other kinds of political commodity circulating in the marketplace. Indeed, reading across Bickham's engraving, we can also understand it as an anthology of poems, five in all, that offers a similar range of rhetorical and narrative modes to a book like *The Whig and the Tory*, and fixes them to a parallel form of graphic compendium, in

which satire ranges across the burlesque, lofty and humble materials of pictorial culture.

The last portrait that we find in *The Whig's Medly* is that of Bickham himself, a self-portrait ostentatiously inserted into the calligraphic rhetoric of the image. The elaborately delineated, monogrammatic initials in the top right corner of the engraving – which, in a highly abstracted manner, seem just on the point of rehearsing the forms and lines of a man's face and wig – occupy the space reserved elsewhere for the portrait head. They offer an insistent, semi-anthropomorphic assertion of Bickham's own presence as a penman, one which supplements the more conventional signs of authorship and professional status occupying the signatorial space at the bottom of the image. This flamboyant marker of identity not only functions as a commercial calling card for the print's viewer, but also dramatises Bickham's self-fashioning as a public, political artist, someone who intervenes in and exploits the dynamics of celebrity and party. In introducing an independent emblem of his own artistic persona alongside the portraiture of his antagonist, he takes his own place within the networks of urban publicity and the narratives of urban politics that are the subject of his satire. In this reconstruction of artistic identity, the individual satirist asserts a new visibility and independence as both author and publisher. Even here, however, Bickham manipulates a parallel rhetoric of elusiveness and disguise. His free-floating monogram, after all, is an engraved sign that is neither fully legible as a head nor fully legible as a name. Like the signature at the bottom of the page, it is made up only of initials, disallowing an immediate recognition of the print's authorship to anyone operating outside the inner realms of print culture. Bickham's print, then, manages to retain a trace of that ironic, aestheticised form of authorial distance displayed by prints like *The May Day Country Mirth* and *Sot's Paradise*, even as it simultaneously projects the artist into the public sphere.

IV

To suggest some of the ways in which *The Whig's Medly* may have functioned in early eighteenth-century London, and to outline the various readings that the print encourages, helps us to appreciate the extent to which the satirical engraving of the period should be understood as a site of political *and* aesthetic exchange. At the same time, *The Whig's Medly* suggests the ways in which the execution of a satirical print could be used to amplify those claims to individual skill and creativity that we earlier saw being asserted by Sturt. Bickham's own doubled status as copyist and inventor is most eloquently signalled by his satire's enigmatic mode of imitation. The engraving offers a dialogue both with images that are ready-made – for instance, the portrait of Cromwell – and, as far as I can tell, with images that are entirely fictional: there is no evidence that 'The Three False Brethren', to give the most prominent example, is anything other than an invented print, which never actually existed. We are thus confronted with a new form of deceit, one that 'copies' images for which there never seems to have been any original. *The Whig's Medly*, through an ironic, highly self-reflexive recourse to the values of the

simulacrum, thus calls into question its own claims to reproductive exactitude. At the same time, through the pretence that only 'real' objects are being copied, the print veils its own inventiveness as a work of art. Thanks to this ambivalent form of interplay, the engraver's functions as reproducer and author are left in flux, and Bickham is able to signal his legitimate claims to both roles without confining himself to either.

The Whig's Medly, as well as providing a complex negotiation of artistic identity, testifies to the fact that a powerful agenda for satiric practice was being generated in London during the earliest years of the eighteenth century, one that, as we shall see, was to be successively adapted, rejected and revived in succeeding decades.[42] This was an agenda that was as much dependent on certain ways of looking, and on certain pathways of interpretation informed by that looking, as it was on the producer's choice of subject or mode of execution. Bickham's print, in this respect, can be seen to have mobilised the circulating gaze of the viewer against a more static notion of visual exchange. Our eyes, focusing on, and finally returning to, the central portrait, are in the meantime encouraged to rove across the disparate and insubordinate array of objects gathered around that portrait, objects which, whitened against the darker background, interrupt and crowd our vision as they trespass the boundaries of 'The Three False Brethren'.

In a print like Bickham's, satire was being defined as an imagery that demanded and enforced a constant oscillation, optical as well as interpretative, between a range of competing, overlapping, graphic materials. This mode of looking in *The Whig's Medly* case both maintains the formal and ideological values of pictorial hierarchy and order – here understood in terms of the authoritative demand on our visual attention made by the dominant, underlying portrait engraving – and destabilises those values, through the simultaneous bringing to sight of the peripheral, the grotesque and the vernacular – here represented by the diverse figures and materials moving out of and across the pictorial margins towards the centre. While, to transplant the words of the journalistic *Medley* of 1710 noted earlier, the early eighteenth-century's viewer's gaze was given a certain 'liberty to ramble' by Bickham's print, that ramble was mapped out as a dialectical form of visual passage and performance, in which the eye's movement back and forth across competing areas of the picture-plane offered a localised metaphor for, and instrument of, the workings of graphic satire as a whole.

28 *The Bubbler's Medley, or a Sketch of the Times*, 1721 (BM 1610). Engraving, $13\frac{3}{8} \times 9\frac{5}{8}$ in. Courtesy of the British Museum.

Chapter Two

Translations

Ten years after the publication of *The Whig's Medly*, another trompe l'oeil satire was released that focused on a very different kind of urban subject matter: we are about to move from the narratives of party politics to those of financial catastrophe. *The Bubbler's Medley, or a Sketch of the Times, Being Europe's Memorial for the Year 1720 (fig. 28)*, was published by Thomas Bowles in the spring of 1721. The poems, newspaper pages, cards and engravings that lie across this anonymous satire comment on the economic crisis that had affected Paris, Amsterdam and London during the previous year. This crisis – known in Britain as the South Sea Bubble – had arisen in London out of a struggle between the South Sea Company, the Bank of England and the East India Company to control the national debt. The South Sea Company, which succeeded in incorporating this debt, simultaneously offered government creditors and outside subscribers the chance to invest in newly created Company stock. Thanks to the Company's ruthless manipulation of a booming financial market, this stock rose to massively inflated heights over the summer of 1720 and attracted thousands of investors. When the bubble burst in the autumn, and the price of stock came crashing down, numerous fortunes were lost and, more significantly, public credit was dramatically undermined.[1] The various images and texts in *The Bubbler's Medley* chart the local topography of this financial collapse, while simultaneously invoking the broader, European economic crisis of which the South Sea Bubble was a part. We are given a glimpse of the chaotic centre of commercal speculation in Paris, Rue Quinquempoix, and a depiction of 'Dutch Bubblers' wandering despairingly through the streets of Amsterdam. Closer to home, the medley pictures the crowded financial district of London's 'Change Alley', which was a warren of streets and lanes lying near the Royal Exchange, the traditional centre of mercantile activity in the city.

The Alley – officially called Exchange Alley – housed a notorious economic subculture, crowded by stockbrokers (popularly known as stockjobbers), foreign agents, middlemen, and small- and large-scale investors, all involved in promoting or subscribing to an immense variety of entrepreneurial schemes. By 1721, the area had become the symbolic focus of the extended post mortem on the Bubble, and was relentlessly castigated as an environment of delusion that had provided a fatal, mysterious impetus for the summer's events. Moreover, as *The Bubbler's Medley* helps confirm, the Alley had also become an important subject for graphic satire in the period. In particular, the Exchange and the narratives it generated were invoked

as crucial references in the English reproduction and translation of a particularly ambitious and influential image of the crisis, Bernard Picart and Bernard Baron's *A Monument Dedicated to Posterity*, one of a series of satirical engravings concerning the Bubble that originated in Amsterdam and were being introduced into London's print market in the spring of 1721. The publication of these prints in the English capital was the starting-point for a sustained pattern of cultural translation that helped condition the identity and development of the satirical engraving in the period, and that provided a basis for more local agendas of satiric practice. This chapter is about this process of translation and response, and about the extent to which a foreign vocabulary of graphic art, and an artistic vocabulary of foreignness, became crucially intermingled in the graphic satires of the 1720s. To begin investigating this relationship, which will lead us, in the final sections of this chapter, to a close analysis of William Hogarth's 1724 satire, *The Mystery of Masonry*, it will be helpful to find out a little more about the mythologisation of Exchange Alley as a crucible of the South Sea Bubble's perverse dynamics, before we return to the ways in which those dynamics were pictured in satiric form.

I

In 1719, Daniel Defoe provided a written tour, *The Kingdom of Exchange Alley*, that emphasised the area's claustrophobic density and indicated the crucial status of Jonathan's and Garraway's coffee houses as places that doubled as sites of conviviality and brokerage. He invoked the metaphor of the sea that was to be replenished in the *Bubbler's Medley*:

> the limits, are easily surrounded in about a minute and a half . . . stepping out of Jonathan's across the Alley, you turn your face full south, moving on a few paces, and then turning due east, you advance to Garraway's; from hence going out at the other door, you go on still east to Birchin Lane, and then halting a little at the sword-blade bank to do mischief in the fewest words, you immediately face to the north, enter Cornhill, visit two or three petty provinces there on your way west; and thus having box'd your compass, and sailed around the stockholding globe, you turn into Jonathan's again; and so, as most of the great follies oblige us to do, you end just where you began.[2]

The Alley, as Defoe's account suggests, was frequently characterised as a self-contained pocket of the city, and as a place dominated not by the architectural symbolism of a single building, but by the succession of spaces, internal and external, encountered by the walker. Unlike the regulated and architecturally bounded environment of the Royal Exchange, dotted with royal statuary, Exchange Alley was a jumbled configuration of streets and passageways that was bereft of an official public iconography, architectural or otherwise. The Alley was articulated instead by a clutter of different facades, and by the paper paraphernalia of posters, notices, subscription announcements and newspapers that littered the walls and pavements. Most crucially of all, the area's identity was tied to the clogged narratives of the street, where multitudes of men and women clustered and

bartered around the stalls set up by the stockjobbers. Indeed, we can suggest that the street space was the prime architectural site of Exchange Alley, framed by the walls on either side, buttressed by the interiors of adjoining coffee houses, and crisscrossed by grids of gossip and news, which here came close to approximating an ubiquitous urban graffiti, both spoken and inscribed.

In journalistic analyses of the Bubble crisis, this spatial architecture was described as having become filled with illusionary forms. Over and over again, the language of nightmare and hallucination was deployed to describe the narratives of the Exchange: a poetic correspondent to *Read's Weekly Journal* wrote in January 1721 of having 'just from Change Alley, harrass'd, come/ To find, if possible, relief at home. . . . I slapt me down in elbow chair/ where in slumber soon I fell/ And dreamt the place was turn'd to Hell/ [and] Jonathan's was Satan's Palace.'[3] *The London Journal* declared that a form of mass hysteria had been at the root of the affair: 'In the late revolution of the Alley, figures and demonstrations would have told them, that it was all frenzy; and that they were pursuing gilded clouds, the composition of vapours and a little sunshine; both fleeting apparitions.'[4] Similarly, the *Weekly Journal* suggested in November 1720 that 'it is very evident, that the whole business was upon no solid foundation, but carried to that extravagant height by the humours and run of the people, who had not leisure to consider what could be the support of such extravagances, and that it surely must terminate in ruin and misery.'[5] In such writings, Exchange Alley had become a fantastical site of difference, a site distinguished not only by a half-hidden, labyrinthine and tangled topography, but also by a collective form of intellectual disorder that precluded all rational thought. In these discourses, the social space of modern finance merged with the imaginative space opened up by the promises of credit: the filling of the one by a multitude of investor's bodies parallels the replenishment of the other with a multitude of unfulfilled desires.

Alongside these kinds of commentary, we find texts which attack the Alley for becoming the arena of an extreme form of commodity fetishism, a fetishism that was most obviously signalled by the thorough elision of gambled capital with the apparatus and shapes of fashion. Critics suggested that the temporary boom had created a new urban class of wealthy *arrivistes*, a 'South Sea Gentry' whose social status was publicly grounded in the ostentatious parade of luxury products. In July 1720, the *Original Weekly Journal* estimated that 'since the late hurly burly of stock-jobbing, there have appeared in London 200 new coaches and chariots . . . about 4000 embroidered coats, [and] about 3000 gold watches at the sides of whores and wives.'[6] This satirical focus was mirrored by the observations of a countryman who remembered travelling to the Alley earlier in the summer. He found the South Sea men 'dressed up in very fine clothes, some with gold and silver upon their coats, and others had great broad ribbons hung on their shoulders.'[7] By the late autumn, however, writers noted that much of this mass of goods had been offloaded onto the pawnshops and the markets of the city: 'walking through the streets of London, in all the proper places where such things are to be look'd for, you may see second-hand coaches, second-hand gold watches, cast-off diamonds and earrings to be sold. Long Lane, Monmouth Street and Mayfair, are full of rich liveries to be sold, nay, and full of rich brocaded gowns and petticoats,

with embroider'd coats and waistcoats: in a word, every place is full of the ruins of Exchange Alley.'[8]

The list of abandoned clothing and accessories (hoop petticoats, earrings, diamonds and gowns) found in the pawnshops and markets indicates the extent to which the Alley was also being refigured as a feminised zone of urban transaction. Framing this formulation of the Alley was the broader metaphor of credit as a form of commercial promise that mimicked the attractions of the alluring female body. Here we should note that the long-standing recourse to the female figure of Fortune as an allegory of the vicissitudes of economic life was being reworked in early eighteenth-century writings on public credit. In the *Spectator*, for instance, Addison had defined Public Credit as 'a beautiful virgin seated on a throne of gold' who was liable, upon hearing bad economic news, physically to degenerate and 'wither into a skeleton.'[9] Writers on the South Sea crisis adapted the figures of Fortune and Credit into someone whose appeal revolved around a dubious dialogue of desire and identification: a writer in *Read's Weekly Journal*, for instance, invoked 'Lady South Sea', an icon who stands as a spectacular visual focus for a diverse crowd of investors, 'all paying her the utmost adoration, and desiring to be admitted to her good graces. Among these were many ladies of the first rank paying their court to the rising mistress of that dome, intermix'd with Jews, Jobbers, Gamesters, Pimps, Valets, Harlots etc.'[10] Similarly, a contemporary song, 'A South Sea Ballad', allegorised speculation in terms of the gaze across at a woman's face: in the Alley, the writer suggests, people both 'sad and joyful, high and low/ Court Fortune for her graces/ And as she smiles and frowns, they show/ their gestures and grimaces.'[11]

If, through such literary conceits, the exchanges of a credit economy were mapped onto an adulterated metaphor of courtship, the actual participation of women in this economy – as investors – was also seen to have introduced an intrinsically unstable, unreasonable and uneducated element into the financial equation. This critique was partly informed by the well documented involvement of affluent women in stock dealing. Nevertheless, the relatively small scale of female investment was rhetorically exaggerated to condemn the destabilising effect of women's involvement in the city's economic life. Their stereotypical preoccupation with gossip, flirtation, chatter and make-up was seamlessly aligned with the ephemeral, seductive, confused and illusory vocabulary of the Alley. The author of *Exchange Alley*, a farce of 1720, declared that 'if you wait on a lady of quality, you'll find her hastening to her house of intelligence in Exchange-Alley', while another writer declared that women flocked 'as near Change Alley as they could, and made it their business to procure Brokers to come to them; their Discourse and Conversation over the *Tea-Table* was the price of stocks.'[12] While the participation of women of fortune reinforced stock-dealing's reputation as an idle, and potentially disastrous, form of urban fashion, the supposed involvement of less respectable females was used to tie the erotics of credit to the domains of disreputable sexual exchange. The retinue of Lady South Sea's admirers, we remember, included not only the female representatives of the urban elite, but prostitutes, and a succession of authors reinforced this tenuous link between the whore and stock-dealing: *Exchange Alley* suggested that the 'women of the town are become dealers in

stocks', while 'A South Sea Ballad' declaimed that 'Young harlots, too, from Drury Lane/ Approach the Change in coaches/ To fool away the gold they gain,/ by their obscene debauches.'[13]

Within contemporary culture, Change Alley had thus become defined as a spatial template of disorder and difference, and as an environment dominated by illusion and artifice. In a resonant phrase, the Change's primary activity, stockjobbing, was described as 'a new invented sort of Deceptio Visus . . . so mix'd with Trick and Cheat, that twou'd puzzle a good logician to make it out by Syllogism.'[14] Having uncovered the narratives of spatial dislocation, mental hallucination, commodity fetishism, fashionable excess, adulterated femininity and sexual desire that the Change was seen to house and stimulate, we can now investigate the ways in which pictorial codifications of the crisis were explicitly aligned with such narratives. Graphic satire, as we noted in the previous chapter, was consistently preoccupied with strategies of pictorial fracture, assemblage and instability. What, then, was the relationship between this hybrid formulation of pictorial practice and an event and a space that were seen to have generated a similarly unstable montage of signs and meanings?

II

On 7 March 1721, the *Post Boy* carried an advertisement by Thomas Bowles announcing that *The Bubbler's Medley (see fig. 28)*, along with several other South Sea satires, was on sale at his shop in St Paul's churchyard. Bowles's business was part of the larger, family-based network of print production and sale that we noted in the Introduction, and in a catalogue he released in 1720, we find the combination of maps, topographical and architectural views, royal portraits, contemporary history engraving and drawing books that characterised the appeal of the other major print entrepreneurs. Bowles stressed his international contacts, declaring that 'At the shop . . . gentlemen may be furnished with all sorts of fine French and Dutch prints, neatly fixed up on frames or without.'[15] Over the following winter, his foreign acquisitions included a set of engravings that was to extend his appeal. Bound in book form, and entitled *Het Groote Tafereel der Dwaarheid* (The Great Mirror of Folly), this collection of images, first published in Amsterdam in the immediate aftermath of the Bubble hysteria, represented a particularly ambitious fusion of high engraving and satirical urban commentary. The prints, executed on a large scale by a variety of distinguished Dutch and French engravers, depicted the freakish events of the summer in a range of pictorial styles, juxtaposing the elaborate forms of allegory and the freakish imagery of the grotesque with a detailed graphic record of the narratives and spaces of the fevered credit economy.[16] As an individual volume, *The Great Mirror of Folly* represented a prestigious graphic commodity operating on an international connoisseurs' market; broken up, adapted and selectively reproduced as single engravings, as it was by Bowles, the book contributed to a new identity for the satirical image in London's graphic culture. Having chosen a number of the Amsterdam prints to reproduce, Bowles

29 A. Humblot, *Rue Quinquempoix*, 1720 (BM 1655). Engraving, $8^{1}/_{2} \times 14$ in. Courtesy of the British Museum.

30 (*facing page top*) Bernard Picart, *Monument Consacrée à la Posteritée*, 1720 (BM 1627). Engraving, $8^{1}/_{2} \times 14$ in. Courtesy of the British Museum.

31 (*facing page bottom*) Bernard Baron, after Bernard Picart, *A Monument Dedicated to Posterity*, 1721 (BM 1629). Engraving, $8^{1}/_{4} \times 13^{1}/_{2}$ in. Courtesy of the British Museum.

commissioned engravers to copy and translate them, and during March he repeatedly advertised these revised images in the capital's daily newspapers.

The Bubbler's Medley is an image that, produced independently of this process, nevertheless bears the traces of Bowles's entrepreneurial takeover of the Dutch prints. 'Quinquempoix Street', the engraving at the medley's centre, is an almost direct, reversed, copy of one of the engravings bound in *The Great Mirror of Folly* (*fig. 29*), which welds the closely observed details of a panicking crowd to the image of a severely compressed urban space. In *The Bubbler's Medley*, a modern, international formulation of satiric representation is thus integrated into a more local, well established category of graphic art, the medley engraving, an appropriation that maintained the medley's dualised status as an ironic repository of

graphic commodities and a multi-layered form of urban commentary. If *The Bubbler's Medley* offered one form of engagement with the formulae of Dutch satire and the narratives of the Exchange, another was generated in the revision of Bernard Picart's great engraving *Monument Consacrée à la Posteritée* (*fig. 30*) in the early months of 1721. The revised version of the print, *A Monument Dedicated to Posterity* (*fig. 31*), was first advertised by Bowles on 28 March 1721, when it was described as offering 'a commemoration of the incredible follies transacted in the year 1720, invented by Monsieur Picart, engraved by Monsieur Baron.'[17]

Comparing the Continental and British versions of the print, we quickly see that Bowles's project amounted to a bifurcated form of cultural translation. The original image, although reversed, is duplicated almost precisely as a pictorial representation, while being thoroughly transformed and trespassed at the level of textual inscription. Although the writing at the base of *A Monument Dedicated to Posterity* is an almost word-for-word translation of the earlier image's caption, a few textual changes *within* the internal frame – the substitution of 'Jonathan's' for 'Quinquenpoix' is the most striking – work to relocate completely the engraving's narratives from the French capital to London's financial district. *A Monument Dedicated to Posterity* thus enjoyed a doubled status in contemporary graphic culture. The print was promoted as an unadulterated facsimile of a celebrated foreign artist's original design, and as an image that offered a pictorial mediation of the locally produced discourses on the Bubble and the Change that we have just been noting.

The spectacular procession that dominates the *Monument Dedicated to Posterity* is shown spilling out of 'Jonathan's' doorway and across Exchange Alley. Looking at the facade of the coffee house, and then across the background of the image, we become aware of the drastically reductive architectural shorthand of the engraving. The satire deploys a flattened, additive architectural emblematics that incorporates the entrances in the background as a succession of dislocated pictorial signs to be deciphered by the attentive viewer; in fact, they refer to the hospitals and asylums suggested as the ultimate destination of the Bubble's victims. While this pattern of representational juxtaposition can be compared to the conventions of satiric practice we recovered in the previous chapter, we can also argue that the spatial and architectural fracture it effects conformed to the readings of the new environments of finance in the city – especially the Change itself – as spaces that were unregulated by traditional spatial or architectural hierarchies. The engraving also suggests that the dynamics of modern finance have dramatically destabilised the demarcations between interior and exterior space, as the arenas of conviviality, conversation and trade become interchangeable. Chairs and tables stand outdoors, and Jonathan's interior is as crowded as the street. In these respects, the print correlates to the mythic anti-architecture of the Change in contemporary literary discourse, an anti-architecture that is pictorially reinforced here by the allegorical mechanics of the clouds rolling across the picture space, which offer another metaphor for the unfixed, impermeable and imaginary clouds of speculation and greed that were seen to have wafted so poisonously around the Alley.

Standing at the centre of this pictorial cumulus, which also incorporates the figures of the devil and of trumpeting Fame, is the nude figure of Fortune, the

32 Nicolas Poussin, *Venus presenting Arms to Aeneas*, 1639. Oil on canvas, 41⅜ × 55⅞ in. Musée des Beaux-Arts, Rouen.

focus of a collective gaze from the 'great throng of people of all conditions and sexes' who run behind the chariot. She throws stock debentures and subscriptions, intermingled with snakes and fool's caps, into the crowd. As we have seen, Picart's articulation of a fickle, eroticised icon of finance was duplicated in the discursive metaphors used to dramatise the crisis. Supplementing this exchange, her inclusion here invokes the components of an established fine art tradition. If we glance at Nicolas Poussin's 1639 painting of *Venus presenting Arms to Aeneas* (*fig. 32*), we can recognise how closely Picart's 'Fortune' approximates the conventions of mythological images which articulated the female body as a site of desire and benevolence. More pertinently, however, Picart's image modernises a depiction of Fortune found in earlier graphic art. *A Monument to Posterity* presents a self-conscious successor to Romeyn de Hooghe's celebrated seventeenth-century etching illustrating the narratives of the *Tabula Cebetis* (*fig. 33*), a classical polemic on the dangers of greed and extravagance that was repeatedly adapted and published in this period – John Davies's translation of the text had appeared in England in 1670.[18] Picart's pictorial concentration on the figure of Fortune reproduces her position in de Hooghe's etching, where she is shown distributing and withholding wealth to and from her followers. Davies's translation had enjoined the reader 'not to admire anything she does, and not to imitate those dreadful bankers, who having received other men's money, are as glad as if it were their own, and are angry when it is called for from them as if some great injury were done them, not remembering that it was put into their hands only for the creditor's convenience to take it when he pleased.'[19] Picart's engraving not only recycles the central, feminine agent of this economic morality tale, but remakes Quinquenpoix – and, in its second identity, Exchange Alley – as a contemporary urban equivalent to the compartmentalised and emblematically loaded environment of the earlier print, one that is similarly punctured by displaced sites of exit and entry, and similarly traversed by chaotic clusters of human victims who follow the undulating narratives of fantasy and

breakdown. *A Monument Dedicated to Posterity* thus demands that the viewer sub-
scribe to a similar model of interpretation to that suggested by de Hooghe's print,
one rooted in an implied spectactorial withdrawal from the crowded excesses of the
scene, but dependent also upon the process of visually tracking and allegorically
decoding a central narrative as it winds across pictorial and social space. Picart not
only appropriates an individual figure from an older tradition of representation but
also introduces an allegorical register of interpretation into the depiction of the
modern metropolis.

 In *A Monument Dedicated to Posterity*, this intersection of allegory with the
iconography of modernity is supplemented by the representation of Folly sitting
in front of the chariot, defined not only by what the caption calls her 'ordinary
attributes', but by an 'ample hoop-petticoat.' Her depiction satirically revises the
allegorical figure of Diana, the goddess of chastity and of the moon, whose
'ordinary attributes' had traditionally been a crescent worn over her brow, and a
chariot drawn by horses or nymphs. In recasting Diana as Folly, Picart modernises
and ironically reworks this formulae; the allegorical figure is dressed up,
and overlaid with the satirical sign language of high fashion and sexual display.
Rather than a chaste and modest goddess, we are confronted with a ridiculous
fashion victim and courtesan, flamboyantly parading her hoop petticoat, fan and
high-heeled shoes, and exposing the underside of her body to public view.
Remembering the critical metaphors of fashion, prostitution and display that
were being used to characterise the Bubble in contemporary London, we can
recognise how intimately this representation would have been linked to the
forms of social commentary stimulated by the crisis. Here, Folly is defined as a
grotesque intermediary between the figure of Fortune and the fashionable female

ARLEQUYN ACTIONIST.

33 (*facing page*) Romeyn de Hooghe, *Tabula Cebetis*, 1670. Courtesy of the British Museum.

34 Frontispiece, *Arlequyn Actionist*, 1720 (BM 1651). Engraving, 8 × 7⅛ in. Courtesy of the British Museum.

investors who cling to the fringes of the crowd. In this process, *A Monument to Posterity* again describes the realm of capital as one inflected, and infected, by the presence of the female body, and by a stereotypically feminine theatre of seduction and invitation.

This satiric representation of South Sea femininity is balanced by an intriguing depiction of the community of male investors thrown up by the Bubble. The fighting figures in the foreground and the sight of a duel in the distance reproduce the narratives of elite violence that were often linked to the crisis. More insidiously, the satire implies that the perversions engendered in the spaces of the new credit economy extended to an extreme homo-socialisation of masculine relations. In the huddle of stockjobbers and investors on the right of *A Monument Dedicated to Posterity*, the fetishization of stock – signalled by the outstretched arms reaching up towards the subscription list brandished above the crowd – intermingles with an amplified intimacy of contact, voices and vision between the men. Most obviously, the pair who stand to the left of the group cradle each other in their arms, their faces almost touching as one holds a hand against the other's wig; a pocket gets picked. An indication of how closely this kind of scenario could be linked to the corporeal excesses of the male body is suggested by another of the Dutch satires, also raided by Bowles, which doubled as a title page for a farce entitled *Arlequyn Actionist* (*fig. 34*). Here, the theatrics of a similar ritual of stock subscription are loaded with the imagery of exposed posteriors and an anal circuit of scatological

regurgitation and flatulent conversation. If the *Monument to Posterity* refuses such an explicit conjunction between the transactions of commerce and the iconography of the arsehole, Picart's print nevertheless cordons off a realm of exchange that redescribes investment in terms of a masculine erotics of touch, expression and spectatorship. Most blatantly of all, the foppish figure in the right-hand corner – a fictionalised portrait of John Law, one of the architects of the French credit scheme – is given an outrageously frank body language of sartorial display and sexual availability. His legs splayed open, and his crotch exposed, he is defined not only by the elaborate accessories of his clothing, and by the studied and effeminate nonchalance of his hands, but also by his lingering upward gaze at a pretty young man who brings him news.

These polarities of feminised and homo-socialised deviance are integrated into a broader imagery of the mock procession that travesties a venerable subject of high art, the ceremonial procession, and could easily be related to contemporary mock parades taking place in practice in the streets of London. In January 1721, *Applebee's Weekly Journal* reported that a group of men had 'caused a hearse, with several mourning coaches after it, to go about St. James, with all sorts of music playing before, and after it, where it is said it was done in derision to the South Sea Mongers.'[20] A week earlier, a correspondent to the same publication wrote of his fear that the South Sea directors themselves would be subjected to such a parade: 'We find your brother writers talk of hanging them, setting them upon asses, and carrying them through the street as a spectacle, and putting them to death, whether there be any law to do so or no.'[21] The rhetoric of Picart and Baron's print is less violent and more exotic: the figures who pull the female protagonists of the Bubble along are the allegorised agents of the various companies who had overstimulated the financial markets, led by the garlanded representative of the South Sea Company. If *A Monument Dedicated to Posterity*, which was geared to being consumed as a refined engraving as much as a vehicle of ridicule, manages to dilute the more excessive and corporeal symbolics of the mock parade, other satires were less decorous. In another engraving from the Dutch collection, clearly dependent on Picart's plate for its narrative and compositional structure, a far more grotesque version of the satiric procession is deployed (*fig. 35*). Here, Law is shown as Don Quixote, perched on a braying ass that releases an anal explosion of cash and shares, and surrounded by devils, a vomiting giant toad, and a freakish version of Sancho Panza.

Bowles's press advertisements make it plain that *A Monument Dedicated to Posterity* was being marketed as the most ambitious and desirable of his South Sea satires; while he used other prints from *The Great Mirror of Folly* as the basis for satirical engravings sold from his shop, Picart's print was consistently promoted as the print entrepreneur's prize commodity, and situated at the head of the newspaper notices he used to announce his current wares. Yet it is important to remember that Picart's image, however individual, operated as part of a city-wide nexus of images and texts that circulated the iconography and narratives of the crisis across a wide variety of formats. To indicate this, it is helpful to turn to an image reproduced in the *Weekly Journal* of 13 May, 1721 (*fig. 36*). In an exceptionally rare subordination of the newspaper front page to a single graphic design, the *Journal* displays a

LAW, als een tweede Don Quichot, op Sanches Graauwtje zit ten ſpot.

Dulcinia en 't Actie Roth,	*In 't groot betoovert Actie huis,*	*Hy kruipt zyn baas na als een pad,*
Verzoekt den Lawen Don-Quichot,	*En Sanche, tot zyn droevig kruis*	*En Klointjemaat te drommels plat*
Op Sanches Eselye, gezeeten,	*Moet voor Bombario hier ſpeelen,*	*Moet rast een ider te beſpotten,*
(Wyl Rosinant wat hooy gaat vreeten)	*Het kan den bloed zo zeer verveelen,*	*Daar een Zot maakt veel duizent Zotten*

35 *Law als een tweede Don Quichot*, 1720 (BM 1662). Engraving. Courtesy of the British Museum.

woodcut representing Robert Knight, the cashier of the South Sea Company, who had fled abroad with a haul of stolen cash. The print is an emblematic hybrid that draws not only on the stock imagery of the Bubble satires, but also on the conventions of the popular broadside illustration. The normative iconography of communication and trade that makes up the paper's masthead is newly juxtaposed with the grotesque trumpeteers and overburdened vessels that sail into the mouths of Hell. The publication was a great commercial success, and the following week's issue opened by declaring that 'the call for this journal (last week) being very extraordinary, upon account of the delineation of *Lucifer's Row Barge* in it, we are desired by several of our correspondents, both in city and country, to present them with it in this week's paper, with an explanation of every representation in the aforesaid cut.'[22] This reprint, and the one and a half page explanation that accompanied it, are testaments to the curiosity generated in contemporary culture by even the crudest graphic satires, and to the interpretative complexity demanded by even the most hackneyed cluster of pictorial codes.

However dissimilar their ascribed worth as cultural objects, and however divergent their levels of technical sophistication, both Picart's elaborate engraving and the *Weekly Journal* woodcut circulated within a graphic and satiric culture that was producing a collective iconography of the crisis. And although the *Monument Dedicated to Posterity* announced its links to a learned tradition of visual and verbal

(1915)

THE Weekly Journal: OR, British Gazetteer.

SATURDAY, MAY 13, 1721.

Lucifer's new Row-Barge for First-Rate Passengers.

GO on, vile *Traytors*! glory in your Sins,
 And grow profusely Rich, by wicked Means;
Ruin your Country for your own By-Ends,
Cozen your Neighbours, and delude your Friends;
Despise *Religion*, ridicule her Rules,
And laugh at Conscience, as the Guide of Fools;
Impov'rish Thousands by some *Publick* Fraud,
And worship *Int'rest* as your only God:
Thus may you gain, in time, a *South-Sea Coach*,
And ride thro' *London*, loaded with Reproach:

Become a proud *Director*, and at last,
Be bound to render what you got so fast.
Perhaps be punish'd, when your *All* is lost,
With *Gallows, Pillory*, or *Whipping Post* :
Or if you save your Gold, be doom'd to float;
To H—ll, in this infernal Ferry-Boat;
Built at the Devil's Cost, now Stock is low,
To waft *Directors* downwards, downwards, ho

1 Q SIR;

36 Front page, *The Weekly Journal, or British Gazeteer*, 13 May 1721 (BM 1716).
Woodcut, 8 × 6⅜ in. Courtesy of the British Museum.

allegory, and was subsequently advertised by Bowles alongside sets of engravings after Raphael's cartoons, this should not blind us to the fact that the print's identity and appeal were also framed by less privileged kinds of images and discourses – the grotesque alternatives in *The Great Mirror of Folly*, the medleys and satires listed elsewhere on the advertisement pages, and the ballads, broadsides, newspapers and fans that carried prints like *Lucifer's Row Barge*. Moreover, the extended caption to Picart's satire helped align the engraving with the jounalistic texts used to dramatise the crisis and demonise the distorted spaces of Exchange Alley. As such, the *Monument Dedicated to Posterity* maintained the status of graphic satire as an imagery that mediated a variety of pictorial forms and urban narratives, and that could be read using a variety of interpretative methods and representational referents. Significantly, this was a satirical agenda that, for the first time in the eighteenth century, received the entrepreneurial support and sanction of a leading player in the London print trade. Indeed, Bowles's own involvement, and his claims to a form of surrogate authorship, were given a clear presence in the framing hierarchy of the print. His commercial identity and address are boldly inserted at the centre of the image's base, while Picart and Baron's names skulk along the edges of a heraldic strip. However grandiose and brilliant Picart's original ambitions, the relentlessly mobile and commodified status of the graphic object meant that they had become subordinate to an English entrepreneur's strategies of pictorial production and consumption, and to an English city's mythologies of urban breakdown.

III

The reworked Dutch engravings sold by Bowles in 1721 offered a number of pictorial formulae that, while novel and successful in the immediate aftermath of the South Sea affair, represented a problematic agenda for graphic production within the central channels of the print market. The Dutch satires collectively offered a disturbing and apocalyptic codification of urban society, one that ultimately called into question the ideological agendas and cultural coherence of precisely that metropolitan constituency whose stability and affluence underpinned the art market as a whole. The detailed critique of consumption in the prints might even have threatened to turn into a self-defeating devaluation of the rituals of purchase and pleasure offered by the graphic commodity itself. More concretely, *The Great Mirror of Folly's* violent pictorial language – crowded with the details of corporeal excess, scatological expulsion and physical disfigurement – represented a grotesque iconography of the urban that flagrantly contradicted the more decorous ideals of polite identity and taste being cultivated in the capital. If the public's fascination with the spaces of speculation, and with an imagery that claimed a high status in the hierarchies of Continental print production, had stimulated an interest in Dutch satire, it is perhaps not surprising that the London print publishers also turned in the 1720s to other, rather different, modes of Continental satire for their own commercial purposes. Here it is worth noting that Bowles, in his consideration of which Bubble engraving to market most assiduously, had chosen an image,

Picart's, that fused the iconography of urban dislocation with an increasingly fashionable, exquisite and Frenchified stylistic vocabulary. Over the next few years, Bowles turned even more markedly to a satiric imagery that loudly proclaimed its links to French art.

The early 1720s saw a concerted promotion of imported French painted and printed goods, and locally produced versions of them, in the London art trade. Philip Mercier, for instance, a French artist working in London, not only painted numerous versions of the newly fashionable *fête galante* but also organised auctions of paintings, including works by Watteau, and produced sets of etchings avowedly taken from the same artist's designs.[23] Print sellers recurrently advertised works drawn from the most prestigious and the less exalted sites of French art. Michael Hennekin, a textile and print importer who owned the 'Great Print and Toyshop on St. Martin's Lane', inserted a lengthy advertisement in the *Daily Journal* of 26 December 1723 that usefully indicates the range of French images available to the urban consumer at this time. He offered a 'variety of large and small French prints for dining rooms, parlours and closets, old prints for collections; likewise prints neatly framed and glazed.' They included engravings of the 'statues and fountains in the garden at Versailles, Poussin's Sacraments, landscapes . . . [and] the galleries of Luxembourg', as well as 'the most diverting and comical dwarfs, never seen in London before, in several books, finely engrav'd.' Hennekin also listed 'the diverting and comical prints of Don Quixote and his man Sancho, finely engraved.'[24] In all likelihood, this refers to a set of engravings published in Paris after Charles Antoine Coypel's paintings of 1714–20. To trace the components of Coypel's images, and their subsequent trajectory within the London print market, will suggest some of the dynamics of the taste for French art that Mercier and Hennekin catered to, as well as indicating the impact made by a mode of satiric engraving that was distinctly different from that represented by *The Great Mirror of Folly.*

Coypel's twenty-five paintings had originally been executed to furnish designs for tapestries that were to be hung in the houses of the Parisian political elite. In 1720, however, a commercial agreement between the artist and a group of French print publishers facilitated their reproduction and dissemination as graphic commodities, produced under Coypel's supervision by a number of distinguished engravers. A collected edition was available by 1723, and it was quickly distributed on the international print market. In London, the engraver Gerard Vandergucht proceeded to produce two sets of twelve prints directly copied from the French engravings after Coypel. One set illustrated a new edition of Thomas Shelton's translation of Cervantes's text, which was published by a group of booksellers in 1725, and described on its title page as including 'a curious set of CUTS from the French of COYPEL'.[25] The other, much larger in scale and more painstaking in its techniques, was released as a collection of fine art engravings, published under the joint auspices of Vandergucht himself from his shop in Bloomsbury and a group of printsellers led by Thomas Bowles. Advertised repeatedly throughout the summer of 1726, their appeal buttressed by the continuing commercial success of Cervantes's text, the prints represented a modern fusion of satirical artistic

practice, literary illustration and the figural and spatial rhetoric of contemporary French art.

If the collective fantasies generated by modern economic exchange had lain at the narrative centre of the South Sea satires, Coypel's images offered a satirical meditation on the delusions suffered by a comic anti-hero who had misguidedly absorbed archaic literary conventions of chivalry and romance as conceptual frameworks for interpreting the real world. Katie Scott has convincingly located these images within a contemporary French debate on the cultural validity of certain structures of monarchical and art institutional power, and situated Coypel's depiction of Don Quixote at the 'indecorous border separating an epic world of classically enclosed forms from a comic plain of grotesques as yet unscored by rational definition.'[26] For the British viewer of the prints who remained outside the circumscribed spheres of French cultural faction, and who interpreted the images across sites quite different from the tapestries hanging above an *hôtel* wainscot, what would have been most striking about Vandergucht's engravings was the way in which they drained Quixote's progress of the explicit signs of the grotesque and the corporeal maintained in Shelton's translation. Instead, they depicted the comic protagonist's psychological disorder as a theatrical focus of genteel laughter, framed by the eroticised but decorous grids of spectatorship and space newly associated with the *fête galante* imagery of Watteau and Mercier. Indeed, the images that Bowles and Vandergucht chose to reproduce were those that correlated most closely to the iconography of the *fête* being promoted in London, and as such were produced as part of the broader process of cultural editing that had rewritten and reframed earlier imported prints.

We can begin to appreciate the translation of Cervantes's text effected by Coypel and Vandergucht's pictorial projects by looking at some of the images chosen for publication in London. In *Don Quixote defends Basilus who marries Quileria by Stratagem* (*fig. 38*), the awkward and elongated body of Don Quixote on the left forms part of a satirical frieze of figures that combines an ironic coupling of lovers with a range of distorted physiognomies and gestures played out across the foreground: we move from the crouching, humpbacked image of Sancho Panza on the left, to the startled eyes and mouth of a cleric standing in the centre, and to the threatening twist of the enraged husband on the right. Significantly, this comic, excessive and potentially violent narrative is framed by a gallery of female viewers who, glimpsed among the trees that rhythmically surround the foreground, help to redefine the central scene as an internalised theatrics of the absurd that is acted out under the watchful eyes of a distanced, feminised group. Coypel and Vandergucht's engravings consistently rework the narratives of Don Quixote in terms of an entertaining and ultimately harmless iconography of theatrical performance, and our spectatorial surrogates – the pictorial audience for this theatre – are consistently figured as, or linked to, an interlocked pictorial cordon of beautiful young women. In this instance, the presence of these women helps to mediate and pacify the polarised markers of masculine conflict and bodily distortion at the edges of the engraving, and complements the parodied stereotypes of the historical romance occupying the print's centre.

37 Antoine Watteau, *The Shepherds*, c. 1716. Oil on canvas, 22 × 31⅞in. Schloss Charlottenburg, Berlin.

To the consumers who first encountered Vandergucht's engravings in 1725, such images would inevitably have been understood in relation to the strategies of the *fête galante* (*fig. 37*), which similarly merged the theatrics of performance and flirtation, the imported costumes and gestures of the comic grotesque and the carefully traced graphs of the female gaze across the landscaped spaces of pastoral.[27] As such, Vandergucht's *Don Quixote* prints were only partially and unsatisfactorily understood by returning to Cervantes's text; they were also conditioned by the pictorial and narrative formulae of French art, formulae that had already been intensively recirculated on the London print market as fashionable markers of refinement. In Vandergucht's series – as we can see even more clearly in *The Entry of Shepherds at Camacho's Wedding* (*fig. 39*) – the grotesque body had become, as in the *fête* itself, an overwrought signifier of comic difference functioning within a broader network of choreographed performance and viewing, here dominated by an undulating chorus of female dancers, and accentuated as spectacle by the presence of the musician and the distant, watching group of *commedia dell'arte* actors.

Such a reading allows us to recognise the ways in which these prints deploy a pictorial vocabulary of elite femininity and theatrical performance to mitigate the excesses of Cervantes's text. Yet we can go on to suggest that the element of interpretative disjunction thus set up in the gap between literary source and finished image formed part of the satirical appeal of the engravings, and returned them

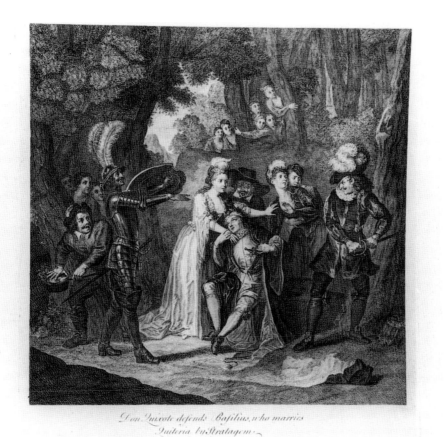

Don Quixote defends Basilius, who marries
Quileria by Stratagem

38 Gerard Vandergucht, after Charles Antoine Coypel, *Don Quixote defends Basilus who marries Quileria by Stratagem*, 1723–25. Engraving, $10\frac{7}{8} \times 11\frac{1}{8}$ in. Courtesy of the British Museum.

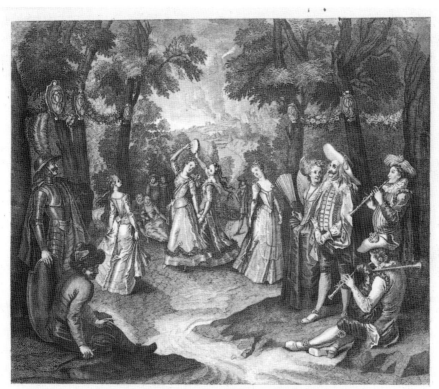

The Entry of Shepherds at
Camacho's Wedding

39 Gerard Vandergucht, after Charles Antoine Coypel, *The Entry of Shepherds at Camacho's Wedding*, c. 1723–5. Engraving, $10\frac{3}{4} \times 11\frac{1}{8}$ in. Courtesy of the British Museum.

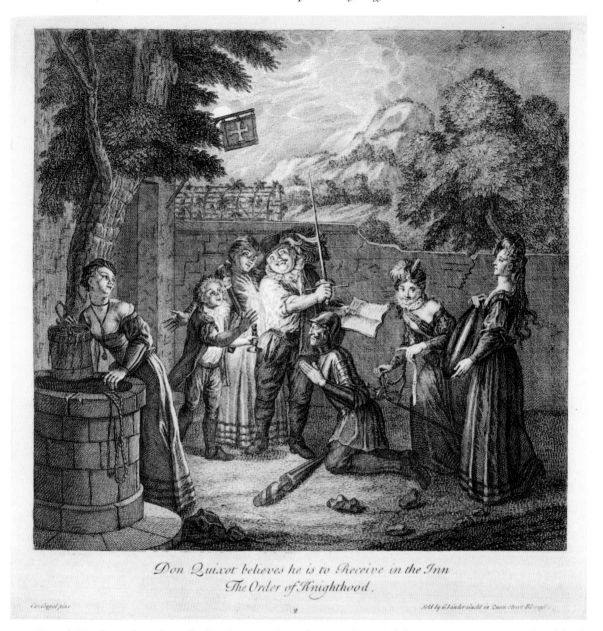

*Don Quixot believes he is to Receive in the Inn
The Order of Knighthood.*

40 Gerard Vandergucht, after Charles Antoine Coypel, *Don Quixote believes he is to Receive...knighthood*,
c. 1723–5. Engraving, 10⅝ × 11¼ in. Courtesy of the British Museum.

to a more explicitly eroticised province of aesthetic pleasure. This disjunction
recurrently focused on what was seen as the easily confused registers of polite and
impolite femininity. In the first of Vandergucht's series of prints, *Don Quixote
knighted in the Inn* (*fig. 40*), Quixote is pictured at the centre of another piece of
mock-ritual. He is being 'knighted' by a tavern owner, whom he had mistaken for
the keeper of a castle, and is again placed at the centre of an line of attractive young
women who offer a variety of responses to the kneeling knight's ludicrous solem-

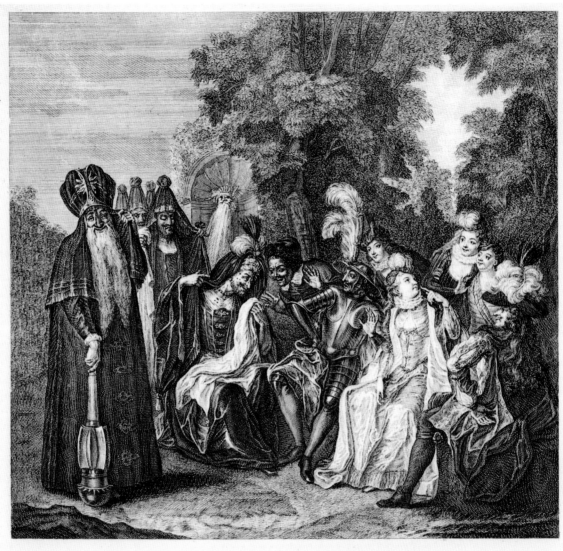

The Afflicted Matron complains to Don Quixote,
of her Inchanted Beard.

41 Gerard Vandergucht, after Charles Antoine Coypel, *The Afflicted Matron complains to Don Quixote, of her Inchanted Beard*, 1723–25. Engraving, $10\frac{3}{4} \times 11\frac{1}{8}$in. Courtesy of the British Museum.

nity. Returning to Shelton's translation of *Don Quixote*, we find that at least two of these women, rather than being the genteel, innocent conduits of laughter they seem, are actually prostitutes, whose residence at the inn fixes its status as an unofficial brothel. Given this information, their seemingly decorous actions in the image become loaded with surreptitious sexual connotations – how clearly, suddenly, the laughter of the whore who carries Quixote's sword and harness becomes aligned to their status in the text as phallic substitutes, which she goes on to strap

around his waist 'with a singular good grace and dexterity.'[28] Even the body language of the figure in the foreground can be read as a coy amalgam of domestic servitude and voyeuristic availability – her body, but not her head, turned to the viewer.

In this respect the print sets itself up as a *deceptio visus* of idealised femininity that the consumer of the print has to decode, generating a play of representations that ironically parallels the disjuncture between sign and referent plaguing Don Quixote's own engagement with the outside world. While Quixote is unable to decipher the prostitute's bodies – rather, he assumes that 'those light hearted wenches that kept him, to be certain principal ladies and dames of the castle'[29] – the viewer is constituted as someone who is defined precisely by his ability to appreciate and enjoy the satirical interplay and slippage between pictorial paradigms of feminine beauty and underlying themes of commodified sexuality and display. This play with the pictorial codes of femininity is extended in another image that deliberately amplifies the confusions of gender for comic effect, *The Afflicted Matron complains to Don Quixote, of her Inchanted Beard* (*fig. 41*). Here, Quixote is situated at the fulcrum of an exchange between a fantastic collection of hirsute women and a predominantly female audience drawn from fashionable society. In this instance, satire operates according to an internal mechanics of contrast and exposure, in which the idealised, enclosed bodies of elite women are confronted with the unmasked, defeminised faces of a series of negative doubles. Again, however, the shock of this confrontation is mediated by the elite, theatricalised forms of viewing and laughter depicted in the engraving, and by the careful splitting of the image, and the environment it depicts, into two discrete halves.

The *Don Quixote* engravings, in the displaced environment of the London print market, offered another reworked agenda of Continental satire, one that decisively removed satire's references from those contemporary, problematic spaces of the urban public sphere that had been so radically articulated by the Dutch South Sea prints. In this commercial translation, satire was effectively cut off from its moorings in the disparate narratives and images of contemporary urban dislocation, tied to a literary discourse rather than a journalistic one and, most significantly, overlaid by the fashionable, fictional and titillating pictorial protocol of the Rococo. Sold by Bowles alongside the Dutch satires, the *Don Quixote* prints thus offered a more genteel, salubrious satirical option to his consumers than the images culled from *The Great Mirror of Folly*, and would have been quickly recognised as a quite different kind of graphic product. It must have a been a suprise, then, when Bowles, early in December 1724, encountered an engraving that clearly gestured to both the Dutch and the French satires he was involved with, even while focusing on an entirely new subject for satire, that of freemasonry.

IV

On 2 December 1724, the *Daily Post* carried an advertisement that announced the publication of *The Mystery of Masonry brought to light by the Gormagons* (*fig. 42*). In the newspaper, the engraving was described as 'a curious print, engraved on a

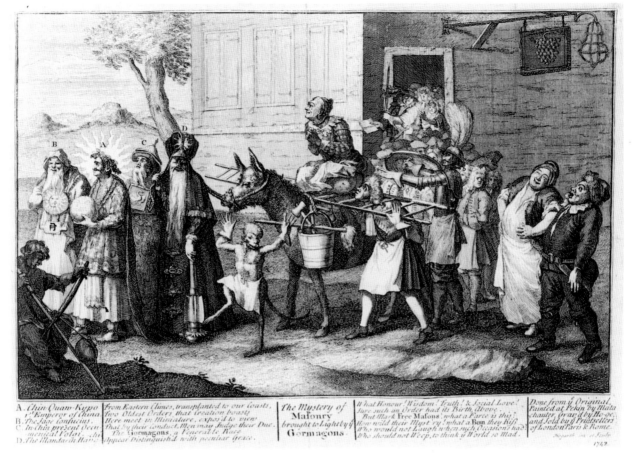

42 William Hogarth, *The Mystery of Masonry brought to light by the Gormagons*, 1724 (BM 2549). Engraving, $8\frac{1}{2}$ × $13\frac{1}{2}$ in. Courtesy of the British Museum.

copper plate, by Ho-ge, taken from an original painting of Malanchantes, by order of the Mandarin Hang-chi, graved at Peking, and a number of them brought over from Rome, by a merchant in the ship Cambridge, and by him left to be disposed of at 12d each, by the print sellers of London and Westminster, and wholesale by Mr Holland in Earl Street near the Seven Dials.' The print, which represented an extended critique of certain factions of contemporary freemasonry, was designed and engraved by William Hogarth, who was coming to prominence as a graphic satirist in London. Trained initially in the workshop of a silver engraver, Ellis Gamble, Hogarth had broken his apprenticeship around 1720 to set up in business as an independent engraver. Within a few years, he had produced book illustrations, trade cards and, in the aftermath of the Bubble crisis, graphic satires which offered a localised version of the Dutch South Sea prints. In 1721 Hogarth had also become involved in illustrating Aubrey de la Mottraye's *Travels through Europe, Asia, and into Parts of Africa*, for which he produced engravings that focused on the rituals, dances and parades of eastern cultures, including a *Procession through the Hippodrome, Constantinople* (*fig. 43*).[30] This image offers a suggestive precedent for

43　William Hogarth, *A Procession through the Hippodrome, Constantinople*, from Aubrey de la Mottraye's *Travels through Europe, Asia etc*, 1721. Engraving, 9³⁄₄ × 13¹⁄₄ in. Courtesy of the British Museum.

The Mystery of Masonry, concentrating on a similarly motley procession of exotically dressed male walkers, who not only carry the accessories of religious ritual but also bear the screened figure of a female in their ranks. Through this context, as the advertisement helps confirm, the ridiculed ceremonies of masonry in the later image are related to the rites and beliefs of the alien cultures documented by Mottraye. Yet again, the narratives of satire are situated within a framework of the foreign.

Looking more closely at the *Mystery of Masonry*, however, confirms that Hogarth's engagement with the pictorial codes of foreignness and cultural difference was far more intimate and complex than this. More specifically, the print functioned in critical, appropriative exchange with the imported categories of graphic satire we have discussed in this chapter. The engraving draws many of its elements from no less than four of Coypel's *Don Quixote* engravings. In the background, we can spot the innkeeper, holding his sword and papers, who stood at the centre of Vandergucht's first print (*see fig. 40*), again juxtaposed with an overhanging signboard and the details of a mountainous landscape. To the left, Trifaldin, the bearded wizard who supervised the unveiling of *The Afflicted Matron* (*see fig. 41*), reappears as part of a comic procession of foreign dignitaries in the foreground. The shaded bank of ground in the left-hand corner, the pitted earth that lies under a trapped freemason's feet and the figure of Don Quixote himself, newly dressed in an apron, are taken directly from the image of the farcical wedding ritual between Basilus and Quileria (*see fig. 38*). The most extensive form of pictorial recycling, however, is effected by Hogarth's reference to, and redeployment of, another of Coypel's designs, engraved by Vandergucht with the title of *Don Quixote takes the Puppets to be Turks and attacks them to rescue two flying Lovers* (*fig. 44*). The butcher who rocks back with laughter, the shocked figure of Sancho Panza and the girl standing at the doorway with a candle in Coypel's image are all transplanted to *The Mystery of Masonry*, where they help frame and illuminate the masonic procession. Most dramatically of all, the figure of the old woman who forms part of the outer circle of viewers in Coypel's picture is yoked into the centre

Don Quixote takes the Puppets to be Turks, and
Attacks them to rescue two flying Lovers.

44 Gerard Vandergucht, after Charles Antoine Coypel, *Don Quixote takes the Puppets to be Turks and attacks them to rescue two flying Lovers*, c. 1723–25. Engraving, $10\frac{1}{2} \times 11\frac{1}{8}$ in. Courtesy of the British Museum.

of the English satire, and unveiled as the grotesque, anal focus of the print's narratives.[31]

Equally unmistakable is the extent to which Hogarth's image reproduces and adapts the pictorial formulae of the Dutch South Sea satires. If his satire's exchange with Coypel's *Don Quixote* had concentrated on replicating a series of dislocated details, *The Mystery of Masonry* reasserts narrative and compositional structures found in the *Great Mirror of Folly*. Let us notice for a moment *The Mystery of Masonry's*

concentration on a spectacular procession of figures, led by a carnivalised collection of exotic stereotypes, and dominated by an allegorical composite of vanity, sexual perversion and exposure who is followed by a throng of figures emerging from an urban doorway. Doing this helps us see how clearly Hogarth's print recycles the satiric structure and subject matter of Picart and Baron's *Monument to Posterity* (*see fig. 31*). Here, too, we can remember the cruder, scatalogical offshoot of Picart's design (*see fig. 35*), which depicted John Law as Don Quixote, bestriding an ass that was similarly loaded with goods and pulled along a chaotic configuration of urban and rural space. Most subtly of all, the *Mystery of Masonry's* central focus on the obscene proximity between a novice's trapped head and an eloquently exposed arse, a relationship celebrated by the dancing monkey in the foreground, recycles the iconography of *Arlequyn Actionist* (*see fig. 34*), where we again find the intimate, triangular conjunction of a bewigged male's profile, a pair of bared buttocks and a monkey. Indeed, in his translation of these details from one image to another, Hogarth has fused the emblematically loaded figure of the monkey in the frontispiece with the prancing body language of the nearby *commedia dell'arte* actor.

Recovering this complex process of appropriation and juxtaposition, we can begin to appreciate how Hogarth, in this print, reaffirmed the satirist's practice as one that was partly defined by an ironic play with different pictorial discourses, and with graphic ready-mades that were available to be broken into and redeployed to generate new kinds of pictorial signification. This satiric reworking of different graphic materials may remind us of the kinds of practice and appeal that distinguished artists such as John Sturt and George Bickham senior, and the precedents of the medley and the political satire. Given the elaborate and almost wholly undisturbed mythologisation of Hogarth that has dominated the historical analysis of the graphic art of this period, it is particularly germane to look at a work which demonstrates how thoroughly he was imbricated in a collective, historically determined framework of satiric practice, and within a set of pictorial and commercial strategies that were generated by numerous individuals working across a myriad of sites. In this context, it is clear that *The Mystery of Masonry* offered an ambitious reassertion of graphic satire's dual preoccupation with contemporary urban commentary and pictorial fracture, assemblage and play. Nevertheless, if Hogarth's print demands to be read as a complex re-ordering of a variety of satiric formats, the engraving's central subject was freemasonry itself, a form of urban organisation that had generated and attracted a stream of discourses and images of its own. Before returning to consider the implications of Hogarth's dialogue with Coypel's *Don Quixote* and the Dutch satires, we need to investigate the ways in which *The Mystery of Masonry's* identity and appeal was conditioned by a controversy concerning this modern, secretive and newly embattled sector of metropolitan society.

★ ★ ★

V

Freemasonry's contemporary prominence was the belated legacy of an important reconfiguration of urban culture that followed the Great Fire of London in 1666.[32] The fire had destroyed 13,200 houses, 89 parish churches and a number of venerable pieces of monumental architecture, including the old Royal Exchange and the Guildhall. The subsequent need to rebuild whole sections of the city attracted massive amounts of speculative capital into the metropolis and drew thousands of masons and other skilled craftworkers to London. The haphazard process of urban renewal that ensued generated a number of new cultural formations, including the gatherings of masons and other expert craftworkers that came to be organised under the auspices and name of freemasonry. The relatively informal beginnings of such associations developed into a strictly policed network of masculine fellowship marked by coded forms of membership, conviviality and conversation. In 1717, the Grand Lodge of Freemasons was established to coordinate the activities of the various urban lodges, which had acquired a genteel if partly hidden status as meeting places for the men of the city's 'middling' classes. In the following years, the order's bid for social prestige and acceptance, hitherto sustained by its intermittent role as a sponsor of scientific and philosophical debate, was channelled into a sustained courtship of the urban aristocratic elite, who were invited to fill the organisation's most prestigious honorary offices. By 1721, the London freemasons had become confident enough to preface their annual dinner with a procession through the city, described by *The Post Boy* of 24 June: 'The senior Masons, having confirmed the Duke of Montague as Grand Master, marched on foot to the Hall in proper clothing and due form; where they were joyfully received by about 150 true and faithful, all clothed.'[33]

The procession – which travelled by coach after 1722 – provided a spectacular, street-level confirmation of the masons' new cultural status, and a set of published *Constitutions*, widely advertised in the newspapers of 1723, articulated an extended textual idealisation of the order.[34] The *Constitutions* were an eclectic combination of modern guidelines for masonic practice and long-established precepts culled from fragments of historical writing. Initiated under the leadership of Montague, they were edited and revised by James Anderson, a Scottish cleric who had come to London and experienced the vicissitudes of city life at first hand. He had been imprisoned for debt and subsequently lost even more money in the South Sea crisis. Such details become more than anecdotal in the light of the *Constitutions'* role as a blueprint for social equilibrium that sought to replenish the ideological vacuum left in the wake of the collapsed ideals of the Bubble. Most radically, the *Constitutions* transformed the abstract mathematical notion of geometry into the conceptual centrepiece of a new ideology of the urban, and offered a manifesto for social organisation founded on the rational, geometric ordering of metropolitan architecture and space. This programme followed a historical account that linked the exotic details of masonic history to the mathematical discourses of ancient Greece – Euclidian geometry is declared to be the 'foundation of all Masonry' – and to the architectural achievements of Augustan Rome.[35] The rebuilding of London was constantly figured by Anderson in terms of this Augustan precedent. The new

Royal Exchange, for instance, is 'all of stone, after the Roman style, the first structure of that use in Europe.' An ideal of geometry, furthermore, was also perceived as encompassing the social relations generated across the spaces this kind of architecture helped define, relations that Anderson describes as being duplicated most perfectly by the organisation of freemasonry itself. This he repeatedly describes as an architectural construct: 'brotherly love' is defined as 'the foundation and capestone, the cement and glory of this ancient fraternity', and the 'whole body' of the order 'resembles a well built arch.' This was a geometry that held both buildings and individuals together: 'let other nations boast at will/ Great Britain now will yield to none/ For the Geometry and skill/ In building Timber, Brick and Stone/ For architecture of each sort/ For curious lodges where we find/ The noble and the wise resort/ And drink with craftsmen true and kind.'[36]

John Pine's frontispiece for the *Constitutions* (*fig. 45*) represents a sustained attempt to translate Anderson's programme of spatial and social equilibrium into graphic form, and offers a suggestive pictorial counterpoint to Hogarth's satire of the following year. The conventions of a ritualised group portrait – the figures in the centre are those of Montague and his successor, the Duke of Wharton, surrounded by the senior officers of the order – are superimposed across a compartmentalised composite of architectural, mathematical and allegorical imagery. The engraving is dominated by a flamboyant display of perspectival recession articulated across a row of columns incorporating the five Classical orders, a row bounded by the framing curves of two stone arches and grounded in the squared paving underneath the masons' feet. Given Anderson's text, it is clear that such features served as crucial pictorial markers in the engraving, symbolising geometry's newly ascribed centrality in the creation of an ideal social space, one where public virtue was supposedly underpinned by the laws of Euclidian mathematics (which are themselves indicated in diagrammatic shorthand at the base of the image) and framed by the rhythms of monumental architecture. The band of figures across the foreground extends this appeal, suggesting a code of genteel fellowship which is conspicuously expressed through the details of dress. The finery of the nobles at the centre of the image links the masons to the most grandiose traditions of aristocratic leadership, while the gloves and aprons symbolise a mythicised matrix of craftsmanship and reconstruction. The sartorial iconography of privilege and labour is thus appropriated by an urban collective which lays claim both to elite acceptance and craft fraternity. Finally, this formation of masculine identity is supplemented by the inclusion of the figure of Apollo, the sun god, who rides across the sky in his chariot. Apollo traditionally embodied the most desirable form of male beauty, combining the attributes of a warrior with the delicate features of a beardless young man. Here, his nearly nude body offers an idealised counterpart to the figures who stand below.

The unruffled patterns of good fellowship implied by Pine's engraving, however, bely a situation that in 1723 was already being severely threatened by the growing factionalisation of masonic politics and by the sustained critique the order was attracting in urban culture. Montague and Wharton, rather than remaining allies, became increasingly associated with two rival groups within the society – Montague with the proponents of social architecture led by Anderson, and

Engrav'd by Iohn Pine in Aldersgate Street London

45 John Pine, frontispiece to the freemason's *Constitutions*, 1723. Engraving, $8^{3}/_{8} \times 7$ in. Courtesy of the British Library.

Wharton with a collection of crypto-Jacobite masons who resented, and militated against, the increasingly extensive links being fostered between the society and the ruling Whig political establishment. The situation degenerated over the following year as Wharton's position – already undermined by his failure to retain the Grand Mastership – was further destabilised by a series of mock-advertisements placed in the London newspapers, which caricatured his grouping as a grotesque mutation of the masonic ideal. The authorship of these notices remains unknown, but they seem to have been part of a campaign aimed symbolically, if not practically, at expelling an unpopular masonic faction from the order. The writer's name for the Whartonians was the Gormagons, who were given a prominence and a history that offered an explicit contrast to the classical antecedents suggested by Anderson, and who were metaphorically aligned with the political opponents to the crown who remained in exile on the Continent. Thus, the *Daily Post* of 3 September 1724 carried a mock-advertisement that was loaded with a rhetoric of comic xenophobia and anti-Catholic aspersion:

> whereas the truly ANCIENT NOBLE ORDER of the Gormagons, instituted by Chin-Quaw Ky Po, the first emperor of China, (according to their account), many thousand years before Adam, and of which the great philosopher Confucius was Ocumenical Volgee, has lately been brought into England by a Mandarin and he having admitted several gentlemen of honour into the mystery of that most illustrious order, they are determined to hold a chapter at the Castle Tavern in Fleet Street . . . The Mandarins will shortly set out for Rome, having a particular commission to make a present of the Ancient Order to his Holiness, and it is believed the whole sacred college of cardinals will commence Gormagons.[37]

Through such notices, local conflict is comically transmuted into a mythology of foreignness and difference, while the dynamics of masculine fellowship are drama-tised, however ironically, as ones threatened by the invasive impetus of mysterious philosophers, disguised politicians and conspiratorial prelates, secretly slipping into London from abroad.

As well as suffering from these elaborately voiced forms of factional infighting, the freemasons were under attack from commentators and satirists working outside the Society, who translated the order's rules of masculine fraternity into perverse codes of same-sex erotics and exhibitionism. 'The Freemasons, A Hudibrastic Poem', first published in 1723 and frequently reissued, represents a good example of this kind of critique.[38] The poem adopts the fictional perspective of a former mason who writes down a series of voyeuristic reminiscences of his time within the order. His text begins by amplifying popular prejudices about the sexual connotations of the society's rites of initiation. The poem is dedicated to 'one of the wardens of the Society of Freemasons' by the author, who 'had the honour, not long since, of kissing your posterior', and it details how the grand mason, having entered the room,

> his breeches low pulled down and shows
> his arse, this all must here expose
> which the new Mason close salutes . . .

and when he thus his Bum has slabbered
And put his sword up in his scabbard . . .
Here only tis that we can see
The arse promotes society.[39]

This conjunction of anal exposure, scatalogical excess and, most provocatively, sodomitical metaphor, was a relentless feature of the most unrestrained of the anti-masonic satires; here it is supplemented by a satirical reference to the secondary pleasures offered by a prostitute brought into the lodge: 'The Masons never will be pleased/ Till with Dame Birch their bums are teased.'[40] In such poetry, the masons were characterised by a gross form of bodily inversion which elevated the posterior as a prime site of masculine identity, conversation and masochistic pleasure, an inversion that is only covered up and righted in public, outdoor life by the dissimulating codes of dress and gesture:

When thus the Mason has been stripped
And well approved, and marked and whipped
They straight are rigged from top to toe
And dressed as fine as any Beau
With gloves and aprons made of leather
A sword, long wig, and hat and feather
Like mighty Don Quixote then they stagger
And manfully they draw the dagger
To prove they're all men of mettle
Can windmills fight, and treatise settle . . .[41]

Here, clearly, we are entering upon the representational territory of Hogarth's *The Mystery of Masonry*. Having outlined some of the discourses, both positive and negative, that defined the order in contemporary urban culture, we can now return more productively to Hogarth's image, and discover how his satire used the pictorial strategies of appropriation and revision to articulate a powerful form of polemical intervention in the controversies concerning freemasonry in the city.

VI

The Mystery of Masonry (see fig. 42) depicts the Gormagons acting out a parodied version of the official masonic procession through the capital, setting out from the Grapes tavern, a fashionable meeting house in Westminster, and immediately moving into a ruralised environment within which the lodge becomes an anonymous oddity. The cavalcade is led by a group of exotically dressed figures who are described in terms which match exactly the vocabulary of the mock-advertisement that had satirised the Gormagons three months before the print's appearance: 'A. Chin Quaw Kypo, 1st Emperor of China; B. The Sage Confucius; C. In-Chin, present Oecumenical Volgi; D. The Mandarin Hangchi'. Recognising this correlation, we can see that Hogarth recycled and contributed to a collective, sustained programme of critique and ridicule. The exaggerated rhetoric of foreignness found

in the print – built up from the details of indecipherable symbols, elaborately patterned materials and outlandish costumes – is integrated with the other forms of satirical commentary that are incorporated in the engraving, which seem to extend its critique into a more general attack on masonry. Most shockingly, Hogarth plays on the caricature of the masons as a perverted, deluded and ritualistic organisation: he not only introduces Don Quixote, who, as we have just seen, was being used to illustrate the hubristic self-deceptions of freemasonry, but also focuses on the obscene, self-abasing forms of lip-service that were supposedly taking place behind the lodges' walls. The comic narratives of masonic initiation, of being locked in oral intimacy with a pair of pocked buttocks – 'what a *Bum* they kiss' the caption exclaims – are tied to a grotesque central figure who functions as a dual signifier of feminine conceit and anal display. On the one hand, she is, like the figure in Picart's *A Monument Dedicated to Posterity*, a modernised, allegorised personification of Folly; on the other, she is redrawn to suggest the masculine, sodomitical mythologies of masonry that were circulating in contemporary literary satire. As such, the old lady, yoked from Coypel's image, deprived of the clinging children who had sentimentalised her earlier appeal and brutally twisted at the waist – her body seems to be going in two directions at once – is suggested as a disturbing, composite figure of difference who destabilises the boundaries of gender as well as those of sartorial decorum and sexual practice.

These different forms of pictorial engagement with contemporary discourses concerning masonry work together to produce a satiric successor to the graphic idealisation of masonic fraternity and space offered by the *Constitutions* frontispiece. The carefully compartmentalised delineation of masculine fellowship, dress and allegory developed by Pine is thoroughly confused and subverted in Hogarth's alternative image of masonic community: the poised exchange between elite males is transformed into a crushed mêlée of bodies and gestures; the aristocratic finery of the order's leaders is replaced by the emblazoned robes of visiting mystics and wizards; and the masonic uniform of gloves and aprons is newly donned by a monkey and a knight-errant; finally, the discreet presence in the margins of Apollo on his horse-drawn chariot is succeeded, as we have just noted, by the allegorised figure of a grotesque female, introduced into the centre of the image and depicted squatting upon an ass. These revisions were not necessarily developed in direct response to Pine's image, but were satirical strategies that gained significance when they were read against the pictorial formulae of masonry articulated in places such as the *Constitutions* frontispiece. More subtly, *The Mystery of Masonry* also offers a satirical form of pictorial play with the spatial agendas of masonic culture. The satire's pictorial space is a fractured entity generated by the meshing together of different pictorial sources, both French and Dutch; unsurprisingly, this leads to an insistently disordered perspective, in which bodies seem to be erratically disproportionate to each other. Space is crushed and upset – compare, for instance, the respective positions and sizes of the laughing butcher, Don Quixote, and the following masons – and the architectural facades of the lodge are flattened out and made awkward. This combination of seemingly trivial details can now be read as articulating an unsettled, disjunctive register of pictorial space that satirically undermines the idealised grids of Pine's engraving, and that offers a culturally loaded

negation of the ideals of social geometry so central to contemporary masonic ideology.

The materials used to develop these engagements with masonry were drawn, as we saw earlier, from a range of imported sources; in this process, Hogarth's engraving could also be read as a critical commentary on those sources. The satire suggests a systematic engagement with a mode of satirical imagery – Coypel's – that was in the process of being adapted for genteel consumption in the metropolis. *The Mystery of Masonry* offers an ironic counterpart to the patterns of graphic translation being effected by Vandergucht and Bowles. Hogarth similarly invokes the French artist's iconography as a modern graphic ideal but, very differently, subjects that iconography to a radical process of revision. In so doing, he politicises a satirical idiom that, in the promotion of Coypel's images, was in danger of becoming disinfected and diluted by the pictorial rhetoric of comic pastoral and the commercialised appeal to polite taste. Hogarth re-emphasises the vocabulary of the obscene that had been so carefully mediated in Coypel's *Don Quixote*, and removes the gendered grids of spectatorial decorum that had muted the grosser excesses of Cervantes's narrative. The ubiquitous signs of flirtation and the comic registers of sexual deviance found in Coypel's images are amplified into a shocking pictorial rhetoric of anal exposure and masculine perversion. At the same time, the theatricalised and landscaped rituals of elite leisure are transformed into the profane emblematics of the urban mock-procession, and the conceptual misjudgements of a fictional anti-hero are integrated into the critique of an equally self-delusive community within modern metropolitan society.

Reinforcing this invitation to a reading that shuttled between the *Mystery of Masonry* and the French engravings, Hogarth sets up a series of comparisons between the activities of the plagiarised protagonists in the anti-masonic satire and their previous roles in Coypel's *Don Quixote*. In both contexts, for example, the figure of the bearded wizard functions as a witness to the satirical unveiling of a sexually ambivalent female body, while the innkeeper's earlier participation in a mock-ritual of ennoblement correlates to his later involvement in the deluded solemnities of masonic initiation and elevation. Collectively, these parallels and references articulate a satirical refashioning of Coypel's *Don Quixote* that not only complicated *The Mystery of Masonry's* exchange with the representations of freemasonry but also, we can suggest, would have inflected the reception of the French artist's images, whether imported or reproduced, in London's print culture.

This strategy of satiric translation is supplemented, as we have seen, by Hogarth's references to the pictorial paradigms of Dutch satire, which had explicitly concentrated on the urban as a subject matter, on collective patterns of social delusion and on a dualised strategy of pictorial assemblage and polemic critique. In this respect, the pictorial fragments drawn from Don Quixote are mapped onto an alternative pictorial order, one that is reformulated by Hogarth's print as a radical, continuing basis for contemporary graphic satire. Here we can remind ourselves that Hogarth's earliest satires – including such images as *The South Sea Scheme* of 1721 (*fig. 46*) – had self-consciously aligned themselves with the newly arrived Dutch engravings. *The South Sea Scheme*, like the images of *The Great Mirror of Folly*, is preoccupied

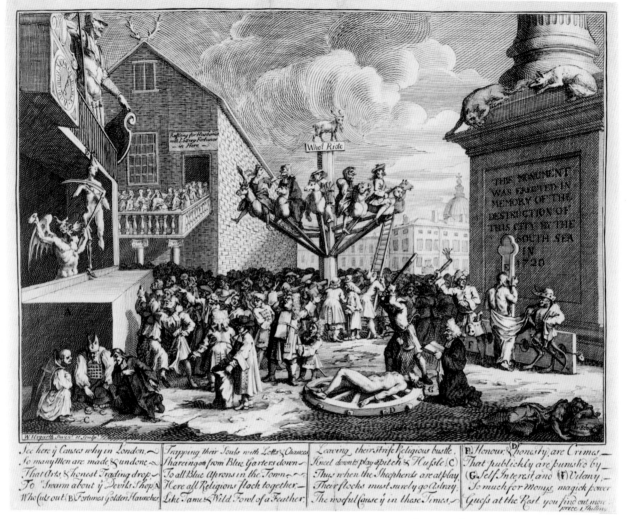

46 William Hogarth, *The South Sea Scheme*, 1721 (BM 1722). Engraving, $8^{3}/_{4} \times 12^{1}/_{2}$ in. Courtesy of the British Museum.

with the crowded, chaotic and deluded cycles of capital investment in the city, and generates a similarly splintered syntax of perspective and space, in which buildings like the Monument to the Great Fire, the Guildhall and St Paul's Cathedral could all be incorporated within the same pictorial schema. Executed only three years later, *The Mystery of Masonry* represents both a testimony to the wider developments of satirical art since *The South Sea Scheme* – developments that are stitched into the engraving's internal fabric – and a reaffirmation of the kinds of focus that had characterised the images of Picart and his peers.

The intimate conjunctions and ironic juxtapositions recovered in a close reading of the image, as well as the variety of interpretative strategies available to the contemporary viewer, confirms the extent to which that viewer – even when ignorant of the full range of *The Mystery of Masonry's* pictorial and textual overlaps – was confronted with a kind of representational profligacy, a lack of semiotic

closure that, despite the brutality of the print's attack, continues to give Hogarth's engraving a somewhat uncertain, ambiguous status. This ambiguity has troubled those art historians who have sought to assimilate the image to the canonical narratives of Hogarth's artistic originality and his concern for moral reform, who have been forced to ignore the range of the engraving's pictorial references and the explicitness of its obscene details. The same ambiguity, more understandably, has also confused those who have tried to tie *The Mystery of Masonry* to Hogarth's own masonic involvement, which has been speculatively back-dated to include the period of the satire's gestation and production.[42] But if the print was intended as a critique of a specific masonic faction, as might seem plausible, why does it then duplicate so precisely the details of an urban critique of masonry as a whole, and include a satirical reference to the 'Two Oldest Orders', rather than just to the Gormagons? Surely the pictorial play with the masonic uniform, and with the gestures and instruments of masonic ritual – buckets, mops, ladders and sledgehammers – offered a form of satirical exposure which brought the entire organisation into disrepute?

Rather than attempt to reconcile these seeming contradictions, which has led in the past to particularly tortuous and unconvincing explanations, it seems more useful to link *The Mystery of Masonry's* unresolved narratives to the forms of representational surplus, dialectical play and authorial irony that we have already begun recovering as an important feature of satiric practice. Hogarth, I argue, duplicates and replenishes this appeal in a modern fashion. The additive pictorial structure of his satirical image again allows and inculcates a multiplicity of readings, generating an interpretative mobility and flux that functions as a crucial index of the artist's own invention, and of his own critical and commercial independence from the materials with which he engaged. This, of course, was the ironical, elusive identity traditionally fostered by the satirist, which is most succinctly expressed by the broken and misleading signs of authorship left by Hogarth on both his print and in the advertisement announcing the appearance of *The Mystery of Masonry*. Hogarth's practice is linked to a mythic, foreign process of production – 'done from the original, painted in Peking' – and his name not only deliberately misspelt but fractured, so that his artistic identity is left publicly incomplete. Even more self-consciously than in *The Whig's Medly*, here the engraver's signature becomes part of a satiric strategy of rupture and ambiguity. This voided naming, however, also remains an eloquent indication of Hogarth's artistic and commercial subordination to the authority of the print publisher, 'Mr. Holland, in Earl Street.' Holland added Hogarth's name in full on later editions of the plate, and in this small but telling change the publisher was responding to the striking growth of the artist's individual celebrity following the initial publication of *The Mystery of Masonry*, particularly from the spring of 1732 onwards. For it was at this time that Hogarth first issued the six plates of *A Harlot's Progress*, to widespread acclaim.

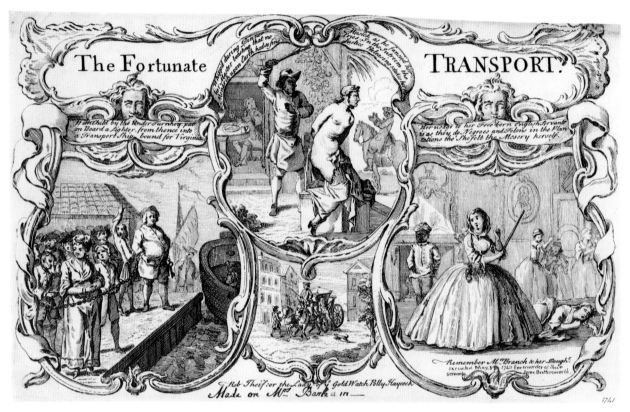

47 George Bickham junior, *The Fortunate Transport*, c. 1745 (BM 2511). Engraving, $12\frac{1}{2} \times 7\frac{5}{8}$ in. Courtesy of the British Museum.

Chapter Three

Re-Reading *A Harlot's Progress*

A Gentleman happened to be walking towards Hampstead, across the fields, when passing by a parcel of hay-ricks, he espied a young woman lying asleep near one of them . . . an agreeable face, a genteel dress, different from the taudry appearance of the hedge-walkers, and the inviting attitude in which the fair one lay, would have tempted the most rigid hermit to have stole a look at the terra incognita, just peeping into view, from under a clean Holland smock, the whiteness of which was rivall'd only by 'Her well turn'd limbs and due proportioned thighs,/ Which pleased by degrees, and with new beauties rise' . . . He stole softly round the rick, and gaz'd for some moments on the pleasant landskip; but least he might never have such an opportunity again, he resolved to make a draught on the spot; and for that purpose put himself in a proper posture, took out his pencil, and was in the middle of the principle Figure of the piece before the nymph awaked; and then it was too late to prevent his proceeding in his drawing.

The Fortunate Transport, c. 1740[1]

What are we to make of this anonymously written alignment of the masculine gaze with the vocabularies of pornography, masturbation and artistic practice? *The Fortunate Transport* is a pamphlet that offers a fictional 'secret history' of a prostitute, Polly Haycock, who, having being deported to Jamaica for her many transgressions, ends up arriving at 'the highest pitch of Pomp, Grandeur and human felicity, by a train of events which, according to all rational probability, must have ended in the most despicable misery.' Rather than regretting her career as a whore, Polly 'laughs at dull morality' and 'is happy being wicked, and great by giving way to Vice and Folly.'[2] This novel codification of the prostitute's fate is supplemented by a satirical critique of masculine patterns of commercial exploitation and brutality, and by numerous detailed accounts of sexual assignations characterised by a relentless, voyeuristic focus on the female body as a site of desire and display. A particularly violent episode in the narrative describes how Polly, having become the slave of a sadistic plantation owner, is 'call'd up, stripp'd naked and tied up to a post in the courtyard, and whipp'd during all the time of dinner, the monster boasting that no monarch on earth had so fine music as he fancied her cries.' Meanwhile, a local Justice of the Peace sees her as he passes by: 'the sight of a fine woman in that dismal figure, with an old Negro labering her with an unmerciful cat and nine tails,

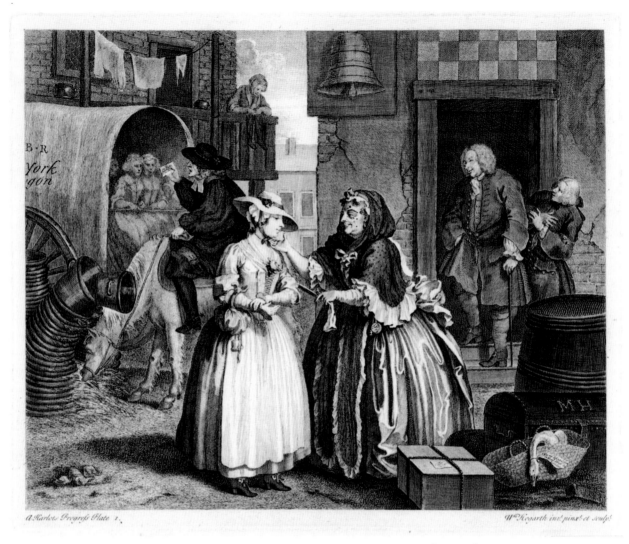

48 William Hogarth, *A Harlot's Progress*, Plate 1, 1732 (BM 2031). Engraving, $11^{5}/_{8} \times 14^{3}/_{4}$ in. Courtesy of the British Museum.

rais'd in the Justice all the sentiments of Humanity, that good nature could suggest on that occasion'. Even this 'good nature' is an erotically inflected one: the Justice promptly acquires her from the landowner, and soon he too makes 'her partaker of his bed.'[3]

The critical moment of the whipping occupies the centre of an etching that followed the publication of the text, also entitled *The Fortunate Transport* (*fig. 47*). Executed by George Bickham junior, the print situates various events of the narrative within a Rococo framework of ornate borders and textual inscription. In the first vignette, Polly is coralled with male deportees as they wait to be transported; in the second, she is displayed to the viewer being lacerated by the servant; and in the third, newly affluent and independent after the Justice's death, she takes a form of retribution for her treatment through the vicious punishment

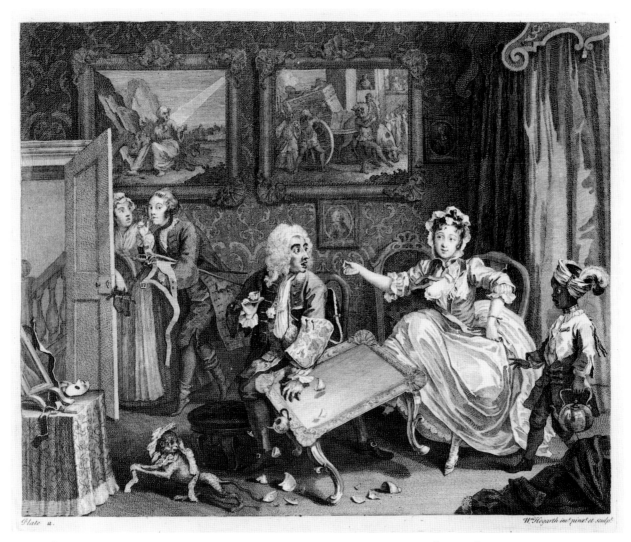

49 William Hogarth, *A Harlot's Progress*, Plate 2, 1732 (BM 2046). Engraving, $11\frac{7}{8} \times 14\frac{5}{8}$ in. Courtesy of the British Museum.

of her own maids. The print functions not only as a supplement to the pamphlet but also as a sustained re-working of an already canonical graphic formulation of a prostitute's life, William Hogarth's *A Harlot's Progress*, published in April 1732 (*figs 48–53*).

<div align="center">I</div>

Hogarth's set of six images delineated the fluctuating fortunes of Moll Hackabout, another fictional whore, from her first arrival in London as a naive countrywoman to a death hastened by neglect, disease and medical incompetence. The first plate of the series depicts the moment just after Moll has alighted from the York coach,

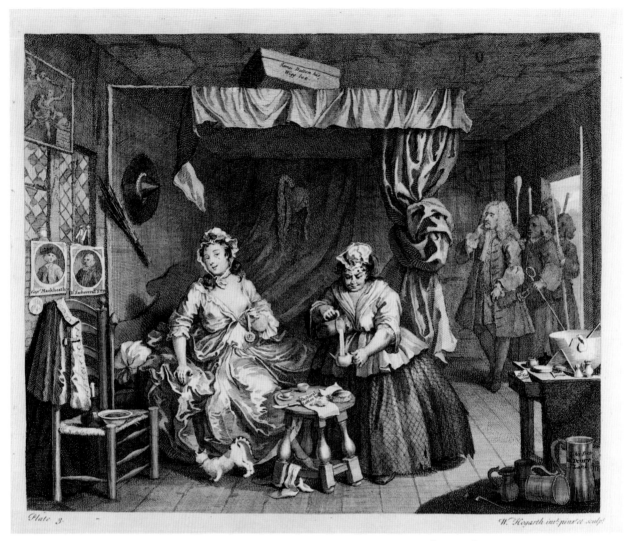

50 William Hogarth, *A Harlot's Progress*, Plate 3, 1732 (BM 2061). Engraving, $11\frac{5}{8} \times 14\frac{7}{8}$ in. Courtesy of the British Museum.

when she is already on the point of being sucked into the city's sexual subculture: Mother Needham, a notorious real-life procuress, reaches out a dubiously welcoming hand, while Lord Francis Charteris, an infamous rake and rapist, stares from a doorway. In the second plate, Moll is shown in an expensively appointed apartment, having ascended the hierarchy of the prostitute's profession to become the kept mistress of a Jewish merchant. In this image, she distracts her keeper, who is clearly paying a surprise visit, while her secret lover, only partially dressed after an interrupted assignation with Moll, escapes out of the door. In the third engraving, Moll is shown having returned to the seedier environs of Drury Lane, being waited upon by a ragged maid, and not realising that she is about to be captured by the contemporary scourge of London prostitutes, Justice John Gonson, shown entering at the door. The fourth image shows her imprisoned in Bridewell jail,

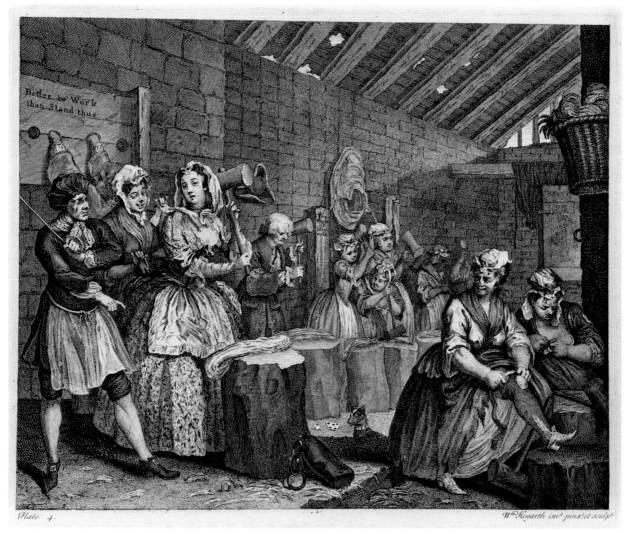

51 William Hogarth, *A Harlot's Progress*, Plate 4, 1732 (BM 2075). Engraving, $11\frac{7}{8} \times 14\frac{7}{8}$ in. Courtesy of the British Museum.

beating hemp while still wearing one of her old expensive dresses, and being threatened by a brutal guard. Finally, Moll's body succumbs to venereal disease and death: in Hogarth's fifth engraving, the harlot, having left prison for a shadowed garret, lies dying in a sweating blanket. She and her illegitimate son are ignored by two arguing doctors, while her attendant rifles her clothes chest in the foreground; lastly, Moll's body, lying in a coffin, is surrounded by a circle of prostitutes and by the inattentive figures of, on the left, a lascivious cleric whose right hand is implied as having sneaked under his neighbour's skirt and, on the right, a flirtatious undertaker who seems to be imploring another prostitute to have sex with him.

If we return to Bickham's etching, we can see that it appropriates various elements from Hogarth's fourth plate of Moll in Bridewell prison (*fig. 51*):

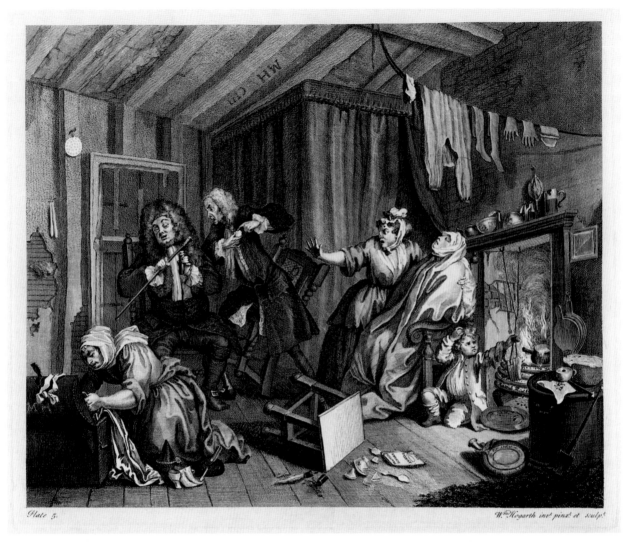

52 William Hogarth, *A Harlot's Progress*, Plate 5, 1732 (BM 2091). Engraving, 12 × 14¾in. Courtesy of the British Museum.

the *Fortunate Transport's* central compartment recycles Hogarth's iconography of physical assault, and the details of the assailant; the final depiction of Polly's tyrannical rule adapts the earlier print's depiction of Moll's gestures and dress, and appropriates three of the figures who toil in the rear; and the left-hand section not only duplicates the grinning woman in the foreground, but the glimpsed figure of the solitary male prisoner, here transformed into a stooped criminal bound in handcuffs. Having noted these references, it would be easy, and partly justifiable, to dismiss Bickham's practice as a rather flagrant plagiarism determined only by the wish to produce a graphic follow-up to a text that was enjoying some commercial success. But, as we have already noted, this form of pictorial borrowing was a crucial strategy of satiric practice, and rarely innocent. What is particularly suggestive about this pictorial raiding and re-organisation is that it encourages us to

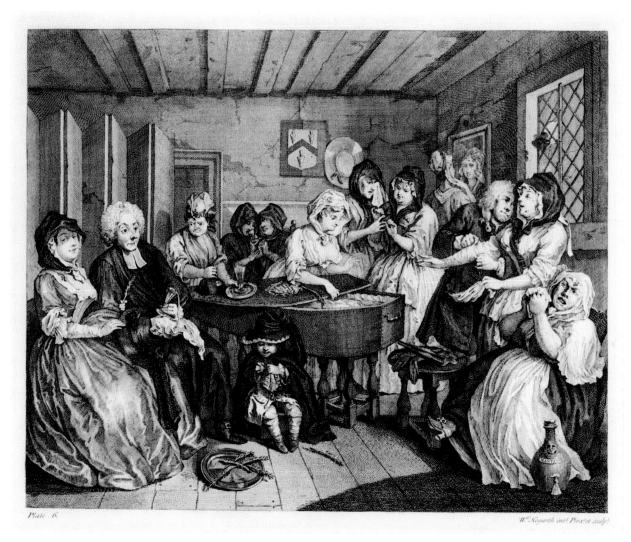

53 William Hogarth, *A Harlot's Progress*, Plate 6, 1732 (BM 2106). Engraving, $11\frac{5}{8} \times 14\frac{7}{8}$ in. Courtesy of the British Museum.

re-read *A Harlot's Progress* as having *already* invoked the narratives of masculine voyeurism and feminine spectacle, and the overlaps of sexual commodification, erotic display, sadistic violence and corrupted authority that underly both versions, textual and pictorial, of *The Fortunate Transport*. In this guise, Bickham's print functions not as an arbitrary point of intersection between *A Harlot's Progress* and a text that clearly invoked a pornographic rhetoric of the prostitute, but as an image that suggests that the two products – Hogarth's print and the salacious literary satire – could have been considered by certain contemporaries as compatible and complementary examples of cultural practice.

This kind of exchange with *A Harlot's Progress* fits rather uncomfortably with what modern interpretations of the series have assumed were its contemporary attractions and meanings. Most influentially, Ronald Paulson, in his exhaustive

and multi-faceted account of the *Progress*, has argued that it would have been understood by contemporaries as both a 'grim moral narrative in which the Harlot is justly punished' and as a sophisticated successor to various religious and classical parables. Paulson has suggested that the series stressed the perils of emulation and the importance of moral choice. At the same time, he has pointed to the precedents and typologies of a variety of literary and representational formats, ranging from the life of the Virgin Mary, the choice of Hercules and the lives of the Apostles to Bunyan's *Pilgrim's Progress,* Cesar Ripa's *Iconologia* and Thomas Woolston's religious discourses. Through a dizzying strategy of analogy and assertion, Paulson reads *A Harlot's Progress* as a highly moralised, learned and philosophical series that was designed to be read in relation to the most prestigious and venerable narratives of Western culture.[4]

This chapter, building on the kinds of re-reading performed by Bickham, will offer a rather different interpretative framework for Hogarth's project. The series has to be seen, I shall argue, as part of a nexus of images and discourses in contemporary culture that dealt with the sexually commodified body of the prostitute, and that oscillated beween demonising that body as an emblem of metropolitan corruption and dramatizing its concurrent status as a fetishized site of urban erotics. If the *Progress* opens itself up to this doubled reading – as both a moralised *and* an eroticised set of images – it also ironicizes this process through satirical play and humour: the moral axis of visual exchange is shown to be thoroughly adulterated by comic and obscene detail, and erotic fascination is compromised not only by the problematic figure of the prostitute, but by the surrogate voyeurs within the images, who are constantly targeted as butts of ridicule or condemnation. It was this dialectical form of pictorial practice that John Bancks lauded in 1738, when he wrote that 'Thy Harlot pleas'd, and warn'd us too/What will not gay instruction do?'[5] Given the terms of his praise, it seems essential to investigate the relationships between pleasure and warning, humour and instruction, that are involved in Hogarth's satirical imagery.

II

One of the earliest and most acute readings of Hogarth's series is that of George Vertue. Some time in 1732, he jotted down in his notebook a description of the origins and development of the *Progress*:

> amongst other designs of his in painting he began a small picture of a common harlot, suppos'd to dwell in drewry lane. just riseing about noon out of bed. and at breakfast. a bunter waiting on her. – this whore's desabille careless and a pretty Countenance & air. – this thought pleas'd many. some advis'd him to make another. to it as a pair. which he did. then other thoughts encreas'd, & multiplyd his fruitfull invention. till he made six. different subjects which he painted so naturally. the thoughts, & striking the expressions that it drew every body to see them- which he proposing to Engrave in six plates to print at, one guinea each sett. he had daily Subscriptions came in, in fifty or a hundred pounds in a Week – there being no day but persons of fashion and artists came to see these pictures

the story of them being related. how this girl came to Town. how Mother Needham and Col. Charteris first deluded her. how a Jew kept her how she livd in Drury Lane. when she was sent to bridewell by Sir John Gonson Justice and her salivation & death–[6]

In spite of the notebook style, Vertue gives a useful summary of the process of expansion and transformation that led to the execution of a series of prints, and a precise index of the responses suggested by the first small, cabinet-sized picture, now lost, which formed the basis for the third plate in the set (*see fig. 50*). What seems clear from his account is that the beginnings of the *Progress* were located in an image that made an explicitly eroticized appeal to the male viewer. Vertue's comments confirm that the young prostitute was loaded with a subtle pictorial paraphernalia of desirability: – 'this whore's desabille careless and a pretty Countenance & air.' His vocabulary is worth excavating: 'desabille' – which the Oxford English Dictionary describes as 'the state of being partly undressed, or dress in a negligent or careless style', the Frenchness of the term hinting at foreign pleasures; 'careless' – a studied casualness of dress and posture, offering a glimpse of the neck, breast and torso; 'a pretty Countenance' – a conventional beauty that offsets the meanness of Moll's surroundings; and, finally, her 'air' – an abstracted mechanics of invitation. All these features must have been quite deliberately designed to provoke a form of consumable fantasy for the male spectator, at however banal a level: 'this *thought* pleased many' (my italics). Moving to the image, we can see that this appeal is reinforced by the represented prostitute looking out at the viewer, which pulls the spectator of the painting into the space that constructs that look – her place of business, her bedroom. Our point of view is that of someone standing in that room, exchanging interested looks; a male observer like Vertue is thus pictorially defined as a potential client.[7]

Vertue's comments also hint at the ways in which Hogarth mediates such implications through a focus on lowliness and squalor. Vertue notes the prostitute's vulgar social status, the demeaned environment in which she is shown living in the engraving – 'drewry lane' – and the threatening presence of the campaigning magistrate Sir John Gonson. Moll is defined as a 'common' harlot, and her companion as a 'bunter', a term the Oxford English Dictionary explains as 'a woman who picks up rags in the street; and used, by way of contempt, for any low vulgar woman'. Her nose lost to disease, the bunter offers a gross counterpoint to the flawless physique of the prostitute in the engraving. Elsewhere, we find other signs of plebeian dissolution: the gold watch that swings in Moll's hand, an emblem not only of the temporal register of the whore's bed but also of thievery and her threat to property and wealth; the clutter of fallen, broken everyday objects; the cracked ceiling and the bare wooden floors. The pictorial rhetoric of seduction is thus confined to the whore's body: outside its ambits, we are presented with an infrastructure of the diseased, the criminal and the vulgar. Simultaneously, the intervention of a local examining magistrate, Sir John Gonson, entering from a doorway on the right, introduces a public representative of moral reform and masculine retribution into the narrative. He is shown on the brink of arresting the prostitute, who remains unaware of his presence, and he provides a highly legible indication of her imminent fate. Gonson was a notoriously assiduous and severe

magistrate at the forefront of a campaign to clear Drury Lane of its brothels, and who frequently sent their inhabitants to Bridewell to beat hemp. Here, he threatens to undermine the intimacy rehearsed by Moll, and to cleanse both this space and, by implication, the pictorial space that he is also shown entering, of their erotic narratives.

Yet it is quickly apparent that Gonson's depiction does no such thing: he is shown pausing, stopped in his tracks by the sight of the Harlot, his public role as a bearer of moral justice temporarily suspended. He gazes at her as yet another voyeur, someone whose appreciation of her desirability stalls the impetus of his reforming mission. The inclusion of Sir John's portrait invokes the imperatives of civic policing but also recycles the interested gaze of the viewer, ironically displacing it to an internal surrogate, one whose public authority is partially undermined through a satirical focus on his salacious surveillance. For, if the male spectator can enjoy in private fantasy the visual exchange with the painted or even the graphic depiction of the prostitute, the representation of this look's public counterpart – the gaze of the figure of authority at the sexual commodity – becomes an immediately unstable one, and subject to ridicule. Not only is Gonson pictorially marginalised, but his troubled spectatorship is captured through an eloquent graphic dichotomy: the curious play of his hands across his body, one completing a gestural iconography of thoughtfulness, the other edging towards his groin. With this subtle conjunction of bodily narratives, we can recognise the correlation to the doubled analysis offered by Vertue, in which he succinctly indicates the *Progress's* capacity to support a concentration on both the pleasurable forms of feminine 'desabille' and prettiness, and on the more gloomy passage of a prostitute's body across a series of disreputable social spaces.

To understand better this dualised, contradictory form of representation, and to see how it fitted into a broader cultural construction of prostitution in the period, we can usefully turn to a range of contemporary writings that discussed prostitution and that closely paralleled the preoccupations and perspectives of Hogarth's series. Firstly, we need to recognise that the narratives and details of *A Harlot's Progress* were crucially informed by a category of texts that can best be described as literary satires on the city – poems and pamphlets, fragments of prose, sometimes whole books, that satirically interpreted the modern capital. These publications, which will be looked at in greater detail later in this book, generated a specifically satirical discourse on the city, depicting it as a warren of corrupted spaces crowded with miscreants, sharpers and fools and dominated by greed, desire, drunkenness and violence. Unsurprisingly, given this project, they recurrently focused on the transgressive bodies and activities of prostitutes, who became dramatised as fascinating templates of urban dissumulation, artifice and corrupted desire. Such writings inserted prostitutes into a specific topography of whoredom in the capital: Tom Brown's *Works*, for instance, which was published in a seventh edition in 1730, offered a satirical calender of illicit activities around the city: 'Wednesday 16: If rainy, few night-walkers in Cheapside and Fleetstreet. Thursday 17: At night, much fornication all over Covent Garden, and five miles around it. Friday 18: Damsels whipped for their good nature at Bridewell about ten. Saturday 19: Jews fornicate away the Sabbath in Drury-Lane and Wild-Street.'[8] However critical, the satirical

narrator of such writings could also recognise himself traversing the same routes across the city as the 'punk', and similarly searching for gullible targets. Ned Ward dramatised this parallel: 'Now gently cruising up and down/ To observe the follies of the Town,/ Wandering around like a Starving Bully/ Or strolling Punk in search of Cully,/ Just bolted from some bawdy-house Alley;/ I glanc'd an eye at every Body.'[9] If prostitutes were centralised as sites of critique, they were also recognised as defined by the same laws of commodification, entertainment, novelty and leisure that conditioned all cultural output in the city, including that of literary production.

These satirical discourses dramatised modern whores as figures who flourished on the dark side of the city's landscape: they crowded the streets at night, emerged from the shadowed and illicit spaces of the brothel and manipulated all the conventional codes of polite dress, make-up and gesture to manufacture a seductive veneer of virtue and invitation. Ward writes in *Hudibras Redevivus* that 'Twas now about that time of night/ When strolling hussies, much too light/ Creep out from Garrets and from Allies . . . New powder'd, patch'd, and paint'd o'er,/ The marks of a retailing whore,/ Came fritting by with muff and Fan,/ Six harlots to an honest man'. He goes on to note that 'a lewd punk, so well we see,/ Will counterfeit true Modesty,/ And look so pious and Demure,/ That few would think the Saint a whore.'[10] This dubious carapace of desirability was described by John Gay in his *Trivia: or, the Art of Walking the Streets of London* of 1716, a third edition of which was published in 1730. He extolled his reader to ensure that 'thy virtue guard thee thro' the roads/ Of Drury's mazy routes, and dark abodes./ The harlot's guileful paths, who nightly stand,/ Where Katherine Street descends into the Strand . . . she will oft the Quaker's hood profane,/ And trudge demure the rounds of Drury Lane . . . Twitches thy sleeve, or with familiar airs/ Her fan will pat thy cheek;/ these snares disdain,/ Nor gaze behind thee, when she turns again'.[11] While Gay suggests the dangerous coyness of their appearance, other writers noted one of their inevitable destinations – Bridewell. The narrator of *A Trip through London, containing Observations on Men and Things*, published in 1728, notes the petition of an apochryphal 'Irish Society of Fortune Hunters' to raise money for 'Mary Merry-Tail, late of the hundred of Drury', who was 'at present detain'd a prisoner in Bridewell, destitute of all necessities'.[12] However brutal, Bridewell is defined in such texts as a temporary holding place that only briefly stills the relentless movement of prostitutes around the spatial circuits of sexual commodification and display. They are seen as intensely mobile and unfixed in both their identity and form, belonging, as Hogarth's harlot does, to a range of different spaces and milieux, and inviting a different reading in each.

These narratives of urbanized mobility and imposture are almost always prefaced by descriptions of the prostitutes' rural background and initial naivety. Thus, the narrator of *A Trip through London* overhears a procuress complaining about the sluggishness of business: 'she had in her custody at that instant a pretty black ey'd Filley, of about fifteen, who could carry the weight of a lord, and had never been bark'd, but that business had been so spoiled of late . . . she doubted whether she should be able to make the money she had cost in fetching from Lancashire.'[13] Other texts maintained the theme. The fact that Mother Griffin, an imprisoned

bawd in Bullock's *Woman's Revenge; or, A Match in Newgate*, a farce of 1728, could disingenuously invert the narrative of the rural innocent being exploited by an evil brothel keeper only showed how conventional the story had become by this date: 'did I not take you from the wagon, a poor ignorant, awkward country girl, with nothing but an old stiff gown to thy back, and instead of making thee a servant, did I not put thee into a goodly condition, gave thee fine cloathes, rick'd thee up, and brought thee into the best company . . . Have I not helped you to rich Jews . . . and English lords?'[14] This starting-point of the prostitute's urban narrative was, of course, the one selected by Hogarth himself: in the first plate of his series (*see fig. 48*), he shows Moll Hackabout as another rural innocent, trapped by a real-life counterpart to Mother Griffin and stared at by the most notorious 'English lord' of all, Francis Charteris. Like Gonson in the third plate, he stands at a doorway admiring her beauty, part of a network of viewing that includes the bawd and that immediately constructs the young woman as a sexual commodity, standing in a street crowded with related incident and detail.

The commercial success of literary satires on the city encouraged an independent but closely related genre of writing in the 1720s, which concentrated upon the London prostitute and her activities as the basis of moral, comic and pornographic commentary. Thus, in the *Golden Spy* of 1723, a collection of 'secret histories' of various kinds of erotic intrigue, we find 'The Whore's Revenge', 'The Political Whores' and 'The Kept Miss' alongside tales of 'The Fortunate Adultery' and 'The Foul Extravagant'.[15] 'The Kept Miss' recycles a formula that was becoming familiar: a beautiful young whore is picked up as a mistress, goes into decline, is sent to Bridewell, gets the pox and is hanged as a pickpocket. This story is intermingled with a satirical attack on the gullibility and depravity of her merchant 'keeper', and with a comic focus on her secret sexual affairs with handsome young actors, dancing masters and army officers. The text veers between resigned condemnation – 'alas! A whore has no thoughts but of herself, her own interests, or her pleasure' – and a literary titillation that foregrounds the image of the semi-naked heroine: 'Phyllis lay in her bed, with her bosom negligently bare, cover'd only with a fine Holland sheet, for the weather was very warm: the sight was so tempting . . .' Pretending to cleave to a position of moral repugnance, such publications were clogged with a pornographic index of sexual insatiability, dramatised here through a winking reference to acrobatic, if screened, sessions of love-making: 'She beckoned him to the coach, and when he was enter'd, she pulled off her mask, and drew up the glasses . . . According to the modes of Covent Garden, he soon made the coach conscious of his vigour, and gave her that delight, that she was resolv'd to take him home to her lodging'. Clearly unable to sustain or condone this behaviour as a model of feminine practice, the story details in a supplementary text the discovery of her unfaithfulness by her keeper, who 'forc'd his way upstairs, and found Madam just rising, and the spark escap'd into the closet.' She is thrown out, and ends up becoming such a familiar fixture of the street that 'none of the *gran gusto* would have anything to do with her; till she fell to filthy mechanics, who had been so much her adversion; from hence to Porters and Footmen', before she is caught 'plying the streets' by 'godly reformers [who] press'd her for Bridewell.'[16]

By the end of the 1720s, this seedy trajectory – duplicated so closely by Hogarth

– had become a staple of such texts, providing a literary blueprint for the way in which the figure of the prostitute could be both glamourised and denigrated. *The Authentic Memoirs of the Life, Intrigues and Adventures of the Celebrated Sally Salisbury*, also published in 1723, elevated the genre of the whore narrative into an independent cultural product. Informed by the conventions of the celebrity biography, the book described the life of the most notorious prostitute of the early eighteenth century through a fictionalised correspondence between her 'most considerable gallants' and the notional author of the text, a Captain Charles Walker. The book both emphasises the poisonous consequences of an involvement with Salisbury – one writer declares that he had been reduced 'from a strong-back'd lusty Fellow . . . to a poor, sickly, puny wretch' – and manages to exonerate her from blame: 'what woman beside yourself has the wit to extenuate the most criminal parts, or art to add a lustre to the beautiful extravagancies of your life?' The author distances himself from the implications of both perspectives through a cultivated use of irony that, as in 'The Kept Miss', allows a dualised preoccupation with the gullibility of her clients and the desirability of her body. A dissolute earl is robbed in his bed – 'they tied him therein, then beat and scratch'd him unmercifully, and afterwards rifled him of his gold watch' – while a lord's son, pulling up her bedclothes, admires her 'most beautiful pair of legs, thighs, and so upwards, to her very bubbles'. Meanwhile, the Justice who commits her to Bridewell not only subjects her to an eroticized form of surveillance – 'let me view her again, says the Justice, calling for his spectacles, and at the same time [giving] her a gentle squeeze of the hand' – but sends a 'private order, that she should not by any means undergo the discipline of the house, he having a design to correct her himself in private.'[17]

It thus seems clear that Hogarth, in organising his own 'Progress', recycled the constituent elements of such texts as 'The Kept Miss' and the Salisbury *Memoirs*. Here, noting the episode of the prostitute's discovery with her 'spark' in the former story, we can look again at the second plate of the series (*see fig. 49*), which shows Moll creating a diversion – flaunting a breast and flirting outrageously, even as she kicks over a table – while her lover sneaks out of the door and her wealthy Jewish keeper, another ridiculed surrogate viewer, clings awkwardly to the etiquette of afternoon tea. This kind of episode, thanks to the success of the whore biography, had become a familiar means with which to castigate the whore's pathological infidelity while invoking her erotic appeal and appetite. Given this parallel, the contemporary viewer's gaze at Moll – who, her head and body swivelled outward, seems implicitly to acknowledge a supplementary spectator – was probably informed by the imaginative recreation of the narratives of illicit love-making that always preceded and followed such interruptions and imminent discoveries in the whore biographies.

Hogarth's prints, we can conclude, provided a graphic engagement with, and revision of, a range of satirical discourses concerning the status and identity of the whore, in which she had become a fulcrum of doubled reading: in both the texts we have been looking at and in his images, the pleasures of the eroticised gaze at her body are constantly invoked and detailed, even as they coexist with the narratives of condemnation and disgust that were her parallel attributes in contemporary discourse. Moreover, we find in the engravings the same pleasure in

undermining the masculine representatives of civic authority and expertise, who are similarly cast as supplementary targets of criticism. Yet, *A Harlot's Progress* does these things as a set of *pictorial* objects that demanded to be understood as cultural products quite separate from the poem, the erotic essay or the prostitute's so-called *Memoirs*. It is all too easy to read Hogarth as a novelist and to collapse his prints into literary formulations. Rather, he was an artist who worked within the painted and graphic spheres of cultural production and consumption in the city, whose practice negotiated and responded to pictorial conventions and conditions governing representation, and whose works appealed primarily to a market for pictorial commodities rather than textual ones. Recognising this, we can now explore the series's exchanges with a heterogeneous range of pictorial representations dealing with the sexually commodified body in contemporary London.

III

In the eighteenth century, the satirical representation of the prostitute was frequently aligned with the pictorial formulae of the mythological nude. In a suggestive confirmation of this relationship, Horace Walpole, the celebrated commentator on the arts in the period, has left us a brief record of a lost work by Hogarth that depicted the goddess Danaë receiving a shower of gleaming coins, in which she is depicted as 'a meer nymph of Drury', accompanied by a decrepit, money-grabbing companion – 'the old nurse tries a coin of the golden shower with her teeth, to see if it is true gold.'[18] Walpole's comments testify to the ways in which the image of the Drury Lane prostitute could be fused to established paradigms of high art: in the instance of the lost painting, her image was clearly being related by Hogarth to the mythological nudes depicted by artists such as Titian (*fig. 54*). Interestingly, the tale of Danaë had become synonymous by the eighteenth century with narratives of prostitution and the corrupting power of money, and was constantly invoked in the whore biographies: in the *Authentic Memoirs of Sally Salisbury*, for instance, a suitor throws a bag of money into Sally's lap, 'just as Jove descended in a shower of Gold upon Danaë.'[19]

What is useful to suggest here is not any possible pattern of pictorial borrowing or dependence between Hogarth's representations of the Harlot in the *Progress* and Renaissance paintings such as Titian's, but the extent to which the depictions of the prostitute he produced might have been interpretatively mapped onto this kind of imagery. A nice example of the ways in which this link could be developed in practice is a satirical etching that was in all probability issued at around the same time as *A Harlot's Progress* (*fig. 55*).[20] The anonymous satirist has added a portrait of Charteris to John Oliver's earlier copy of Giorgione's *Sleeping Venus*, then thought to be wholly the work of Titian (*fig. 56*). The effect was to destabilise the erotic and aesthetic boundaries between the fine art engraving and the topical etching, and to reconstitute the image of the ideal nude as a potential sexual victim and mistress. This was done through precisely the same mechanism of the distorted portrait and the leering masculine gaze that we see in Hogarth's first plate, which similarly shows the aristocratic rapist stumbling across the sight of a desirable and

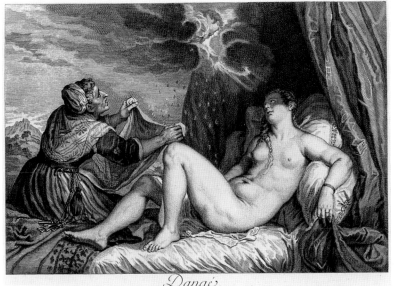

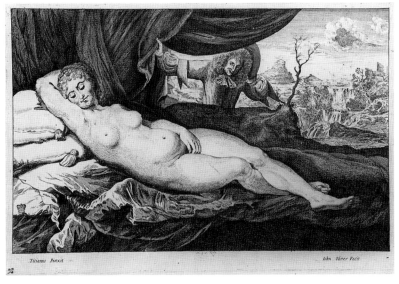

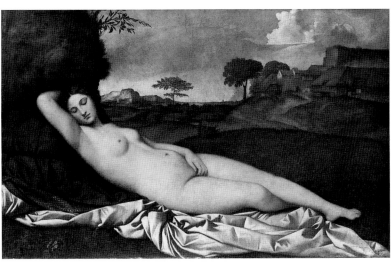

54 Louis Desplaces, after
Titian, *Danaë with Nursemaid*,
eighteenth century. Engraving.
Courtesy of the British Museum.

55 George Bickham junior (?),
after John Oliver, *Sleeping Venus
and Charteris*, c. 1732
(BM 1411). Engraving, $8\frac{3}{8}$ ×
$13\frac{1}{4}$ in. Courtesy of the British
Museum.

56 Giorgione, *Sleeping Venus*,
c. 1507–10. Oil on canvas, $42\frac{1}{2}$
× $68\frac{1}{2}$ in. Gemäldegalerie,
Dresden.

consumable woman. Reading the one satire against the other, as many print consumers of the time would have done, emphasises the extent to which Moll could be understood to represent a modernised version of older pictorial Danaës and Venuses.

Having suggested the ways in which *A Harlot's Progress* can be seen to relate to certain traditional representational formulae – to which we can add those generated within Dutch and English art during the seventeenth century[21] – I should like to argue that the series's dominant exchange was with a variety of alternative vocabularies emerging from more local and more recent sectors of painted and graphic culture. We can begin by noting the preoccupations and methods of a fashionable genre of modern art being produced in the capital – painted 'conversations' that depicted the salacious narratives of sexual intrigue in contemporary settings.[22] Pieter Angellis's *A Company at Table*, of 1719, exemplifies the genre and depicts a fictionalised setting that is part-country house and part-brothel, occupied by a lascivious collection of males who pester, escort and sexually proposition a variety of women, ranging from the confident, outstretched figure on the left to the displaced, pre-pubescent market-girl on the right (*fig. 57*). However sophisticated the setting, the picture is clearly suffused with sexual detail: the oysters, both proferred and discarded, were a conventional emblem of promiscuity in the period, while the frisky dog, its shadow brushing against the hem of the girl's skirt, offers a parallel allegory of animal desire. We only have to turn to the couple sitting on the left-hand side of the final plate of the *Progress* (*see fig. 53*) to see how closely Hogarth recycles and resituates the components of this kind of painting. In both images we find an equivalent gaze outward from a complicit female, a similarly tilted wine glass and – in a detail discreetly hidden by Hogarth – a parallel dance of drunken male fingertips across a female thigh. The engraving's accompanying focus on another attempted seduction corresponds to the kind of activity that goes on throughout the earlier painting, and that is similarly distributed across a ragged figural arc spanning the width of the picture plane.

While Angellis's picture offers a suggestive painted codification of the disreputable woman, it seems clear that the figure of the whore was more usually encountered in graphic art. On 10 April 1730, for instance, the *Daily Post* carried an advertisement declaring that 'at the Picture Shop near St. Dunstan's Church in Fleet Street are sold . . . the very curious prints of Don Fransisco [Charteris], Sally Salisbury, Jonathan Wild, and Jack Shepherd.' The notice of Salisbury's portrait indicates the extent to which there was already a market for the graphic image of the prostitute; if we look at the frontispiece to the *Authentic Memoirs*, we can see that it was one that could picture her, as Hogarth depicted Moll, as an urban beauty (*fig. 58*). This portrait was part of a broader process of pictorial production that circulated such images across the sites of the frontispiece and the book illustration. The 1730 edition of Tom Brown's satirical works, for instance, includes an engraved depiction of the narrator's encounters with two whores in a brothel – 'brisk, gay, and awkward, with sickly smiling countenances, slatternly dress, and dirty shoes' – (*fig. 59*).[23]

A more ambitious and suggestive focus on the contemporary prostitute was offered by another satirical genre. *The Cully Flaug'd* (*fig. 60*), an early eighteenth-

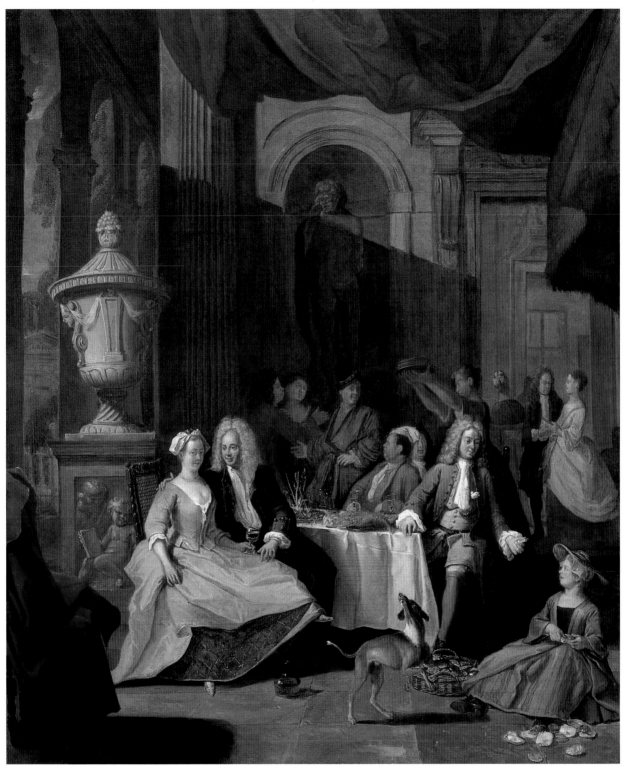

57 Pieter Angellis, *A Company at Table*, 1719. Oil on canvas, 29¼ × 24½ in. Courtesy Richard Green Galleries.

58 *Sally Salisbury*, frontispiece to the *Authentic Memoirs*, 1723. Engraving, $3\frac{3}{4} \times 2\frac{3}{4}$ in. (oval). Courtesy of the British Museum.

59 *The Baudy House*, in Tom Brown's *Works*, 1730. Engraving, $4\frac{3}{4} \times 2\frac{7}{8}$ in. Courtesy of the British Museum.

century mezzotint after a design by Marcellus Laroon the Elder, was typical of a graphic format that combined a self-consciously erotic and satirical agenda with a high degree of technical competence. The mezzotint shows a beautiful young prostitute spanking the buttocks of a decrepit old customer with a birch rod: 'What Drudgery's here! what Bridewell-like Correction!/ To bring an Old Man to Insurrection./ Jirk on Fair Lady, Flaug the Fumblers Thighs/ Without such Conjuring th' Devil will not rise.' The print's satirical attack is directed at the perverted tastes of a modern 'Cully' or fool and is also aligned with a pictorial codification of the prostitute as a desirable and sympathetic pictorial centre; she is described, however ironically, as a 'Fair Lady', and is clearly meant to embody a sexual ideal. Her dress, pinned back to reveal the extended profile of her lower stomach and leg

The Cully Flaug'd

What Drudgery's here! what Bridewell-like Correction! Jirk on Fair Lady Flaug the Fumblers Thighs
To bring an Old Man, to an Insurrection. Without such Conjuring th' Devil will not rise

Lauron pinx.

60 After Marcellus Laroon, *The Cully Flaug'd*, c. 1700. Mezzotint. Courtesy of the British
Museum.

to the viewer, also displays her pudenda to a staring client – and however ridiculous
we find this surrogate viewer, we are expected to complete the visual circuit set up
within the engraving by his gaping eyes and tilted spectacles, and to imagine what
he is looking at, even as we criticise that look.

Laroon's design confirms that the image of the prostitute could function both as

a conduit for and a target of satirical polemic, and in this role, could be appreciated as a site of pleasure as well as a protagonist within supposedly corrupt rituals of sexual exchange. Images like Laroon's were meant to be read as erotic as well as satirical vehicles, and as such would rarely have surfaced in the spaces and conversations of polite society; rather, they functioned as the successors to a tradition of pornographic art that similarly focused on the prostitute as an agent of satiric exposure. Recent scholarly work on the early history of pornography has clarified its generic role as a vehicle of social commentary throughout the period: as Lynn Hunt writes, 'In early modern Europe, that is, between 1500 and 1800, pornography was most often a vehicle for using the shock of sex to criticize religious and political authorities'.[24] Laroon's combination of pornographic and satirical preoccupations is thus, in itself, not new; what is modern is the way in which he situates these narratives within a specifically contemporary and secular context, one that focuses on a stereotypical dupe of civil society rather than on a cleric or politician, and does so using the fashionable stylistics of the mezzotint.

We have now seen that there was a crowded imagery of prostitution circulating in the capital, one which Hogarth intervened in, reworked and replenished in his *Progress*. We only have to place Laroon's image next to the series to see that Hogarth invoked a similar range of satirical identities and relationships in his juxtaposition of the prostitute with the ridiculed male representatives of civic and aristocratic authority, and with the tools and narratives of sexual violence and bawdy-house hospitality. In doing so, Hogarth clearly adapts and recycles representational discourses that were circulating not only in *The Cully Flaug'd*, but in painted and graphic culture more generally. These were the kinds of materials out of which *A Harlot's Progress* was forged, and within which the series can most suggestively be situated. Yet, for the most part, these were also materials that operated on the margins of painted and graphic culture. The unstable, threatening and eroticised figure of the prostitute was, unsurprisingly, prohibited as subject matter for polite art in the period. The comparison with her mythological pictorial predecessors only highlighted the distance between these sanctioned, aestheticised sites of desire and the corrupted, meretricious and plebeian body of the contemporary whore. As a consequence, prints like those of Laroon, and satirical book illustrations like those that accompanied Brown's *Works*, which pulled this body into graphic representation, remained tainted with aesthetic and cultural illegitimacy. They were perceived as part of a quasi-pornographic nexus of satirical images and texts which were precluded, because of their indecent narratives, from enjoying a wide sanction among the city's growing constituency of polite print buyers. Given these circumstances, we now need to explore how and why Hogarth was able to adapt this seemingly unpropitious pictorial material into the basis of a highly successful commercial project, one that dramatically expanded the audience for graphic satire in the capital, and made the genre popular with the men and women of polite society.

★ ★ ★

IV

A Harlot's Progress refers to a broad contemporary debate on prostitution taking place in the journalistic outlets of polite urban society. This debate was articulated most frequently in the daily and weekly newspapers, which not only updated their audiences about the progress of various campaigns to eliminate or restrict the spread of the 'wretched tribe' through the city, but disseminated a highly regulatory and prohibitive vocabulary of social control. This rhetoric is typified by a correspondent to the *Universal Spectator* of 21 March 1730, who describes the streetwalker as 'a sort of creature, whose wickedness and wretchedness can hardly be parallel'd or described', and goes on to declare that 'it is somewhat horrid to walk along our streets at night, where multitudes of these prostitutes, like evil spirits, are tempting all they meet. . . . I wish these remarks would stir up the magistrates of this great city to exert their authority, and put the laws severely into execution. Were proper officers appointed every night to clear the streets of these lewd women, and were they constantly committed to hard labour, as the law directs, I make no doubt, but in a little while the PUBLICK would find the good of it.'[25]

The discussion on the best ways to combat this perceived threat had been galvanised by the publication in 1725 of Bernard Mandeville's *A Modest Defence of Public Stews*, which had controversially advocated the institution of a system of state-regulated brothels: 'the encouraging of public whoring, by erecting stews, will not only prevent most of the evil consequences of this vice, but even lessen the quantity of whoring in general, and reduce it to the narrowest bounds which it can be possibly be contained in.'[26] The almost uniformly critical responses to Mandeville's tract denounced it as an incitement to further immorality, and stressed the success of alternative methods of reformist and judicial regulation; the author of an *Answer* to Mandeville's tract pointed to the '89,393' people arrested 'for Debauchery and Prophaneness' over the previous thirty-five years, and concluded that 'a wonderful check hath been given to the Prevalency of the most scandalous vices, and in many instances a visible Reformation hath ensued.'[27]

By the beginning of the 1730s, as Ronald Paulson has noted, this debate was fuelled by constant newspaper notices announcing the arrest of various well-known prostitutes and the progress being made by Gonson in his attempts to cleanse the streets.[28] Through May and June 1731, in particular, there were almost daily reports on the suppression of disorderly houses by the magistrate and his associates. On 20 May, for instance, the *Daily Post* carried news concerning the arrest of a Moll Harvey, who was '(as usual) very outrageous in her behaviour, and not only beat the Constables, but the Justice too before whom she was carry'd, so that they were forced to tie her hands together, and with much difficulty got her to Prison.' As we have repeatedly seen, the graphic satires of the period were intimately responsive to the most controversial issues of urban society; their primary status as pictorial objects circulating within the capital's art market intersected with a supplementary identity as vehicles of social and cultural polemic that recycled and mediated the rhetoric of public opinion. *A Harlot's Progress* continued and exploited this role, situating itself at the centre of a broader 'polite' discussion on prostitution. Hogarth's series demanded to be read as a topical form

of pictorial commentary on that shocking but compelling subject of contemporary debate, one that even incorporated the portraits of some of the most celebrated heroes and villains of the controversy – Gonson, Charteris and the infamous Mother Needham, the procuress who had died in the pillory in May 1731.

A Harlot's Progress supplemented this exchange with the discourses of social regulation and control by introducing a self-consciously moralised agenda into the depiction of the prostitute. In tracking the development of the *Progress*, we recognise that, as the number of images increased, so did the opportunities for more explicitly didactic and reformist readings. We move from the provocative image of a woman who flirts with the viewer to the tragic depiction of a corpse lying in a coffin. By making Moll's decline central in the final few prints, and depicting so attentively her path towards death, Hogarth offers a melancholy narrative of corporeal breakdown that allows the *Progress* to be partially understood as an exemplum of wasted youth and moral collapse, and as an extended critique of the evils of prostitution. As the latter, the series was easily aligned with the strident, journalistic condemnation of the trade that we have just noted, which becomes pictorially articulated both by the contexts within which Moll's body is placed and by the inexorable process of her body's dilapidation and decay.

The series also complemented contemporary prejudices concerning feminine virtue and the virginity that was seen as the primary mark of respectability among unmarried women in polite society. Losing one's virginity outside marriage was frequently dramatised as the first step towards the kind of squalid end faced by Moll. As a tract on the subject claimed, there was little hope for 'those unhappy women, whom one false and fatal step hath plunged into all the miseries of prostitution, and left them no return from shame, from sorrow, from disease, and from death.'[29] Moll's diseased body, subjected in the series to a constant non-marital form of sexual penetration, could become a powerful metaphor for the dangers facing the unwary female; in this context, the *Progress* could be purchased and consumed as a negative guarantor of polite models of sexual restraint. In this way, the prostitute was refigured as an allowable subject of modern art, in that she could function as an intimidatory, moralised centre for authoritarian discourses concerning the sexual economies of the capital and the problematic maintenence of feminine virtue within them.

These processes of moralising and making topical the representation of the prostitute might not, it seems to me, have been sufficient in themselves to render the progress of a harlot an acceptable and popular subject of ambitious engraving within polite society. Just as important was Hogarth's decision to underpin his project with a refined apparatus of commercial display. Hogarth's first painting was shown in his studio on the east side of Covent Garden, but by the time the painted and engraved sets were complete, he had moved across the square to live and work in the house of his father-in-law, Sir James Thornhill, the most distinguished British painter living in the capital. Clearly, this relationship helped legitimize Hogarth's claims as an ambitious modern artist and situated him in a new context, that of a privileged artistic inheritor: as a contemporary poet declared, 'Fame first design'd to make thee known,/ In being Sir James Thornhill's son;/ Then Heav'n, its mighty Pow'r to shew,/ Gave thee Sir James's Genius too'.[30] Hogarth exhibited

61 Hendrik Goltzius, *The Visitation*, c. 1593. Engraving, $18\frac{1}{2}$ × 14 in. Courtesy of the British Museum.

the completed, painted *Progress* in Thornhill's domestic premises, alongside the engravings he had made after the pictures, all of which were displayed for perusal by potential customers. This arrangement helped confer on the paintings and the prints a status generated by the space in which they hung – the detour to the artist entrepreneur's studio became incorporated within a visit to a celebrated gentleman painter's house. Furthermore, the prints themselves were given a higher status by their juxtaposition with their painted referents, which by their nature as paintings, enjoyed a superior prestige to engraved images. The co-ordination of their display allowed the viewer and print consumer to situate themselves as people buying into the painted product, as well as the engraved one, when they visited the studio. Finally, by exhibiting a series of engravings within a studio space, Hogarth was able to suggest a teasing form of commercial withdrawal for his reproduced images, increasing their respectability as aesthetic objects by suggesting their independence of the more popular mechanisms of the print market and the more conventional outlets of the print shop and the coffee house.

Such a setting might also have encouraged a connoisseurial meditation upon the ways in which Hogarth's series, as Ronald Paulson has suggested, operated in an analogous – a negatively analogous – relation not only to the paintings of beautiful goddesses by artists such as Titian, but also to the pictorial Progresses of religious art, and in particular to the Life of the Virgin.[31] The imaginative juxtaposition of Hogarth's first plate with a traditional image of the Visitation, for instance – Hendrik Goltzius's engraved representation of Mary being met by Elizabeth offers a particularly intriguing point of comparison (*fig. 61*) – could be seen to introduce a purified narrative counterpoint to Moll's entrance into the city, and a particularly

prestigious aesthetic referent for Hogarth's project. On one reading, of course, the comparison of the two images confirms the traditional, playful, satirical engagement with the iconographies of high art taking place in *A Harlot's Progress*; indeed, it can be seen to indicate an exceptionally transgressive and potentially scandalous form of transmutation. However, at the level of negative analogy, a form of comparison that temporarily represses the satirical play with the feminine that we have also discovered in Hogarth's series, the imaginative mapping of one pictured body – Moll's – onto that of another – the Virgin Mary's – could easily be understood as a morally and aesthetically resonant exemplum of difference that was grounded in, and reinforced by, the perceived allusion to a venerable and elevated formula of religious art.

The utilisation of the series format, which may well have encouraged this kind of comparison, tied Hogarth's practice to more modern strategies of artistic enterprise and emulation in the city. Individual engraver entrepreneurs, as we noted in the Introduction, frequently depended on the subscription to a series of images to generate substantial income. Elisha Kirkall, for instance, advertised in March 1730 a subscription project for his mezzotint prints after Raphael's cartoons at Hampton Court, which were distinguished by the novelty of being available in 'green, yellow, red or any other tint desired'; on 4 April of the same year the etcher Hamlet Winstanley advertised that his 'Twenty prints from original pictures, in the collection of the Rt. Hon. Earl of Derby' were available to subscribers, in his shop next to the Bedford Coffee House; in January 1731, Vertue advertised 'Twelve prints of celebrated English poets', and in February, John Pine published 'Proposals, for Engraving and Printing by subscription, on copper plates, The Works of Horace'.[32] Meanwhile, one of the most active and ambitious of Hogarth's competitors, Gerard Vandergucht, advertised in January 1730 that he was not only selling prints of Coypel's 'Don Quixote' series, of Raphael's 'Cartoons' and of sets of 'Academy Figures', but also 'Six prints of the Labours of Hercules'.[33] Looking at the list of these artists and their works, we can quickly see that the series had become the conventional modern vehicle for high engraving in the capital, depicting distinguished subjects drawn from history, religion and literature, and frequently focusing on the idealised body of the male hero. Hogarth, in adopting the same format to represent a very different subject, thus colonised a pictorial framework that enjoyed a high degree of aesthetic respectability in the period and that, however incongruously, helped control and mediate his satiric focus on a modern anti-heroine.

In maintaining the habitual dependence on subscription that characterised the engraved series, Hogarth loaded his project with yet another mark of prestige. Rather than being geared to a mass market, the *Harlot's Progress* was initially aimed at a polite audience of urban consumers, the 'persons of fashion' that Vertue describes as having visited Hogarth's studio each day. The subscription project ensured that this exercise in cultural consumption was perceived as a relatively exclusive process that was untainted by the presence of less affluent consumers, who could neither afford the price of a guinea a set nor feel comfortable in the genteel surroundings in which the images were displayed. In the newspaper advertisements for the series, Hogarth emphasised that 'no more will be printed than are and shall

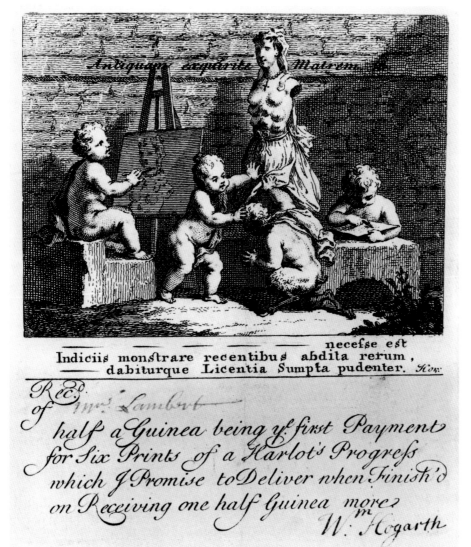

Indiciis monstrare recentibus abdita rerum, — dabiturque Licentia Sumpta pudenter. Hor.

62 William Hogarth, *Boys Peeping at Nature* (subscription ticket for *A Harlot's Progress*), 1732 (BM 1943). Engraving, $3\frac{1}{2} \times 4\frac{3}{4}$ in. Courtesy of the British Museum.

be subscribed for, nor Subscriptions taken for more than will receive a good Impression', which reinforced the notion of a collectible, limited edition of images. This process was sealed by the issuing of a sophisticated ticket to each subscriber (*fig. 62*), which offered an allegorised, and aesthetically elevated, key to the central preoccupations of the series. The card shows a putto painting a bust of 'Nature' on the left, while another putto attempts, rather unsuccessfully, to restrain a young satyr glancing under the statue's robed skirt; a fourth figure, clearly representing an engraver, works to one side. The ticket's size and iconography adapt the conventions of the contemporary engraver's trade card – those of John Burton and Paul Fourdrinier (*figs 63 and 64*), issued in 1726 and 1731 respectively, offer comparable combinations of similar pictorial elements. Hogarth's ticket is not only a commercial form of artistic guarantee signed by the artist, but an image that pictorially ties

63 John Burton, trade card, 1726. Engraving. Courtesy of the British
Museum.

64 (*right*) Paul Fourdrinier, trade card, 1731. Engraving, $9\frac{1}{2} \times 5\frac{1}{2}$ in.
Courtesy of the British Museum.

the series to the tasteful vocabulary of idealised infantile bodies and Classical
statuary, and that frames this imagery with the learned fragments of Latin tags and
inscriptions.

Looking more closely at the card, however, we can see how the various
strategies of pictorial and spatial mediation which I have just been outlining –
processes which helped make the engravings aesthetically and commercially accept-
able within polite culture – were understood to have supplemented, rather than
overwritten, the satirical and eroticised focus of *A Harlot's Progress*. For the sub-
scription ticket offers a brilliant encapsulation of Hogarth's doubled practice in the
Progress, in which the satirist is situated as someone who acknowledges both the
more decorous codes of polite art – here signalled by the censored portrait taking
form on the canvas – and the surreptitious, sexualised alternative signified by the
gaze of the satyr. The depicted engraver, working outside these exchanges, inte-
grates both forms of representation, and both forms of spectatorship, into his own
work. The Latin caption indicates what Hogarth perceived as his main preoccupa-
tions: 'A difficult subject must be presented in new terms, – and licence is allowed
if it is used with care.' In the series, the 'difficult subject' – the representation of
the prostitute – is presented in a range of pictorial vocabularies available in modern
print culture, and licence – artistic and erotic – is both allowed and carefully
patrolled. As such, *A Harlot's Progress* is defined as a set of satirical images that self-

consciously oscillates between different, seemingly contradictory forms of representation – between the irreverent and the didactic, the titillating and the moralised, the obscene and the edifying – and that offers a dialectical imagery of a figure being mythicised, both inside and outside the *Progress*, as a scandalous but fascinating fixture of modern urban life.

<div style="text-align:center">V</div>

This reading is confirmed if we look at a number of contemporary published responses to the *Progress*. No less than six were released in the two years after the first appearance of Hogarth's prints. They take a variety of forms: three purported to be literary 'explanations' or 'keys' – either in prose or verse – to the work; another was published as a ballad opera, *The Jew Decoy'd; or, the Progress of a Harlot*, based on the 'keen satyr in sly Hogarth's prints'; another was written as a 'grotesque pantomime entertainment', and sold as a playscript at a theatre in which the pantomime was being performed; finally, we can include the poetic inscriptions, often quite elaborate, that accompanied unauthorized copies of the set.[34] Traditionally, these texts have been dismissed as crude, plagiaristic adjuncts to the prints, rapidly churned out by Grub Street hacks, and thus the products of men with neither the time nor the connoisseurial faculties required to do Hogarth's work justice.[35] A closer examination, however, reveals a succession of complex and unstable exchanges with the engravings, exchanges that, in an urban culture devoid of a well-developed journalistic category of art criticism, combined the demands of literary explication with a variety of interpretative modes. Rather than suggesting a coalescence of ideas about the series's contents and meanings, they indicate a striking polarity of opinion about how the images should be understood.

The Progress of a Harlot, 'as she is described in Six Prints, by the Ingenious Mr Hogarth' appeared only days after the engravings' first publication. This pamphlet was a textual hybrid built up by combining fragmentary responses to the images with a prostitute's fictionalised autobiography. In this text the Harlot is incorporated as the confident narrator of sexual anecdotes revolving around secret observation and mastubatory indulgence: 'I ventured to peep out, and saw them in a posture, with which I have been well-acquainted with since, though a stranger to it at that time . . . They all retired out of the barn except myself, who lay purdue on the straw, diverting myself with my favourite Erasmus' (a generic category of eighteenth-century pornography).[36] An intermittent exchange with the contents of the images is welded to a comic narrative of promiscuity and masquerade, one that includes jokes about the size of a sailor's penis and descriptions of the pleasures of Vauxhall Gardens with a story of sexual initiation, promiscuity and decline. While *The Progress of a Harlot* is a somewhat discordant composite of discourses, hastily thrown together, it also indicates the quickly perceived openness of Hogarth's images to literary relocation and adaptation: in this example, the images could be situated in relation to a comic, teasing narrative of serial seduction and surreptitious assignation.

A sixty-four page poem published in the following week, entitled *The Harlot's*

Progress, being the Life of the Noted Moll Hackabout, exhibited similar preoccupations, but was grounded on a far more thorough analysis of the engravings. The poem not only offered a ribald reading of the images – 'pardon me, Sir', its author writes to Hogarth, 'if ought I may/ Too plain in luscious colours lay,/ I write but what you make them say'[37] – but supplemented the illicit narratives they were seen to contain with a range of alternative themes and preoccupations, including those of feminine revenge and masculine guilt. Significantly, the male narrator of this second redaction – which I shall call *Moll Hackabout* for clarity – continually and very deliberately confuses the pleasures of looking at the image of the sexually com-modified body with the pornographic fantasy of a temporary, if anxiety-laden, sexual communion with the body itself. The critique of prostitution, in this account, is welded to a powerful rhetoric of sexual addiction and consummation. Thus, when faced with the engraving of Moll beating hemp in Bridewell, the narrator moves quickly from the vocabulary of condemnation to that of fraught desire: 'Whoring, the greatest plague there is;/ Inslaves its followers more than all/ The snares in which Mankind can fall . . . [yet] When Moll I view'd at Hempen Block,/ Brocaded gown, and laced Smock . . . I could have ventured Plague and Pox/ And all that fills Pandora's box,/ To've had a silly snotty Pleasure,/ But she, poor girl, was not at leisure.'[38]

However comic and ironic, this kind of writing reads the images as ones generating a surplus of sexualised readings. Consequently, *Moll Hackabout*'s elabora-tion of the *Progress* is littered with obscene allusion. Charteris, the aristocratic rake who we see in the doorway of the first plate, is described, for instance, as having 'flew at Hackabout,/ Who scream'd, and from him turn'd her Back-about;/ But he, as void of grace as fear/ Began to charge her in the Rear'. Meanwhile, the canto dealing with the third plate notes the birch rod hanging on the wall, 'with which full many a bum was bang'd,/ To whip 'em [her clients] into a feeling spirit,/ Before they enter and inherit.' In the same canto, the writer deciphers the voyeuristic gaze of Gonson at the door, using terms that echo George Vertue's description of the viewing taking place outside the print: 'Sir John behind the curtain stood,/ The sight would have done Ulysses good,/ He viewed the siren's disabil,/ Her shape – and in surprize stood still/ Her skin as white as cream in spring./ Her air, her shape, her ev'ry thing/ Did almost slake him; but his zeal/ Overcame his passions.'[39] Noting these textual and critical strategies alerts us to the fact that the first sustained responses to Hogarth's *Harlot's Progress* offered an exchange with the images that was self-consciously vulgar and priapic, and revolved around a comic perspective of corporeal excess and perversion. Given the art historical concentration on the series as a 'modern moral subject', we might expect to find that a poem like *Moll Hackabout* quickly fell by the literary wayside. On the contrary, however, the poem was the most commercially successful of all contem-porary literary responses to the engraved *Harlot's Progress*, reaching a fifth edition by the end of the year.

However popular the readings of Hogarth's images offered by *The Progress of a Harlot* and *Moll Hackabout*, they also provoked a severe form of reprimand from another writer engaged in a similar commercial enterprise. In the preface to *The Lure of Venus; or, A Harlot's Progress*, a poetic redaction of 1733, Joseph Gay rails

against the two publications of the previous year, and suggests that in his poem the reader will find 'more sense, and less obscenity . . . than in both the others; and I have endeavour'd to make a useful moral run through the whole.' In Gay's poem, Moll is defined as someone who, just before her death, repents of her sins; the vanity, ambition and desire for revenge that characterise her life as a whore are succeeded by a moralised form of retrospective regret. The reader is encouraged to view her career, as represented in Hogarth's engravings, as an exemplum of the evils that surround prostitution, and as a form of pictorial instruction and deterrence. Significantly, Gay suggests that this reformulation is particularly important if the series is not to be consistently misread by the prints' female audience. In his preface, Gay suggests that a more explicitly moralised redaction has become necessary, 'lest, what is designed to instruct, should only serve to debauch the minds of my readers, especially females.' He goes on to offer a specific warning to 'Females! the wily Harlot's Net Beware, Pleasing's the Lure, but fatal is the snare.'[40] Clearly, if the series was seen to incorporate an eroticized set of visual signs, they were only to be recognised by male viewers; in contrast, the 'pleasing lure' of these signs for the female spectator – the possibility of an identification with the figure of the prostitute – threatened all the tenets of polite feminine identity. For, as Bernard Mandeville wrote in 1725, 'young girls are taught to hate a whore, before they know what the word means'.[41] In Gay's text, the harlot is described for the female reader as a woman whose fate exemplifies the consequences suffered by those of their sex who deviate from the constraints of class, family and marriage: 'Wanton ambition led my thoughts away,/ And made me foolish, from my parents stray/ Or had I been some poor honest man's bride/ I'ad lived in comfort, and with honour dy'd.'[42]

Like Gay's poem, the verses that accompanied Elisha Kirkall's mezzotint copies of the series, published in November 1732, assumed a female authorial voice to stress the images' value as instruments of caution to women; 'Fly, fly, betimes the treach'rous gilded Bait/ And warn'd by her example shun her fate:/ Beware of Man, who would to vice ensnare;/ But most of all, of our own sex beware/ View these instructive scenes – a Bawd's pestif'rous breath/ Brings shame, want, punishment, disease and death.'[43] What these lines and Gay's poem suggest is that Hogarth's *Progress* generated a gendered framework of interpretation: the engravings were to be looked at differently by men and women, and were expected to posit different meanings for both sexes. While recognising this, we should not assume that this distinction was at all rigid in practice. Rather, the engravings encouraged a dualised structure of response, heavily weighted towards gendered modes of consumption, within which the images could alternately be situated, even by the same viewer. In particular, the male spectator was allowed an interpretative latitude that could acknowledge both the moralised platitudes and the voyeuristic pleasures offered by Hogarth's images. This latitude was prohibited to contemporary females by texts like Gay's and Kirkall's; nevertheless, the near-panicked tone of their warnings is an eloquent, if an indirect, indication that women, too, were seen to be engaging with Moll as a glamorous, subversive and tragic anti-heroine, rather than as an exemplary object of dissuasion.

The interpretative dualities sustained by Hogarth's images become even more

apparent when we look at the ways in which the various literary redactions we have noted negotiated the depiction of Moll's death, the final print in the series (see *fig. 53*). Gay's poem manages to articulate the Harlot's death as that of a rehabilitated victim, and to redefine her as an accomplished embodiment of feminine grace who had met an untimely end. 'Chloe', the prostitute who gazes into the coffin, becames a bearer of poetic eulogy, and the screened site of the Harlot's prone body reconstituted as a poignant counterpoint to the seedy circle of activities that surround her: 'O cruel death! Couldst not thou find a prey/ Who fought thy Dart, and curs'd thy dull delay/ But thou must strike my friend, in whom was seen/ Each tempting grace, and fair as beauty's queen . . . Heart breaking thought! To be cut off so soon,/ In blooming youth, 'ere life had reached its noon.'[44]

While *The Lure of Venus* attempts, rather uncomfortably, to keep the Harlot's death within sentimental discourses of feminine remembrance, the two 1732 poems concentrate, with coarse good humour, on the surreptitious sexual exchanges that are going on elsewhere in the image, and on the ways in which the prostitutes hoodwink the corrupted male representives of mourning. As we have seen, Hogarth places the figure of a young prostitute, gazing out at the viewer with a knowing smile, next to the seated clergyman, whose right hand, shielded by a hat, creeps under her dress. To confirm this underhand narrative, Hogarth includes an easily decipherable metaphor of ejaculation, the overspilling glass clasped by the clergyman's fingers. The author of *The Progress of a Harlot* quickly recognised and supplemented these pictorial clues: 'Mr Parson, beginning to be a little elevated, must needs be meddling with one of the ladies, who (while he was in the midst of his amorous play), pick'd his pocket of his watch.'[45] Similarly, the undertaker, in the process of getting his pocket picked, is ridiculed in *Moll Hackabout* for attempting to persuade the whore he flirts with to sleep with him for nothing: 'Poor fool! For half an ounce or less,/ He might have kissed her every place;/ Her tail he might have kiss'd, or kicked it;/ Or more, the hungry dog might have lick'd it.'[46]

Meanwhile, the verses that accompanied Kirkall's copy of this final print recognise both the edifying and salacious elements of the image. Like Gay's poem, Kirkall attempts to negotiate the image as a moral exemplum for the female viewer: 'See here, too easy fair, the untimely end −/ Of one, who chose not virtue for her friend'. At the same time, the author of the verses cannot refrain from noting, and apologizing for, the image's concurrent focus on the masturbatory clutch of the clergyman's left hand, which he half-explains away through a remarkable allusion to Hogarth himself: 'Should any at one posture take offence −/ As all must do, who are not void of sense,/ Know that (the best excuse which can be made)/ *The Painter's drawn himself in Masquerade*.' This last phrase is difficult to decipher, but the suggestion is surely that Hogarth's complicity with the figure of the clergyman, and with the hidden narratives taking place underneath the prostitute's dress, ultimately amounts to a semi-disguised form of self-portraiture.[47]

This splintering of readings between the obscene and the polite was partly the result of contemporary patterns of cultural commodification. Hogarth's images quickly became subject to an intense process of graphic and discursive reproduction, revision and dissemination that deconstructed their pictorial

vocabulary according to a variety of entrepreneurial and cultural agendas. These responses took the form not only of literary redactions and substitutes, but also of a stream of unauthorised graphic copies sponsored by large-scale entrepreneurs like Bowles and Overton. Moreover, the nature of the *Progress* as a narrative succession of satirical prints in itself precluded semiotic closure, for it encouraged a reading *between* the images, and opened up a series of interpretative spaces outside the frame that could be replenished by reference to pornographic and comic representations, as well as to those of moral deterrence or sexual probity. If the viewer was implicitly positioned as a second author, filling in these gaps, the rewritings of the *Progress* that we have just been studying commodified this process, and instituted it at the level of the supplementary text. Nevertheless, I would argue that the range of responses generated by *A Harlot's Progress* was ultimately a function of the internal contradictions and dualities of Hogarth's six pictures. And, having spent some time suggesting the textual, pictorial and spatial matrix out of which *A Harlot's Progress* emerged, and having detailed the different readings that the series stimulated in contemporary culture, I would like to return for one last time to the images themselves, and to think about how the satirical dialectic we have been recovering operates as an organising feature of the series as a whole.

VI

One of the defining characterisitics of *A Harlot's Progress* as a succession of images is the way in which the series opens out and then closes down our view of Moll's body. This dynamic works to split the *Progress* into two halves. We move from the virginal enclosure of the prostitute's clothing in the first plate, to her post-coital casualness in the second, and her state of flirtatious *désabille* in the third. Conversely, while the fourth plate removes the Harlot to an alien, brutalized environment, the fifth represents her as little more than a glimpsed profile emerging out of a bundle of blankets; the sixth emphatically removes the Harlot as a physical presence altogether. In this respect, the dialectical identity of the prostitute in contemporary culture is carefully embedded in a temporal narrative that allows the viewer to register both the attractions and the dangers of the whore. While the former register demands that Moll be made increasingly available as a bodily presence – in the third plate she is only just kept on this side of nudity – the narratives of her decline and death invite the ultimate removal of her body, which remains a disturbingly loaded signifier of sexual availability, from representation. We are able to replenish her image morally only when it is offered as an absence, something that we cannot see, something that functions as an emptied space at the pictorial centre. Significantly, even this final, resonant form of corporeal vacuum is destabilised by the narratives that surround it. As we noted earlier, one hidden bodily site of narrative – Moll's – is accompanied by another that evokes an entirely different form of spectatorial uncovering. As well as piercing the screen of the casket, and imagining the dead body that lies within its cushioned interior, we are expected to pierce the sartorial screen wrapped around the live prostitute in the foreground, and imagine the intimate, groping play of fingers, legs, and lingerie underneath. The

female body – even when covered up – is again figured as the site of both moral inculcation and licentiousness.

In this last guise, Moll's body is partly defined by the gaze of a female spectator who offers an explicit alternative to the masculine viewers who crowd the earlier prints and whose looks constantly defined her as a sexual object. Here we can remember the ways in which the laundered re-interpretation of the series offered by writers like Joseph Gay were largely geared to women readers: if the earlier plates offered a series of dubious surrogates for the male viewer of the prints, the final image replaces these with a watching female, whose contemplation of the coffin's interior offers an adulterated, but nevertheless feminised avenue of vision. Tracking back across the prints, we can see that this concentration on spectatorship, and on internal points of view, is a carefully orchestrated strategy of the series as a whole. We can note the way in which the first three images dramatise points of entry and exit, all of which become loaded with the weight of the masculine gaze: thus, Charteris stands in the open doorway in plate one, Moll's lover tiptoes out of the open door in plate two, and Gonson pauses, along with his cronies, in an equivalent place in plate three. The doorway, it is clear, functions in these images as a metaphorical point of sexual entry into feminine space, one that is articulated by the look of the men who cross its boundaries. Meanwhile, the final three plates close these apertures up: Moll is locked away in plate four; in the fifth print, the door is shut, and in the sixth, it is blocked by a screen that offers yet another form of spatial quarantine and compartmentalisation. And while the sadistic jailer continues to train his eyes on the figure of Moll in Bridewell, thereafter men look away, at each other, and at other prostitutes, rather than at the central protagonist of the *Progress*. Taking their place in the final plate, the figure standing over the coffin offers a feminised form of visual guardianship that reinforces a domesticated and de-sexualised reading of the hidden body. Across the six engravings, the viewer is thus proffered, and asked to engage with, a series of carefully organised spectatorial circuits, which encourage us both to focus on and to avert our eyes from the ambivalent figure of Moll herself.

Alongside this play with the body and spectatorship, *A Harlot's Progress* would also have encouraged a powerful form of spatial voyeurism on the part of eighteenth-century viewers; that is, the environments depicted in the engravings offered striking counterpoints to the spaces within which the prints themselves would have been habitually viewed. The *Progress* depicts a number of scandalous and secretive interiors, and frequently does so using a perspectival scheme in which the corners of the engravings are bisected by the lines of a ceiling or a floorboard. We are thus encouraged to read the images as pictorial boxes, theatrical spaces that smoothly recede from the picture plane and that situate the viewer as a vicarious onlooker and participant within their ambits. Their slavish detail depicts a thoroughgoing inversion of the narratives and arrangements of the decorous interior. Here, it is worth thinking of the ways in which the pictures and prints that are depicted hanging in the spaces Hogarth describes would have offered a supplementary, ironic mimicry of the *Progress's* own position on any given wall. Through such means, the series encouraged the viewer imaginatively to move into the spaces it described, and simultaneously to read those spaces as environments of difference,

visually allowable only at the level of representation, and designed to be read against the more normative arrangements of the domestic interiors within which they were consumed.

In all these ways, the series oscillates between different representations of the prostitute and her environment. We can now indicate the ways in which these dialectical shifts were reinforced by the actual, physical patterns of viewing encouraged by the *Progress* from the first moment it hung as a set in Hogarth's studio. On the one hand, the series format demands that we physically distance ourselves from these images to appreciate their overall effect and the pictorial and narrative rhythms that link the different images together. Indeed, to perceive this continuity and coherence requires that we subject the set to a generalised form of looking and interpretation, in which we stand back, both physically and metaphorically, from the individual components of the series, and come to some more abstracted conclusions about their collective meaning, context and significance. In this respect, the *Progress* correlates to the kind of reading seen in the eighteenth century as fitting for the most elevated forms of representation, which appealed to the judicious, wider perspective of the educated viewer. On the other hand, each image of the *Progress* is crowded with details that encourage a near-microscopic form of close-up looking, a process that affords one of the great pleasures of the prints, as well as encouraging the obsessive kinds of pictorial code-breaking that have frequently bedevilled studies of Hogarth's work. The series is littered with seemingly arbitrary objects that can be quickly translated into a flood of clues: playing cards, abandoned teeth, sprigs of yew, pamphlets, jettisoned items of clothing, to give just a few – all these ask to be read as scattered interpretative keys. This kind of spectatorial hunt was a form of viewing highly preoccupied with the local, the minute, the emblematic, and as such represented a rather different agenda from that of the generalised response to a pictorial series. Indeed, this 'microscopic' form of interpretation, as Harry Mount has suggested, was sometimes seen in the period as actively militating against a reasoned, comprehensive form of spectatorial response: 'If the eye is distracted by details and the picture cannot be comprehended as a whole, then any moral it conveys is likely to be overlooked.'[48] In the *Progress*, we can say, the blurring of interpretations suggested by this doubled mechanics of representation complemented and reinforced their dialectical agenda: the viewer was again being actively encouraged to move between different forms of reading, here played out across the space in front of the different pictures.

This interpretative mobility was amplified, as we have seen, by the dramatisation of the semiotic gaps left between the images in *A Harlot's Progress* as ones that could be replenished by a variety of representational and literary references. Significantly, when Giles King produced an authorised copy of the *Progress* later in the year, he filled this external space with two smiling satyrs (*fig. 65*). The satyr was a conventional allegory of both satiric exposure and sexual desire in early eighteenth-century graphic art, and in King's engraving the two figures freight the pictorial outside of the *Progress* with a secondary framework of masculine, voyeuristic exchange with the female body; their mirrored gaze across the images is both critical *and* lascivious. While King's images offered one form of pictorial supplement, another was generated by his translation of the *Progress* onto the surfaces of a fashion accessory:

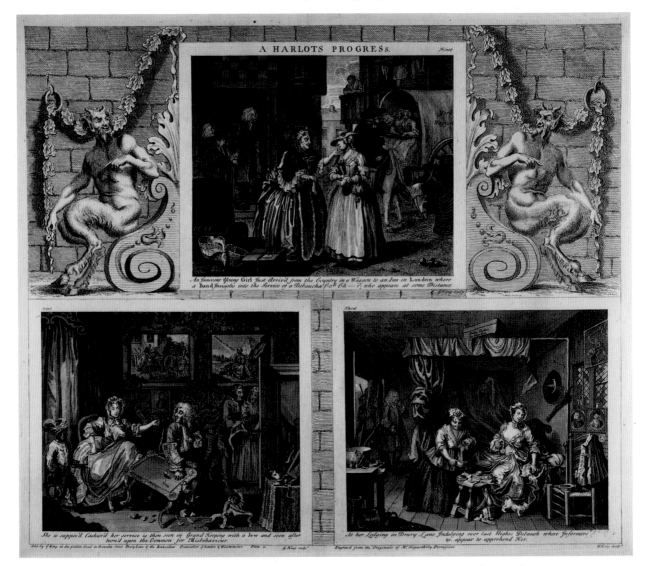

65 Giles King, after Hogarth, *A Harlot's Progress*, Plate 1, 1732 (BM 2033). Engraving, $18^3/_8 \times 21^1/_2$ in. Courtesy of the British Museum.

as an advertisement of July 1732 noted, the female consumer could now buy, or be bought, 'Six prints of the Progress of the Harlot on a Fan, three on each Side, curiously-Engrav'd; wherin the Characters are justly preserv'd, and the whole not varied from the Originals. Printed in divers beautiful Colours. Price 2s. 6d.'[49] King's advertisement suggests not only that the series was deemed appropriate for the female viewer, but helps us imagine a male viewer seeing the *Progress* in physical juxtaposition with the face of the fan-holder herself. The relationship between the two was a characteristically unstable one − if the woman's face offered a specific kind of secondary frame for the images, they in turn offered a dialectical codification of their carrier: she could alternately be seen as using the fan and its imagery as a barrier that screened her from the male gaze, or be

understood as to some degree complaisant with the surreptitious sexual narratives of the images she held in her hand. She could, like the fan and the series itself, be read both ways.

VII

A Harlot's Progress promoted satire as a pictorial genre that could occupy graphic culture's mainstream while retaining many of its traditional features and concerns. The series maintained the engraved satire's focus on the deviant, the modern, the topical and the urban, and continued to reshuffle and destabilise the generic hierarchies and boundaries of the graphic arts. The *Progress* reasserted the satirical print's independence of any single textual or pictorial referent, and again defined the viewer as a close reader who was able to appreciate the images' strategies of play and juxtaposition. In these ways, the series, like the satires we have looked at in previous chapters, continued to encourage a mobile, playful and ironic form of viewing, continued to resist any kind of interpretative fixity and continued to filter the various contemporary associations of its subject matter through a satiric matrix of representation. At the same time, Hogarth's prints managed, through a series of pictorial and commercial mediations, to render these artistic and interpretative strategies legitimate and attractive for a polite print-buying public. Hogarth's series, which seemingly plays on the margin of polite and impolite representation, worked to redraw that margin as a central, if temporary, site of modern graphic art.

In this process, the artistic identity of the graphic satirist was also being redefined. One of the striking features about *A Harlot's Progress* compared with earlier satires is that its strategies of pictorial dialogue and exchange are more obviously subordinated to a rhetoric of artistic invention. The very mobility, range and elusiveness of the series's pictorial references – the fact that each image can be linked to, but not seen as directly quoting, high art, book illustration and pornography – becomes an index of the artist's own originality and of his ability thoroughly to transform representational materials into new forms and arrangements. This claim was buttressed, in practice, by Hogarth's personal monopolisation of the roles of painter, engraver and publisher of his images. By arrogating each of these roles to himself, Hogarth took other people out of the conventional chain of print production and sale, and was able to market himself and his work as operating inside an individualised zone of graphic art. These shifts in the construction of the satirist's artistic and economic identity have frequently, and erroneously, been understood either as a function of Hogarth's supposed artistic uniqueness or as a consequence of his particularly fractious personality. Rather, they were powerfully conditioned by broader developments in graphic art, which affected the community of London engravers as a whole.

We have already suggested that satire provided a cultural space for the promotion of artistic individuality in the capital, and that graphic culture as a whole had long been characterised by the attempts of engravers to establish themselves as artists rather than craftspeople, operating outside the dominant centres of the print

market. We have also noted the proliferation of independent entrepreneurial schemes by engravers in the city, which framed and helped condition the appeal of Hogarth's series. By the early 1730s, a community of engraver entrepreneurs had harnessed their long-term artistic ambitions to a new degree of economic and cultural power. Nevertheless, if this community was to compete successfully both with the major print publishers and with the increasingly popular print auctions, they required a greater level of commercial protection and incentive. In particular, engravers militated against the unauthorised copying of graphic images by the major print sellers, a habitual response to particularly successful pictorial projects. Indeed, no less than eight pirated versions of *A Harlot's Progress* are mentioned by Hogarth's earliest biographer, many of which appeared in the immediate aftermath of the series' first publication.[50]

These grievances concerning the constant threat of plagiarism, and the aspirations to artistic and commercial independence that lay behind them, galvanised a group of engravers to campaign for a parliamentary copyright act to safeguard their work. On 7 February 1735, a petition calling for such an act was presented to the House of Commons, drafted by a small group of artists and engraver entrepreneurs, many of whose names are familiar to us: Joseph Goupy, William Hogarth, George Lambert, John Pine, Gerard Vandergucht, George Vertue and Isaac Ware. After a successful series of readings and meetings, an Engraving Copyright Act was passed into law, coming into effect on 25 June. The Act provided engravers with a legislative form of protection over their artistic property, declaring that 'every person who shall invent or design, etch or work in *Mezzotinto* or *Chiaro Oscuro*, or, from his own works and invention, shall cause to be designed and engraved, etched, or worked in *Mezzotinto* or *Chiaro Oscuro*, any other print or prints, shall have the sole right and liberty of printing and reprinting the same for the term of fourteen years.'[51] While the Act's most direct consequence was to make the plagiarism of original designs a legal offence, its underlying effect was to codify a notion of graphic property that complemented the ideals of individual invention and entrepreneurialism. The engraver, rather than being defined as part of a collaborative, hierarchical network of collective production and sale – the commercial blueprint promoted by the major print publishers, and embedded in the customs of the trade – was now given an even greater opportunity to promote himself as an independent artistic and economic producer whose works competed in an open market of graphic commodities protected by law.

The *Harlot's Progress* represented a powerful manifestation of, and contribution to, the shifting ideological and economic dynamics of graphic culture in the years leading up to the Engraver's Act. The series' dazzling display of artistic inventiveness, its production as a work of art that denied the traditional specializations of the print trade, and its promotion as a commodity tied directly to the spaces of the studio – all had already helped construct an identity for its producer as a liberal artist who had managed to escape the restrictive conventions, both artistic and commercial, of the capital's print trade. For Hogarth, this was a role that the Engraver's Act reinforced and that he was to play to the full throughout the rest of his career. It is also one that has been accepted at face value by generations of art historians. By contrast, what this chapter has begun to argue is that, in the *Progress* and beyond,

Hogarth continued to maintain the satirist's traditional critical engagement with, and dependence upon, the representational materials and commercial networks of London's graphic culture, while simultaneously promoting himself as an elevated practitioner of the arts whose work remained independent of those materials and networks, and indeed transcended them. It is a testament to the success of Hogarth's self-generating mythology of artistic independence that this mythology has tended to occlude his work's continuing, essential dialogue with a wider realm of images, discourses and practices in the city, and has tended to overshadow the other competing formulations of satiric art and identity that were being generated in urban society. It is these alternative modes of art and authorship, ones that both aligned themselves with, and distanced themselves from, Hogarth's example, that will be the subject of the next two chapters.

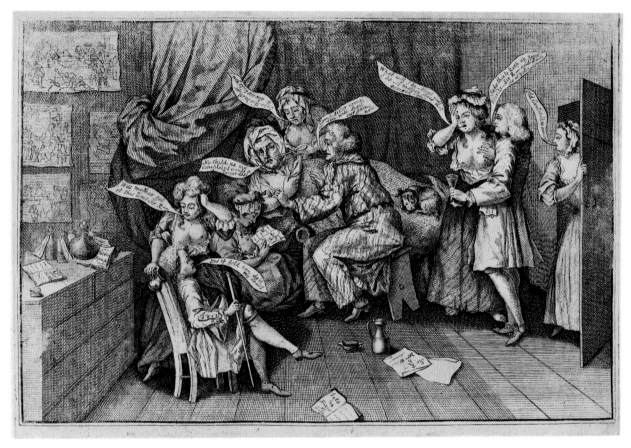

66 '*A Satire Unexplained*', c. 1735 (BM 2268). Engraving, $7\frac{3}{8} \times 11\frac{3}{8}$ in. Courtesy of the British Museum.

Chapter Four

Satire, Politics and Party

Among the hundreds of early eighteenth-century satires housed in the British Museum, there is a curious, rather awkward engraving, described in the museum's catalogue as 'A Satire Unexplained' (*fig. 66*). The anonymous print, which was probably executed in the mid-1730s, is in an unfinished state, printed before the engraver had completed his work. The speech bubbles, while left empty on the copper-plate, have fortunately been filled in by the hand of an earlier owner, who has, in the catalogue's words, 'added with a pen, the words which are supposed to be spoken by the persons represented . . . These inscriptions have been copied from a finished impression of the print.'[1] How can we best explain this odd image? The engraving depicts the crowded bedroom of a brothel, in which a common bawd drifts towards death under the ministrations of an incompetent physician. Nearby, lounging on a chair, a gentleman flirts with a bare-breasted prostitute while, nearer the door, another client proffers a glass of wine to a weeping companion. The print, we start to recognise, is a jigsaw of familiar materials. The dying woman in the elaborately curtained bed, the useless doctor, the cluster of whores, the priapic males whose hands creep across breasts and crawl underneath skirts – all offer easily decipherable substitutes for the figures and fixtures of *A Harlot's Progress*. This thoroughgoing form of pictorial appropriation and exchange is neatly signalled by the prints hanging on the bedroom wall, which include a reversed copy of the third plate of Hogarth's *Progress*, complete with a schematic outline of the puritan's hat hanging over Moll's bed.

Here, however, the recycled pictorial language of the brothel is fused with the vitriolic narratives of party politics. Reading the hand-inscribed speech bubbles, and the fragments of text littering the floor and the sideboard, it seems – my reading remains speculative – that the central, prone figure of the dying woman is meant to be understood as an allegorical embodiment of a failing nation, brought low and made ill by the corrupting practices of the political physicians of state. Much more explicitly, the seated figure in the foreground is clearly intended as a scandalous portrait of Sir Robert Walpole. His name, cut short to preclude the possibility of prosecution – 'Sir R–', 'Sir R–', 'Sir R–' is written in two of the speech bubbles and on the letter lying on the floor – is a satirical mantra repeated across the image, and he is newly depicted as a diminutive, lecherous rake, more preoccupied with sex and gold than with responsible government. We have already become familiar with Walpole's representation in contemporary satire. *The late P-m-r M–n–r (see*

fig. 1) offered an alternative but complementary view of the Prime Minister, one that similarly meshed a number of pictorial and textual discourses together and recast them in grotesque, comic form. Looking at another satirical attack on the politician, which transplants him into the squalid world of Hogarth's *Progress*, only confirms that such images need to be understood as pictorial as well as political constructs, whose mediation of different graphic vocabularies was a critical part of their role as vehicles of extra-parliamentary polemic. This chapter will trace the ways in which the political satire functioned and developed during the second half of the 1730s and the early 1740s, when political prints dominated satirical art in London.[2]

<div align="center">I</div>

Throughout these years, Sir Robert Walpole's Whig party controlled Britain's parliamentary government. Working in tandem with a sympathetic king and queen, George II and Caroline, the prime minister not only consolidated his own status at Westminster and the court, but also populated the political and bureaucratic infrastructure of his ministry with office-holders who were directly or indirectly dependent upon his favour for their positions and for their continuance in them. A careful supervision of parliamentary legislation, and a similarly judicious management of the electoral constituencies in the country, ensured that even in times of crisis the Whig ministry was able to depend on the support of a majority of Members in parliament.[3] In the face of this monopoly of institutional power at Westminster, oppositional activity was forced to seek alternative channels of political action. Particularly in the decade before Walpole's resignation in 1742, the anti-ministerial opposition, frustrated by the blockage of influence, patronage and office at the centre of government, turned to and exploited extra-parliamentary means of political debate and public opinion in the city in order to counter and criticise the Whig government. The newspaper, the journal and the pamphlet – products that had traditionally negotiated political issues – were joined by the theatre, the fair and the print shop as sites that mediated and generated intense political controversy and criticism. And as urban cultural production became increasingly defined by its antipathetic stance to the personalities and factions of the court and Westminster, so political opposition itself became framed by the dynamics of cultural commodification. In particular, satire – whether literary, theatrical or pictorial – transformed urban political dissent into a commercial product to be consumed in the marketplace. In this process, anti-ministerial polemic inevitably became reformulated according to the conventions of satirical practice: political critique was harnessed to certain modes of address, packaging and persuasion and deliberately conflated with them. Conversely, the formal mechanics of satire could themselves become defined as oppositional: in the case of graphic satire, this meant that the agendas of pictorial play, juxtaposition and ironic reference we have traced throughout this book were intermittently understood as newly politicised modes of pictorial organisation.

The various categories of political satire being produced in the city, whether textual, performative or pictorial, catered to a politically knowledgeable and sophisticated urban community. In addition to its unusually broad franchise, which included all male householders, the city of Westminster supported a voluble and active political culture embracing thousands of people who were not eligible to vote. A crucial nexus for this activity was the metropolitan meeting-place where men could sit and talk in a salubrious atmosphere: in 1739 it was estimated that there were a total of 551 coffee houses, 207 inns and 447 taverns, as well as scores of beer and brandy-houses, in the central districts of London.[4] Many of these places supplied their customers with free newspapers and journals, which helped stimulate and inform discussion. The assiduity with which such publications were consumed can be gauged by the fact that each issue of a leading opposition weekly, *The Craftsman*, was estimated in the 1730s as being read by at least 40 people.[5] In places like the coffee house, which catered to a highly literate public that lived in the shadow of the official institutions of state power, political argument developed into a crucial component of urban community and masculine identity. Extra-parliamentary debate became part of an independent network of discourse and practice that remained free of the oligarchical, plutocratic and aristocratic influences of Whig power, and that constituted an alternative realm of political life.

This urban constellation of spaces and activities also fostered what the historian Nicholas Rogers has described as an agenda of radical Toryism, which offered its adherents a framework of political beliefs and a sense of embattled community. Radical Toryism is a term used by Rogers to define a shifting alliance of 'dissimilar and wide-ranging groups, merging together in a chorus of protest to the Whig regime – out-of-place aristocrats, ambitious lawyers, wealthy tradesmen, dissident journalists, independent artisans, and the plebeian rank and file. It was a defensive alliance, a common front against the arbitrary implementation of ministerial power backed by law and privilege.' One of its main strongholds was the central spatial artery of the city, 'stretching from Temple-Bar to Charing-Cross, and northwards along Drury Lane and St Martin's Lane to Long-Acre', in which 'much of the political activity of the opposition was concentrated.'[6] In between elections – when the area was galvanised by the attempts to elect independent members of parliament – this environment supported a residual culture of political dissent informing much of the satirical production being generated in the same area. The basic tenets of radical Toryism – a persistent attack on the centralising and corrupting powers of the executive, a call for freer and more frequent parliaments, a critique of the growing alliance between financiers and the Whigs and a fear that British interests were being subordinated to the Hanoverian loyalties of the king – were precisely those that resurfaced in the literary, theatrical and graphic satires of the 1730s, which operated in an especially intimate relationship to each other during these years, and which collectively generated a powerful project of cultural and political protest.

The interrelated nature of satirical production at this time can best be indicated by analysing a controversy that provoked a particularly draconian ministerial response. It began with the publication in March 1737 of a journalistic satire

entitled 'The Festival of the Golden Rump'. This anonymously written text appeared in a recently founded oppositional journal, *Common Sense*, and took the form of a literary 'vision', in which the narrator witnesses a grotesque form of idol worship that parodies the servile rituals of George II's court. The dreamer is led to a temple, and finds

> an altar about five foot high, in which the pagod was placed. This idol was an human figure, excepting Goat's legs and feet, like those given by the poets to *Satyrs*. His head was made of wood, his body to the waist of Silver, and his posterior of Solid Gold . . . On the right Hand of the Pagod stood the Tapanta (or High Priestess) dress'd like a *Roman* Matron. Her Stola was of Gold Brocade, adorn'd with Diamonds. She had in one Hand a Silver Bell, and a Golden Tube in the other, with a large Bladder at the End, resembling a common Clyster-Pipe. The Bladder was full of *Aurum potabile*, and other choice Ingredients, which at proper seasons, was injected by the *Tapanta*, into the Fundaments of the *Pagod*, to comfort his Bowels, and to appease the Idol, when he lifted up his cloven foot to correct his Domesticks. However, his fury was sometimes so very sudden, that he imparted visible marks of it on all who stood near him, ere the Priestess could apply the Golden Clyster. And sometimes the storm was so violent that the Priestess was unable to apply the Tube to those parts . . . On the left Hand of the Idol, opposite the Tapanta, stood the chief Magician, or Vicar-General: His Habit was a Robe of blue Velvet, his cassock of White Satin, embroidered all over with flying Dragons. He was called *Gaster Argos*, from his Belly, which was as prominent as the Pagod's Rump. Beneath his suringle were the words in Gold Characters, AURI SACRA FAMES. In his Hand was a Rod, which he waved to and fro, like Harlequin Faustus in a modern Pantomime. This Rod, my Friend told me, belonged heretofore to Pharaoh's chief Magician, and would change itself into a serpent, whenever Gaster cast it on the Ground.[7]

This extract indicates the dense, allusive and obscene political allegory that formed much of the literary satire in anti-ministerial journals and newspapers. The cloven-footed Pagod, farting across the temple, represents George II, while the High Priestess, applying a clyster-pipe up his rectum, is meant to signify Queen Caroline; the chief magician, distinguished by his huge stomach, is Walpole.

In 'The Festival of the Golden Rump', oppositional polemic is reformulated according to a deliberately exaggerated rhetoric of fantasy that defines the court and its milieu as a perverse space operating outside the legitimate boundaries of political life. And however humorous or fantastical, this text was part of a broader effort to destabilise the ways in which the monarchy and, more persistently, the prime minister were being represented in the officially circumscribed realms of poetic panegyric and patriotic dedication. In scores of published literary satires the conventional vocabulary of political writing is parodied, fragmented and transformed. In this case, the litanies of accomplishment and deference that were habitually affixed to official discussions of a monarch or minister's merits are rewritten as a narrative of corrupted ostentation and bestial festival. The tale proceeds to describe how the Pagod's followers troop in and deposit pots of gold

at his feet; a dragon metamorphoses from the magician's rod, and goes on to devour these gifts. This concentration on alien ritual deliberately mimics the traveller's tales, enduringly popular components of the capital's book market, that focused in similar detail on the religious and political customs of distant communities. Through such references, 'The Festival of the Golden Rump' subjects the rites and environments of contemporary rule to a process of satiric estrangement that reformulates the familiar in terms of the foreign.

Satirical texts like these defined themselves as literary assemblages which deliberately confused and intermingled different categories of writing, and that demanded to be distentangled by the close reader if they were to reveal their true meanings. A correspondent to *Common Sense*, responding to the account of 'Rump Worship', declared that 'you have mix'd the allegorical and historical part so together, that it is only for men of the deepest reading and penetration to separate them.'[8] On the contrary, we can suggest, such combinations of generic play and political ridicule had by this time become all too familiar, and quickly recognisable, components of literary satire. Even if the reader was unable to decipher all the available clues and metaphors, the siting and the rhetoric of pieces like the 'Festival of the Golden Rump' would immediately have been understood as a form of political dissent and its thinly veiled allegorical substitutions quickly deciphered as part of a broader apparatus of ridicule.

This interpretative transparency was exploited by Walpole himself when, in May of 1737, he declared that he had in his possession a theatrical version of the Golden Rump narrative, which he proceeded to use as an excuse to clamp down on the capital's playhouses. The authorship of this two-act farce, of which no copy is known to exist, remains unclear, but Walpole may well have secretly commissioned it in order to help legitimate his call for close govermental supervision and censorship of theatrical productions. The personalised excesses of the satire – particularly its scurrilous attack on the royal family – and the legibility of its most basic allegories allowed Walpole to present it as evidence of the treasonous and disloyal turn of modern theatre. Reading out the most obscene passages of the theatrical *Golden Rump* to Parliament, Walpole used them as a catalyst with which to speed the passage of legislation closing all unlicensed theatres. Only Drury Lane and Covent Garden were left open, and it was made a criminal offence to perform a play for profit unless it had received the assent of the Lord Chamberlain. Whatever the circumstances of its immediate production, the *Golden Rump* was evidently seen as exemplifying and maintaining the insidious process of political playwriting and performance that had come to characterise venues like the Little Theatre at the Haymarket, Henry Giffard's playhouse in Goodman's Fields, and the annual fairs of Smithfield and Southwark. In such environments, the satirical farce had succeeded pantomime as the most radical and novel form of theatrical entertainment, and writers like Henry Fielding had rapidly come to prominence thanks to their formulation and exploitation of the genre.[9]

Like the journalistic satire that it so closely depended on and adapted, oppositional drama of this period fused its political polemic with an ironic reshuffling and confusion of generic categories. Furthermore, it self-consciously deconstructed the barriers between theatrical spectacle and audience response and,

in doing so, complicated the modes of interpretation that were seen to operate within the sphere of the playhouse. The two theatrical hits of the mid-1730s, Fielding's *Pasquin* and his *Historical Register for the Year 1736*, which was performed in the spring of 1737, testify to this merger of oppositional critique with formal experimentation. *Pasquin*, describing itself as 'a Dramatick SATIRE on the TIMES', took the form of two plays in rehearsal, 'A COMEDY call'd THE ELECTION, and a tragedy call'd the Life and Death of COMMON SENSE.'[10] A sustained exposure of parliamentary corruption in the first is coupled with an allegorical account of the ignorance of lawyers, doctors and divines in the second; both 'rehearsals', moreover, are constantly being interrupted by actors, dancers and prompters who break down any semblance of theatrical illusion, and offer a secondary form of theatrical self-referentiality that supplements the deliberate artificiality of the rehearsal itself. Similarly, the *Historical Register* offered a multiplicity of parodies and allegories. The title apes the annual volumes of *The Historical Register* which listed the main public events of the year; the play again incorporates the figure of a dramatic author as one of its protagonists – significantly, he is called Medley – and shows a production in rehearsal; Walpole is repeatedly alluded to as an emblem of stupidity and greed; finally, its action, which revolves around an auction and the casting of a Shakespearean history, is set in Corsica, matching the kind of exotic displacement found in 'The Festival of the Golden Rump'. What becomes clear is that both literary and theatrical satire offered complex programmes of writing that fragmented and yoked together a variety of discursive – and, in the case of the playhouse, performative – codes and deliberately left the signs of this practice open. The readers or viewers were asked to explore the fractures of the text and the drama, and to enjoy the narratives generated by the author's playful juxtaposition. The pleasures of satire were as much dependent on appreciating this montage as they were on recognising the political and social targets of a given text or spectacle.

It will be all too obvious that this kind of practice parallels what I have repeatedly suggested was a defining characteristic and mode of appeal of the graphic satire, something that is confirmed and complicated when we look at an engraving that was published in early May 1737, also called *The Festival of the Golden Rump* (fig. 67).[11] It was engraved and probably designed by Gerard Vandergucht. In the print, the satyr substitute for George II is twisted round and we are confronted with the image of his farting arse; to his right, we see Caroline administering the golden clyster-pipe; behind her stands the figure of the Whig ecclesiast Archbishop Gibson. To the King's left stands the full-bellied figure of Walpole, and in the shadows in the foreground, the prime minister's brother Horatio looks on, holding a pair of scales. Cluttering the edges of the engraving, a crowd of courtiers carry pots of gold on their heads or spring back at the shock of seeing and hearing the Pagod. Trophies stand in the centre foreground and a curtain decorated with the idol's emblem hangs over a space that is defined as a mock classical interior with pilasters and shallow niches. Clearly, the print is highly dependent for its narratives on the satirical text published earlier in the year: in this respect alone it was indeed, as it claims, 'designed by the Author of Common Sense.' Yet the engraving is also an independent pictorial commodity, which satirically reworks a variety of pictorial genres and was geared to being enjoyed and deciphered as a

67 Gerard Vandergucht, *The Festival of the Golden Rump*, 1737 (BM 2327). Engraving, $7^{1}/_{4} \times 9^{7}/_{8}$ in. Courtesy of the British Museum.

complement to, and not just as an illustration of, its increasingly notorious literary precedent.

Vandergucht's print maintains many of the preoccupations and motifs that had come to characterise political satire over the previous decade. Here, we can usefully glance at Hogarth's *The Punishment inflicted on Lemuel Gulliver*, published in December 1726 (*fig. 68*). While its narratives clearly correspond to those of Swift's *Gulliver's Travels*, an anti-Walpole allegory issued two months earlier, Hogarth's satire also recycled the scatological rhetoric of the Dutch South Sea Bubble prints. The hero of the fable is shown being pierced and purged by a gigantic clyster-pipe, operated by a swarm of Lilliputians whose activities allegorise the state of contemporary Britain as one of corruption and decay. In the right foreground an overdressed politician is shown supervising proceedings, while in the background a deluded group worship and bring gifts for the statue of Priapus. *The Festival of the Golden Rump*, we can now recognise, maintained the characteristics of such satires. Vandergucht has renewed the focus on the buttocks, rectum and

The Punishment inflicted on Lemuel Gulliver by applying a Lilliputian fire Engine to his Posteriors for his Urinal Profanation of the Royal Pallace at Mildendo which was intended as a Frontispiece to his first Volume but omitted

68 William Hogarth, *The Punishment inflicted on Lemuel Gulliver*, 1726 (BM 1797). Engraving, $7^3/_8 \times 12^1/_8$ in. Courtesy of the British Museum.

clyster-pipe that we find in Hogarth's engraving, and continued a preoccupation with the details of ministerial supervision and idolatrous ritual. A repository of pictorial conventions was clearly available to the satiric engraver, which in both Hogarth and Vandergucht's prints worked in intimate exchange with specific texts in current circulation. Yet, as we can now explore more thoroughly, the appeal of *The Festival of the Golden Rump* was that of a graphic product which denied a subservient relation to the literary propaganda of the day, and which asserted its own ambitions as an independent work of pictorial satire.

Throughout the previous decade, in the daily and weekly newspapers, Vandergucht had regularly advertised his series of engravings after Raphael's *Cartoons*, one of a number of versions that were issued during the first half of the eighteenth century, and which confirmed their status as a canonical model of elevated history painting. If we turn to the fourth of Raphael's pictures, *The Blinding of Elymas (fig. 69)*, we can see how thoroughly *The Festival of the Golden Rump* represents a play with the spatial, gestural, architectural, physiognomic and inscriptional codes of this kind of history painting. In both images a figure of authority is mounted on a central podium inscribed in Latin, and in both, he is situated at the centre of a frieze of shock and response – the bearded courtiers who skulk around the background and edges of the satire correspond in their expressions and poses to the men who cluster around the proconsul in Raphael's painting, particularly the figure who stands at the extreme left of both images, his hands similarly raised in surprise. In addition, *The Festival of the Golden Rump* recycles the

69 Raphael, *The Blinding of Elymas*, 1515–16. Cartoon, 11ft. 2¾in. × 14ft. 7½in. Victoria and Albert Museum, London.

basic structure of the arched niches that we find in the background of the cartoon, and the later image of the prime minister's brother, Horatio Walpole, his out-stretched right arm holding a pair of scales, his left hand clasped behind his back, offers a confirmatory adaption of the pose and position of Paul. Rather than attempting to take this specific comparison any further, it is sufficient to emphasize how *The Festival of the Golden Rump* satirically revised both the iconography of history painting and, perhaps more importantly, its conventional narratives of Christian and civic heroism, religious conversion, classical authority and masculine fortitude. Through the parody of pictorial forms, through the encouragement to read the contemporary engraving against its Renaissance precedent, modern hier-archies of power and government are called into question and exposed as grotesque distortions of antique models. The satirical line-up of king and queen, corrupt minister and servile cleric, together with the unthinking retinue of courtiers, operates as a graphic pastiche that superimposes the freakish bodies and gestures of exotic ritual upon the paradigmatic pictorial spaces and narratives of history.

In this satirical version of high art, it seems certain that Vandergucht was also invoking the iconography and narratives of alien festival that had been detailed in Bernard Picart's great illustrations to the *Ceremonies and Customs of the World* (*fig. 70*), first published in 1724, and incorporated in an English edition in 1730. In Picart's illustration, a group of genuflecting acolytes surrounds the elevated, grotesque figure of a priapic, elephantine god, his legs those of a satyr — as are those of the body standing in the centre of the *Festival of the Golden Rump*. Recognising the compositional, figural and narrative correlations between the two images, and remembering the play with foreignness and exoticism that formed such an important part in the textual version of the Golden Rump satire, we can see how clearly the imagery of monarchy was being mapped onto the most shocking iconography of anthropological art. Here, the etiquette of the contemporary court was being critically aligned with the barbaric customs of foreign lands, and the respectable institutions and offices of Christian government were overlaid with the gross practices of pagan idolatory.

Significantly, Vandergucht swivels the central figure of the Pagod round, which not only allows the narrative of rump worship to be explicitly detailed but also, more surreptitiously, introduces an obscene invocation of the king's shielded genitals into the engraving's narratives. To understand the implications of this

70 Bernard Picart, *La Divinité qui selon les Chingulais*, 1724, from *Ceremonies et Coutumes Religieuses des Peuples Idolatres*, 1728. Engraving, $5\frac{3}{4} \times 8$ in. Courtesy of the British Library.

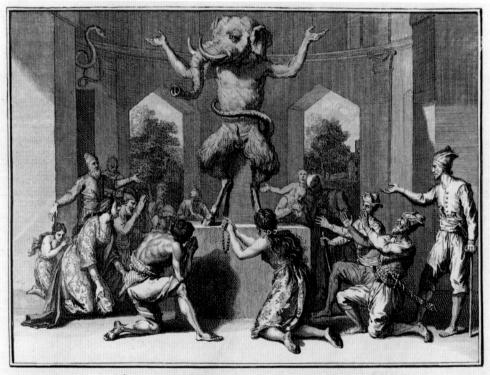

La DIVINITÉ qui selon les CHINGULAIS, donne la Sagesse, la Santé & les biens &c.

71 Hendrik Goltzius, *Farnese Hercules*, 1617. Engraving, 16 × 11½ in. Courtesy of the British Museum.

satirical strategy, it may be helpful to glance at a canonical codification of the rear view of a masculine figure, Hendrik Goltzius's Renaissance engraving of the statue of the *Farnese Hercules* (fig. 71). In Goltzius's print, a dramatic paean to heroic strength, mythological power and sculptural skill is importantly mediated by the inclusion of the two male viewers in the image, and by our perspective from behind the depicted statue. These factors simultaneously open up and foreclose a reading of the image informed by the physical desirability of the nude depicted within it: the space of homoerotics is overlaid by the narratives of connoisseurship, and both we and the spectators in the image have to be constructed as participating in an aesthetic of male beauty if our doubled gaze at the front and back of the body is not to be misconstrued as an eroticised one. While Goltzius's image was clearly understood to control this potential slippage of interpretation, and to define the male nude as an inert, decorporealised site of art historical appreciation, the satirical exchange with such figures was far more irreverent. Returning to the *Festival of the Golden Rump*, we can appreciate how thoroughly it subverted the canonical iconography of the statuesque masculine nude. Vandergucht has carefully deline-ated the muscular furrows of the pagod/king's back and arms, giving them a mock-heroic status that deliberately suggests the idealising conventions of antique sculpture. Instead, however, we are confronted with a gross, living, spurting statue, the buttocks of which become the grotesque focus of our gaze. Rather than the

virtuous figure of Hercules, we are offered the promiscuous, sexually excessive and corporealised figure of a satyr. Here, his traditional role on the edge of an image is exchanged for one at the pictorial centre: rather than functioning as a lascivious supplement to the frame, he operates as a satirical focus. And if our reading of this body is dominated by the scatalogical rhetoric of the illuminated arse, a majority of the print's protagonists, including Walpole himself, are shown staring in startling proximity at the king/satyr's exposed and, in this case, clearly shocking *other* side. The doubled, connoisseurial gaze at the elevated male nude, from both inside and outside the image, becomes redefined as an obscene network of looking that is confronted with the low bodily sites of flatulence and lust.

This play with spectatorship and corporeality, which must have informed the contemporary debate on the obscenity of the theatrical 'Golden Rump', supplemented the other forms of pictorial revision and reference we have traced. Given this multiplicity of available readings, it is clear that Vandergucht's print offered an equivalently complex programme of interpretation and inference to the literary and theatrical satires of the period, similarly mixing the 'allegorical and historical'. *The Festival of the Golden Rump*, moreover, demonstrates how the sponsors and producers of contemporary political satires were seeking to promote the format as an ambitious category of contemporary graphic art, one that could compete not only with other kinds of satire in the print market, but also with those non-satirical goods – ranging, in this case, from history engraving to anthropological illustration – that it internally responded to and adapted. That this claim to cultural status was a serious one is again confirmed by the care and attention devoted to the detail and finish of the plate. Vandergucht's work conforms to the suggestion made by an earlier author that satire 'requires a certain delicacy and masterly address to wrap up foul meanings in clean linen.'[12] Thanks to its crisp draughtsmanship, its cleansing passages of light and its delicate web of engraved lines, *The Festival of the Golden Rump* is able to translate these injunctions into pictorial terms; significantly, in the engraving there are none of the faecal traces described in the text as having been spattered on people's bodies by the Pagod's anal explosions. Vandergucht, whose involvement in the image is repressed both by the collaborative nature of his venture with 'the Author of Common Sense', and by the veil of anonymity needed to avoid any threat of ministerial prosecution, is thus able to reassert his 'masterly address' through a subtle display of technical refinement and formal decorum, which complements his display of artistic invention and reference.

II

Images like *The Festival of the Golden Rump* were commercially displayed in the company of other prints, frequently in spaces that either adjoined or overlapped the public realms of political debate. A striking confirmation of this customary conjunction of aesthetic and political experience is provided by an engraving of Westminster Hall, first published in 1738 and entitled *The First Day of Term* (*fig. 72*). The Hall, situated next to Parliament and a network of taverns and coffee

WESTMINSTER HALL. | THE FIRST DAY OF TERM. | A SATIRICAL POEM.

When Fools fall out, for ev'ry Flaw | Thro 'Pleas Demurrers the Dev'l &all | One of ý Gown, discreet and wise, | A Serjeant limping on behind —
They run horn mad to go to Law, | At length they bring it to the Hall, | By Proper means his Witness tries; | Shews Justice Lame, as well as Blind;
A Hedge awry, a wrong plac'd Gate, | The Dreadfull Hall by Rufus rais'd, | From Wreathocks Gang not Right or Laws | To gain new Clients some dispute,
Will serve to spend a whole Estate; | For lofty Gothick Arches prais'd; | H'asures his trembling Clients Cause; | Other protract an Antient Suit,
Your Case the Lawyer says is good, | The First of TERM, the fatal day — | This trains his Handkerchief whilst that | Jargon and Noise alone prevail —
And Justice cannot be withstood; | First from ý Courts th'. clam'rous bawl | Gives the kind ogling Nymph his Hat; | While Sense and Reasons sure to fail;
By tedious Process from above, | The Criers their Attorneys call: | Here one in Love with Choiristers | At Babel thus Law Terms began,
from Office they to Office move; | | Minds Singing more than Law Affairs. | And now at Westm — er go on.

72 Charles Mosley after Hubert-François Gravelot, *The First Day of Term*, 1738. Engraving, $10\frac{3}{8} \times 12\frac{1}{2}$ in. Courtesy of the British Museum.

houses, contained the law courts and was thus the prime meeting-place for lawyers and politicians, and a hotbed of political news. It was also, as a close examination of the engraving reveals, an important nexus of print culture in the capital, lined with print shops, book shops and pamphlet stalls. In such places, images like the *Festival of the Golden Rump* became part of a crowded, shifting and spectacular visual display, which defined the satire not only as a specific commodity for sale, but also as part of an interdependent network of exhibition and consumption encompassing

a variety of goods. This wider sphere of cultural and commercial activity was undergoing important changes in the period. Thanks to the subscription of a growing number of affluent Londoners to a polite agenda of identity and consumption, new kinds of cultural commodity and new ways of packaging and promoting traditional products were being introduced into the urban market. Most importantly for us, the changing demands of the metropolitan clientele for pictorial goods encouraged new ways of defining the graphic image as a commercial product. To understand certain aspects of this process a little better – and, more specifically, to explore its impact on the identity and appeal of the political satire – we can profitably turn to the English career and work of the French artist who designed *The First Day of Term*.

Hubert-François Gravelot came to London in 1732 to assist Claude du Bosc in engraving the English version of Picart's *Ceremonies et Coutumes* and left fourteen years later, having in Vertue's words 'obtained a reputation of a most ingenious draughtsman during the time he has been at London.'[13] Gravelot's technical proficiency, the undulating linear quality of his designs, the delicacy with which he depicted both male and female protagonists, and his brilliance at redeploying the modern rhetoric of French drawing for a range of graphic projects, had quickly assured him an artistic celebrity in the capital. His success – he reputedly took savings of more than £10,000 back to France[14] – can best be attributed to the process by which the version of Continental art in which he specialised became transformed into a commercial aesthetic: the codes of the French rococo came to serve as commodified markers of gentility on the urban market for cultural goods.

For decades, as noted in Chapter Two, the local consumption of contemporary French imagery had served as a reliable signifier of social refinement. In the 1730s, this elision of claims to social status with the vocabulary of Continental design expanded beyond the boundaries of fine art and was exploited by the promoters of entrepreneurial ventures that ranged from book publishing, fan making and ceramics to furniture design and commercial advertising. The rococo became defined as a purchasable key of refinement for the affluent shopper, who could consume a wide range of products operating in stylistic unison, which were collectively characterised by a standardised form of aesthetic packaging. The shop that sold luxury goods became increasingly redefined as a window onto the possibilities of private gentility, its products promoted as polite accessories for the urbane consumer, and ubiquitously framed by the highly reproducible and flexible rhetoric of recoco design. While this formal fluidity correlated perfectly with the newer, more mobile structures of capital and credit in the city, it also helped to legitimise visually a modern ethos of entrepreneurialism, consumption and identity.

This synthesis of roles becomes clearer if we look at Gravelot's design for a snuff shop trade card (*fig. 73*), which indicates the artist's versatility and suggests the need to place his graphic works in a wider framework of cultural production. The snuff shop was part of a burgeoning network of business practices catering to the luxury goods market in the capital; Gravelot's image integrates the depiction of John Lhuillier's premises and the details of sale within a decorative and narrative structure that idealises the mechanics of commercial exchange in the city. The prelimi-

73 Hubert-François
Gravelot, trade card for
John Lhuillier, c. 1740.
Engraving. Victoria and
Albert Museum.

naries of purchase are recorded as a polite and studiously informal activity, in which
the gentleman consumer and the neat shopkeeper are depicted in easy proximity.
The shop itself is defined as a space of trade and comfort: the barrels on one side
are balanced by the elegant stool on the right. More dramatically, an elevated
emblematics of business is fused into the elaborate, swirling, shell-like cartouche
that frames commercial information with a pictorial vocabulary of decorative
intricacy and commercial progress. The leaves of tobacco plants merge into the
undulating curves of the frame's edges and, above, the labelled urns signifying the
successful transformation of the natural plant into an imported commodity stand
round a pelican feeding her young, a detail invoking not only the shop's sign, but
the mythically munificent role of the shopkeeper in the urban economy. Commis-
sioning Gravelot to design his trade card clearly enabled Lhuiller to link his business
to a visual codification of politeness being generated in metropolitan culture;
conversely, the trade card indicates the extent to which the rococo was colonised
as a signifier of commercial decorum, a pictorial etiquette that naturalised, softened

and even historicised – at the rear of the image we can glimpse the pediment of a classical column – the dynamics of urban business.

Alongside the modest business of trade card production, Gravelot was busily contributing to a range of other entrepreneurial projects from the mid-1730s onwards. In particular, he was heavily involved in book illustration, producing frontispieces, headpieces and tailpieces for published translations of Homer and Virgil and designing illustrations for a collected edition of Dryden. Gravelot also illustrated more topical texts, including a satirical poem called 'The Toast' in 1736 and, two years later, a new edition of John Gay's poetic *Fables* published by John and Paul Knapton. The publication of the *Fables* followed the release of a collection eleven years earlier, and the advertisement to the second volume declares that 'we hope they will please equally with his former Fables, though mostly on subjects of a graver and more political turn.'[15] Indeed, the new series offered an ambitious programme of political satire that targeted the corruption and arrogance of Walpole's administration. More significantly, through their format, the *Fables* domesticated and rendered polite the discourses of oppositional critique: the publication was designed to be purchased and read in the respectable household, by men and women. To this end, the poems' structure maintained and modernised the venerable literary blueprint of moral homily established by Aesop, and replenished a didactic mode praised effusively by the *Spectator* earlier in the century: 'amongst all the different ways of giving Counsel, I think the finest and that which pleases the most universally, is FABLE, in whatever shape it appears. This way of instruction excels all others; because it is the least shocking, and the least subject to Exception.'[16] Gay's poems thus offered yet another channel of anti-ministerial critique, one that penetrated into the most private realms of polite culture. Meanwhile, Gravelot's illustrations provided a complementary fusion of the narratives of anti-ministerial polemic with a newly fashionable formula of graphic art.

The sixth fable of the series, entitled 'The Squire and his Cur', accompanied by a detailed image designed by the Frenchman and engraved by his compatriot, Gerard Scotin (*fig. 74*), told the story of an honest country squire and his violent and untrustworthy dog. The fable is prefaced by an extended warning against the duplicity of ministers: 'the politician tops his part,/ Who readily can lye with art . . . By that the int'rest of the throne/ Is made subservient to his own . . . Thus wicked ministers oppress,/ When oft the monarch means redress.' The tale that follows allegorises this threat in contemporary terms, with the squire and his cur as thinly veiled substitutes for the king and Walpole, and the country tenantry with whom they engage clearly symbolising the British people. The dog, causing havoc across the estate and described seducing a 'fav'rite bitch', is ultimately punished thanks to the tenants' complaints to their good-hearted landlord: 'The Squire heard truth. Now Yap rush'd in;/ The wide hall echoes with his din:/ Yet truth prevail'd; and, with disgrace,/ The dog was cudgell'd out of place.'[17]

Gravelot's design shows the squire in conversation with the representatives of the aggrieved tenants outside his country house; the cur snarls at his feet. The image rewrites this hierarchical relationship as a conversation between polite equals: the sartorial, gestural and physiognomic equivalence of the two men articulates an ideal of social co-existence beween the aristocrat and the urbane commoner. Similarly,

74 Hubert-François Gravelot, illustration from John Gay's *Fables*, 1738. Engraving, $6\frac{1}{16} \times 4$ in. Courtesy of the British Library.

the presence of a loaded marker of landed dominance, the walled-in country house, is pacified by the softening presence of the tree and the symbolic openness of the squire's window. The image's role as a vehicle of political satire is thus overlaid with its subtle negotiation of the narratives of social difference. More pertinently, it is clear that such an image represented a form of political critique that had become thoroughly reconciled with the new narratives, iconography and pictorial syntax of politeness being articulated in contemporary London. As in the trade card, social (and political) exchange is depicted as a genteel engagement between

75 Hubert-François Gravelot, *The European Race*, 1739 (BM 2333). Engraving, $8\frac{1}{2}$ × $15\frac{5}{8}$ in. Courtesy of the British Museum.

76 Hubert-François Gravelot, *Fee Fau Fum*, 1739 (BM 2434). Engraving, $5\frac{1}{4}$ × $9\frac{1}{8}$ in. Courtesy of the British Museum.

77 Hubert-François Gravelot, *The Itinerant Handy-Craftsman, or Caleb turn'd Tinker*, 1740 (BM 2448). Engraving, 11½ × 7¼ in. Courtesy of the British Museum.

reasonable individuals, and overlaid with a recognisable combination of decorative and symbolic codes signifying refinement. In such illustrations, political dissent is made pictorially polite.

Supplementing such enterprises, Gravelot participated in the production of individual graphic satires. His design for a satire of 1739 entitled *The European Race* (*fig. 75*) depicts a landscape crowded with the venerable components of fable – pigs, elephants, lions and bears – who intermingle with figures of allegory and the conventional butts of political satire: the image is inscribed to Walpole, ironically described as 'the Greatest Politician in Europe'. In the same year, Gravelot designed *Fee Fau Fum* (*fig. 76*), which humorously depicts the minuscule figure of Walpole encountering successively the gigantic personifications of the Sinking Fund, the French minister Cardinal Fleury, an amalgamated France and Spain and, lastly, France, Spain and Sweden. In this image, the narratives of political polemic are again situated in decorous settings and suffused with the signs of refined drawing: Walpole's comic escapades take place in front of a theatrical backdrop of carefully delineated ruins, castles and temples, placed in arcadian landscapes.

The appeal of this modern formulation of political satire for an urbane audience of consumers clearly encouraged the attempt by Whig sympathisers to respond with an equivalent pictorial format, and to appropriate Gravelot's skills for pro-ministerial purposes. On 14 June 1740, *The Itinerant Handy-Craftsman, or Caleb turn'd Tinker (fig. 77)* was published, engraved after a design by the Frenchman. The print depicts the fictionalised editor of the *Craftsman*, Caleb d'Anvers, as an itinerant and ineffectual 'mender' of Constitutions, being laughed at by a disbelieving Irishman as he stands tinkering with a huge urn representing the British constitution, punctured rather than plugged with opposition calls for place bills, periodical parliament bills and bribery bills. What is important to note here is that the appeal and impact of the satire would have been as much dependent on its conformity to codes of pictorial elegance as on the popularity of its polemic attack. Although the print's narratives are specifically linked to a series of articles that had run in the pro-ministerial *Daily Gazetteer*, its desirability as a consumable commodity was anchored in its obvious artistic provenance, and on the way the image rehearsed a polite iconography of political conversation, ruralised grandeur and pictorial framing. Despite being the target of satiric ridicule, d'Anvers is depicted as an elegant, laundered and poised version of the rural troubadour, while the laughing, sympathetic figure of his interlocutor is given almost precisely the same clothes and pose as the gentleman buying snuff at John Lhuillier's shop. Like the illustration to Gay's fable, the men's representation offers a harmonious form of pictorial balance that, however comically, reproduces the genteel etiquette of conversation depicted earlier; a couple of scroll-like speech-bubbles gracefully echo the twists of the frame. The two men, moreover, stand in a depopulated rural arcadia, bounded by the rhythmic succession of houses, windows and trees that we found in Gravelot's earlier illustrations and satires. This is a space entirely evacuated of the bodies, conflicts and disruptions that characterised the public sites of political debate in the city. Bounding this environment, the pictorial frame re-articulates the fertile forms of the landscape as an abstracted, intertwining group of curving lines that incorporates the print's title as a decorative supplement. Here, the fierce, embattled and paranoid rhetoric of political dissent is almost entirely subordinated to the decorous calligraphy of a specific pictorial formula, in a print that was clearly suitable, as so many of the advertisements to Gravelot's prints make clear, to be framed and hung up in the affluent interior, and left to co-ordinate with the other luxury products of the polite household.

This reformulation of satire not only testifies to the successful integration of the genre in polite circuits of print consumption, but was one that clearly mounted a challenge to the traditional identity of the satirical engraving in urban culture. Rather than operating at a critical distance from the dominant modes of graphic promotion in the capital, Gravelot's satires asserted their compatibility with them. Rather than flaunting a formal agenda of ironic assemblage and generic subversion, his prints homogenised the details of satirical attack according to a versatile formula of representation operating across a range of pictorial environments. And, finally, rather than exposing the obscene, vulgar or grotesque narratives of political hypocrisy, images like *The Itinerant Handy-Craftsman* performed their own pictorial censorship that screened such details out. Indeed, the success of these images

offered a new version of the graphic satire that rendered it almost wholly complicit with the polite dynamics of pictorial production and consumption being marketed in the city. Recognising these developments, we need to ask how other satirists responded to the forms of political satire that Gravelot's work had come to exemplify, and to explore the ways in which his example was both duplicated and contested in contemporary London.

III

The two George Bickhams, father and son, have flitted in and out of this narrative, and we have found their output a striking resource with which to analyse the continuities and changes that occured in graphic satire, and in print culture more generally, throughout the first half of the eighteenth century. By the late 1730s the younger Bickham had become as well known and as commercially visible as his father, producing goods that ranged from detailed reproductions of Poussin's paintings to printed fans; his shop in the Strand became an environment in which consumers could browse through scores of different graphic products bearing his signature. In an advertisement of 1738, he claims to engrave 'all sorts of curious works, viz history pieces, heads, landskips, architecture, maps, tickets, coats of arms, cyphers and shopkeepers bills, with their proper decorations . . . as also all sorts of writing.'[18] As we saw earlier, Bickham was also involved in the production of didactic publications designed to improve both the writing and drawing skills of the aspirational consumer. In 1732, he engraved a series of designs after Picart for *A New Drawing Book of Modes*, and later released *The Young Clerk's Assistant, or Penmanship made Easy, Instructive and Entertaining*.[19] These vehicles of technical and moral improvement were accompanied in his output by more clandestine and problematic material. Bickham was a commercial pornographer, and a government search of his premises in the early 1740s unearthed 'About 150 Obscene books with all Sorts of Obscene Postures', as well as the rolling press that facilitated his studio's prolific output.[20] Finally, and more significantly for our present purposes, during the late 1730s Bickham became involved in publishing political satires, which increasingly became his commercial speciality. He was not only an ambitious and skilful engraver but also, like his father, a staunch opponent of the Whigs and someone who espoused his radical Tory views in a series of pamphlets. The extremism of his political opinions – he published a text that compared Walpole to the traitorous, executed adviser to Edward II, Pierce Gaveston, and, as noted in the Introduction, another entitled *An Enquiry into the Merits of Assassination*[21] – earned him the attention of ministerial agents, who repeatedly raided his shop for treasonous, as well as obscene, graphic material. Having spent some time discussing his *The late P-m-r Minister* at the beginning of this book, we can now ask how indicative it was of the political satire he produced in this period.

In March 1740 Bickham published *The Stature of a Great Man, or the English Colossus (fig. 78)*. The print depicts Walpole as a gigantic statue, bestriding Britain like the ancient Colossus of Rhodes and situated in a landscape crowded with the signs of overseas defeat, commercial collapse and maritime breakdown. His pocket

78 George Bickham junior, *The Stature of a Great Man, or the English Colossus*, 1740 (BM 2458). Courtesy of the British Museum.

THE Monuments that mightie Monarches reare,
 COLOSSO'S ſtatiies, and Pyramids high,
In traƈt of time, doe moulder downe and weare,
Ne leaue they any little memorie,
 The Paſſenger may warned be to ſay,
 They had their being here, another day.

Scindétur veſtes, But wiſe wordes taught, in numbers ſweete to runne,
geminæ frangen- Preſerued by the liuing Muſe for aie,
tur et aurum, Shall ſtill abide, when date of theſe is done,
Carmina quem Nor ever ſhall by Time be worne away:
tribuent fama
perennis erit: Time, Tyrants, Envie, World aſſay thy worſt,
Ovid: Amor: E- Ere HOMER die, thou ſhalt be " fired firſt.
leg: 10.

" Exitio terras
cum dabit vna
dies. Ovid: Ergo cum ſilices, cum dens patiatur aratri
 Depereant ævo, carmina morte carent.
Ovid: Eleg: vltim: Cedant carminibus Reges, Regumque Triumphi,
 Cedat et auriferi ripa beata Tagi.

79 Gerard Bockman, after Thomas Gibson, *Sir Robert Walpole*, c. 1740. Mezzotint, $13\frac{1}{8} \times 10\frac{1}{4}$ in. Courtesy of the British Museum.

80 Illustration from Henry Peacham's *Minerva Brittana*, 1612. Woodcut, $3\frac{1}{4} \times 4$ in. Courtesy of the British Library.

is full of cash from the Sinking Fund, a National Debt provision that he is accused of plundering; the medallion of St George hanging from the Garter is turned into the image of a fox; and a piece of paper introduced into his left hand is loaded with a parodied defence of the prime minister's failed foreign policy. Outside the boundaries of the frame, a quotation from Shakespeare's *Julius Caesar* associates Walpole's authoritarian rule with a dictatorial Roman predecessor, while at the print's base Bickham has included a quasi-antiquarian description of the ancient statue, with an account of its construction and eventual fall: 'it stood 50 years, & at last was thrown down in an Earth-quake.'

Alongside this extensive programme of textual inscription, Bickham's image again effects a radical form of pictorial revision and play that meshes together the components of a variety of representational categories. The print clearly adapts its portrayal of the prime minister from the mezzotints made after Thomas Gibson's painting of the politician (*fig. 79*), which gave Walpole a cohesive iconography of power, focused on the star on his chest and on the Garter riband clinging to his portly torso. Bickham's print not only satirically dislocates a canonical image

of Walpole from its original context but also links it to a revitalised formula of emblematic commentary: if we look at a page from a celebrated seventeenth-century emblem book, Henry Peacham's *Minerva Brittana* (*fig. 80*), we can see how Bickham has maintained and modernised a venerable graphic tradition tying the figure of the Colossus to a narrative of hubristic vanity and inevitable decline. Peacham's woodcut, showing the gigantic statue dominating the entrance to Rhodes, a boat similarly passing between its outstretched legs, is suffixed with a declaration that 'The Monuments that mightie Monarchs reare,/ *COLOSSO'S* statues, and Pyramids high,/ In tract of time, doe moulder downe and weare,/ Ne leaue they any little memorie'.[22] In fusing together, and complicating, these pictorial genres, Bickham's etching maintains the hybrid form of pictorial organisation we have been exploring in this book. At the same time, *The Stature of a Great Man* is crowded with a series of details drawn from one of the prints by Gravelot we have just been looking at, *The European Race* of 1739 (*see fig. 75*). If we compare the background of Bickham's satire to Gravelot's image, we quickly see that the sleeping dog, the column of petitioning merchants, the ships, cliffs, two castles and flags are all lifted from the earlier engraving.

This final set of appropriations invites us to think more about the relationship between Bickham and Gravelot's work. Bickham's contacts with the French artist were more than merely pictorial. Between 1737 and 1739 the two men had worked together on Bickham's most ambitious commercial venture, *The Musical Entertainer*, which offered metropolitan subscribers a collection of 100 intricately engraved song-sheets, published in instalments, which were heavily promoted in the capital's print market on the basis of their elaborate headpieces: 'the whole to be curiously engraved on copper plates, and embellished not only with all variety of penmanship, and command of hand: but with headpieces, in picture-work, and other decorations, as landskips adorned with figures expressive of each subject.'[23] The headpiece images were adapted from a wide range of mainly French pictorial sources, among them the works of Boucher; supplementing this programme of graphic raiding, Bickham also commissioned Gravelot to design a series of images for the collection, including a view of Vauxhall Gardens which precariously mediated the environment's ambivalent contemporary reputation as a site of genteel pleasure (*fig. 81*).[24] *The Musical Entertainer*, it is clear, marked an explicit attempt on Bickham's part to exploit the fashionable rococo as a pictorial vocabulary and as an appropriate accompaniment to the modern, commodified activities and spaces of leisure in the city. We have seen, however, that the subsequent extension of this pictorial rhetoric to the sites of political satire – particularly in the work of Gravelot – entailed a significant alteration in the appeal and identity of the satirical engraving. How did Bickham, who clearly identified his commercial production with both the traditional codes of satire and the modern formulations of the rococo, respond to and negotiate this shifting codification of the political print?

A remarkable satire was issued by Bickham in July 1740, only weeks after the release of Gravelot's *Itinerant Handy-Craftsman*, and entitled *The Cardinal in the Dumps, With the Head of the Colosus* (*fig. 83*). The print depicts the French minister Cardinal Fleury staring gloomily at a portrait of Admiral Vernon, who had risen to the status of a national hero after his naval victory at Portobello in 1739; in

81 Detail from George Bickham junior, after Hubert-François Gravelot, headpiece for 'The Adieu to the Spring-Gardens', 1737, included in *The Musical Entertainer*, 1738 (BM 2465). Engraving, $6\frac{7}{8} \times 12\frac{5}{8}$ in. Photograph: The Witt Library.

subsequent months, the admiral was adopted by the opposition as a political icon, whose heroism and independence was repeatedly contrasted with the prime minister's supposed pusillanimity. In the background, Walpole's decapitated head is perched on a pole, and through a hole in the graffitied wall we catch a glimpse of the British fleet, and a national flag flapping over a country house. The engraving clearly responded and contributed to the heroisation of the admiral that was taking place in contemporary London: as a poem published in March 1740 declared, it was Vernon who 'FIRST hath rous'd' Britain 'from her passive Sleep,/ And bid her Thunder vindicate the Deep.'[25] Moreover, the contrast Bickham's image draws between the patriotic nobility of the naval commander and Walpole's tyrannical corruption was one reproduced across the opposition press, leading the *London Evening Post* to suggest that 'a certain great Man should interpret all the Applauses heap'd upon Admiral Vernon as so many Satires upon himself.'[26]

Alongside these explicit exchanges with anti-ministerial polemic, however, Bickham's satire operates as an ambitious, combative and multi-faceted pictorial

82 George Bickham
junior, frontispiece to
*The Life and Death of
Pierce Gaveston*, 1740
(BM 2462). Engraving,
$5\frac{1}{2} \times 4\frac{1}{2}$in. Courtesy of
the British Museum.

intervention in the increasingly crowded networks of the politicised image. Even
more extensively than *The Stature of a Great Man*, it both reproduces and ironicises
the vocabulary of the polite political satire found in Gravelot's work, appropriating
certain crucial elements of the French artist's designs, and re-inscribing them within
a new, far less decorous pictorial schema. We can immediately recognise the
representation of Fleury as taken from Gravelot's design for *Fee Fau Fum* (*see
fig. 76*); similarly, the house in the background reproduces the one standing on the
left of the *Itinerant Handy Craftsman* (*see fig. 77*); more generally, the depiction of a

83 George Bickham junior, *The Cardinal in the Dumps, With the Head of the Colosus*, 1740 (BM 2454). Engraving, $12\frac{1}{2} \times 7\frac{7}{8}$ in. Courtesy of the British Museum.

walled garden, the tree trunk (which is recycled from the third plate of *Fee Fau Fum*) and the elaborately decorated cartouche all invoke the details of the depopulated rural arcadia, and its abstracted framing counterpart, that we found in Gravelot's designs for fables and satires. Here, however, they are broken up, juxtaposed with a series of other graphic codes and pictorially vandalised. In an especially intriguing form of satiric overwriting, Bickham's print includes a dense rhetoric of graffiti, scrawled across the enclosing wall. A crude, vulgar and plebeian iconography of dissent, of hastily drawn gallows, harried travellers and screaming heads, is aggressively superimposed on the genteel surfaces of the garden.

Even more dramatically, the ruptured head of Walpole, jammed onto a spike, introduces a gross symbol of political betrayal into the image. In this period, it is worth remembering, the decapitated heads of traitors were still placed on public display in the city, and in oppositional imagery and discourse Walpole was constantly being compared to executed ministers of the past: as we have already noted, Bickham himself released a pamphlet, issued later in the year with a telling frontispiece (*fig. 82*), making this comparison and the symbolism of execution explicit.[27] The depiction of the prime minister in *The Cardinal in the Dumps* not only stimulated such associations but also made them articulate at the level of pictorial juxtaposition. For it is clear that *The Cardinal in the Dumps* was designed as a satirical pendant to Bickham's *The Stature of a Great Man* (*see fig. 78*) issued four months earlier. This is apparent not only from the later satire's format and subtitle, but its equivalent use of a quote from Shakespeare's *Julius Caesar*, decrying the dominance of a single figure over the political realm. Once we look at the two prints together, and recognise the continuity between one and the other, the representation of Walpole's head in the second image becomes even more shocking: it is a death mask pulled directly from the elaborate portrait of Walpole in the first satire, disrobed of all the sartorial paraphernalia of power. The head's grotesque, smiling nakedness has been ripped off the luxuriously clothed body of Bickham's previous print. Meanwhile, the ironic invocation of statuary that characterises *The Stature of a Great Man* is again made in its pendant: the inscription at the top of the image compares Walpole's head not to the colossus at Rhodes but to a barber's block, the wooden bust used to display wigs in the shops of the city. As such, the extravagantly bewigged scalp of the earlier image is re-articulated as an inert, denuded and abandoned accessory of urban fashion.

Tracing these self-reflexive patterns of reference and play confirms the extent to which Bickham maintained a traditional satirical agenda of pictorial production, even as he ostensibly sought to imitate the kind of appeal being made by prints designed by Gravelot. *The Cardinal in the Dumps* is framed as a commodity by the fashionable signs of the rococo, but proceeds to reorganise and supplement those signs in accordance with a graphic agenda aligning pictorial insubordination with political dissent. The print demands interpreting as an image that both mimicked the strategies of the *Itinerant Handy-Craftsman* and *Fee Fau Fum* and parodied them. In particular, the print is characterised by forms of satiric dissonance that confute the graphic homogeneity which marked the polite political satire. We can note four clashing categories of portraiture, for instance, including the striking juxtaposition of the Romanised profile of Vernon – his depiction offering an ideal

return to Rome's 'Breed of Noble Bloods!' mentioned in the caption – with the caricatured, screaming face on the wall. Such details reassert an older pattern of graphic satire. As in many of the engravings we have looked at in earlier chapters – Hogarth's *Mystery of Masonry* offers a particularly suggestive precedent – in Bickham's hands the satirical print continued to assert its dialectical relationship to the fashionable modes of graphic art being disseminated in the capital, gesturing to their vocabulary and associations as signs of aesthetic legitimacy, but concurrently subjecting them to an extended process of graphic deconstruction. In such prints, graphic satire maintained its role as a pictorial genre self-consciously operating both inside and outside the polite conventions of the wider market for engraved commodities, even as it became an increasingly popular commercial product in its own right.

<div align="center">IV</div>

In the decade after the appearance of *The Cardinal in the Dumps*, Bickham came to dominate the market for political satires in the capital. In 1747, he was able to advertise 'One hundred Large Half Sheet, POLITICAL PRINTS, the largest variety in London; Bound or Single, Plain or Coloured, and at the lowest prices.'[28] This near-monopoly of production, and the formulaic nature of a number of the political satires being released under Bickham's auspices, did not mean, however, that his studio stopped producing a diversity of products. The market clearly continued to support a broad range of satirical images, which were designed to be appreciated by a variety of consumers: an advertisement for a print released in 1742 by another print entrepreneur declared that it was 'calculated to hit every body's [taste]; it will please all true patriots and true Britons, and make those laugh that are neither. For the men of no party it will serve as an adornment in their homes; and it will highly divert the ladies at their spinets, their Toylets or Tea-Tables.'[29] Bickham's success was dependent on his skill at producing a mixture of images that, while clearly anti-Whig in their politics, were able to be appreciated by a similarly diverse audience, and his output in these years included more of the ambitious graphic hybrids that we have analysed in this chapter, as well as examples of a new kind of satirical print, the personalised caricature. To end, I would like to juxtapose these two categories, looking at a couple of prints issued by Bickham during the 1740s: the first represents a striking return to satirical practices covered earlier in this book and the second articulates a complex response to the fashionable Italianate caricature as a vehicle of pictorial wit.

Bickham's persistent engagement with traditional conceptualisations of graphic satire is confirmed if we look at *The Champion; or, Evening Advertiser* (*fig. 84*), released only a few months after *The Cardinal in the Dumps*. This medley print reproduces the conventions of an earlier pictorial category; specifically, it resurrects a format that had largely passed out of use, thanks to the impact of Dutch satire in the early 1720s and the commercial success of Hogarth's various ventures in the 1730s. Indeed, since its heyday in the early decades of the century, the medley had survived mainly in the form of frontispiece illustrations to print publisher's

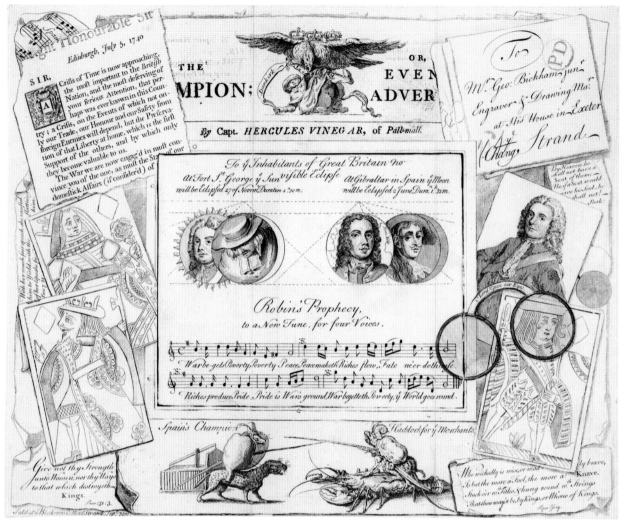

84 George Bickham junior, *The Champion, or Evening Advertiser*, 1740 (BM 2452). Engraving, $11\frac{3}{8} \times 14$ in. Courtesy of the British Museum.

catalogues (*fig. 85*). Bickham's print offered a self-conscious display of return to a venerable pictorial genre and a familial tradition of satiric production. George Bickham senior, we remember, had specialised in the satirical adaptation of the medley and his son's exploitation of the form maintains many of the features – particularly the play with portraiture – that had defined the genre in earlier years. In the younger Bickham's medley, a crowded array of signs, ranging from playing cards to mock-astronomical diagrams, constitute a multi-faceted attack on Walpole's rule. He is shown being eclipsed by Cardinal Fleury, his representation an ironic counterpoint to the accompanying image of Vernon eclipsing a Spanish admiral; a song-sheet carries a satirical tune entitled 'Robin's Prophecy'; at its sides, the playing cards and their accompanying verses allude, on the left, to George II's reputed affair with Sophia Walmoden, and on the right, to Walpole's rivalry with the Duke of Argyll: the prime minister is depicted as a knave of diamonds,

86 Illustration from John Ogilby's *Aesop's Fables*, 1668.

85 (*left*) Frontispiece to John Bowles's Print Catalogue, 1731. Engraving. Courtesy of the British Museum.

juxtaposed with the Duke's portrait. At the top of the print, the opposition newspaper's normal masthead of Hercules slaying Hydra is transformed into an image of the defecating Fleury being attacked by an eagle. A fragment of a news report emanating from Edinburgh, Argyll's stronghold, is balanced by the displaced authorial signature in the form of a postmarked address. At the base of the engraving, the depiction of a fighting mouse and frog, appropriated from a seventeenth-century edition of Aesop's *Fables* (*fig. 86*), offers a canonical, if grotesque, metaphor for political faction.

Like *The Cardinal in the Dumps*, Bickham's medley reasserts the satirical image's status as a complex montage of signs that requires the viewer to uncover their various interrelationships and to appreciate the play between different representational and discursive categories. The pair of spectacles that lie over the simulacrum of assembled papers, one lens falling precisely round the knave's head and formally

echoing the circular images running across the centre of the engraving, allegorise the close reading that such satires demanded. In *The Champion*, a relay of portrait types is meshed with the most scandalous and insistent discourses of journalistic, poetic and musical opposition, fused with the parodied forms of the popular astronomical chart and tied to a flamboyant display of technical skill and versatility that offered a brilliant array of imitations cut across a single copper plate. Here, we can again suggest that *The Champion* revitalised an older index of artistic virtuosity as an alternative to the 'French' modes of design and engraving being disseminated across the capital, and offered a different pictorial and spectatorial programme from the polite political satires being produced by artists like Gravelot. In this case, the image is not intended to be seamlessly aligned with the other products of graphic culture, but is situated as an ironic repository of contemporary graphic art, in which the satirical overlaps between different graphic commodities are dramatised rather than glossed over.

Five years later, in the immediate aftermath of Walpole's death in 1745, Bickham released a satirical etching that seems to make a very different appeal. *A Courier just Setting out* (*fig. 87*) shows Walpole at the beginning of a journey to hell, being seen off by a clutch of politicians, both in and out of office. The image is ironically marketed as a reproduction of a drawing 'Sketch'd from ye life while his boots were greasing' and, as we can now explore, defines itself as a politicised equivalent to the caricature prints that were currently enjoying popularity in London, and

87 George Bickham junior, *A Courier just Setting out*, 1745 (BM 2629). Etching, $5\frac{3}{4} \times 11$ in. Courtesy of the British Museum.

A travelling Governour.

88 Arthur Pond, after Pier Leone Ghezzi, 'Dr James Hay as Bear-Leader', 1737. Etching. Courtesy of the British Museum.

that had joined the rococo image as a fashionable import into the city's graphic culture. During the first half of the century caricature had been perceived as a specifically aristocratic and touristic pictorial genre, sponsored by gentlemen on their travels to Italy, and executed by artists like Pier Leone Ghezzi in Rome. The caricature portrait, which enjoyed a distinguished provenance in the sketches of Renaissance artists like da Vinci and later the Carracci brothers, was customarily regarded as a marker of individual status, its characteristic exaggeration of facial and bodily features prized as a humorous index of aristocratic uniqueness. The genre's pictorial syntax – the rapidly transcribed, on-the-spot, capturing of likeness through the sketched line – was enjoyed as a graphic metaphor for the elite values of nonchalant virtuosity, and valorised as a badge of membership in a closed community of travellers. In the 1730s, however, Arthur Pond, a London print entrepreneur who had himself travelled to Italy and met Ghezzi, published a series of etchings that reproduced some of the Italian master's caricatures alongside others by Annibale Carracci.[30] Pond's scheme not only catered to a fine art print market in the capital, but exploited the increasing attraction of the genre as a polite entertainment practised at home as well as abroad. Within genteel society caricature had

become an index of refinement that married the values of the sketch as a sign of accomplishment to the demonstration of satirical wit and individual observation. Ghezzi's images of Grand Tourists and their governors (*fig. 88*) were appreciated as the most elevated contemporary models of the genre, combining physiognomic detail and distortion with a graphic style that was ostentatiously rapid and 'unfinished', the reproduced lines of his pen jerking and jabbing across the page, and frequently devolving into scribbles.

Returning to *A Courier just Setting out*, we can see how clearly it aligns itself with this fashionable mode of graphic satire. Bickham's image, which is as jaundiced about Walpole's successors as it is about the dead prime minister himself, offers a sustained display of caricatural skill. On the right, we are confronted with the notoriously gargantuan profile of Sir John Hynde Cotton's stomach and the rapidly sketched outlines of Henry Pelham's gesturing figure. In the background, Walpole's doctor is depicted with a deliberately finer line, a conventional means of establishing depth in the caricature drawing, and here a concurrent metaphor for his social inferiority. On the left, Lord Carteret is shown holding a sherry glass, and both he and William Pulteney are represented handing over their mail for the next world. Meanwhile, the dead prime minister, loaded with bribes, sits on an ass with a man's face. Clearly, the print promotes itself as a contemporary, local and politicised equivalent to the types of caricature marketed by Pond, and the scandalous appeal of the image's grotesque narrative – which ascribes Walpole's long, painful illness and death to medical malpractice, and yet again invokes a visionary image of the prime minister's dead body – is supplemented by the new fashionability of caricature as an artistic form. Through this supplement, Bickham loads the political satire with an index of graphic prestige and novelty that flaunted its links to high, aristocratic culture and to the artistic traditions of the Continent.

Yet if Bickham's image is dominated by the modern economy of the caricature, *A Courier just Setting out* also maintains the strategies of satirical appropriation and revision we have been uncovering throughout this chapter. To begin with, we can note the fact that the print's depiction of Pulteney blatantly adapts a detail from a 1741 print entitled *The Motion* (*figs 89, 90 and 91*), which had concentrated on the anti-Walpolean opposition in a critical, humorous and semi-caricatural way. More tellingly, the depiction of the humanised animal would have reminded the urban print buyer of an older tradition of satirical anthropomorphism. Indeed, Bickham's image clearly recycles the central components of an image that he himself had produced in the 1730s, entitled *An Ass loaded with Preferments* (*fig. 92*), which attacked ecclesiastical corruption under Walpole and similarly adapted an image from an older graphic series, Laroon's celebrated *Cries of London* (*fig. 93*). What we are recovering, then, is a continuing form of pictorial reference and play that integrated the novel format of caricature into a durable convention of satiric practice. In later years, of course, caricature was going to exert an increasingly powerful hold on political satire and acquire a pictorial centrality that has lasted to this day. In the period under study, however, the imported vocabulary of Ghezzi and the Carracci continued to be conditioned by alternative pictorial and satiric practices.

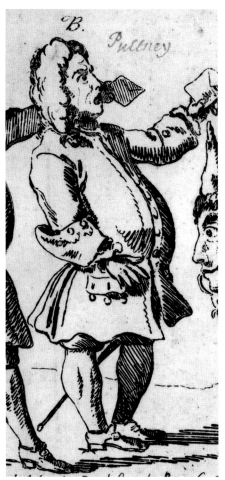

89 (*above*) *The Motion*, 1741 (BM 2479). Etching, $6\frac{7}{8} \times 11\frac{5}{8}$ in. Courtesy of the British Museum.

90 (*far left*) Detail from fig. 87

91 (*left*) Detail from fig. 89

92 George Bickham junior, *An Ass loaded with Preferments*, 1736 (BM 2269). Engraving, $7\frac{5}{8} \times 7\frac{3}{4}$ in. Courtesy of the British Museum.

93 P. Tempest, after Marcellus Laroon, from *The Cries of the City of London*, 6th edition, 1711. Engraving, 15×9 in. Courtesy of the British Museum.

Looking at *The Champion* and *A Courier just Setting out* suggests the continuities, as well as the shifts, in the strategies of production and interpretation that defined the political satire in this period. Such an analysis, however brief, also confirms the need to understand such images as ones that offered a visual, as well as a textual, mediation of political discourse, bound by the conditions and conventions of the engraved image as an artistic product and a commercial commodity. Both *The Champion* and *A Courier just Setting out*, like the other political satires we have studied in this chapter, recycled and responded to the pictorial formulations of the political available in contemporary culture, as well as incorporating the language of parliamentary and extra-parliamentary debate within their boundaries. As John Brewer has written, 'much of the success of the eighteenth century political print stemmed from its use of a visual vocabulary and of visual conventions whose rich allusiveness was savoured by its viewers.' Brewer goes on to argue that the enduring historiographical 'trivialisation' of the political satire's primary status as a category of graphic art 'prevents us from seeing the prints historically, from grasping their meaning and significance for an eighteenth century audience.'[31] This chapter has sought to contest this trivialisation, and to set a new agenda for studying the early Georgian political satire.

At the same time, I have suggested that, contrary to the workings of political satire at certain points later in the eighteenth and nineteenth centuries, the satirical engravings of the period were only intermittently the instrument of an organised party machinery willing to plough money into the sponsorship of individual prints. Sometimes, as in the case of Gravelot's *The Itinerant Handy-Craftsman*, it does seem probable that groupings of political activists must have made a conscious decision to commission specific images, although evidence for this kind of patronage is, unsurprisingly, scarce. More frequently, however, satires seem to have been published as independent graphic products, whether by individual print publishers or by individual engraver entrepreneurs like Bickham, each of whom recognised and exploited the political print's artistic and commercial appeal in a highly politicised, visually literate and relatively affluent urban culture. Given these circumstances, it would be wilful to confine these engravings to the narratives of political history; rather, we also have to insert them into the contemporary narratives of graphic art. To conclude, while it pays to be attentive to the potential power of these images as instruments of party propaganda, and to the fact that this power could occasionally be harnessed to an orchestrated, funded programme of political attack, it is equally important to recognise that the graphic satire's explicitly political contents or messages were only part of its make-up and appeal. Just as crucially, prints such as those by Bickham, Gravelot, and Vandergucht also had to carve out a distinct pictorial and aesthetic identity for themselves in a crowded and competitive market for engraved goods.

Chapter Five

Satire and the Street:
The Beaux Disaster

In 1747, the *British Magazine* published a comic, first-person account of a 'Beau's Sunday Morning Walk', in which an extravagantly dressed male is followed around London by a growing crowd of amused onlookers, who are astounded by his affectations and over-elaborate clothing: 'in short, they all stared, all grin'd, and after a thousand twitchings of one another by the sleeve, laughed most immoderately.' The beau proceeds to get trapped in a 'narrow passage, where, to crown my vexation, what should present itself to my view, staring me as it were full in the face, but a smoaking buttock of Beef.' The overly precious narrator and his urban entourage soon become caught in an even more noxious alleyway, crowded with food stalls, made murky by steam and clogged with people waiting for slops: 'all was smoak, stink, and the steam of reeking victuals, on the one side; all beggars, vermin, nastiness, and stinks of another kind, on the other . . . figure to yourself, the extreme delicacy of my taste, the ticklish tenderness of my paltry stomach . . . added to the plague of unmannerly gaping fools about me, and say whether the most savage breast must not be moved to pity me in this distressful situation; hemmed in with miseries all round, boil'd beef, and beggars on each hand.' He continues lamenting his fate as someone forced to listen to the 'nauseous jokes of a set of such monsters, [and] be set up as it were for a publick spectacle of derision.'[1]

At some point during the next couple of years, Anthony Walker engraved *The Beaux Disaster* (*fig. 95*), which duplicated and extended the literary satirist's central themes and preoccupations.[2] Another male fashion-victim – called 'poor Fribble' in the caption – is depicted in the aftermath of an argument with the tradesmen of Butcher's Row, a street close to Temple Bar, the gate we can glimpse in the background. He has been hooked by the back of his elegant trousers to a butcher's shopfront, where he swings helplessly among hanging hunks of pork and beef. He is watched not only by the owners of the street's meat and fish shops, but also by carmen, a cluster of ragged women, a trio of fashionable walkers and, on the left, a prostitute and two male passers-by. Above, from an opened window over the butcher's, we can spot the ghostly head and shoulders of another woman, surveying the scene. Walker's image is a complex and crowded example of social satire, and this chapter will use an extended analysis of his print as the basis for a broader

The BEAUX DISASTER.

Ye Smarts, whose Merit lies in Dress,
Take warning by a Beaux Distress,
Whose Pigmy Size, & ill-turn'd Rage
Ventur'd with Butchers to engage.

But they unus'd Affronts to brook?,
Have hung poor Fribble on a Hook,
While foul Disgrace, expos'd in Air,
The Butchers Shout, & Ladies stare,

Satyr so strong, ye Fops, must strike you
How can you think y Fair will like you,
Women of Sense, in Men despise
The Anticks, they in Monkeys prize.

95 Anthony Walker, *The Beaux Disaster*, c. 1748 (BM 2880). Engraving, $7\frac{1}{4} \times 11\frac{1}{2}$ in. Courtesy of the British Museum.

investigation into the workings and appeal of this category of graphic art in the London of the 1740s.[3]

I

In the engraved social satire, polemic and humour were fused with an acute sense of the city as a succession of environments to be deciphered and imagined: the streets, squares, public buildings and pleasure parks of the capital were dramatised as a grid of spectacle and narrative that constituted the subject of artistic practice. As we have noted, this kind of graphic art had been produced periodically throughout the first half of the century. The South Sea Bubble satires, for instance, had focused on Exchange Alley as a spatial crucible of illusion, greed and spectacle, and Hogarth's *Harlot's Progress* had deliberately invoked the narratives and inhabitants of Drury Lane. By the 1740s, as the continuing expansion of the print market encouraged a complementary increase in satirical images, a number of independent

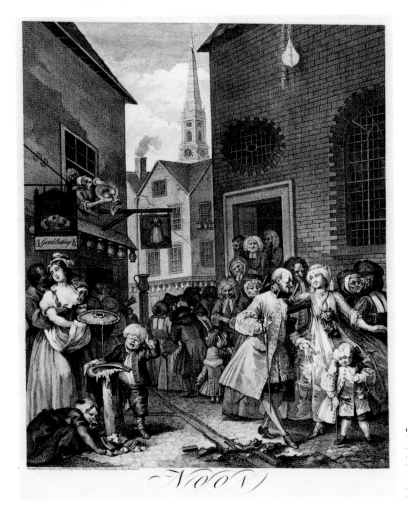

96 William Hogarth,
Noon, 1738 (BM 2370).
Engraving, $17^{3}/_{4}$ ×
$15^{1}/_{4}$ in. Courtesy of the
British Museum.

engraver entrepreneurs became involved in designing, executing and publishing
social satires. These artists produced a diverse range of engravings that were marked
by their individual interests and skills and by their distinct commercial identities
and ambitions, but what is striking is the collective coherence of the social satire
in this period. However different from each other, these satirical prints shared
a circumscribed range of critical preoccupations and pictorial practices. This
graphic inter-referentiality was not only exploited to promote the social satire
as a distinct kind of product with its own specialised appeal, but was also a
self-conscious form of exchange that is often signalled in the internal workings
of the images themselves: the social satire encouraged its viewers to appreciate
the correspondences between engravings produced by different artists working in
the same genre.

 We can begin to appreciate this exchange a little better by comparing *The Beaux
Disaster* with two of Hogarth's social satires. On the one hand, Walker's image is
powerfully reminiscent of *Noon* (*fig. 96*), the second of the *Four Times of Day* series
Hogarth published in 1738. In both prints, we find a humorous focus on the

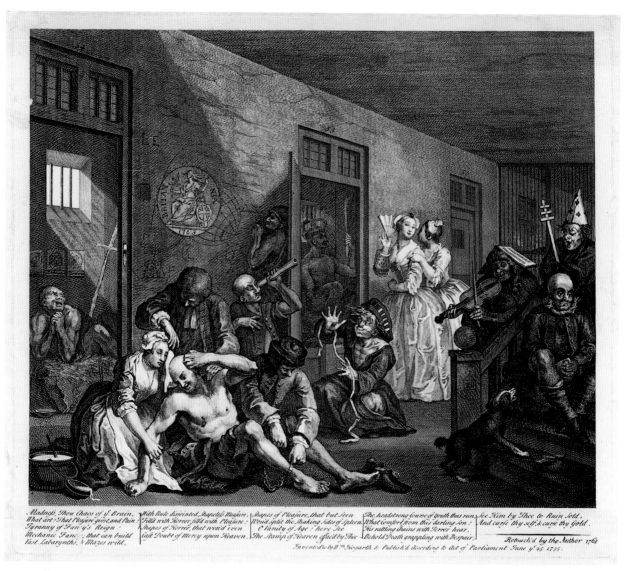

97 William Hogarth, *The Rake's Progress*, Plate 8, 1735 (BM 2246). Engraving, 12⁷⁄₁₆ × 15¼ in. Courtesy of the British Museum.

polarities of plebeian and fashionable culture, mapped out across a drain-bisected cobbled street, and framed by the pictorial staccato of signboards and windows. On the other hand, we can usefully turn to a detail in the final plate of Hogarth's *Rake's Progress* (fig. 97), first published in 1735. Hogarth's image shows the chaotic, lunatic interior of Bedlam, the city's most notorious madhouse. In the background, two fashionable women have come to enjoy the grotesque theatre offered by the asylum, which had become a habitual stopping place on any extended tour of the city. It is quickly apparent that, in their appearance and actions, this couple offers a near-precise precedent to the two fashionable women who stroll out of the right-hand side of the image in *The Beaux Disaster*. Their reappearance in Walker's print

98 Louise Phillipe Boitard, *Taste A la Mode, 1745*, 1745 (BM 2774). Engraving, 8 × 12¼ in.
Courtesy of the British Museum.

– along with the barking dog that stands in the foreground of Hogarth's engraving
– offers a satiric underpinning for the kinds of viewing that are shown taking place
in the later image, one that works to evoke an even more confused and turbulent
environment than Butcher's Row. Reading the one image against the other,
the city street becomes aligned with the crazed dynamics of the madhouse, and
the fop's plight is related to the kinds of abject spectacle being consumed by the
shielded looks of Hogarth's women.

As well as engaging in dialogue with Hogarth, *The Beaux Disaster* maintains and
modifies the pictorial and narrative formulae of more recent social satires dealing
with the illusions and deceits of fashion. Louis Phillipe Boitard's *Taste A La Mode,
1745* (*fig. 98*) shows a parade of fashion victims and flamboyantly dressed courtesans
drifting through St James's Park. Published in September 1745, Boitard's print
played on the definition of the park as a site of sartorial ostentation and sexual
assignation, in which women of the aristocracy mingled with vulgar female pre-
tenders, and in which dubious coquettes and well disguised prostitutes roved
among predatory army officers, licentious rakes and overdressed, feminised fops.
The engraving is dominated by the squat figure of a woman dressed in a gargantuan
hooped petticoat, an item of clothing that was widely castigated by contemporary
satirists as a gross form of fashionable excess. The anonymous author of *The
Enormous Abomination of the Hoop-Petticoat*, also published in 1745, declared that 'the
very sight of these cursed hoops is enough to turn any one's stomach.' He goes on

to bemoan their blurring and inversion of the signs of class: 'there is not a cobbler's wife (at least in London) but wears a hoop as well as the greatest lady in Great Britain.' Short women had particular problems with the hoop petticoat: 'they strut and waddle, like a crow in a gutter, to the great diversion of the ill-natured, and no less concern to the compassionate spectator.'[4] In *Taste A la Mode, 1745*, the discomfited and socially gauche central figure is surrounded by females whose dress and gestures open up readings relating to the erotic narratives of the park: in particular, the figure on the left, whose deliberate manipulation of the hoop offers a blatant form of bodily display, is in all probability meant to represent a prostitute or courtesan, engaged in a preliminary form of sexualised exchange with the male figures on the picture's edge. This duo, their arms entwined, provide a pictorial and metaphorical counterpoint to the two interlocked young fops in the right foreground, seen from behind, who are almost entirely defined by the outlines and excesses of their clothing.

Returning to *The Beaux Disaster*, we can rapidly appreciate the extent to which Walker's engraving maintains this satirical concentration on sartorial extravagance, social emulation, sexual availability and emasculated foppishness. The print deploys a similar, if somewhat more down-market, frieze of figures to the one found in Boitard's print: the female on the left, whose exposed leg and tapping finger suggest that she too is a prostitute, plying the street for business; the amused duo of male walkers, one of whom is about to be propositioned; the cluster of laughing plebeian women in the centre, whose ragged, hooped skirts present a tattered mimicry of elite dress; the ridiculed male fashion victim, decked out in a fastidiously arranged outfit that is in the process of being ruined; and the trio of affluent strollers on the right, the women locked into tight-fitting stays and enormous hoop-petticoats, the man sauntering along the alley, his hand tucked indolently into an expensive waistcoat. Recognising these compositional and iconographic continuities enables us to locate Walker's image within a particular strand of social satire that played on the hubristic and transgressive narratives of contemporary clothing, which are dramatised in the caption to *The Beaux Disaster*: 'Ye Smarts whose Merit lies in Dress,/ Take warning by a Beaux Distress.' In articulating this pictorial polemic, however, *The Beaux Disaster* relocates the protagonists of fashion to the street. In doing so, Walker's engraving deliberately and explicitly responds to another satirical print focusing on the humours of modern attire, John June's *The Lady's Disaster*, published in December 1746 (*fig. 99*).

June's image, like Boitard's, centres on a woman wearing a huge hoop-petticoat, who has become stuck between a wall and a bollard on the south side of the Strand. She is suddenly exposed as a vulnerable, spectacular centre of a pattern of looking and laughter that spirals out from the chimney-sweeper's assistant lying at her feet to the disparate collection of people standing nearby. In *The Lady's Disaster* the fashionable female body is subjected to, and assaulted by, the plebeian gaze. The print's caption apocryphally declares that the image was 'drawn from the fact. Occasion'd by a Lady carelessly tossing her Hoop too high, in going to shun a little Chimney sweeper's Boy who fell down just at her Feet in an artful surprise at ye enormous sight.' The boy's ogle at the view between her legs represents a visual invasion of the publicly enclosed, genteel body by a soiled worker, a sexualised

THE LADY's DISASTER.—— *nil ortum tale.* Hor.

If Fame say true in former Days,
The Fardingale was no disgrace';
But what a Sight is here reveal'd!
Such as our Mothers ne'er beheld.
A Nymph in an unguarded hour,
Alas! who can be too secure'?)

Dire fate has destin'd to be seen',
Entangled in her wide Machine'?
While Carmen, Clowns, & Gentle folks
With satisfaction pass their Jokes.
Some view th'enameld Scene on high
And some at bottom fix their Eye'.
Publish'd according to Act of Parliament Decem 7th

Mark well the Boy with smutty face,
And wish themselves were in his place.
Whose black distorted features show,
There's something—to be seen below.
And Awfull grinning at her Foot
Cries smooth'sweep! Madam for your Soot

While from his Stall the leering Jew,
Would gladly have a better view.
In moderate bounds had Celia drest.
She'd ne'er became a publick Jest'.

Drawn from the Fact. Occasion'd by a Lady carelessly
tossing her Hoop too high, in going to shun a little
Chimney sweepers Boy who fell down just at her Feet
in an awful surprize, at y enormous sight.

99 John June, *The Lady's Disaster,* 1746. Engraving. Courtesy of the British Museum.

trespass confirmed by the metaphor of his working tools, and by the vocabulary quoted in the caption: he asks her to allow him to 'sweep! sweep! Madam, for your soot.' His gaze is shared by what this text describes as a 'leering Jew', clutching his goods, and desiring to 'have a better view.' Meanwhile, a motley crew of soldiers, window-cleaners and carmen congregate around the stricken woman, laughing uproariously; on the right, a shadowed bootblack shuffles cheerfully away. June also includes on the left a coterie of fashionable walkers who seem to join in the general mirth, but here they are juxtaposed with – indeed, their passage is about to be hindered by – the figure of a ragged itinerant, his lank hair, ripped clothes and battered hat ironically contrasted with their wigs, silks and fans. His dog urinates on the hem of one of the women's embroidered dresses. In a striking instance of pictorial revision, June had taken his image of the beggar and his dog from Balthasar Nebot's painting of *Covent Garden Market* of 1737 (*fig. 100*). Yet whereas Nebot's painting had depicted a narrative of genteel benevolence and plebeian

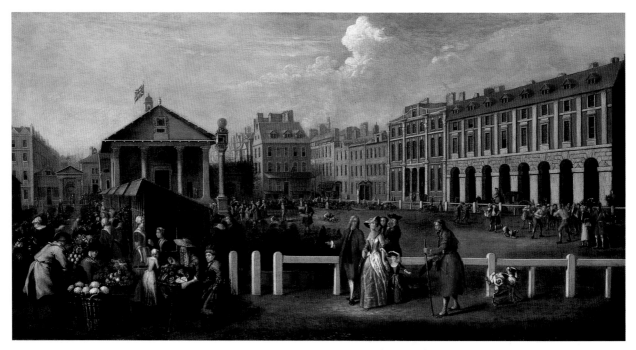

100 Balthasar Nebot, *Covent Garden Market*, 1737. Oil on canvas, 25$\frac{1}{2}$ × 48$\frac{3}{4}$ in. Tate Gallery, London.

gratitude – the beggar, on the right, is made a picturesque recipient of the polite gaze and a worthy object of an affluent family's charity – June's engraving highlights social difference and animosity, introducing, most obviously through the eloquent gesture of the animal, an explicitly insubordinate rhetoric of ridicule. In *The Lady's Disaster*, this exchange takes place outside the punctured facade of a city-centre brothel, an identity confirmed by the phallic and prophylactic *double entendres* of the 'Bishop's Hat' street sign above. Prostitutes look down from the first-floor windows of the brothel, their breasts slipping out of dishevelled blouses and nightgowns. In the background, standing ironically apart, we can see the upper facade of St Mary's Church in the Strand.

Alongside its satirical focus on social antagonism, June's print works to suggest the relationship of fashion, prostitution and consumption in the modern capital. In this period, as Hugh Phillips has so brilliantly demonstrated, the Strand had become the central artery of production and display for the city's luxury goods trades.[5] Clothes and material shops dominated the walk from Charing Cross to Temple Bar, and the urban pedestrian was able to peruse and purchase goods at a bewildering variety of retail outlets: milliners, staymakers, linen drapers, button makers, men and women's mercers, woollen drapers, haberdashers, clothiers, hosiers – all had premises on the street, their shops mingling with those of furniture makers, booksellers and goldsmiths. The Strand thus functioned as a crucial space of commodification in the city, a milieu in which the glitter of exquisite metals, the shine of imported silks and the sight of coloured cloths were first transformed into a coherent commercial spectacle in the windows and interiors of a shopping avenue. *The Lady's Disaster*, however, is set in that part of the Strand adjacent to

Drury Lane, where the smartest clothes shops stood only yards away from the city's most notorious concentration of brothels. June's image merges these two spaces, and their associations, rewriting the fashionable street in terms of a salacious stress on the forms of display and consumption that take place on the floor *above* the shop windows. *The Lady's Disaster*, which deliberately juxtaposes the victim of fashion with the prostitutes in the windows, exposes both to a form of deconstruction that enables them to be read according to an eroticised dialectics of the seen and the obscene. While the fractured, repetitive upper bodies of the prostitutes imply the pleasures lying behind the shadowed windows, the stranded 'nymph' is also split into two – by the rigid diagonal of her dress – which opens up her lower body to view and to similar forms of eroticised looking. The viewer is thus given a metaphor of the female body as a composite entity, mapped across the upper and lower storeys of the street and dispersed across the commodified sites of fashion and sexual advertisement.

The Beaux Disaster, of course, focuses on a trapped male, and moves the satirical narratives he suggests to a space that, while lying adjacent to the Strand, was nevertheless perceived as a far more boisterously popular environment. Yet it is also clear that Walker intended his image to serve as a belated pendant to June's satire. This is most obviously signalled by the print's title and format, in which another 'disaster' is shown taking place in a pictorial environment that precisely mirrors June's composition and that is also accompanied by a series of inscribed verses written at the base of the print. Again, we find a concentration on a ridiculed follower of fashion, and the street audience that laughs at his predicament is similarly split into the fashionable and the plebeian. Indeed, deciphering the various onlookers, we can spot a replica of June's carman, his whip leaning casually over his shoulder, as well as the ghost-like reminder of the women watching from the first-floor windows. *The Beaux Disaster* also details the overlapping iconography of the London street signs, a stream of images which similarly curves over the rooftops of jammed coaches and sedan chairs. The details of a rudimentary, vernacular architecture, made up of butcher's shopfronts and benches, are once more juxtaposed with the emblematics and outlines of a famous public building, in this case Wren's Temple Bar. Walker's image is thus both a duplicate and companion to June's, even as it asserts its concurrent identity as an independent graphic commodity that could, as later print publisher's catalogues make clear, be purchased and appreciated as a single print.

In all these ways, Walker's satire functioned to insert itself into an established and constantly expanding network of satirical representations of the city. The different images produced by artists like Hogarth, Boitard, June and Walker generated, we can now suggest, a satirical topography of the capital, in which a range of different environments – Soho, Bedlam, St James's, the Strand and Butcher's Row, to give just the examples we have looked at – were integrated into a strikingly coherent representational schema, one that was homogenised by the repetitions of narrative and subject matter exhibited from one plate to another, and formally grounded in the iconographic, compositional and textual rhythms established across this imagery as a whole. In this process, the city was collectively dramatised as a site of spectacle in which the stereotypical representatives of different classes, sexes and professions

were ironically exposed and intermingled, and placed in critical relief against a
succession of metropolitan environments. Let us now explore the ways in which
this category of engraving competed with, and responded to, alternative pictorial
representations of the urban.

II

It is particularly suggestive to compare the social satire with the topographical prints
of the period, which were enjoying increasing status and sales in contemporary
London. As an example, we may contrast *The Lady's Disaster's* depiction of the
Strand with another mid-century view of the same street, John Maurer's *A
Perspective View of St Mary's Church in the Strand near the Royal Palace of Somerset,
London*, executed in 1753 (*fig. 101*). Maurer's print is one of the scores of 'perspec-
tive views' of the city that were being promoted by the major print entrepreneurs
during the 1740s and 50s. This kind of print followed a compositional formulae in
which a dramatic form of perspectival recession encourages the eye to move
quickly from a widened foreground area to the far background of the image;
through this organisation, the city was dramatised as an architecturally regularised

101 John Maurer, *A Perspective View of St Mary's Church in the Strand near the Royal Palace of Somerset, London*,
1753. Engraving, $7^{1}/_{16} \times 10^{3}/_{4}$ in. Courtesy of the British Museum.

and geometrically ordered environment, framed by sweeping facades and rows of windows that arrow into the distance. Complementing this visual and spatial geometry, the views focused on the elaborate facades of high architecture, both modern and antique, which reinforced an image of the city as a succession of grand public buildings, civic, courtly and ecclesiastical. Beneath these urban landmarks, figures stroll at a decorous distance from each other, while coaches, sedan chairs, carts and wheelbarrows offer a hierarchy of transport that is evenly balanced across the picture space. Cumulatively, all these details help to construct the capital as an architecturally, socially and spatially ordered environment, defined by a pervasive form of equilibrium. Any hint of dirt and noise is evicted, the crowd is absent and buildings shine in the sunlight.

This is the polite ideal of the city, pictorially packaged by images like Maurer's. Such prints were not only sold individually, but also as sets: collectively they constituted a form of graphic transport across the city's main thoroughfares, monuments and public buildings. Looking at a succession of such images thus offered a pictorial tourism that mimicked the itinerary and pleasures of the coach trips across the capital enjoyed by affluent Londoners and visiting foreigners in the period. These prints, frequently designed and engraved by foreign artists, were often given a second, French, caption that not only helped make the engravings more appealing to the Continental visitor but also, more importantly, offered a venerable mark of elegance and learning to the local buyer: even as he collected these images of a native subject matter, the English consumer was also defining himself in relation to a cosmopolitan index of pictorial and linguistic refinement. The local audience was thus, to a certain extent, consuming London through the perspective of the tourist, a perspective which habitually rewrites the city as a laundered site of spectacle in which the popular is either reformulated as the picturesque or excluded from view altogether.

This polite spectacularisation of the capital was reinforced by the fact that prints like Maurer's were designed to be viewed not only on a wall or in a folio but also in what were called 'optical pillar machines'. In the late 1740s, the optical pillar machine – also known as the zograscope – became a fashionable private accessory in London's wealthier households. These instruments were made up of a suspended convex lens and a pivotally adjustable mirror, mounted on a stand, into which prints were placed and in which they acquired a striking semblance of three-dimensionality. Viewing a series of perspectives of London in the zograscope thus generated an illusion that the spectator was actually passing through the capital itself. In this mode, the city was being represented as a seamless succession of cleansed and ordered spaces, consumed with the fluidity and the elevated perspective of an affluent traveller or tourist moving through the capital in a sedan chair or coach. His or her enclosed gaze from behind the moving window was tranformed into an even more heavily quarantined form of spectatorship, cut off from the street altogether and taking place behind closed doors.[6]

Prints like *The Lady's Disaster*, we can now suggest, duplicate but also distort the topographer's focus. June's engraving is also a view of a specific section of the city and, more pertinently, offers a similar concentration on St Mary's Church, which is labelled 'New Church on the Strand', and situated at the end of a similarly

sweeping urban facade. In these ways, the social satire offered a certain approxima-
tion of the perspective view's components, and situated itself as an imagery that
colonised the same spatial and pictorial territory as the urban prospects marketed by
the major print publishers. At the same time, it is clear that June's work offered a
very different reading of the city, and a very different form of viewing, from an
image like Maurer's. St Mary's Church is not only squeezed into the picture's edge
but half hidden behind a mass of coaches, signs and whips; the shapes and outlines
of public architecture are not clarified and made easily available for the viewer but
are obscured and disturbed by a host of dissonant details. The visual disturbance
this generates is characteristic of a broader difference between the topographical
prospect and the social satire: while the one dramatises clear lines of sight – the
uncluttered view down the city street – the other dramatises a very different model
of spectatorship, one which demands that we work our way through a mass of
overlapping, clashing pictorial elements, which offer a deliberate metaphor for the
cluttered, chaotic nature of the street itself.

Part of this crush, of course, is the crush of bodies, and if in the topographical
view we are given a slightly elevated perspective, floating just above the road, in
the social satire we are brought dramatically down to street level, and given a close-
up look at the figures who walk along the pavements and across the cobblestones.
Here, the decorous space between such figures is sucked out, and we are presented
with an urban environment that is riddled with the dangers and comedies of being
too close. The perspective view's subdued narratives of shopping, strolling and
travel are replaced by an explicit focus on sexual consumption, plebeian comedy
and sartorial pile-up. This, then, is an alternative form of spectacle to that offered
by the perspective prospect, one in which the hierarchies of architecture, space and
class are both maintained and subverted, and in which we are not so much
quarantined from the street as positioned – however metaphorically and fantastically
– right in its midst.

Looking again at *The Beaux Disaster*, we can see that it too provides an image of
the street that both gestures to and contradicts the formulae of the engraved
topographical prospects of the city. Walker's print maintains the perspective view's
concentration on a specific social space, dominated by a familiar architectural
landmark, Temple Bar, but simultaneously introduces a detailed focus on the
plebeian protagonists and fashionable interlopers who crowd that environment. *The
Beaux Disaster*, like social satire in general, thus offered a dialectical alternative to
prints like Maurer's and to the concept of the city they promoted.

At the same time, Walker's satire ironically engaged with another category of
polite, urban representation, the fashion engraving. In the first half of the eight-
eenth century, a developing French iconography of fashion was constantly being
adapted and packaged on the London print market. A striking example of the way
in which codes of representation and dress were becoming linked in this process are
the illustrations to *A New Drawing Book of Modes*, published by Richard Ware in
1732 (*fig. 102*).[7] Based on a set of Parisian prints by Bernard Picart, which were
reproduced by George Bickham junior and Benjamin Cole, the drawing manual
offered a handbook for the amateur that substituted the gestural and sartorial
rhetoric of a Continental *beau monde* for the classical imagery customarily suggested

as models for artistic imitation. Bickham's page of hands, gloves and fans offers an orchestrated index of fashionable gestures that highlights the curl of the fingers, the pull of the glove and the fall of a cuff as fragments of a bodily language of gentility. Here, the exquisiteness of the outlines to be copied is aligned with the sophistication of these gestures; furthermore, the drawing hand, wrist and arm of the amateur, tracing these lines, would themselves transcribe arcs and curves across space correlating to the movements of the fingers and forearms within the page. Dress and drawing thus become a unified nexus of polite social practice, and are integrated into a process of genteel autodidacticism and repetition that learns fashion as it learns drawing.

While Bickham's illustration offers a fragmented rhetoric of fashion, a series of engravings published by John Bowles in 1744 offered the English audience a more explicit and complete graphic focus on dress. His catalogues of the period describe the images as follows: '*Gentlemen's modern Habits* by Mons. Gravelot, being six very agreeable prints of gentlemen at full length in modern dresses. Each plate is eleven inches deep, and seven inches wide; they are curiously engraved. Pr. 2s.6d. the set. *Ladies modern Habits* by Mons. H. Gravelot; these are six agreeable postures of women at full length in modern dresses, the same size and price as the former set, being a proper companion thereto.'[8] The prints, which were engraved by another Frenchman working in London, Louis Truchy, depict a series of standing or strolling single figures (*fig. 103*). Collectively, the twelve images articulate a

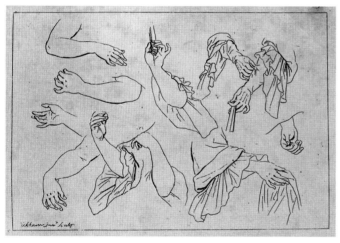

102 George Bickham junior, after Bernard Picart, from *A New Drawing Book of Modes*, 1732. Etching. Courtesy of Roger Hallett.

103 (*right*) Louis Truchy, after Hubert-François Gravelot, fashion plate, 1744. Etching. Victoria and Albert Museum.

choreographed pattern of polite clothing and gesture that is rhythmically played out from print to print and from sex to sex. Individually, they offer frozen representations of sartorial and postural decorum which were designed to be consumed not only as elegant graphic commodities but also as blueprints for dress and deportment: the purchaser of these engravings could exploit them as a useful guide to the most modern look – the right type and tilt of hat or bonnet, the smartest cut of sleeve, the precise thrust of hand under waistcoat, the most exquisite conjunction of fan and silk. Despite being produced, advertised and sold within a largely urban market, and despite promoting a metropolitan sartorial *chic*, the engravings depict their subjects walking along spaces that bear no obvious loyalty to the capital: the figures pass through entirely depopulated and heavily abstracted pastoral environments. Here, in a pattern of withdrawal and displacement that reminds us of Gravelot's earlier political satires, the idealised body, whether male or female, is subjected to a form of pictorial isolation that distances that body from the problematic signs and exchanges of the city.

Walker's print satirically transplants this recently established pictorial rhetoric of polite dress to the street. While *The Beaux Disaster* clearly maintains June's device of introducing a cluster of elite men and women into the satire, Walker's depiction of these figures, in the lower right corner of the image, is indebted in its details and technical sophistication to the precedent of Gravelot's engravings. In particular, the male figure on the extreme edge of his print could almost have walked in from the fashion plate we have just been looking at; but here he is framed not by the cross-hatched marks of a modern arcadia, but by the shadowed figure of a stall assistant, by gutted carcasses and by hunks of meat hanging from hooked beams. Next to him, his companions' gestures – made up of languid forearms, pliable wrists and the twist of a fan in the fingers – duplicate those of the *Drawing Book of Modes*, but are here destabilised by a new setting and adulterated by the depiction of another arm, hand and fan on the other side of the image, playing out a very different dance. In these various ways, *The Beaux Disaster* positions itself in ironic relation to a modern ideal of male and female fashion-ability being developed in polite culture, which is pictorially mapped onto an environment – Butcher's Row – where those ideals were always going to seem comically inappropriate, and be threatened with ridicule and assault. The social satire again internalises the vocabulary of polite representation – which inevitably serves to reinforce the cultural authority of that form of representation – and then subjects it to displacement and play.

III

In the discussion of *A Harlot's Progress*, we related Hogarth's engravings to literary satires which focused on the city as subject matter. I should now like to consider this kind of writing in more detail and suggest that, in many ways, it shared the perspectives and preoccupations of a social satire like *The Beaux Disaster*. The literary genre which is most relevant here, and which enjoyed an enduring appeal in this period, was the extended satirical 'walk' across London, in which the various

pockets of urban culture were comically investigated and relentlessly ridiculed. Exploring the capital, tracking across its forbidden zones as well as its polite environments, the male narrators of these texts not only toured the public realms of the street, but also entered the spaces that stood behind the urban facade and that abutted the most obscure alleyways. Their rhetoric is both comic and condemnatory: they not only communicate the perverse transactions that defined different social spaces, but also temporarily participate in them, however ironically, before withdrawing to their apartments to subject what they have seen to hyperbolic reproach and disdain.

The seminal models for these satiric 'tours' were Tom Brown's *Amusements Serious and Comical, Calculated for the Meridian of London* and Ned Ward's *London Spy*, turn-of-the-century publications which were repeatedly reissued throughout the period and heavily advertised in the London newspapers.[9] In these writings the city's thoroughfares are presented as crowded and overwhelming environments of noise and confusion; years before the publication of *The Beaux Disaster*, for instance, the narrator of Brown's *Amusements* had already focused on Temple Bar, to which he had taken an innocent foreign companion:

> He sees an infinite number of different machines, all in violent motion, with some riding on the top, some within, others behind, and Jehu on the coach-box, whirling towards the devil some dignified villain who has got an estate by cheating the public. He lolls at full stretch within, with half a dozen brawny, bulk-begotten footmen behind . . . Some carry, others are carried. 'Make way there,' says a gouty-legged chairman, that is carrying a punk of quality to a morning's exercise; or a Bartholomew baby-beau, newly launched out of a chocolate house, with his pockets as empty as his brains. 'Make room there,' says another fellow, driving a wheelbarrow of nuts, that spoil the lungs of the city 'prentices and make them wheeze over their mistresses as bad as the phlegmatic cuckolds, their masters, do when called to family duty. One draws, another drives. 'Stand up there, you blind dog,' says a carman, 'will you have the cart squeeze your guts out? . . . Here a sooty chimney-sweeper takes the wall of a grave alderman, and a broom-man jostles the parson of the parish. There a fat greasy porter runs a trunk full-butt upon you, while another salutes your antlers with a basket of eggs and butter. 'Turn out there, you country putt,' says a bully with a sword two yards long jarring at his heels, and throws him into a kennel.[10]

In such texts, the street is defined as a crushed and confused network of signs, what Brown later describes as 'an amazing medley of all manner of contrarities.'[11] It is a space in which voices, bodies and vehicles overlap and crash into each other, and in which the boundaries of class are both dramatised and threatened. Brown's text highlights the disjunctions between the lolling worthy, sealed up in the privatised vacuum of the coach, and the drivers and chairmen who swear so crudely in the thoroughfare; between the grave alderman and the chimney-sweep who appropriates his privileged place against the street wall; between the fleeced beau and the shouting nut-seller pushing a wheelbarrow; and between a scurrying broom-man and a local cleric. Alongside these forms of conflict, the street is

witness to other forms of satirical contrast. The gross, stumbling language of corporeal decrepitude – of blind dogs, spilt guts, gouty legs and wheezing lungs – intermingles with the imagery of machinery and motion. The glimpsed emblems of sexual commodification and desire are thrown together with the more prosaic signs of the marketplace – the image of a courtesan is juxtaposed with that of a basket of eggs and butter, and a barrowload of nuts is used to introduce a salacious, comic narrative of sexual transgression between apprentice and mistress. On the satirical walk, then, urban space is defined by its aggressive but entertaining heterogeneity; in Brown's words, it presents 'a hurry of objects' for perusal, and is a 'hodge-podge, a pleasant confusion, and a perfect amusement.'[12]

A text like Brown's provides a suggestive literary parallel to, and precedent for, an image like *The Beaux Disaster*. As the extract from Brown suggests, these writings frequently focused on the same kinds of tensions between polite and popular culture that we see being acted out in Butcher's Row. Text after text, for instance, plays on the clash between the wealthy, cocooned traveller and the insubordinate plebeian, and frequently does so through the metaphor of the coach crash, an event which brings down the physical and cultural barriers between the enclosed spaces of elite travel and the open, unprotected spaces of the street. John Gay's *Trivia; or, the Art of Walking the Streets of London*, first published in 1716, describes a dramatic example:

> The dustman lashes on with spiteful rage
> His ponderous spokes thy painted wheel engage,
> Crush'd is thy Pride, down falls the shrieking Beau
> The slabby pavement crystal fragments strow,
> Black floods th' embroider'd Coat disgrace,
> And Mud enwraps the Honours of his Face.[13]

Here, the narratives of a traffic accident are transformed into a violent spectacle of class difference and antagonism: not only does the dustman aggressively attack the 'painted wheel' of the beau's carriage, but the beau's embroidered coat and face are spattered with a plebeian make-up of mud and dirt.

While the dangerous crush of coaches, chairs and bodies provided one staple topic for satirical authors, another was the ubiquitous but highly ambivalent language of dress, which offers another suggestive parallel to *The Beaux Disaster*. In the satirical 'walk', the street was dramatised as a site in which the sartorial signifiers of identity were as various and confused as the voices and vehicles that passed by. Frequently, these texts suggest the emulatory narratives that underlie the codes of fashion; the author of *A Trip through the Town*, for instance, remarks that 'it is a hard matter to know the mistress from the maid by their dress; nay, very often the Maid shall be much the finer of the two.[14]' The visitor to London in Brown's *Amusements* makes a similar complaint: 'I have not yet learnt to distinguish Female quality from the wives and daughters of mechanics, any other way by their coaches and Attendance.'[15] More pertinently, men's clothing was a constant preoccupation; in particular, the figure of the fop or the beau, caricatured as a vain, emasculated creature of fashion, attracted extended satirical criticism. Ward's *London Spy*, for example, described him as a narcissistic, animated tailor's dummy, roving the

streets: 'he's a strolling assistant to drapers and tailors, showing every day a new pattern and a new fashion.'[16] In *Trivia*, John Gay wrote that 'you'll sometimes see a fop, of nicest tread,/ whose mantling peruke veils his empty head/ At every step he dreads the Wall to lose,/ And risques, to save a coach, his red-heeled shoes.'[17] This invocation of a fop's red heels, flashing in front of the muddied wall, suggests how even the smallest details of dress and appearance could be read as keys to character and ambition.

In this process, the emblems of dress were integrated into the moving assemblage of signs circulating at ground level, an assemblage that – as in Walker's print – was framed by the street dressing of the shop signs hanging above. Brown describes this elevated comic strip of representations:

> From the Gaming-house we took our walk through the streets; and the first amusements we encountered were the variety and contradictory language of the signs, enough to persuade a man there were no rules of concord among the citizens. Here we saw *Joseph's Dream*, the *Bull and Mouth*, the *Hen and Razor*, the *Ax and Bottle*, the *Whale and Crow*, the *Shovel and Boot*, the *Leg and Star*, the *Bible and Swan*, the *Frying-pan and Drum*, the *Lute and Tun*, the *Hog in Armour*, and a thousand others that the wise men that put them there can give no reason for.[18]

Here, the overlapping images and names that snake along the street's upper tiers offer a metaphor for the fluctuating mesh of signs dominating the space below. In aligning these two levels of signs, and proposing the one as an allegory for the lack of concord found in the other, the satirical tour redefines the street as a mobile site of spectacle, a haphazard, constantly shifting repository of images that was being mediated and momentarily stilled by the ironic gaze of the satirical narrator. This spectacle encompassed not only the street setting – the conglomeration of shopfronts, building facades, signboards and rooftops that physically organised the urban environment – but also the mass of figures passing through social space. The coach traveller, the courtesan, the maid and the beau are briefly highlighted as individuals, and then ironically integrated into a temporary, comic and spectacular collective, created out of the transgressive confusions of the street and fixed in place by the literary mechanics of the satirical text itself.

Brown made this focus on the street's public explicit: 'The public is a great spectacle, always new, which presents itself to the eye of private men, and amuses them.'[19] In deciphering this public spectacle, the satirist was mythologised as a connoisseur of the city, an educated male walker who surreptitiously scoured London looking for amusing points of conflict and comedy. He roved the thoroughfares, parks and alleyways of the capital with a quizzical and leisurely eye. His walk was described as a digressive and interrupted ramble, while his gaze was codified as quick and critical, made up of a succession of glimpses, never clinging too long to a single subject. A nice, if rather decorous and tidied example of this kind of satirical spectatorship is suggested by Gay's *Trivia*, which, moving between the rhetoric of castigation and that of good humour, explicitly appeals to a community of 'careful observers, studious of the town.'[20] Gay's narrator, as the extended title to his poem suggests, is someone who spends his days and nights

turning walking into an 'Art', a spatial tracery drawn across the city by the undulating tracks of the satirist's footsteps, and visually articulated by the walker's critical eye, which, in its fleeting encounters with the protagonists of the street, treats the ostentatiously wealthy and the 'rude' poor with equal disdain. Walking in the shadow of patrician and plebeian cultures, Gay's narrator pretends to belong to neither; rather, he relishes the conflicts and clashes generated at the troubled urban intersections of class, and watches them from a discreet spatial and cultural distance, before moving on.

This strolling, satirical perspective is markedly different from that assumed by the narrators of other texts on the city produced in the period. The quintessentially polite site of literary journalism, *The Spectator*, was published between 1710 and 1714 and consciously promoted a genteel blueprint for urban living. What is striking about the journal, looked at as a whole, is the extent to which it avoids direct description or discussion of the characters and events of the street; rather, the city is normally observed and interpeted through the mediating sites of the coffee house, the club, the playhouse and, most indirectly of all, the country estate. Through this textual strategy of spatial withdrawal, the capital becomes defined as a network of shielded spaces, linked by the values of assembly and conversation, and cut off from the abusive and anarchic narratives of the city's thoroughfares, alleys and pathways. A rare and telling exception to this lack of engagement with the capital's streets is the issue published on 11 August 1712, which details a tour of London. Even here, however, the view from inside a moving coach is naturalised as the normative mode of visually consuming the city, while the experience of the outside – of unprotected social space – is dramatised in terms of threat and vulnerability. The narrator declares that 'I find it always my Interest to take Coach, for some odd Adventure among Beggars, Ballad Singers, or the like, detains and throws me into Expence.' When he momentarily alights from his vehicle, and resolves to walk 'out of Cheapness', he is immediately accosted by a 'ragged Rascal, a Beggar who knew me', who demands money, and who draws the attention of the 'Mob' to their altercation. The narrator, quickly making his excuses, leaves to 'sneak off to a Coach.' Having escaped this confrontation, and newly ensconced in his vehicle, the narrator can comfortably sing the praises of the capital: his 'satisfaction increased as I moved towards the City; and gay signs, well dispos'd streets, magnificent public structures, and wealthy shops, adorned with contented faces, made the joy still rising till we came into the centre of the City, and Centre of the World of trade, the Exchange of London.'[21] Here, the city is made visible by the privileged perspective of the coach; from behind the moving window, the capital can be valorised as a thriving, harmonious environment of commercial wealth and social contentment. Outside, it is suggested, the view becomes cluttered and obscured by the vulgar bodies and entreaties of the poor: the city, in its polite guise, becomes suddenly and momentarily invisible, blocked out of sight.

The literary figure of the satirist, in contrast to the coach-bound 'Spectator', walks the streets rather than being carried through them, and describes with delighted irony the kinds of catastrophe that the Spectator seeks so desperately to avoid. If, again, the one kind of text can be seen to have confirmed and regulated

the other, it is clear that the perspectives of the satirical 'walk' across the capital were very close, in general, to the perspectives depicted by a social satire like *The Beaux Disaster*. In the engraved commentary on the street, as in those literary equivalents, we discover a humorous focus on the spectacle of class conflict, fashion, signboards and the exposed body, a focus that, rather than being ostentatiously partisan or moralised, is articulated in a deliberately ironic and distant manner. Texts like Brown's and Gay's, we can now suggest, offered an easily invoked supplement to the framing captions of poetry incorporated in social satires like *The Beaux Disaster*. The urban consumer, of course, was able to move between both types of commodity, and enjoy the echoes and repetitions at play between both word and image.

IV

In this chapter we have found that Walker's engraving not only maintained the broader conventions and concerns of graphic and literary satires, but also maintained satire's traditionally dialectical engagement with polite cultural materials, ranging from the topographical print to the fashion plate. Now, however, I should like to complicate these findings by analysing in more detail the ways in which *The Beaux Disaster* revises and redeploys satiric practice. In particular, I want to suggest that the print, however critical in its perspectives, and insubordinate in its methods, deliberately blurs the boundaries between satirical and polite modes of representation, and redraws the dialectical relationship between them as a more conciliatory, dialogic, exchange. In the last two chapters, we have seen that artists as different as Hogarth and Gravelot had sought to produce images that mediated between satirical and polite readings; Walker's image extends and refines this process. To demonstrate this form of pictorial negotiation, we can analyse successively *The Beaux Disaster's* re-articulation of the street as a form of theatre, its representation of history and its construction of spectatorship. In all these ways, Walker's engraving expresses a version of social satire that, while highlighting the discordancies of the city, simultaneously muted them through a polite pictorial rhetoric of theatricality, modernisation and spectatorial withdrawal.

To begin, we can suggest that *The Beaux Disaster* theatricalises the street space in a highly explicit way. For the contemporary viewer, the image's concentration on the figure of 'Fribble' would inevitably have reminded them of the character with the same name famously played by David Garrick in a farce he had written entitled *Miss in her Teens*, first performed at the Theatre Royal in Covent Garden in 1747. In invoking this character, Walker was not so much linking his image to a specific scene in that play – there are none that correspond exactly with the event depicted in the satire – but rather refiguring his depiction of a crowded pocket of urban space in relation to the entertainments and pleasures of the modern stage. *The Beaux Disaster* depicts a street theatre in which the fop – just as at the Theatre Royal – functions as a spectacular focus for a range of actors and viewers. In Garrick's play, Fribble had also come under attack from the representatives of popular culture: he complains of an argument with a 'hackney coach fellow' which

provoked widespread mirth – 'the masculine Beasts about us fell a laughing.' The encounter ends up with Fribble being whipped on the fingertip and fainting: 'while I was in this condition, the Mob pick'd my pocket of my purse [and] my scissors.'[22] *The Beaux Disaster*, in depicting a similarly humorous scene, thus duplicates the strategies of modern stage comedy in pictorial form, and redefines social conflict as a theatricalised form of farcical spectacle. In doing so, Walker picks on someone who had become a stereotypical butt of polite as well as plebeian laughter in the period, and who demands further investigation – the figure of the fop, also known as the beau.

Garrick's Fribble exemplifies the mid-eighteenth century notion of the fop. He is described by a female character in the play as 'speaking like a lady for all the world, and never swears as Mr Flash does, but wears nice white gloves, and tells me what ribbons become my complexion, where to stick my patches, who is the best milliner, where they sell the best tea, and which is the best wash for the face, and the best paste for the hands.'[23] Garrick's codification of the fop drew upon a long-established stereotype, and maintained his traditional identity as a precious, vain, emasculated slave of fashion who uses his knowledge of dress, make-up and frippery to wheedle his way into the attentions and affections of women. The term 'fop' was also a staple of non-theatrical satire in the mid-eighteenth century when it was used interchangeably with the word 'beau', whom the *Gentleman's Magazine* in 1748 described as 'that strange thing made for shew,/ That compound of powder and nonsense, a beau.'[24]

In contemporary writings, the beau was perceived as a figure hovering ambivalently between different genders, and as someone whose bodily identity had become wholly subordinated to the rhetoric of commodified appearance. Robert Campbell declared in 1747 that 'there are a number of beings in and about this metropolis, who have no other identical Existence than what the Taylor, Milliner and Perriwig-maker bestow upon them. Strip them of their distinctions, and they are quite a different species of Beings; have no more relations to their dressed selves, than they have to the Great Mogul, and are as insignificant in society as Punch, depriv'd of his moving Wires, and hung up on a peg.'[25] This reference to an artificial, puppet-like body was a constant metaphor in discussions of the fop: he was defined as a decorporealised plaything, a 'toy', a mechanised hermaphrodite. Significantly, the ubiquity of the fop as a site of satirical critique coincided with the fashion for 'pantines', paper puppets which, by the end of the 1740s, had become common playful accessories for elite females. Writers were quick to make the comparison: a correspondent to the *Gentleman's Magazine* in 1748, having discussed the craze for the puppets in high society, goes on to describe the fop as a 'creature, whose dress bespeaks him man, but his occupation a something less than woman. A puppet too plays in his tender fingers! their gentle touch directs the paper limbs, whose antic postures draw a grin on his unmeaning face.' The fop, in this account, is described as 'a Fribble, a blank in the creation, a living Pantine, a meer machine moved by folly.'[26] Other writers amplified this notion of the fop as a disembodied entity hanging like a dressed-up mobile around women's bodies: a satirical poet in an issue of the *Gentleman's Magazine* published in 1747 described the fop as 'The Dangler: A Dangler is of neither sex,/ A creature born to tease and vex . . . The

creature gives but small offence,/ contented with a small recompense;/ A whisper in a public place,/ A simper from a smiling face.'[27] On the other hand, the fop was frequently compared to a traditional satirical trope of stupidity and imitation, the monkey. *The Female Rake*, for example, declared that 'Our modern Fashion yet more monstrous grows,/ Apes commence Suitors, and Baboons turn Beaus.'[28] In this second kind of discourse, the fop is re-articulated as a freak on display, his fine clothes serving only to emphasise the ape-like distortions of his body. Oscillating between the rhetoric of the emptied sign and that of animality, satirical texts on the beau/fop thus collectively defined him as a spectacular site of difference, confronting and confirming polite ideals of masculine identity.

If we look again at Walker's print, we can now see that it provides a complex visual mediation of such discourses. In *The Beaux Disaster* the fop is situated in his habitual place at the centre of a collective feminine gaze – 'the Butchers Shout & Ladies stare' declares the caption – but redefined as a comic spectacle that could be read two ways. To adopt the perspective of the plebeian women watching on the left, his juxtaposition with the hanging carcases reinforces his status as a decorporealised composite of commodities, an intruder from the fashionable realms of the Strand whose finery makes a ridiculous contrast to the naked meat. Meanwhile, for the fashionable women on the right, themselves defined and sealed off from the street by their clothing, he can be reconstituted as a grotesque counterpart to the gutted flesh, someone whom the caption successively describes as a 'pigmy' and a 'monkey', swinging from a butcher's hook. At the same time, the print redeploys the metaphor of the puppet that we noted earlier: Fribble's jerking, flailing body, hanging by a thread, and framed by the horizontals and verticals of the stall, irresistibly conjures up the stereotypical image of the fop as a *pantine*, a dangler, a piece of machinery providing a dumb form of comic spectacle. Divorced from his habitual female controllers, he is instead manipulated, hung up and spun by a clutch of brawny males. Finally, the fop's parallel codification as a decorporealised form of representation, as a sign rather than a body, is suggested in the engraving by his comic assimilation into the display of street signs; he, too, juts out above the pavement and temporarily offers an entirely incongruous iconography of commercial identity for the butcher's stall, one that parodies the sober maritime imagery swinging on the other side of the street.

In *The Beaux Disaster* the fop is not only constituted as a theatrical focus for the street's temporary and permanent inhabitants, but is also integrated into a space that provides a parallel form of action, response and laughter to the playhouse. This pervasive theatricality – reinforced by the division of the street space into differently classed viewing positions, just as in the London playhouses themselves – helps to mediate the print's concentration on Butcher's Row as a subject. The focus on the representatives of a particularly independent sector of popular culture is re-articulated in the playful formulae of theatrical comedy, in which the plebeian participants and protagonists are recast as cheerful performers and audience, rather than as figures with any real grievance against the polite or the fashionable; indeed, their target, the fop, is redefined as someone who can be laughed at by both classes at once. In this respect, the street becomes pictured as a space in which there is a comic *performance* of conflict, rather than conflict itself. Walker's image, which at

one level seems to be preoccupied with a central narrative of popular antagonism and ridicule, thus concurrently works to defuse that antagonism by turning it into a form of graphic theatre.

<p style="text-align:center">V</p>

Another form of mediation is effected through *The Beaux Disaster's* depiction of Temple Bar and Butcher's Row. Temple Bar, which was erected in 1672, had been designed by Christopher Wren as a monument celebrating both the reinstated monarchy and the re-emergence of the capital from the ruins of the Great Fire of 1666. The gate stood at the intersection between the old City of London and Westminster, and its role as an edifice straddling two different social spaces generated a variety of urban associations from the late seventeenth century onwards. Initially, the archway had been intended as a ceremonial point of entry into the City for the reigning monarch, a function complemented by the statues of different kings and queens occupying the niches on either side of the gate. More powerfully, however, the Bar had became the conventional destination for popular, royalist processions held in the late seventeenth and early eighteenth centuries, a place where thousands gathered to watch effigies of the Pope and the Pretender being thrown onto huge bonfires. The gate's status as a spectacular focus of popular allegiance to the king was reinforced by the practice of impaling traitor's heads on spikes erected on the Bar, and in Walker's image we can just see the remains of two of the men executed after the 1745 Rebellion.

In *The Beaux Disaster*, this resonant landmark of the capital is juxtaposed with the goods and occupants of Butcher's Row, a street that enjoyed a venerable reputation as a fiercely independent and active base of plebeian culture. This reputation was partly founded on a central event in the area's history, the Burning of the Rumps of 1660. In February that year (shortly before the Restoration of the monarchy), the butchers of the street had taken part in a popular, pro-monarchical riot against the Rump Parliament, in which urban discontent had been most dramatically symbolised by the brandishing, burning and spitting of meat taken from the butcher's shops. According to Pepys, fourteen bonfires were erected between Ludgate Street and Temple Bar, as the streets around the gate – at that time a wooden construction – framed a dramatic insurrectionary spectacle, in which the hanging, burning rump (*fig. 104*) became the sacrificial, carnivalesque focus of plebeian laughter and derision.[29]

These historical references become all the more significant in our reading of *The Beaux Disaster* when we realise that Walker's satire offers a thoroughgoing reinvention and modernisation of the spaces, structures and protagonists depicted by Hogarth in his seminal representation of the event, *Burning the Rumps at Temple Bar (fig. 105)*, which illustrated an episode from Samuel Butler's poem 'Hudibras' of 1663–68. In the earlier image, first published in 1726, but still on sale in the 1740s, there is the same rhythmic perspective of facades ending in the potent symbolism of the gate, here shown from the east side. Again, body parts are stuck on spikes on top of the Bar. Meanwhile, closer to us, we find an older array of

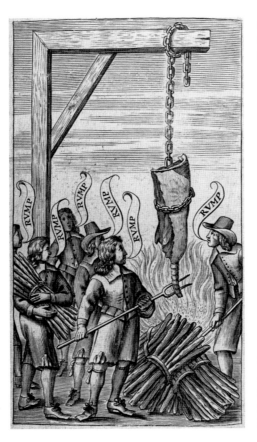

104 Frontispiece to *The Rump*,
1662. Engraving, 5 × 3 in. University
of York Library.

105 (*below*) William Hogarth,
Burning the Rumps at Temple Bar,
1726 (BM 514). Engraving, $9\frac{5}{8}$ ×
$19\frac{1}{2}$ in. Courtesy of the British
Museum.

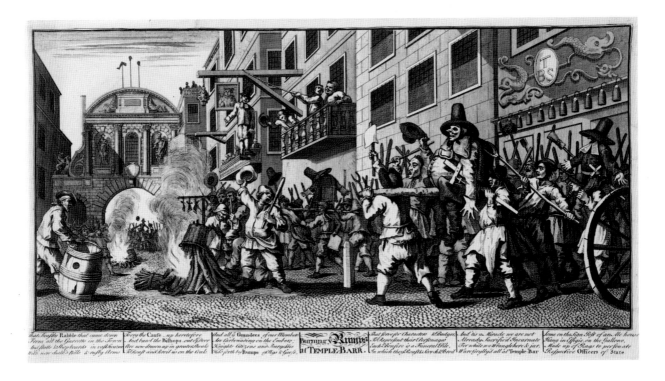

swinging effigies, street signs and hunks of meat, which are integrated into a masculinised display of popular defiance and laughter. The iconography of *The Beaux Disaster* would have maintained some of these historical associations for the contemporary viewer, and was available to be read alongside Hogarth's formulation of popular, urban self-assertion. Through this historical reference, a seemingly innocuous and humorous form of street comedy is mapped onto a register of plebeian anarchy that is shown, however diluted, as continuing to define the area around Temple Bar. The residues of Hogarth's image that can be glimpsed in *The Beaux Disaster* thus correlate to the residues of popular resistance and independence informing the modern narratives of Butcher's Row. Fribble's dangling body, on this reading, parallels the swinging puppets of the hated Parliamentarians, made up of straw and clothing, that hang above the street in Hogarth's engraving. Here, the fop's plight can be seen to allegorise a pervasive pattern of urban conflict that is as venerable as it is endemic, and that revolved around the confrontation of the grotesque bodies of the populace with the disembodied representatives of their social betters.

Yet what is even more striking about *The Beaux Disaster* is the rewriting of these narratives and their assimilation into a very different network of meanings. If Hogarth depicted the environment adjoining Temple Bar in terms of history, politics and masculinity, Walker redefines it as one governed by the narratives of fashion and commodification, and populated by women as well as men. The traditional identities of Temple Bar and Butcher's Row are thus overlaid and invaded by the characteristics of modern commercial culture. This process of re-reading and modernising urban space is confirmed by a pictorial gentrification that both tidies and contains the plebeian. This begins, on Walker's part, with his depiction of Butcher's Row itself. In the 1740s the Row was still a notoriously dilapidated and seedy conglomeration of half-timbered houses, with overhanging upper storeys that leaned precariously over the street. Walker replaces them with the flat-fronted Georgian facades that dominated the commercialised sectors of the nearby Strand. In doing so, he mutes the dissonant vernacular of walls which, in reality, marked the resistance of Butcher's Row to the influx of modern life. Walker performs a similar graphic laundering on the street's inhabitants. We have only to compare his depiction of the poor's faces with those depicted in *Burning the Rumps at Temple Bar* to recognise a very different codification of the popular body: rather than the crude physiognomic distortion of the marchers in Hogarth's image, Walker's plebeian protagonists are given faces that are infantile, cheerful, almost sweet, and dotted with dimples (*figs 106 and 107*).

Meanwhile, Walker also introduces into the image the more well-to-do figures of the two gentlemen on the left – both of them ignoring, at least temporarily, the display of the prostitute – and the affluent group on the right, who are suspended ambivalently between the codes of polite fashion and sartorial excess. The contemporary viewer could read the trio in two ways: either as a group to be aligned with the fop as targets of the print's satire or, more probably, as a cluster of figures separated from him, and suggested as models of a more legitimate mode of attire and gesture. Unlike their counterparts in *The Lady's Disaster*, they are not impeded or confronted with an antagonistic itinerant; rather, they are depicted as smiling

106 Detail from fig. 95

107 Detail from fig. 105

with the crowd, even as they escape out of its clutches and back towards the safer ambits of the Strand. This hint of a more genteel commercial environment existing just outside the frame reinforces our sense that the depicted space in *The Beaux Disaster* is one functioning on the fringes of the polite public sphere, adjacent to the commercialised spaces of gentility rather than entirely alienated from them. As a final guarantor of pictorial decorum, Walker unifies the various individuals and narratives of the street through laughter, which here operates as the agency of a momentary social reconciliation that neutralises the signs of class difference and anxiety, and simultaneously inflects the response of the viewer, injecting into interpretation the innoculatory pleasures of the comic.

The Beaux Disaster, in its various gestures to the traditions and representations of Temple Bar and Butcher's Row, thus situates the conflicts between the fashionable

and the vulgar in a specific historical context, while at the same time dramatising a new mythology of modernity, one that refigures plebeian space in terms of polite architecture, physiognomy, tourism and laughter. Again, then, we are aware that Walker's social satire works both to focus on, and withdraw from, the disturbing fault lines of urban culture. Having explored this dynamic in relation to both the theatricalisation of the street and the graphic reordering of spatial history, we can now look at the ways in which *The Beaux Disaster* constructs spectatorship in similar terms.

<div align="center">VI</div>

The social satire offers a formula of spectatorship that – like the literary satires we noted earlier – associates the viewer with the viewpoint of a male walker in the street. In terms of perspective, our eye-level is typically suggested as that of someone standing in, or passing through, the thoroughfares, alleyways and parks of the city. In *The Beaux Disaster*, this kind of spectatorial positioning is dramatised by the walls of the buildings that tower on either side of the image, which work at the level of representation to insert us in the alleyway and close us in. From this vantage-point, the viewer is not only given the sense of sharing the space occupied by the image's protagonists, but is encouraged to align his or her gaze, however temporarily, with those of the numerous surrogate viewers standing in Butcher's Row itself. The print depicts a series of looks that, intersecting across the picture space, make up a complicated optical web: while the fop is the prime spectatorial focus within the image, a series of other figures look away and at each other, their eyes meeting and missing as they criss-cross the alleyway. The consumer of Walker's print is thus given a host of opportunities to track those looks and in doing so to see the street from a multiplicity of perspectives. We are encouraged, if only for an instant, to co-ordinate our gaze with the look of a butcher, a strolling dandy, a prostitute, a carman and a shop assistant. In this mode, as in June's *The Lady's Disaster*, the spectator's viewpoint is mapped onto, and aligned with, the fragmented, chaotic forms of vision that the street engenders.

If the print encourages this kind of spectatorial masquerade and identification, it is nevertheless apparent that *The Beaux Disaster* simultaneously distances the viewer from the internally delineated perspectives of Butcher's Row. Most obviously, while we are given the viewpoint of someone who has wandered into the passageway, that viewpoint is also separated from the crowd. The foreground space is emptied and we are metaphorically constructed as enjoying a near-invisibility just beyond that space; none of the figures nearby looks out, and we are placed in the shadows. The viewer is thus assigned a pictorially orchestrated, voyeuristic *apartness* from the figures in the street, one that redefines them as the satiric objects of the gaze, rather than as fellow participants in it. Given this distance, our eyes can range freely and ironically over the frieze of bodies and objects that span the picture space, and subject each of them to a humorous form of critical examination. And if this strategy of visual distancing reminds us of the ironic apartness traditionally cultivated by the satirical writer or artist, even as he entered into the street's

narratives, it can also be newly understood as a polite form of surveillance, in which the popular and transgressive bodies of Butcher's Row, and the space they occupy, are subjected to the all-encompassing and carefully differentiated gaze of the genteel urban viewer, watching from elsewhere.

VII

The Beaux Disaster, then, not only maintains the traditional preoccupations of social satire but also makes them more appealing to the polite audience for graphic art in the capital. In the previous chapter, we saw Gravelot's political satires functioning in a similar way. The French artist had left London in 1746 and Walker's work – in *The Beaux Disaster* and beyond – may be understood as occupying the vacuum left by his departure.[30] Walker, who had been an apprentice of an engraver and print seller working in Fleet Street, John Tinney, was only in his early twenties when he produced *The Beaux Disaster*, an engraving which confirmed his precocious reputation as a brilliant draughtsman. The image is marked by a sensitivity of line and tone that overlays the depicted subject matter with yet another mark of graphic gentility and elegance. As such the print provides a particularly complete and delicate deployment of French codes of drawing by an English artist, which also reinforces the claims of the social satire as a refined graphic product. It is not only that we find traces of Gravelot's iconography in *The Beaux Disaster*, but also that we are presented with a near-facsimile of the linear syntax that he had contributed to British graphic art, and that had become established as a modern, polite aesthetic.

 This repackaging of social satire helps us recognise that Walker's self-concious appropriation of John June's and William Hogarth's pictorial vocabulary in *The Beaux Disaster* functioned not only as a gesture of continuity and indebtedness, but also as part of a process of polite adaptation that was reconfiguring the identity and traditions of the genre. The pictorial vocabulary of refinement and improvement present in the image could be extrapolated outwards to suggest a wider refinement and improvement of social satire as a category of the graphic arts. This was a way of defining satire that functioned to defuse the genre's continuing potential as a radical category of representation and urban commentary in mid-eighteenth-century London, and that sought to homogenise the genre's continuing diversity under the auspices of politeness. Having begun to suggest that we should situate Walker's image within a broader redefinition of social satire's appeal in graphic culture, we can proceed to examine a strident and highly self-conscious response to this process of redefinition, that constituted by Hogarth's set of six prints, issued in the spring of 1751, entitled *Beer Street*, *Gin Lane* and *The Four Stages of Cruelty*.

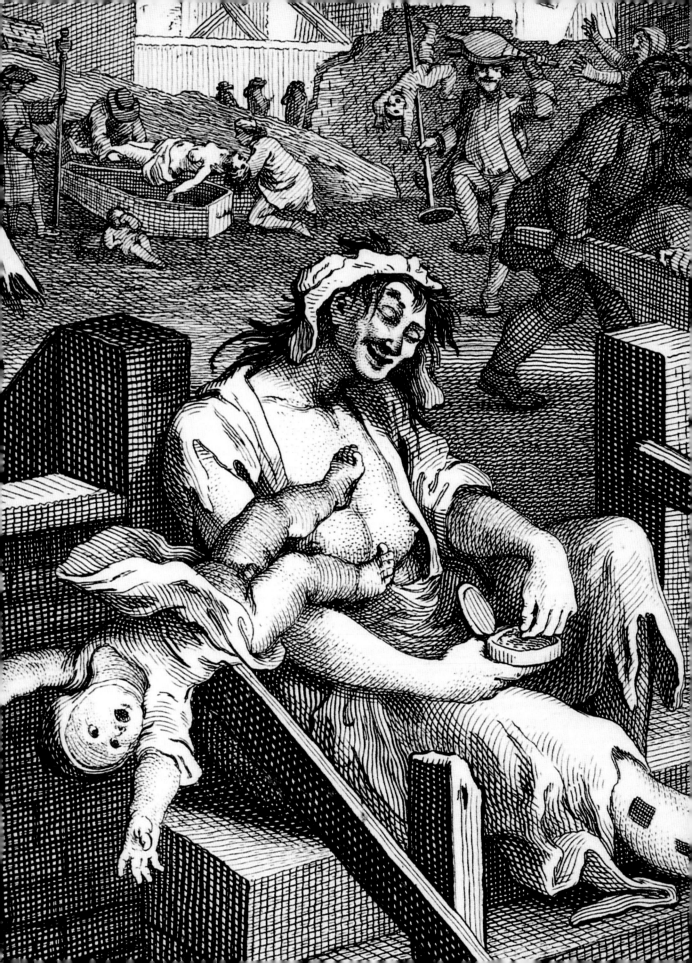

Chapter Six

The Spectacle of Difference

The subscribers to the *London Magazine*, like thousands of other newspaper and journal readers in the capital, were repeatedly confronted in the early months of 1751 with articles and poems dealing with a single topic – gin. In January, the periodical published a verse which was described as having been 'chalked on the smitten of an Infernal Gin-Shop': 'BRITON! if thou wou'dst sure destruction shun/ From these curst walls, as from a serpent run,/ For thee a thousand Deaths in ambush lie,/ Fatal to all, who dare approach too nigh.' In March, the liquor was attacked in the magazine as 'that subtle poison which glides pleasantly thro' the veins; that liquid fire which parches the entrails; and debauching, and unhumanizing the understanding, rouses the mad quaffer to theft, murder, and the most enormous crimes.' Later in the month, a correspondent sent in a couplet satirising the contents and profits of another dramhouse: 'Of Gin, the mighty reservoir behold,/ Where Satan's piss is chang'd to sterling gold.' And in February, the journal had published a poem that coupled this kind of rhetoric with the shocking description of an individual victim: an 'Epitaph on a GIN-DRINKER' declared that 'Half burnt alive, beneath this dung-hill lies/ A wretch, whose memory the safe despise./ Her brain all tumult; ragged her attire;/ The sport of boys when wallowing in the mire.'[1] This invocation of the crazed lush as the figural centre of the writings on gin addiction was frequently duplicated outside the pages of the *London Magazine*. In *The Morning Walk; Or, City Encompass'd*, for instance, which was also published in 1751, W. H. Draper dramatised an encounter with an inebriated bride being carried through the streets of the Fleet district of London: 'Behold! What shocks the eye, intoxicate,/ A tatter'd female drunk, with sulph'rous GIN,/ In high procession borne . . . her legs wide-sprawling, portrait true of shame . . . All conquering GIN, how great thy triumphs here!'[2]

I

In February of the same year, William Hogarth published *Gin Lane* (*fig. 109*), which similarly centres on the figure of a female gin-drinker, and situates her as the compelling focus of the spectator's gaze: sprawling across the stairwell of a St Giles gin shop, she dominates the engraving with a lugubrious abandon. Having glanced at some fragments of contemporary poetry and prose, we can already begin to

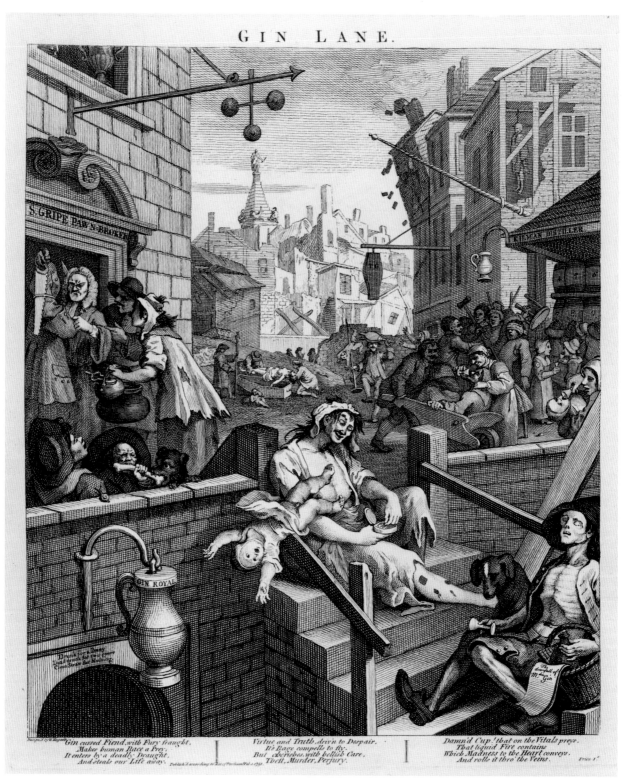

109 William Hogarth, *Gin Lane*, 1751 (BM 3136). Engraving, $13\frac{7}{8} \times 11\frac{7}{8}$ in. Courtesy of the British Museum.

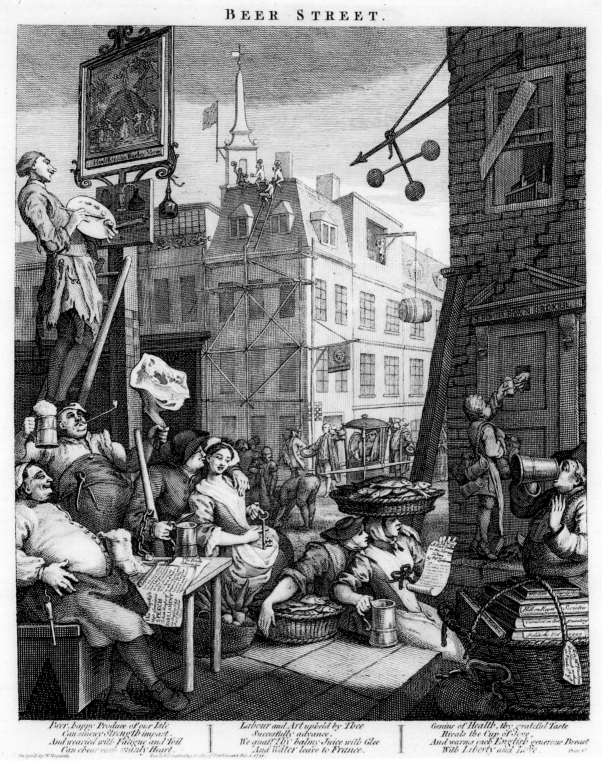

BEER STREET.

Beer, happy Produce of our Isle
Can sinewy Strength impart.
And wearied with Fatigue and Toil
Can chear each manly Heart.

Labour and Art upheld by Thee
Successfully advance,
We quaff Thy balmy Juice with Glee
And Water leave to France.

Genius of Health, thy grateful Taste
Rivals the Cup of Jove,
And warms each English generous Breast
With Liberty and Love.

110 William Hogarth, *Beer Street*, third state, 1751 (BM 3126). Engraving, $14\frac{1}{8} \times 11\frac{7}{8}$ in. Courtesy of the British Museum.

suggest that her representation operates in exchange with a series of contemporary discourses that engaged with the questions of alcoholism and its victims in highly specific, and highly gendered, ways. Uncovering these exchanges encourages us to look at the engraving afresh, which in this case is especially difficult, for *Gin Lane* has acquired a somewhat petrified and too-familiar status as a representation of eighteenth-century London. The print has served as the ubiquitous adjunct to social histories of the period, and is usually deployed to provide a seemingly authentic snapshot of the less salubrious aspects of metropolitan society in Georgian Britain. Meanwhile, *Gin Lane's* art-historical identity has traditionally been determined by, and integrated into, the heroization of William Hogarth as an artist standing alone in the graphic culture of his time, and firmly linked to his perceived role as a didactic, moralistic artist.[3] The interpretation of the engraving in these terms has rather unquestioningly, if unsurprisingly, relied on Hogarth's own retrospective statement, in the autobiographical notes published after his death, that *Gin Lane* and its pendant piece, *Beer Street* (*fig. 110*), 'were done when the dreadful consequences of gin drinking was at its height. In *Gin Lane* every circumstance of its horrid effects are brought to view in terrorum. Nothing but idleness, poverty, misery and ruin are to be seen. Distress even to madness and death, and not a home in tolerable condition but pawnbrokers and the Gin shop.' Hogarth goes on to write that 'Beer Street, its companion, was given as a contrast, where the invigorating liquor is recommended in order to drive the other out of vogue. Here all is joyous and thriving. Industry and Jollity go hand in hand.'[4]

This summary of the prints' contexts and meanings, although extremely helpful, has remained uninvestigated, and frequently been allowed an unimpeachable sufficiency as a key to interpretation. Rather than submitting to the dictates of authorial authority, this chapter will re-examine *Gin Lane's* contemporary identity and concentrate on the print's status as a graphic commodity operating in an economy of cultural production and consumption extending far beyond Hogarth's studio.[5] I shall propose that Hogarth's image operated as a complex intersection in that economy, mediating a range of representations, both pictorial and textual, and generating a variety of readings that resisted the interpretative closure suggested by Hogarth's own retrospective account of the image's gestation and appeal. Further, I shall argue that *Gin Lane* demands to be understood not only as a vehicle of reformist polemic but also in terms of the functions and traditions of graphic satire; in other words, that Hogarth's pictorial intervention in an intense contemporary debate concerning urban addiction and breakdown offered a powerful reformulation of the identity and appeal of the satirical print on the contemporary art market. While *Beer Street*, as we shall see, parallelled and partly continued the satirical imagery produced by engravers like Walker, *Gin Lane* provided a dramatic alternative. The print resurrected an older, less reassuring iconography of the city, depicting St Giles as a chaotic dystopia crowded with decrepit, skeletal, skewered and cadaverous bodies. Here there is no laughter, no trace of elite fashion, no ironical gesture to the decorous narratives of the polite public sphere. Instead, Hogarth's image articulates a pictorial rhetoric of abjection that focuses on the prone female figure as a symbol of urban breakdown and as a spectacle of excess and difference.

In exploring and explaining this redefinition of graphic satire, I shall bracket my analysis of *Gin Lane* with shorter discussions of both *Beer Street* and the other four prints that were being advertised by Hogarth in the February newspapers, which he described as representing 'the Subject of Cruelty.'[6] In *The Four Stages of Cruelty*, even more than in *Gin Lane*, particularly strident forms of denunciation and deterrence are meshed with an aestheticisation of the most extreme kinds of corporeal and social violence. What needs to be examined is how and why this disturbing combination of representations became the basis for commodities sold on the marketplace as ambitious works of art.

II

A few weeks after the publication of *Gin Lane*, *Beer Street* and *The Four Stages of Cruelty*, an anonymous writer published *A Dissertation on Mr Hogarth's Six Prints*, which declared itself to be 'a proper key for the right apprehension of the author's meaning in those designs.'[7] The pamphlet, which runs to more than sixty pages, begins by taking the form of an extended textual walk round the capital; having traversed the horrific, gin-soaked environs of St Giles, the narrator strolls into 'Beer Street' with relief:

> Here methinks I begin to breathe fresh air; the people have healthy wholesome looks, and the children are plump, sprightly, and of a cheerful countenance; the men are hale and robust, and the women have their true natural complexion, heightened with a ruddiness that gives a glow to every beauty ... Here I fancy is good living: for where are so many signs of Jollity, and Health and Cheerfulness appears in every countenance, there can be no want of the necessaries of life. Besides, everybody seems busy and merry in their various trades and occupations; some are singing, some are laughing and joking among themselves, all with good humour in their faces, and industrious in their business.'[8]

This rather free response to Hogarth's image – there are no children, plump or otherwise, in the engraving – nevertheless remains loyal to *Beer Street's* most explicit level of meaning, in which a cheerful and prosperous community of skilled workers occupies a London square undergoing reconstruction. We are provided with abundant narratives of ease and improvement. Working men – a butcher, a blacksmith and a paviour – sit and stand with resplendent self-satisfaction outside the Barley Mow, a grand public house, their hands clutching tankards of ale. A speech by the king on the 'Advancement of Our Commerce' falls across the table and, underneath, the piles of vegetables and fish brought from the capital's markets are symbols of plenty complemented by the patriotic hunk of British beef being brandished in the air above. Beyond, a road is busily being rebuilt and in the background the calligraphic criss-cross of scaffolding on the facade of another alehouse underwrites the distant view of roofers and tailors. They raise their hats and flagons to the king's and the nation's health. Meanwhile, deep in shadow, a ruined pawn-broker's premises falls apart, the scarred wall propped up by a plank

of wood; the faceless proprietor's forlorn hand reaches out through the door for a last source of relief.

Hogarth's print supplements the mythical narratives depicted in the Barley Mow's own sign, where an older ritual of prosperity, the harvest dance, has been newly painted. In delineating a modern, urban version of such communal pleasures, *Beer Street* exploits and amplifies the growing respectability of the large alehouse in mid-eighteenth-century London. Earlier in the century, complaints about urban alcoholism had concentrated as much on the tavern as on other drink outlets: the author of a *Dissertation upon Drunkenness* of 1727, for instance, complained of the 'vile obscene talk, noise, nonsense and ribaldry . . . together with the fumes of tobacco, belchings, and other foul breakings of wind, that are generally found in an ale-room.'[9] In succeeding years, however, as Peter Clark has demonstrated, the larger alehouses of the city were increasingly marketed as more genteel environments, places of rendezvous for petty entrepreneurs and skilled craftworkers where business could be combined with pleasure, where the literate could read the newspapers provided on the premises, and where the visually curious could peruse the prints and ballads that increasingly formed part of the interior decor.[10] This form of institutional improvement operated in parallel with the promotion of beer as a healthy and venerable elixir that was indispensable to the rhythms of urban labour and trade. The *Dissertation* on Hogarth's prints declares that 'strong beer nourishes the blood and comforts the Intrails. 'Twas thus, with its noble companion Roast Beef, that gave vigour to the arms of our brave Ancestors.' In modern London, the same writer declares, periodic sips from a communal jug of ale provide the workers with 'new spirits, and a refreshment which trickles through every vein of them, by which they feel themselves comforted, and fresh vigour and strength added to go on with their work to the end of the day.'[11]

The caption to *Beer Street* reinforces such associations with newly acquired political and nationalist narratives, in which beer is seen to be a guarantor of social freedom and patriotic fellow-feeling: 'Genius of Health, thy grateful Taste/ Rivals the cup of Jove,/ And warms each English generous Breast/ With Liberty and Love.' In a variety of ways, then, Hogarth's print maintains and intervenes in a wider project of cultural and commercial rehabilitation for the 'happy produce of our Isle', a project which depended for its coherence and success on the concurrent demonisation of gin as a 'foreign' liquor that, unlike beer, was being distributed from squalid, subterranean outlets spread across the city.

These narratives in *Beer Street* contributed to a broader pictorial aesthetics of urban improvement being generated in mid-century London. In the previous chapter, we discussed the vogue for the urban topographical 'prospect', which customarily defined the city's social spaces as thriving environments of trade and communication, framed by the sunlit, uncluttered, sweeping facades of modern architecture, and dotted with religious and civic landmarks. *Beer Street* – and it is important here to remember the explicitly topographical reference of the print's title, however apocryphal – partly maintains the iconography of the urban prospect, including as it does such characteristic details of the genre as the succession of sunlit windows, the glimpsed church steeple and the taxonomic delineation of a myriad trades and occupations. More importantly, Hogarth's engraving echoes the imagery

111 Samuel Scott, *An Arch of Westminster Bridge*, c. 1750. Oil on canvas, 53½ × 64½ in. Tate Gallery, London.

being produced to represent and celebrate the extensive urban reconstruction and spatial reorganisation taking place in contemporary London. The most celebrated example was the erection of Westminster Bridge between 1738 and 1750, a structure which was continually invoked as a public symbol of urban prosperity and expansion, described by its architect as a 'very great ornament to the capital of the British empire . . . and a considerable means towards the increase of Trade, Manufacture and the Useful Arts.'[12] Numerous artists, most famously the Italian painter Canaletto, executed views of the emergent structure at mid-century; here, I would like to turn briefly to Samuel Scott's *An Arch of Westminster Bridge*, executed early in the 1750s (*fig. 111*).[13]

Alongside the painting's dramatic delineation of the bridge's newly built facade, caught between the sun and the stretching shadows of evening, we find an abbreviated but eloquent figural narrative of labour and relaxation that closely relates to that outlined in *Beer Street*. On the last piece of scaffolding to cling to the bridge, two masons exchange a tankard of ale, their gesture commemorating not only the end of the working day, but the completion of the twelve-year building project. On the river, a boatman gently eases the tiller through the water as he, like Hogarth's stately blacksmith, puffs contentedly on a long pipe. Nearby, the back

of an assistant bends over another pile of produce, while under the bridge two
other boatmen, pausing from work, smoke and talk at their leisure. In Scott's
painting, as in Hogarth's print, the narratives of urban reconstruction are harnessed
to a mythicised, and heavily masculinised, iconography of popular productivity,
affluence and leisure. The conflicts generated within urban society by capitalist
expansion, and the gaps that inevitably emerged between the demands of a
commercial patriciate and the desires of a plebeian workforce, have, it seems, been
ironed out.

Comparing *Beer Street* to Scott's painting, however useful, also accentuates the
differences between the two images and powerfully suggests that we revise and
complicate our account of Hogarth's print. For as much as his engraving seems
to promote an ideal of urban prosperity, it also – systematically, it seems to
me – exposes that ideal as comic, provisional, constantly punctured. Here, very
differently from the classic topographical and architectural view, the participants
of popular culture are pulled into close-up: we are encouraged to scrutinise
their every gesture. And so we can look again, more carefully, at the group of
cheerful figures who straddle the foreground of the image. Should they really be
taken seriously as the vanguard of a new urban prosperity? They are equally
available to be read as a grotesque and comic allegory of corporeal, plebeian excess,
an allegory made up of gigantic pot-bellies, absurd slabs of meat and salacious sweet
nothings whispered into the ear of a housemaid, a woman whose swinging key so
obviously signifies her sexual availability. It is an allegory choreographed by the
dance of the beadle's fingers over this woman's breast, and extended across the
foreground, moving along the most notoriously degraded of all London street-
traders, the Billingsgate fishwomen, and concluding in the corpulent figure of the
porter on the right, his face buried in a flagon. Elsewhere in the print, we find
other traces of comedy and contradiction. In the background, we can glimpse the
familiar figure of a squat fashion victim, her hoop-petticoat trapping her in the
confines of a sedan chair, who has been left marooned in the street while her
carriers stop for a quick drink. Most intriguing of all, however, is the figure of
the penurious sign-painter on the left, someone whose dress and body offer an
immigrant semiotics of gin culture in this laundered environment. His gaze,
ignoring the larger sign's mythical evocation of a rural utopia, focuses on the more
surreptitious emblematics of the gin bottle dominating the smaller sign beneath.
Meanwhile, his smile, suggesting the secret pleasures of this forbidden commodity,
seems further to scramble the certainties of reading fostered by the print's strident,
univocal caption.

What becomes clear is that Hogarth's image fuses the visual platitudes of urban
renewal with an alternative, satirical system of representation, a combination that
correlates in many ways to the mid-century patterns of social satire we uncovered
in the work of an artist like Anthony Walker. In *The Beaux Disaster* (see fig. 95), we
saw that an ironic and critical view of street culture was harnessed to a more
positive, polite pictorial codification of the metropolis. Comparing *Beer Street* with
Walker's image suggests how closely Hogarth was, in this instance at least, working
according to a set of conventions and demands shared by other graphic satirists in
the city. This is particularly apparent if we look at an earlier state of *Beer Street* (fig.

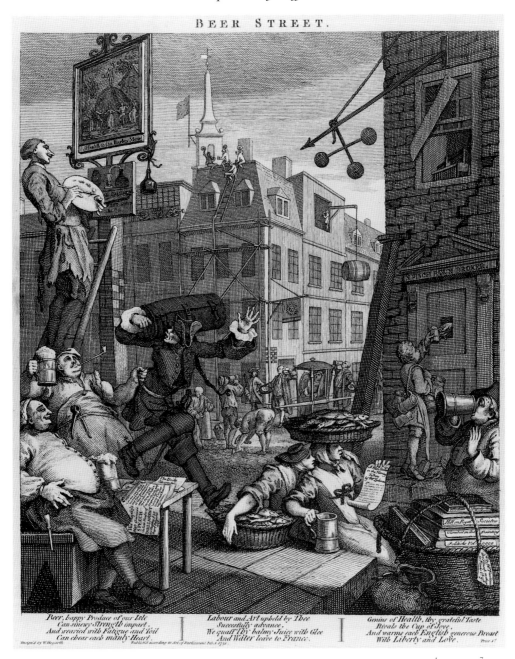

BEER STREET.

Beer, happy Produce of our Isle
Can sinewy Strength impart.
And wearied with Fatigue and Toil
Can chear each manly Heart.

Labour and Art upheld by Thee
Successfully advance.
We quaff Thy balmy Juice with Glee
And Water leave to France.

Genius of Health, thy grateful Taste
Rivals the Cup of Jove.
And warms each English generous Breast
With Liberty and Love.

112 William Hogarth, *Beer Street*, first state, 1751 (BM 3126). Engraving, 14⅛ × 11⅞ in. Courtesy of the British Museum.

112), which includes the suspended, ridiculous figure of a Frenchman being baited by the laughing butcher and blacksmith. He is a perfect stand-in for Fribble, the Frenchified fop who dangled from a butcher's hook in Walker's print, and similarly functions as an emasculated counterpoint to the hearty, vulgar representatives of the city's petty crafts. When Hogarth re-engraved this section of the copper plate, this

comic figure was replaced by a hunk of meat and the preliminaries of a sexual exchange, further visual echoes of *The Beaux Disaster*. However indirect such connections may seem, they confirm the extent to which the multiplicity of readings offered by *Beer Street* conformed to a collective, modern formulation of the social satire as an ironic composite of signs that allowed the spectator a certain critical distance from the depicted communities of the street, and a considerable latitude of interpretation, even as he or she was invited to subscribe to an idealised iconography of the capital as a space of commercial prosperity, social harmony and urban renewal.

<h1 style="text-align:center">III</h1>

If *Beer Street* mapped a satirical topography of the city familiar to the modern consumer of graphic art, *Gin Lane* described an urban prospect with a difference. Hogarth's monumental anti-heroine lies at the centre of a centrifugal narrative of urban disintergration that is unleavened by any hint of humour, ironic or other-wise. Her eyelids are heavy with alcohol, her mouth is pulled into a lopsided grin and her tattered clothes are left open to reveal sagging breasts and legs blotched with a patchwork of disease. She pinches snuff as her infant charge falls headlong over the low railings at her side. Around her, we are shown a chaotic configuration of narrative and space. In the lower-right corner of the engraving, a skeletal ballad seller lies spread-eagled across the steps. On the left, the children who lean on a brick wall are near bestial figures, precociously decrepit, sharing a bone with a dog. Above them, a woman dressed in rags, her hair sprouting out of a tattered headcloth, waits to plead with Gripe the pawnbroker to take her meagre collection of household goods. To their right and further back, a parish beadle watches while the naked figure of a young woman is lowered into a coffin. Her crying infant is left abandoned on the street, and beyond we can spot part of a funeral procession that drifts past the broken walls. Nearer, a man dancing a lunatic jig, battering his head with some bellows, lurches forward carrying a child impaled on a spike. Outside Kilman the distillers, a riot of cripples takes place and the crude props of plebeian disability – stools, crutches, walking sticks – are brandished as weapons. Closer by, a woman pours gin into the mouth of an elderly female invalid crammed into a wheelbarrow, her gesture repeated by the mother standing next to the wall. Between them, we are shown two charity children drinking from gin glasses, their numbers sewn on their sleeves. The space all these figures occupy is loaded with a melancholy staccato of shop signs – the pawnbroker's three globes, the undertaker's coffin, the barber's striped pole, the distiller's and gin shop's flagons – and defined by a pervasive disorder. Walls both collapse and reveal a horrific glimpse of private life in the city: a suicidal barber hangs from the beam of a ceiling, dressed only in his nightshirt. St Giles is thus pictured as an environment blasted by the consequences of urban drunkenness, and in the sunlit background we are offered a mangled anti-architecture of tottering windows, gigantic rafters and naked brickwork.

In focusing so assiduously on the details of alcoholism and urban breakdown, Hogarth's print participated in, and was informed by, a contemporary debate on

urban lawlessness and mortality rates that operated in dialectical opposition to the discourses of urban improvement and health mediated by *Beer Street*. The rhetoric of commercial prosperity was habitually framed and reinforced in metropolitan society, then as now, by the invocation of threatening, invasive narratives of vice, disease and difference. The two most frequently cited sources for concern at mid-century were the dramatic crime levels being experienced in the city, and the leap of mortality rates in the capital, particularly those of infants. Henry Fielding, in his *Enquiry into the Causes of the Late Increase in Robberies*, also of 1751, wrote of his fear of being 'assaulted, and pillaged, and plundered . . . I can neither sleep in my own house, nor walk the streets, nor travel in safety.'[14] In the same year, Corbyn Morris published his *Observations on the past growth and present state of the City of London*, the conclusions of which were widely disseminated through the daily and weekly newspapers. Using an extensive array of statistics drawn from the city's bills of mortality, Morris highlighted 'the increasing destruction of adults and infants in this city and the present increasing diminution of the christenings in London beneath the burials.'[15]

Retrospectively, it seems quite straightforward to attribute any rise in crime – particularly of violent crime – to the influx of newly disbanded sailors and soldiers into the city after the cessation of international hostilities in 1748. The capital was forced to absorb thousands of men who, entering an already overcrowded employment market, denied any government support and brutalised by two years of war, turned *en masse* to the city's highly developed criminal subcultures for a means of subsistence. Meanwhile, the period's high mortality rates can most logically be explained by the chronic problems of overpopulation and inadequate poor-law provision, which spawned a dramatic rate of infectious diseases among the city's poorest communities. Such explanations, which imply a high degree of state and municipal responsibility for these problems, were ignored by most writers on the issues of crime and mortality in favour of alternative hypotheses, one of which involved laying the blame on gin. Fielding, for example, ascribed a large share of the period's criminality to 'a new kind of drunkenness . . . that acquired by the strongest intoxicating liquor and particularly by that poison called Gin'.[16] Simultaneously, Morris attributed the disturbing infant mortality figures among the urban populace almost wholly to 'the enormous rise of spiritous liquors. For it is beyond dispute that such liquors are become the common drink, and even the food too, if it may be termed, of these people.'[17] Gin not only becomes a slow form of murder in his account, encouraging a protracted and terminal self-neglect, but also kills young children and threatens birth itself, a position maintained by a correspondent to the *General Advertiser* of 14 March 1751, who lamented 'the fruit of the womb, blasted before it has seen the light.'[18]

Gin's notoriety was bound up with its class and environmental associations. Cheap to distil and buy, the spirit was a product very explicitly associated with the capital's poor, and thus not only linked to the threat of social disorder but also to the danger of a decline in the labouring and military base of British trade. *The General Advertiser* writer warned that the 'excessive use of the spiritous liquors' ensures that 'the spirit of industry must be sunk, and the hands which should carry on the trades and manufactures of the Nation enfeebled.'[19] Fielding asked, 'Does

not this polluted source, instead of producing servants for the husbandman or artificer; instead of producing recruits for the sea or field, promise only to fill alms-houses and hospitals, and to infect the street with stenches and diseases?'[20] As well as being tied to the poorest sectors of the London populace, gin production and consumption were explicitly linked to certain parts of the city. As early as 1727, a commentator had noted that, 'in the fag-end and outparts of the town, and all places of the vilest resort', gin was sold 'in some part of almost every house, frequently in cellars and sometimes in the garrett.'[21] St Giles was perhaps the most infamous of all these urban danger zones, choked by poverty and constantly described in terms of its physical dilapidation, mass drunkenness and promiscuous levels of everyday violence. Fielding described the area's horrors in his *Enquiry*, detailing the private houses 'set apart for the reception of idle persons and vaga-bonds' in the parish, 'all accommodated with miserable beds from the cellar to the garret', which were 'adapted for whoredom' and 'no less provided for drunkenness, Gin being sold in them all at a penny a quartern; so that the smallest sum of money serves for intoxication.'[22]

In the textual engagement with the disordered body language and symbolic confusions of mass drunkenness, the female gin-drinker, as we have noted, was consistently articulated as the central agent of gin's disruptive workings. In concen-trating so powerfully on this figure in his print, Hogarth monumentalised what had become a highly charged allegorical site of metropolitan disorder in mid-century London. This explicitly gendered form of urban mythology was tied to the traditional feminising of gin itself, nicknamed either 'Mother Gin' or 'Madam Geneva'. The liquor's effects, furthermore, were often described in stereotypes relating to the insidious allure and dangers of the feminine: a poem published in the *General Advertiser* of 1 February 1751, for example, described a fictional 'label for a Gin-bottle' that linked the drink to a venerable female representative of corruption and loss: 'When fam'd Pandora to the clouds withdrew,/ From her dire box, unnumber'd Evils flew,/ No less a crime this Vehicle contains:-/ Fire to the mind, and Poyson to the veins.' More insistently, gin was tied to a broader dramatisation of female drunkenness as a phenomenon of the modern city. A correspondent to the *British Magazine* of 1747, in a letter entitled 'Of the Effects of drinking among women', wrote that 'there is one [vice], which has never yet occur'd to you or to any of your friends to speak of; I mean that of drunkenness in its most detestable appearance in the female part of the world.'[23] Over the next few years, however, the subject became a cliché of critical commentaries on urban society: the author of *A Present for Women addicted to Drinking*, first published in 1750, declared that 'I take this pernicious custom of drinking, which prevails amongst Women at present, to be the great source of that corruption and Degen-eracy, which all the world must allow to be the subject of a just and general censure.'[24]

Gin drinking was condemned as the most dangerous and pervasive catalyst of female alcoholism, which critically threatened the coherence of the family, tres-passed the boundaries of marriage and lured wives and mothers out of their homes into the dubious haven of the dramhouse: 'the labouring workman toils for penury', claimed a contemporary tract, 'while his wife and daughters spend his

honest earnings at the gin-shop; the family is neglected, industry laid aside, and the unhappy family are either reduced to a workhouse, or forced to beg or steal for support, and at last die in want and infamy.'[25] Similarly, the author of *A Present for Women addicted to Drinking* suggested that 'when you see the kitchen in disorder, the children half-naked, and the house in a universal litter, your indignation will rise at the thought of what occasions it; you will, from that moment, look upon a dram-glass as a more dangerous instrument than a Blunderbuss, and believe a distiller's shop more fatal to the peace of society, than a gunsmith's.'[26] This dramatisation of the lush's addiction as a dangerous counterpoint to the normative formulae of feminine domesticity and filial devotion was frequently accompanied by attacks on working women's propensity to the spirit. In Robert Campbell's *The London Tradesman* of 1747, for example, the discussion of petty craftswomen is dotted with such references. He describes button makers who 'make a very handsome livelihood of it, if they are not initiated into the mystery of gin-drinking'; silk throwsters 'who may make good bread of it, if they refrain from the common vice of drinking and sotting away their time and senses'; and bodice makers who, 'if they apply themselves, and refrain from gin, may get from five to eight shillings a week.' The fallible, however, ended in the chandler's shop: 'in these shops maid-servants and the lower class of women learn the first rudiments of gin-drinking, a practice in which they soon become proficient, and load themselves with diseases, their families with poverty, and their posterity with want and infamy.'[27]

The repetitiousness of this vocabulary indicates quite how embedded such narratives had become in contemporary culture, and *Gin Lane* depended for much of its coherence and meaning on the exchanges the print made with such discourses. In these terms, the anonymous lush in the centre of the engraving embodies and extends an allegorised index of social breakdown generated in contemporary London, and works as a pictorial anchor for the broader framework of feminine deviance and debilitation distributed across the image. Moving outwards, we are presented with a succession of girls and women who collectively live out the fatal progress of gin, ranging from the charity children to the old woman in the wheelbarrow, from the housewife at the pawnbroker's door to the near-naked figure of a dead mother, hovering over a coffin that seems too small for her. This cycle of details returns ineluctably to the seated figure in the foreground, who, we can conclude, is designed to be read as a corporeal stand-in for the social collapse that surrounds her. In the same year that Hogarth's print was published, the author of *The Vices of the Cities of London and Westminster*, writing of the general ills of the city, warned of 'the dangerous malady that preys upon the Body Politic . . . the distemper is indeed dangerous, the whole mass is corrupted, every limb and member seized with a mortal gangrene, and a complication of diseases puzzles the skills of the Physician.'[28] *Gin Lane* focuses on someone who fleshes out this metaphor of the body politic, and whose depiction turns the minutely observed signs of feminine addiction and disease into something akin to an allegory of urban collapse.

★　★　★

IV

In his representation of the lush and her surroundings, Hogarth reworked older iconographies of social dislocation that similarly centralised the prone, public female body as a signifier of suffering and abjection. Graphic satire, as we have noted throughout this book, engaged with a variety of pictorial materials, and *Gin Lane* mediates the language and grammar of both high and satirical art. We can begin to recognise the former by juxtaposing Hogarth's print with an engraved reproduction of a local site of public commemoration, Gabriel Caius Cibber's *Allegory of the Great Fire of London* (*fig. 113*). Executed in 1672, this is a sculptural relief fixed to the west side of the Monument to the Fire that stood, and still stands, at the entrance to the City of London. In the mid-eighteenth century, Cibber's work remained one of the most democratically available pieces of high art in the capital, open to scrutiny from a mobile public of passers-by and visitors. Nicholas Goodnight's engraving of the relief – which includes an extended textual explanation of its contents – was published soon after the sculpture's completion. Here, in a complex fusion of allegory, portraiture, emblematical detail and architectural record, a narrative of urban collapse and regeneration intimately analogous to that offered by *Gin Lane* and *Beer Street* is yoked into a single image. And if we think of *Gin Lane* as one half of a pictorial pairing whose other half depicted cheerful builders and scaffolding and that boasted a dense vocabulary of metropolitan reconstruction, we can see how clearly Hogarth's two images used a publicly established visual model. In this model, as Goodnight's caption explains, the forlorn, semi-naked woman situated on some (collapsing) stone steps explicitly allegorises London's disintegration, representing 'the City of LONDON, sitting in ruins, in a languishing posture, with her head dejected, hair dishevelled, and her hand carelessly lying on her sword.' Here, however, she is shown on the brink of rescue: above, goddesses carrying the emblems of Peace and Plenty hover in the clouds, and on the right, the king stands as the masculine guardian of civic order and restoration, perched on the arched platform that we find converted into the entrance of a gin shop in Hogarth's image. Underneath the arch, the figure of Envy, bare-breasted and wild-haired, already offers a grotesque feminine counterpoint, an alternative form of allegory, to the idealised, vulnerable representative of the city.

Hogarth, in *Gin Lane*, thus gestures towards a recognisable, allegorical iconography of the suffering female body as an index of urban breakdown, but fuses this vocabulary with the imagery and narratives of an alternative pictorial regime of feminine identity and social space, one generated within graphic satire itself. The imagery that is most crucial and relevant to the construction of urban breakdown and the abject female body that we find in *Gin Lane* was that generated by the gin crisis of 1736. In September of that year, a parliamentary bill banning the unlicensed sale of spirits had come into force. This was a notoriously unpopular, unworkable and ultimately short-lived piece of legislation, threatening thousands of itinerant and petty gin sellers with extinction, and thoroughly undermining the distilling trade that helped supply them with their products. The day before the act came into operation saw both a massive display of military force in the capital and a communal demonstration of near-carnivalesque defiance: as the *Daily Journal*

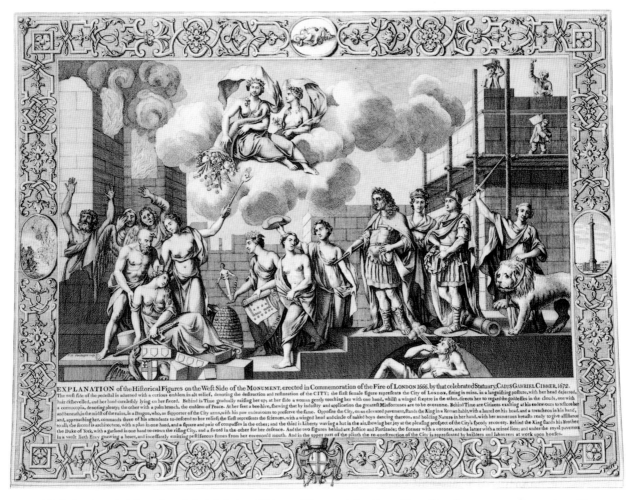

113 Nicholas Goodnight, after Gabriel Caius Cibber, *Allegory of the Great Fire of London*, c. 1700. Engraving. Courtesy of the British Museum.

noted, 'A vast number of people assembled yesterday at the Gin shops, Distillers and Public Houses about the Town, and in the suburbs, who in some places insulted people as they passed by, and many of them got egegiously intoxicated by way of taking leave of the pernicious liquours to which they have been so long enamoured.' The next day, the same paper reported that 'several persons were committed, some to prison, some to hard labour, for publicly and riotously proclaiming "No Gin, No King".'[29]

The controversy surrounding the act generated a spate of graphic satires, including *The Funeral Procession of Madam Geneva* (fig. 114), which shows a mock parade of distillers moving towards St Giles's churchyard. In fact, the same print was reissued by John Bowles in 1751, only months after the appearance of *Gin Lane*. *The Funeral Procession of Madam Geneva* played on the urban symbolism noted by the *Daily Journal* of 28 September 1736: 'Mother Gin lay in State yesterday at a Distiller's shop in Swallow Street near St James church; but to prevent the ill-

114 *The Funeral Procession of Madam Geneva*, 1736 (BM 2277). Engraving, 9 × 13¾ in. Courtesy of the British Museum.

consequences of such a funeral, a neighbouring Justice took the undertaker, his men and all the mourners into custody.' In the engraving, her shrouded coffin is carried across St Giles, followed by a notorious local beggar called Loddy, who heads a train of distillers venting, as the caption declares, 'their loud complaints in vain.' Meanwhile, women, children and cripples – a grotesque pantheon clearly rearticulated in *Gin Lane* – litter the foreground. They variously collapse on the ground, fight, pour each other drinks and get their clothes ripped by a dog. Dominating this cluster of figures, the female gin-drinker is constructed as part of an alienated, feminised community – its male members emasculated through childhood or disability – that is wilfully self-destructive and wholly unconcerned with its public status as a highly visible and repugnant group. Women turn inwards, to each other and to the gin bottle, rather than look out. Again, we are shown St Giles as an environment crowded with the marks of breakdown and death, with gravestones, a coffin and the pillory standing on a distant hill. Most radically, the social instability of this environment is accentuated by a discordant play of perspective

115 *The Lamentable Fall of Madam Geneva*, 1736 (BM 2278). Engraving, $12\frac{1}{8} \times 11\frac{5}{8}$ in. Courtesy of the British Museum.

that breaks up pictorial space and – like *Gin Lane* – allows the viewer a glimpse into the morbid interiors lying behind the public facades of the street. On the left, for instance, the front of a gin shop, dominated by the figure of a barmaid, is placed next to the dislocated details of a graveyard. Above, two boys sit astride yet another fragile parapet. Finally, in a direct reversal of the cultural trespass exhibited in Hogarth's two prints, the *Funeral Procession of Madam Geneva* shows a prosperous artist entering the scene, carrying the palette and paintbrush that we also find wielded by the ragged sign-painter in *Beer Street*.

The *Lamentable Fall of Madam Geneva* (*fig. 115*), also published in 1736, confirms that the imagery produced during this earlier gin crisis had already focused on the plebeian female as a personification of drunkenness. The dramatically foreshortened body at the image's centre is explicitly defined as 'Madam Geneva', someone who represents both a foreign spectre of difference and a pictorial model for the surrounding spiral of women. In *The Lamentable Fall*, she lies sprawled on her back, her skirt hitched up around her hips, her breasts bare and her hand clutching a glass, while nearby another ragged woman stands crying. Closer to us, a lush vomits in the street and a swaying mother and child stroll miserably away. Recognising these features, we can begin to appreciate the ways in which Hogarth's later print – which includes an inscribed reference to 'The Downfall of Madam Gin' – renews this conflation of the lush with the gendered symbolics of gin as a commodity, and maintains her identity in the *Lamentable Fall* as a figure lying at the centre of a feminised circle of narrative. Interspersed among the central figures of the earlier engraving, moreover, we can see a host of other details that reappear in *Gin Lane* – the ballad seller in the foreground, the references to disability and amputation, the depiction of a wheelbarrow's desultory progress, the pictorial concentration on signposts and pamphlets, on staves, steeples and crutches. The print's caption highlights a parallel narrative of plebeian barter and idolatry: 'Queen Gin for whom they'd Sacrifice/ Their Shirts or Smocks, nay both their Eyes.' Meanwhile, a Billingsgate fishwoman, prefiguring the pair of fishsellers in *Beer Street*, wanders across the image and the overwhelmingly male beer drinkers who cheer on the left offer a precise precedent for the contented workers who raise their hats and flagons in Hogarth's later image of urban renewal and masculine cheerfulness.

Spending a little time looking at these two earlier prints – to which we can add another published in the same year, 1736 (*fig. 116*) – makes it clear that *Gin Lane* recycled and depended upon an older satirical iconography of urban breakdown and feminine alcoholism, and situated itself as a successor to a well established mode of graphic imagery generated in the metropolitan print market. Hogarth's engraving, we can now argue, functioned as a point of intersection which mediated both the monumental vocabulary of high art and other, far less decorous modes of representation. As such, it maintained the agenda for graphic satire that we have been recovering in this book, whereby the satirical image, alongside its role as a vehicle of urban social commentary, operated in exchange with a variety of pictorial genres, both high and low. Having begun to establish this mode of practice in relation to *Gin Lane*, and having unearthed its reliance on a crowded repository of pictorial conventions and cultural stereotypes, we can now more

To the Mortal Memory of
Madam Geneva.
Who died Sep.r 29. 1736.
Her Weeping Servants &
loving Friends consecrate
This Tomb.

cease to drop distill no more.

I.Vandermijn Inv.t et Sculp.

To thee, kind comfort of the starving Poor!
To thee Geneva, that art now no more!
This sad but gratefull monument we raise:
Our Arms we yield, no more our Sun shall blaze.
Lo. where Supine her mournful Genius lies,
And hollow barrels eccho to her cries;
On casks, around, her Sad Attendants stand,
The Bunter Weeps with basket in her hand,
His useless Worm the sad Distiller liens.

The Boy with heavy heart for Succour Sues;
What gave her birth now helps her Tomb to build,
The Tub a Spire, A Globe the Can unfill'd.
High in the Air the Still its head doth rear,
And on its Top a Mournfull Granadeer
The Clean white Apron as a Label shown
The dreadfull cause of all our Grief makes known.
Hither repair All ye that for her Mourn.
And Drink a Requiem to her Peacefull Urn.

Published according to Act of Parliament Oct.18. 1736. Sold by y Printsellers of London and Westminster. For Bill. see Gent.l Mag. Ap.1736. Price 6.d Sep.29. 1736.

116 *To the Mortal Memory of Madam Geneva*, 1736 (BM 2279). Engraving, 10⅛ × 7⅝ in.
Courtesy of the British Museum.

clearly concentrate on the print as a pictorial representation. And in this sense, even when we recognise the continuities and parallels between *Gin Lane*, Goodnight's engraving and the 1736 satires, what is also striking are the very different workings of Hogarth's later image. On the one hand, his satire entirely denies and destabilises the narratives of civic rescue present in Cibber's sculptural relief: the lush's pitted body is divorced from both the representatives and spaces of succour, and the church steeple in the background, topped by a royal statue, stands as a stark reminder of the absence of Christian, civic or royal intervention in the engraving. On the other hand, *Gin Lane* evicts all the signs of good cheer and masculine joviality that crowd into the earlier satires, displacing them systematically to its companion, *Beer Street* – a hiving off of representation that emphasises the extent to which St Giles is made utterly impenetrable to any kind of comic, picturesque or positive narrative. In this process, the print also effects a pictorial and interpretative partitioning of social space, one that cordons off a sector of the city and its inhabitants from the more normative narratives and environments of the metropolis. It is to the implications of this acute form of representational ordering that we shall now turn.

<div align="center">IV</div>

The press announcement of the imminent publication of *Gin Lane*, *Beer Street* and *The Four Stages of Cruelty* declared that 'the Subjects of those Prints are calculated to reform some reigning Vices peculiar to the lower Class of People.'[30] What is immediately striking about the advertisement is Hogarth's invocation of 'reform' as an interpretative key to the prints' function and meanings. While earlier sets of his engravings had been partly understood as moralised and didactic commodities, this mode of exchange had been meshed, as we have repeatedly seen, with a variety of other kinds of ironic, humorous and satirical reading. What distinguishes the promotional packaging of the mid-century prints is the extent to which it reconstructs Hogarth's artistic identity as that of a modern guardian of public morality. He declares in the same announcement that, in the hope of rendering the prints 'of more extensive Use, the author has published them in the cheapest manner possible.' On reflection, it is clear that an engraving like *Gin Lane*, even at a shilling, remained out of the financial and the cultural reach of the slum dwellers that it described, people with neither the money nor the inclination to make such a purchase feasible. Rather, the print's 'Use' was geared to a broad and broadly affluent metropolitan public of cultural consumers, people whose interest in the print market was fused, in Hogarth's appeal, to their collective sense of insecurity concerning the encroachments and consequences of an increasingly demonised gin culture. If *Gin Lane* and its companion were available to be bought by the respectable tavern owners, shopkeepers and master-craftsmen of the city, men who could hang them on their walls as warnings and inspirations to their customers and workers, the prints also articulated a message that closely matched the fears and prejudices of those genteel consumers who had little direct contact with popular culture. For both kinds of audience, the artist offers a moralised pictorial agenda

that reinforces a model of social division and distinction – what he has depicted, he suggests, is 'peculiar to the lower Class of People'. In *Gin Lane*, this peculiarity is pictorially as well as rhetorically confined to a tightly circumscribed, proletarian realm: the image effects a sustained piece of quarantine that cordons off what is simultaneously dramatised as excessive and threatening. 'Reform', we can conclude, is translated into a process of social, spatial and pictorial containment.

In performing this kind of graphic compartmentalisation, Hogarth was responding to certain contemporary discourses defining the relationship between polite culture and the poorest members of urban society. In her persuasive analysis of the workings of charity in eighteenth-century London, Donna Andrew has usefully uncovered the normative standards of charitable discrimination in the period.[31] Guidelines, both formal and informal, were being set up in this period to distinguish between those sectors of the urban populace that deserved financial and educational help, and those whose behaviour precluded their receiving any form of assistance whatsoever. While the 'deserving' or 'able' poor were defined as victims or unfortunates who were given the chance to redeem themselves through charitable rescue, other sections of plebeian society were described as having been so colonised by vice that they were not allowed the indulgences of pity and philanthropy. Those who were degraded enough to 'prefer an Idle and Vagabond life of beggary before honest labour, ought not to be encouraged in it by relief', fulminated Thomas Secker in a 1738 sermon before the Lord Mayor, 'but abandoned to the wretchedness which they chuse.'[32] Typical of this condemnatory attitude is the anonymous *Dissertation on Hogarth's Six Prints*, which declares that common beggars go straight to the gin shop each evening 'and spend the charity they have been collecting the whole day from the benevolence of well-disposed people, who give for God's sake, and from principles of humanity, which incline them to relieve those who appear as real objects of compassion. These wretches, however, having for a long time bid adieu to the very sense of shame, laugh at the credulity of their Benefactors, and ridicule the Goodness that has supply'd them with the means of supporting their nightly riots.'[33]

In such writings, the proletarian underside of urban plebeian culture is constructed as insubordinate and manipulative, feckless and grotesque. In a city which was being intermittently dramatised through narratives of crisis as well as renewal, these paranoid mythologies of difference and disobedience framed more celebrated displays of urban benevolence, which tended to be linked to institutions like the Foundling Hospital, set up to look after the abandoned children of the poor. Hogarth was himself a director and an artistic contributor to the Foundling in the late 1740s, but *Gin Lane* offers a very different pictorial and narrative agenda from the imagery associated with the Hospital.[34] A print after Samuel Wale, entitled *A Perspective View of the Foundling Hospital* (*fig. 117*) and executed in 1749, shows a troop of poor women bringing children to deposit inside the gates of the building. Wale's image codifies a legitimate, polite iconography of poverty: the women, drained of individuality by dress and pictorial distance, operate as cyphers replicating the postures, gestures and dress codes of modest and stoic subservience embodied in the statue of Charity dominating the courtyard. Their contemporary dilemma and tragic individual histories – they are shown on the point of giving up

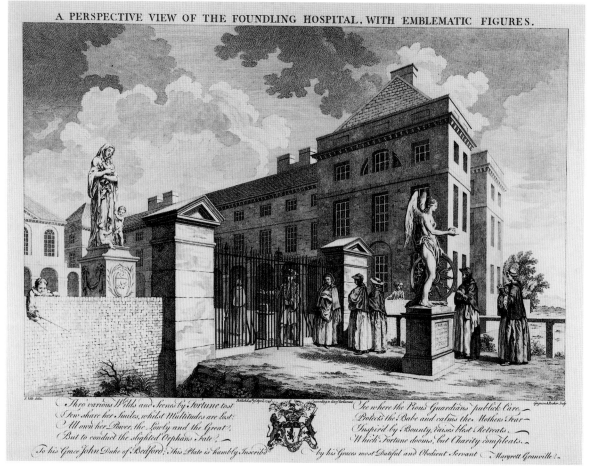

A PERSPECTIVE VIEW OF THE FOUNDLING HOSPITAL, WITH EMBLEMATIC FIGURES.

Thro' various Wilds and Scenes by Fortune tost
Few share her Smiles, whilst Multitudes are lost:
All own her Power, the Lowly and the Great,
But to conduct the slighted Orphans Fate?

To his Grace John Duke of Bedford; this Plate is humbly Inscribe

See where the Pious Guardians publick Care,
Protects the Babe and calms the Mothers Fear
Inspir'd by Bounty, raises blest Retreats,
Which Fortune dooms, but Charity compleats.

by his Graces most Dutiful and Obedient Servant Margrett Granville

117 Charles Grignion, after Samuel Wale, *A Perspective View of the Foundling Hospital, with Emblematic Figures*, 1749. Engraving. Courtesy of the British Museum.

the infants they hold so tightly to their breasts – are similarly neutralised and abstracted by the textual and sculptural references to Fortune in the print. The women shuffle along a highly ordered spatial and representational network, supervised by watching men and dominated by the institutional symbolics of the building itself.

Returning to *Gin Lane*, we can see that a very different rhetoric of abandonment and misery has succeeded the imagery of Wale's print. The female protagonists who so passively pad towards the hospital with their children are replaced by a set of women who are scattered wildly across the image and who abandon their infants to the street, the gin glass or the dogs. At their centre, the plebeian woman is pictured in ways which defy all charitable narratives. Rather than being represented at a discreet distance and enclosed in a neat uniform, her body is pulled close, stripped, and detailed as a dilapidated conjunction of nakedness and disease. Rather than clinging onto her child, she sends it cartwheeling over the edge of the steps. Rather than moving quietly through a hospital gate, she lies across the gateway of

a gin hole. And rather than the feminine symbolics of Charity and Fortune, we find those of Madam Geneva. These contrasts suggest the extent to which the narratives and imagery of Hogarth's print offered an explicit alternative to the ideologies of benevolence and the representations of charity in the city. This was a dialectical rather than a dichotomous form of difference, however: images like *Gin Lane* helped to order plebeian culture into compartmentalised sectors of the legitimate and the illegitimate poor, the worthy and the unworthy objects of polite generosity. As such, the engraving participated in a regulatory mapping that split 'low' culture, and the sectors of the city it occupied, into fragmented, disparate spheres. Exploiting a renewed, near-panicked preoccupation with urban misrule, *Gin Lane* brought a stereotypical female representative of that misrule into sharp critical focus and in doing so dramatised her divergence from the iconographies and environments of plebeian female deference so assiduously crafted by artists like Wale.

VI

This account of the image's so-called reformist appeal addresses a venerable tradition of reading Hogarth's prints as didactic vehicles, a form of interpretation which normally stops at this point and moves on to other matters. Here, however, it is crucial for an understanding of *Gin Lane's* contemporary identity to recognise that, in its focus on a body ejected from the legitimate ambits of the polite public sphere, the engraving simultaneously offered a powerful *aestheticisation* of the deviant female. It is useful to remind ourselves of the verses on the drunken female at the beginning of this chapter, and to recognise that poems like 'The Morning Walk' and the 'Epitaph upon a Gin Drinker', although part of a broader reformist pattern of discourse, also highlighted the potency of the lush as a site of urban spectacle – grotesque, terrifying, but impossible to take one's eyes away from when traversing the city. Hogarth's retrospective comment that 'horrid effects are brought to view in terrorum' in the print dramatises this kind of look, which was maintained and extended in the literary responses to the engraving released later in 1751. A remarkable poem published in the *General Advertiser* on 7 March 1751, and thus only weeks after the release of Hogarth's print, offers a particularly subtle translation of the kinds of reading generated by *Gin Lane*. Entitled 'Strip Naked, or Royal Gin forever', and subtitled 'a picture', it defines the lush as a new type of defiant anti-heroine:

> I must, I will have GIN! – that skillet take –
> Pawn it; no more I'll roast, or boil, or bake.
> This juice immortal will each want supply.
> Starve on (ye brats) so I but bung my eye.
> Starve? No! – this gin doth mother's milk excel;
> Will paint the cheeks, and Hunger's darts repel –
> The skillet's pawned already – take this cap;
> Round my bare head I'll you brown paper lap –
> Ha! Half my petticoat was tore away
> By dogs (I fancy) as I maudlin lay.

How the winds whistle through each broken pane!
Thro' the wide yawning roof how pours the rain!
My bedstead's crack'd; the table goes hip-hop –
But see! The GIN! – come, come, thou cordial drop!
Thou sovereign balsam to my longing heart!
Thou husband! Children! – Ah! – we must not part!
(Drinks) Delicious! – Oh! down the Red Lane it goes;
Now I'm a queen, and trample on my woes.
Inspired by GIN, I am ready for the Road;
Could shoot my man, or fire the king's abode.
Ha! My brain's crack'd – the room turns round and round:
Down drop the platters, pans: I'm on the Ground.
My tatter'd Gown slips from me: what care I?
I was born naked, and I'll naked die.

The poem offers the most stimulating textual equivalent to, and exchange with, *Gin Lane* that I know. It mimics and conflates the different stages of feminine collapse that Hogarth distributes across the picture space, and it assembles a diversity of vocabularies – the quotidian lists of the housewife, the subversive rhetoric of domestic insurrection, the stupefied claims to royal identity, the redirected tenets of filial tenderness – as the fractured murmurings of a single voice. Rather than being written from the viewpoint of the male observer, the poem's first-person narrative gives us the lush's perspective (though, indeed, probably written by a man): we are thus forced into a form of identification that, however troubling and temporary, destabilises our normative position outside her body, and encourages an imaginative participation in the practices that both the poem and the print concurrently castigate.

In the poem, we also find a disturbing vocabulary of striptease, in which a pawned cap, a torn petticoat and abandoned gown fall away to reveal the body of a naked female lying on the ground. In 'Strip Naked' a doubled agenda of social criticism and textual undressing forcibly evokes the traditional focus of the sexualised male gaze, the nude female body, even as that body is rewritten as a visual index of disrepute and mortality. The poem's oscillation between these male-constructed polarities of femininity matches what in the print can be recognised most obviously in the relationship between the central protagonist and the near-naked body of the young woman hanging over the coffin. Moving back and forth between the two bodies presents the viewer with a form of voyeuristic consumption that binds the conventional, eroticised emblematics of the female nude with those of death and disease, generating an aesthetics of abjection that exploits the residual fascination of what has been jettisoned from the ambits of the polite social body, even as that expulsion is confirmed.[35]

This severe instability of spectatorship was recognised by the author of the *Dissertation on Mr Hogarth's Six Prints*. The pages dealing with *Gin Lane* constantly highlight the fraught kinds of looking generated by the sight of the female drinker, and detail a series of encounters with such figures in the less salubrious parts of the capital. The author suggests that the male reader only needs to

take a walk through the outparts and suburbs of the city, and in almost every street, lane or alley he passes thro', he may see such scenes of horror and misery, as must amaze and shock his very soul. In one place he will find a little blind Gin-shop crowded with a parcel of poor wretches, with nothing but rags or tatters to cover them . . . Go to any chandler's shop in the same neighbourhood, and tho' you shall see nobody in it, yet if you pass thro' it into an adjoining room, you will seldom fail of seeing half a Dozen or half a Score of the same kind of gentry, refreshing their spirits with a glass of juniper; these are generally Females, Servant-Maids, and the wives of middling sorts of people who live thereabouts, who will perhaps visit the same shop ten times a day.[36]

Viewing the print is thus translated into the classic form of roving masculine investigation that had come to define the fictional role of the urban satirist, one that in this case is dramatised through the confrontation of his deciphering eye with the 'blind' gin shop, a place that remains invisible to the normal observer and that is filled with women clothed only in rags. We, too, are thus invited to imagine the forbidden spaces and bodies that lie behind the shadowed entrance of the gin shop in Hogarth's engraving; indeed, the oddly suspended viewpoint encourages us to look not only over and beyond the wall, but down into the murky depths of the environment below.

In the *Dissertation*, this process of visually piercing the secretive, feminised environments of the city's underworld is accompanied by a narrative of the lush's metamorphosis that evokes the memory, however blighted, of a previous erotic ideal, before overlaying it with more debased narratives of sexual exchange: 'if she is young, handsome and unmarried, the bloom of her beauty is soon changed for red pimples on her face, or a dull sallow complexion . . . besides, the girl who is given to drinking, exposes herself to those opportunities which rakish loose fellows watch for to make an attempt upon her honour; and 'tis but too true that they oftener succeed this way than any other.' Again, the text can only incompletely overwrite the eroticised bodies of the women with the narratives of corporeal breakdown. The author goes on to dramatise the encountered scene as one that itself ought to be clothed, hidden from view, but that insistently demands and invites representation: 'alas! I wish I could draw a curtain before the Scene, and hide from Mankind the shame and disgrace which they have brought upon themselves.' Ostentatiously failing to do this, the writer proceeds to offer an acutely spectatorial account of the drinkers' communal identity: 'what crowds of them may you *see* early in the Morning at one of the shops where these poisonous liquors are vended? *Examine* their various Dresses. *See* what a ragged, tatter'd condition they are in! Yet enlivened by the pestiferous draughts, all are in high spirits, ranting, swearing, and talking all manner of ribaldry.'[37] What we find throughout the *Dissertation*, as in the snatches of poetry dealing with the female victims of gin, is thus a bifurcated and heavily gendered vocabulary of assiduous, thrilled exploration on the one hand and visual and physical repulsion on the other, a form of textual (and sexual) tracking in which the masculine narrator is constantly confronted with an abject, feminised spectacle of difference.

Returning to the image which generated these contemporary observations, we

may now recognise the extent to which *Gin Lane* maintained a traditonal satiric strategy of pictorial practice, in which the viewer was allowed to engage imaginatively with localised forms of deviance. Yet if this aesthetic was to mesh successfully with the discourses of social regulation we have outlined as a parallel part of the print's appeal, discourses which stressed the utter alienation of the gin-drinker from the tenets of polite culture, the pleasures of vicariousness had to be carefully recast as the certitudes of estrangement. This is partly why Hogarth's image reads so differently from a satire like John June's *The Lady's Disaster* (*see fig. 99*), looked at in the last chapter, which flaunts a titillating aesthetics of urban voyeurism. Hogarth, in contrast, has sought to define the sprawling woman as someone who has ultimately lost her claim not only to charity but also to desire. This is partly achieved through a pictorial stress on the lush's patches of disease and on her utter absorption in an alien economy of addiction, but it is more powerfully effected through the destabilisation of the signs of gender themselves: the woman's body is loaded with a series of signs traditionally used to connote masculinity – her sheer size, her broad shoulders, her powerful arms and legs, even the expansiveness of her pose. We can go on to suggest that the pictorial syntax of the engraving reinforces this process of de-feminisation. The stark infrastructure of cross-hatching that covers the image, which was a consequence of Hogarth's decision both to work 'in the cheapest manner possible' and to distance himself from the pictorial rhetoric of French engraving, provides a formal vocabulary deliberately distanced from the delicate, swirling language of line associated with the rococo. All these processes of pictorial reformulation, however much they continued to allow the insidiously eroticised kinds of reading we found in 'Strip Naked' and in the *Dissertation*, functioned to mediate and control the satirical focus on the publicly visible, partially clothed female body. In sum, while Hogarth's image licenses the fraught pleasures of gazing at a representation of an abandoned woman, it anchors these pleasures to an exaggerated pictorial rhetoric of moral condemnation and spectatorial disavowal.

VII

If, in *Gin Lane*, this organisation of viewing and interpretation was accompanied by the more reassuring iconography of *Beer Street*, the *Four Stages of Cruelty* presents a series of images which not only accentuated the kinds of visual exchange I have outlined but also functioned as an undiluted taxonomy of corporeal violence. Here, I shall concentrate on the third and fourth prints in the series, *Cruelty in Perfection* and *The Reward of Cruelty* (*figs 118 and 119*). The two images represent the culmination of another moralised 'progress', that of Tom Nero, someone whose brutalised childhood leads inexorably to the murder of his mistress, to his own capture and execution, and to a horrific dissection at the hands of the London surgeons. Rather than spending time tracing the complex resonances of 'cruelty' within contemporary debates on criminality and social disorder, I should like to discuss Hogarth's images alongside a series of closely related pictorial categories – those of the anatomical illustration, the murder print and the political satire – in

order to explore the ways in which *Cruelty in Perfection* and *The Reward of Cruelty*, like *Gin Lane* and *Beer Street*, should be understood as images which mediated a range of graphic vocabularies circulating in contemporary culture. Furthermore, such an approach will allow us to relate the distinctive modes of defining the body and its spectators that we have recovered in *Gin Lane's* workings to a broader aesthetics of the abject being generated and revised in contemporary art.

Cruelty in Perfection, the penultimate image of Hogarth's series, focuses on the figures of the captured highwayman, Tom Nero, and the mistress he has just murdered, who represents an even more violent conjunction of femininity and violence than that found in *Gin Lane*. Pregnant, and eerily undisturbed in her body language, she almost seems to float over the pavement; most shockingly, her neck, wrist and fingers have been sliced open with the knife proferred in front of Nero. Her butchered throat, from which blood trickles onto the stone below, parallels her open mouth, while the indentations of her hand are as clinically precise and as neatly executed as the topiary nearby. Her lacerated finger points to the goods she had just stolen from her mistress, and the letter that lies like a caption at her feet explains that she was a previously loyal servant whose seduction by Nero has led inevitably to her own corruption and sorry end. Meanwhile, a posse of figures surrounds the highwayman, who has been tracked down to a country churchyard which had clearly served as an illicit, midnight rendezvous: the scene is dramatically illuminated by the moon and the glare of lanterns.

The Reward of Cruelty, in contrast, shows Nero's own body under the knife, being dissected by surgeons in the aftermath of his execution. A hand delves into his rib cage, a blade pierces his eye sockets and a young assistant worries at his feet with a scalpel. Nero's heart and intestines spill out onto the floor, where they are loaded into a bucket and eaten by a dog. Physicians, surgeons and, in the background, members of the public, crowd the scene, which is presided over by a seated figure whose baton, like Nero's dagger in the previous print, points at the torso of the eviscerated body below. On either side of the image, the skeletons of other recently dissected highwaymen are depicted with chilling smiles, pointing at each other, their arms and fingers duplicating the gestures of the distraught male on the left and of Nero himself.

This final print has often been used to illustrate discussions of the controversy surrounding dissection in these years, which centred on the purchase of recently executed felons by companies of surgeons. As Peter Linebaugh has so brilliantly chronicled, this commodification of the corpse provoked consistently violent and interventionist action on the part of the metropolitan crowd, who frequently snatched the warm bodies of executed men and women before they were removed to be cut up.[38] Dissection was popularly regarded as a barbarous form of post mortem that prevented the passage of the soul from the body after death, and this anxiety was coupled with a frequently voiced criticism of the surgeons as rapacious and brutalised men who paid no respect to the basic decencies of a Christian burial. Hogarth's print, as well as providing a deliberately shocking delineation of the trespassed body, turns its satirical focus onto the company of surgeons, using the tools of physiognomic distortion to define them as a group of self-satisfied exploiters of criminality. Such readings are familiar in the literature on the artist; what is

CRUELTY IN PERFECTION.

Price 1s. 6d.

To lawless Love when once betray'd,
Soon Crime to Crime succeeds;
At length beguil'd to Theft, the Maid
By her Beguiler bleeds.

Yet learn, seducing Man! nor Night,
With all its sable Cloud,
Can screen the guilty Deed from Sight;
Foul Murder cries aloud.

The gaping Wounds, and blood stain'd Steel,
Now shock his trembling Soul:
But Oh! what Pangs his Breast must feel,
When Death his Knell shall toll.

Published according to Act of Parliament Feb.1.1751.

Designd by W.Hogarth.

118 William Hogarth, *Cruelty in Perfection*, from *The Four Stages of Cruelty*, 1751 (BM 3159). Engraving, 13⅝ × 11⅝ in. Courtesy of the British Museum.

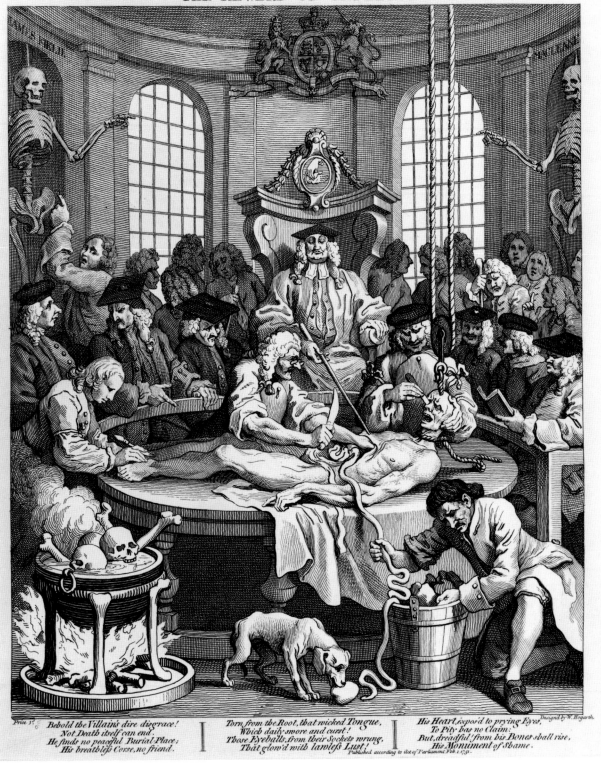

119 William Hogarth, *The Reward of Cruelty*, from *The Four Stages of Cruelty*, 1751 (BM 3166). Engraving, 13⅝ × 11⅝ in. Courtesy of the British Museum.

less often explored is the way in which *The Reward of Cruelty* engages with a specific category of graphic art in order to articulate its different forms of polemic – that of anatomical illustration.

A perusal of the period's newspapers confirms the frequency with which equivalent displays of dissection were being advertised to the urban public – three courses in anatomy were publicised in the *Daily Advertiser* of 18 January 1749, for instance – and the increasing availability of anatomical engravings in the city's print shops. In July 1748, for example, John and Paul Knapton were publishing plates of 'Albinus's Anatomical Tables', while in October, Dan Browne was promoting 'Anatomy improved and illustrated . . . engraven by the Best Hands in England.'[39] Such images were defined as the most modern products of a long-standing tradition of graphic practice, one most famously associated with Italian and Dutch artists. Looking at a representative sample of this tradition, Jacob de Gheyn's seventeenth-century engraving of the Anatomical Theatre at Leiden (*fig. 120*), we can see how closely *The Reward of Cruelty* appropriated the conventions of this category of image. In de Gheyn's picture, we not only find an equivalent concentration on the

120 After Jacob de Gheyn, *The Anatomical Theatre at Leiden,* c. 1616. Engraving. Rijksmuseum.

121 Michael Vandergucht, from James Drake, *Anthropologia Nova.* 1727. Engraving, 10 × 6½ in. Courtesy of the British Museum.

examination of the disembowelled body by an older and a younger surgeon, but also the dogs, the three skulls, the bucket, the windows, the skeleton, the semi-circular hand rail and even the reading onlooker that are reproduced in Hogarth's engraving.

More modern anatomical prints offered a suggestive merger of the kinds of pictorial narrative distributed across the two final engravings of *The Four Stages of Cruelty*. Michael Vandergucht's illustration to a 1727 edition of James Drake's *Anthropologia Nova* (*fig. 121*) depicts, very curiously to the modern eye, an anatomised body wandering into a scene from its own past. The engraving combines the depiction of a flayed highwayman's figure with a detailed narrative of his violent exploits and capture in the background. As in the two final prints of Hogarth's series, we are given a glimpse of the criminal both before and after his execution. Looking briefly at the work of de Gheyn and Vandergucht confirms that Hogarth, in his iconography of cruelty, was reorganising and adapting the codes of a specific kind of anatomical imagery, one that had long been a mainstay of graphic culture, and that focused not only on the sundered cadaver and the narratives of criminality, but on the critical intersection of the body and the law.

These preoccupations also surfaced in another contemporary genre of graphic art, the murder print.[40] This kind of image was normally issued as a quickly executed engraving or woodcut, most often accompanying the sensational ballads, pamphlets and books dealing with violent death that were a major staple of contemporary publishing. Hogarth's engravings on cruelty, though far more sophisticated in their technique and details, shared the appeal of such images, which habitually focused on the lives and deaths of individual murderers, and harnessed their depiction to a moralised denunciation of their misdeeds. Significantly, the author of the *Dissertation on Hogarth's Six Prints*, moving quickly through a discussion of the *Four Stages of Cruelty*, proceeds to recount a series of gruesome murder stories at great length; the pamphlet ends by taking the form of an extended true-crime narrative, and largely abandons its role as a vehicle of art criticism. This textual detour alerts us to the partial engagement of Hogarth's images with the venerable iconography of murder that existed in British graphic art. Here, we can look at a seventeenth-century woodcut showing William Purcas killing his mother with a dagger (*fig. 122*), which offers a crude but suggestive precedent for the third plate in Hogarth's series, while a more modern example of the genre (*fig. 123*) demonstrates the way in which such illustrations similarly concentrated on the gory details of amputation, knives, running blood and buckets for severed heads.

These two images makes it clear that there was an established iconography of murder in graphic culture, distributed across both the popular woodcut and book illustration. Interestingly, Hogarth's decision to hire John Bell, a wood-engraver, to produce woodcuts of the two final engravings of the series (*fig. 124*), aligned his images even more closely to the traditional format and appeal of the murder print. The need for mass publication had long encouraged the use of wood as a durable medium that could sustain thousands of impressions, and had also generated a customarily simplified graphic shorthand that could be appreciated by the wide audience such images solicited. Both versions of *Cruelty in Perfection*, which concentrate so morbidly on the traces of murder written across the body – as the captions

The vvofull Lamentation of *William Purcas*, vvho for murtherin his Mother at *Thaxted* in *Eſſex* was executed at *Chelmsford*.
To the tune of, *The rich Merchant*.

122 Illustration from 'The Woeful Lamentation of William Purcas', c. 1641 (BM 298). Woodcut, $3\frac{3}{8} \times 4\frac{7}{8}$ in. Courtesy of the British Museum.

123 (*right*) Illustration from *A Narrative of the Barbarous and Unheard of Murder of Mr John Hayes*, London, 1726.

have it, the 'gaping wounds and bloodstain's steel' — and which focus so powerfully on the terrified reaction of the killer — 'Oh! What pangs his Breast must feel' — thus reproduce the classic components of the murder print and tied them to the workings of an ambitious project of graphic satire. In this process, Hogarth maintained a traditional satiric strategy of pictorial appropriation and reference, yoking together the graphic formulae of a range of pictorial categories and harnessing them to a strident pattern of social polemic.

In his meshing of pictorial codes, and in his preoccupation with the violated victim of crime, with the executed body and with those who gazed at this body, Hogarth also closely related his practice to other forms of graphic satire being produced in the city. George Bickham junior's *The Conduct of the Two Brothers*, published in February 1749 (*fig. 126*), was advertised as depicting 'a most horrid, barbarous, and cruel murder committed on Brittania',[41] and offered a particularly savage attack on the two leading ministerial politicians of the day, the prime minister Henry Pelham and his brother, the Duke of Newcastle. They are accused of plundering Britain's resources in the interests of a foreign-born king, George II, and the dynasty of Hanover. The two men work under the supervision of another

124 John Bell, after William Hogarth, *Cruelty in Perfection*, 1750–51 (BM 3160). Woodcut, 17½ × 14½ in. Courtesy of the British Museum.

presiding male, this time the strangely effeminate figure of the king himself. Underneath, the twisted body of Britannia sprawls across a wooden block, her legs splayed, her arms hacked off at the shoulder and dropped absently to the floor by the figure of Newcastle on the right. Pelham, leaning over her gutted torso, pulls at her intestines, playing them out to a winch operated by two assistants, where they are twisted round a revolving barrel. Britannia's entrails slide down to the ground and are licked up by a white horse, the traditional symbol of Hanover.

125 Pietro Testa, *The Martyrdom of St Erasmus*, c. 1630. Etching, 10⅝ × 7⅜ in. Courtesy of the British Museum.

In this print, then, Britannia is also depicted as a contemporary female murder victim, and as someone who is simultaneously subjected to the same kind of posthumous mauling as Tom Nero. As in *The Four Stages of Cruelty*, the print focuses on the prone, abject, butchered body as a site of polemic, and juxtaposes this with the figures of its brutal assailants. Moreover, the internal logic of the gaze at this body correlates precisely with that defined in Hogarth's *Cruelty in Perfection*. In Bickham's print, the narratives of dismemberment are accompanied not by the expressions of cool, professional efficiency expected of the executioner, but by the wide-eyed, open-mouthed faces of horror. Nero's face articulates a similarly fraught form of spectatorial exchange: even though his head is turned away from his victim, his gaze remains obsessively fixed on her wounded body. His look becomes part of the broader pattern of looking and not-looking articulated across the image, which is succinctly encapsulated in the face of the lantern carrier, only half-hidden behind a shielding hand.

What we noted as the oddly emasculated depiction of the king in the *Conduct of the Two Brothers* is one of the by-products of Bickham's characteristic strategy of satiric appropriation and revision: his print reworks Pietro Testa's etching of *The Martyrdom of St Erasmus* (*fig. 125*), in which the executioners act under the

126 George Bickham junior, *The Conduct of the Two Brothers*, 1749 (BM 3069). Engraving, $10\frac{1}{4} \times 7\frac{1}{4}$ in. Courtesy of the British Museum.

supervision of the goddess Minerva. Bickham's exchange with Testa's print invokes a fine art tradition of Italian printmaking and reproduces an older iconography of state violence: St Erasmus was an early Christian saint murdered by the Romans. Thanks to this process of pictorial appropriation and intersection, we are offered a disturbing conflation of male and female bodies. Not only is the portrait of the king caught in the pictorial uniform and physiognomy of Minerva but also, more critically, the executed figure herself is a grotesque compound of masculine and feminine signs. The perfunctory breasts, the long hair falling to the ground, the traditional attributes of Britannia lying at the base of the wooden block – all coexist rather uncertainly with the continued traces of the old saint's gnarled body; the scrawny torso, the knobbly knees, the ropey neck. Returning to the two final plates of *The Four Stages of Cruelty*, and reading them against Bickham's image, we can now more clearly see that while Hogarth has split up the sexes in *his* depiction of the two vandalised bodies, he has also encouraged us to read them as equivalents. Shuttling between Hogarth's two prints, our eye is invited to map the one body onto the other, to assimilate the similarity of pose, the doubling of the outstretched arm, the repetition of the pointing forefinger, and to recognise the two prints as articulating a *composite* figure of abjection, one that shocks not only because of the invocation of bodily trespass and public violence, but also because of the destabilisation of gender boundaries. Again, the spectacle of difference is generated through a series of representational disturbances that operate at the levels of narrative and of pictorial organisation, juxtaposition and contrast.

Recognising the different ways in which Hogarth's images colonise and perpetuate the workings of different pictorial genres helps us to understand the extent to which graphic satire was participating in a collective form of cultural and artistic practice at mid-century. In Hogarth's and Bickham's prints, the depiction of the violated body involved both an ambitious engagement with contemporary discourses concerning criminal, judicial and political violence, and an extensive process of pictorial exchange, which entailed bringing a series of representational systems into unsettling contact. In this process, graphic satire produced a politicised aesthetics of the abject that also defined itself in critical relation to more polite forms of representation, and to other pictorial codes of the body. To illustrate this, it is helpful to turn to a prescription issued by the third Earl of Shaftesbury earlier in the century, directed to the creator of portrait busts. He had suggested that choosing the exact point, or line, at which the sculpted head was to be separated from the sculpted torso was a crucial factor in the work's aesthetic decorum, for 'if anything be added or retrenched the *Piece* is destroyed. 'Tis then a mangled trunk, or dismember'd body, which presents itself to our Imagination . . . the section, if unskilfully made, being in reality horrid, and representing rather an *Amputation* in surgery, than a seemly *Division* or *Separation* according to Art.'[42] *The Four Stages of Cruelty*, we can conclude, offered a pictorial practice that deliberately inverted the territories of the 'seemly' and the 'horrid'. In doing so, of course, Hogarth also confused the boundaries so carefully set up by Shaftesbury between amputatory forms of pictorial practice and the neat divisions of art. On these terms, paradoxically, graphic satire came to mirror the very forms of dissection it attacked, not only in its cannibalisation of other forms of imagery but, more importantly, in its

characteristic project of stripping, breaking up and opening out the represented body, and presenting little more than a pictorially 'mangled trunk, or dismember'd body . . . to our Imagination.'

Having subjected six prints issued by Hogarth in 1751 to a rather detailed analysis, and offered an alternative 'key for the right appreciation of the author's meaning in those designs' to that proclaimed in *A Dissertation on Mr. Hogarth's Six Prints*, I shall conclude by suggesting that they functioned to re-establish the mythology of Hogarth's own difference as an artist, and to play a critical role in the reconstruction of his public persona in print culture. However much his strategies of pictorial appropriation, revision and play betrayed his utter dependence on the traditions of the satirical genre, and on a previously established realm of representations to engage with, plunder and subvert, Hogarth continued to claim an artistic and commercial identity that was distinct from those constructed by such contemporaries as Bickham, June, Boitard and Walker. While this was a form of self-fashioning that brilliantly exploited the mechanics of the press, and of the advertisement, it was also tied to the kinds of image Hogarth was seeking to market. In his so-called 'popular prints' at mid-century his distinctiveness as an artist was pictorially signalled, as we have seen, by the harnessing of ostentatiously moralised narratives to a complex iconography of the abject. This chapter has sought to explain how this project arose out of a specific set of historical and artistic conditions, and how images like *Gin Lane* and its companions defined themselves both with and against other kinds of graphic satire.

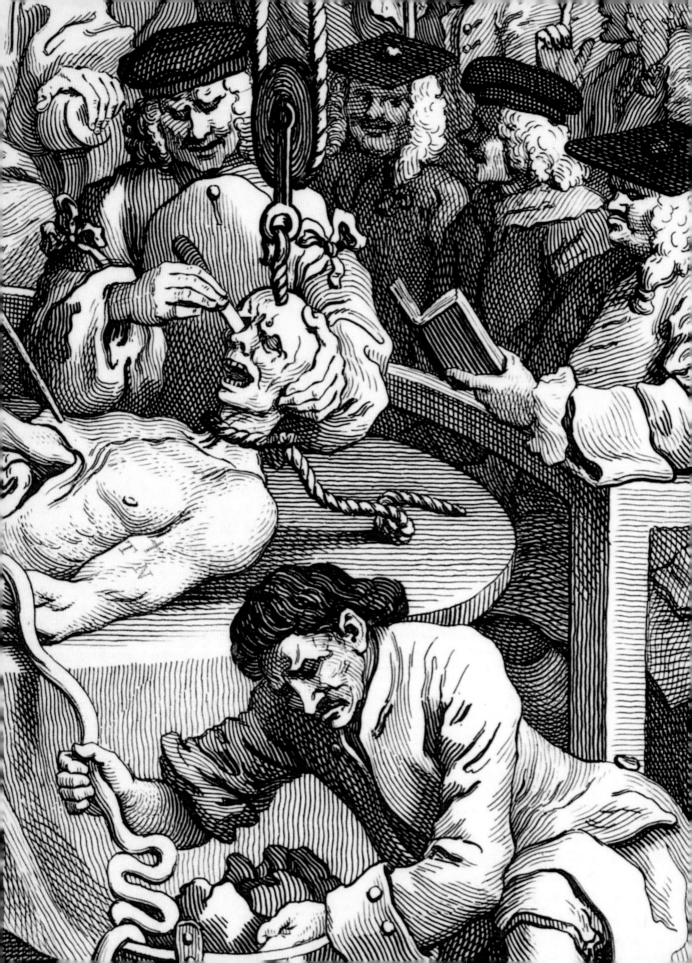

Conclusion

In October 1748, a correspondent to the *Universal Magazine* pointed out that, 'in regard to engraving on copper-plates in general . . . this island may be said scarce to have sought after this pleasing and useful art, till the latter end of Queen Elizabeth's reign, yet I may say with great justice to the taste of the present age that no people ever more encouraged the artificers in this branch, as may be exemplified by the great numbers of curious copper-plates daily published in this nation.' The writer goes on to list twenty-eight 'excellent hands' working in the city, including Hogarth, Bickham and Boitard and declares that it 'must be acknowledged even by those of other nations, that we are in a fair way to vie with, and, if possible, to exceed them in the improvement of this art.'[1] This book has detailed the vital contribution of the satirical print to the thriving, native graphic culture described by this writer, and has sought to suggest the form's characteristics and development throughout the first half of the eighteenth century. In the process, we have recovered the graphic satire's contemporary status as an eclectic vehicle of social, political and pictorial commentary, whose independent identity as an art form was paradoxically dependent on its responsiveness to a range of other kinds of representation. In other words, we have discovered that the satirical engraving, even as it enjoyed a distinct graphic language of its own, was also a highly parasitic genre, continually absorbing and adapting pictorial and textual vocabularies produced elsewhere. As such, the engraved satire simultaneously distinguished itself as a distinct commodity within graphic culture and functioned as an ironic, insubordinate barometer of that same culture's central narratives and assumptions.

The *Universal Magazine's* effusive rhetoric, even as it encompasses the names of artists such as Hogarth and Bickham, belies the challenges that graphic satire encountered in the years ahead. While the ever increasing diversity and capaciousness of the print market offered plenty of room for the products of a wide range of satirical printmakers, the 'improvement of this art' noted by the magazine's correspondent related more particularly to the increasingly widespread adoption of a polite model of artistic practice and consumption in the city, exemplified by the appeal of modern print entrepreneurs such as Arthur Pond, Thomas Bakewell and the Knapton brothers.[2] These businessmen exploited a growing demand for affordable fine art engravings which, while being specifically geared to a local market, continued to bear the hallmarks of Contintental and aristocratic sophistication. We can trace this wider development of graphic culture back to the formation of a distinctly 'polite' cultural ideal at the beginning of the century, first

discussed in the Introduction, which allows us to conclude that the satires we have been studying provided a series of diverse responses to a continuing and increasingly insistent cultural challenge. The images produced by Hubert-François Gravelot and Anthony Walker, for example, offered a clearly visible reconciliation between certain traditional forms of satirical practice and the modern visual codes of polite art. Meanwhile, engravers such as George Bickham junior and John June maintained a loyalty to more radical satiric strategies that militated against an unproblematic conformism to these visual codes. Yet even this more recalcitrant mode of satire was in danger of losing its artistic and polemic credibility. The diversity of practices and images generated within the genre could itself be seen as the product of the cultural leeway that was becoming accepted as one of commercial society's defining characteristics: in this respect, the satire was fast being legitimised as an acceptable and unthreatening cultural outpost, a harmless nexus for the contemporary artistic engagement with dissonant, deviant and grotesque subject matter. The format was easily recast as an emblem *of* modern commercial society – a repository of signs allegorising urban heterogeneity and diversity – rather than a form of critical commentary *on* that society.

Hogarth's response to these circumstances at mid-century, exemplified by those prints of his that we looked at in the last chapter – *Beer Street, Gin Lane* and *The Four Stages of Cruelty* – was a dualised one. On the one hand, his set of six engravings exploit and amplify graphic satire's contemporary status on the aesthetic margins of print culture. If *Beer Street* remained an image that reminds us of the polite forms of cultural reconciliation attempted by artists like Walker, *Gin Lane* and the *Four Stages of Cruelty* deliberately asserted their distance from the iconography of politeness, and flaunted their refusal to tidy up and launder satire's traditional focus on the deviant underside of urban society. Indeed, they offered an unrelenting focus on the most repugnant, vulgar, and threatening members of London's proletarian and criminal subcultures. On the other hand, the same images were aligned with an equally extreme rhetoric of condemnatory polemic and moralisation, one that itself exploited and amplified polite discourses of social and cultural control.

Now we can see more clearly that Hogarth's images took graphic satire in two directions simultaneously: towards a disturbing aesthetics of the abject operating on the extreme fringes of the city's visual culture, and towards a prescriptive iconography of moral didacticism that functioned at its paranoid centre. In doing so, they dramatised the continuing importance and appeal of engraved satire as a pictorial mediation of urban debates and anxieties, but also accentuated how thoroughly estranged satire's imagery had become when compared to the other kinds of visual art being promoted in London's print market. And thus, even though they may have seemed to offer a new way forward for graphic satire, Hogarth's prints, with their gutted carcasses, pregnant corpses and impaled children, ultimately suggest an acute form of pictorial as well as social crisis, in which satire was being forced to trade in the most extreme and horrific kinds of graphic imagery in order to maintain its appeal in the contemporary print market. In the years that followed, graphic satire was going to find new, less alienated ways of defining itself as an art form within London's visual culture.

Notes

Introduction

1 *A Harlot's Progress* is the subject of the third chapter, while I discuss *Gin Lane* and *Beer Street* in Chapter Six. The second chapter will also deal in depth with one of Hogarth's prints, *The Mystery of Masonry brought to light by the Gormagons.*

2 Chapters One, Four and Five will look in detail at the work of graphic satirists other than Hogarth.

3 Diana Donald has noted this kind of satiric inter-referentiality in her *The Age of Caricature: Satirical Prints in the Reign of George III*, New Haven and London, 1996.

4 Discussions on politeness in this period have been indebted to Jurgen Habermas's work on the bourgeois public sphere, *The Structural Transformation of the Public Sphere: An Inquiry into a Category of Bourgeois Society* (trans. Thomas Burger with the assistance of Frederick Lawrence), Cambridge, Mass., 1989. For the most important art-historical investigations into the relationship between visual representation and politeness in eighteenth-century England, see David Solkin, *Painting for Money: The Visual Arts and the Public Sphere in Eighteenth-Century England*, New Haven and London, 1993; Stephen Copley, 'The Fine Arts in Eighteenth-Century Polite Culture', in John Barrell, ed., *Painting and the Politics of Culture: New Essays on British Art, 1700–1850*, Oxford, 1992; and Ronald Paulson, *Popular and Polite Art in the Age of Hogarth and Fielding*, Notre Dame and London, 1979.

5 Bickham's print has been reproduced and briefly discussed in a number of books, including Herbert M. Atherton's *Political Prints in the Age of Hogarth: A Study in the Ideographic Representation of Politics*, Oxford, 1974, and Jurgen Doring, *Eine Kunstgeschicte der fruhen englischen Karikatur*, Hanover, 1991.

Mine, as far as I know, is the first extended discussion of the print, however.

6 For detailed discussions of the series to which *Morning* belonged, see Ronald Paulson, *Hogarth*, vol. 2, *High Art and Low, 1732–1750*, Cambridge, 1992, ch. 6, and Sean Shesgreen, *Hogarth and the Times-of-Day Tradition*, London, 1983.

7 Both quotations are taken from P. K. Elkin, *The Augustan Defence of Satire*, Oxford, 1973, pp. 11, 13, which I have found a highly useful source for ideas on eighteenth-century definitions of satire; Cocker's quotation is not footnoted; Goldsmith's is drawn from Oliver Goldsmith, *An Enquiry into the Present State of Polite Learning in Europe* (1759), in *Collected Works of Oliver Goldsmith*, ed. Arthur Friedman, 5 vols, Oxford, 1966, vol. 1, pp. 314–15.

8 Charles Gildon, *The Laws of Poetry*, London, 1721, pp. 136–7, quoted in Elkin, *Augustan Defence*, p. 37.

9 The extract of *The Dunciad* in *The late P–m–r M–n–r* is an adaptation of lines 605–18, in Book IV, from the edition of 1743. See Alexander Pope, *The Dunciad*, ed. John Sutherland, 3rd edition, New Haven and London, 1963, pp. 403–05. For a discussion of the political implications of Pope's poetry which also illustrates Bickham's satire, see Maynard Mack, *The Garden and the City: Retirement and Politics in the Later Poetry of Pope, 1731–1743*, Oxford, 1969, esp. chapter 4.

10 *The Champion*, Tuesday, 28 February 1740, quoted in *The Champion: Containing a Series of Papers, Humourous, Moral, Political and Critical*, London, 1741, vol. 1, p. 316.

11 This borrowing has also been noted by Doring, *Eine Kunstgeschichte*, p. 281.

12 For a discussion of Ribera's sheets of physiognomic studies, see Jonathan Brown, *Jusepe de Ribera: Prints and Drawings*, Princeton, 1973, pp. 69–72.

13 Ned Ward, *The London Spy* (1709 edition), ed. Paul Hyland, East Lansing, 1993, pp. 164–5.

14 Tom Brown, *The Works of Tom Brown, Serious and Comical*, 7th edition, London, 1730, vol. 3, p. 253.

15 *Choice Emblems, Divine and Moral, Antient and Modern, or Delights for the Ingenious, in above Fifty Select Emblems Curiously Engraven upon Copper Plates*, 6th edition, London, 1732.

16 *Ibid.*, pp. 107, 108.

17 Kirkall's engraving illustrates Tom Brown's *Works*, the same publication that housed the critical commentary on religious hypocrites we have just been noting.

18 Alongside John Brewer, *The Pleasures of the Imagination: English Culture in the Eighteenth Century*, London, 1997, see also Paul Langford, *A Polite and Commercial People: England 1727–1783*, Oxford, 1989, and Lawrence Klein, *Shaftesbury and the Culture of Politeness: Moral Discourse and Cultural Politics in Early Eighteenth-Century England*, Cambridge, 1994.

19 Brewer, *Pleasures of the Imagination*, p. 102.

20 Reproduced in *The Gentleman's Magazine and Historical Journal*, vol. 9, 1739, p. 545.

21 This image is reproduced in Paul Langford, *Walpole and the Robinocracy*, Cambridge, 1986, p. 257. Langford illustrates a suggestive range of political satires, accompanied by brief captions and prefaced by an introduction which concentrates on the political satire's party and parliamentary contexts.

22 No. 454, Monday, 11 August 1712, from *The Spectator*, ed. Donald F. Bond., 5 vols, Oxford, 1965, vol. 4, p. 98.

23 *The Foreigner's Guide*, London, 1730, p. 52.

24 For a range of paintings of Covent Garden in this period, see the Tate Gallery exhibition catalogue, *Manners and Morals: Hogarth and British Painting*, 1700–1760, London, 1987, pp. 67, 117, 195, 229.

25 See Shesgreen, *Hogarth and the Times-of-the-Day*, from which I reproduce de Passe's engraving. For a critical view of this reading, see Alastair Lang, *In Trust for the Nation: Paintings from National Trust Houses*, London, 1995, p. 58, n. 1.

26 Tim Clayton's *The English Print Trade, 1688–1802*, London, 1997, which I read after this book had been written, is a vital contribution to our knowledge about the contemporary print market.

27 The Paul Mellon Centre for Studies in British Art in London has a photocopied collection of most of the surviving print publisher's catalogues of the period.

28 For the painting auctions that were a parallel feature of the London art market, see Iain Pears, *The Discovery of Painting: The Growth of Interest in the Arts in England, 1680–1768*, New Haven and London, 1988, pp. 57–67.

29 *The Daily Courant*, London, 18 February 1706.

30 *Ibid.*, n.p.

31 *The Daily Advertiser*, 9 December 1743.

32 Contrary to some of the received narratives of eighteenth-century print culture, such shops were common even in the early years of the century. Reading the newspapers of the day, and encountering the numerous advertisements installed by the owners of print shops, it is clear that, even before the passing of the Engravers' Act in 1735, scores of businesses sold prints in the city. Their numbers expanded dramatically throughout this period, however, as the increasing proliferation of print advertisements in the newspapers demonstrates.

33 *The Daily Courant*, London, 23 April 1730.

34 Ned Ward, *The London Spy*, p. 81.

35 See George Vertue, *Notebooks*, 6 vols, *The Walpole Society Journal*, vols 18, 20, 22, 24, 26, 30 (1930–55). The references to London's engravers are to be found in vol. 20, p. 11, and vol. 30, p. 197.

36 Vertue, *Notebooks*, in *The Walpole Society Journal*, vol. 22, 1933–34, p. 146.

37 See Jonathan Richardson, *An Essay on the Theory of Painting* (1715), 2nd edition, London, 1725. This notion of the engraver was most famously developed and extended by William Hogarth. For a more extended discussion of these matters, see Martin Myrone's excellent MA thesis, 'George Vertue (1683–1756) and the Graphic Arts in Eighteenth-Century Britain', Courtauld Institute of Art, University of London, 1994.

38 *The Champion*, 6 March 1742.

39 Here it is worth noting that Hogarth employed the distinguished French engraver Bernard Baron to assist him in engraving the plates of his *Four Times of Day*. Baron's involvement guaranteed the set's formal sophistication.

40 Nicholls' image comes from a book entitled *London Described*, published by Thomas and John Bowles in 1726 and reissued in 1731, but would also, presumably, have been available to consumers as a single print.

41 It is clear that Bickham, like Hogarth, advertised in a number of papers, of which *The London Daily Post* was only one. See, for example, his advertisement in *The Daily Advertiser*, 9 December 1743.

42 Hogarth mounted a particularly assiduous advertising campaign for these prints, stretching back into 1737. See, for example, *St James's Evening Post*, 10–12 May 1737.

43 For a seminal discussion of this 'wider world of goods', see Neil McKendrick, John Brewer and J. H. Plumb, *The Birth of a Consumer Society: The Commercialization of Eighteenth-Century England*, London, 1982.

44 For a salutary discussion of this issue, see Eirwen Nicholson, 'Consumers and Spectators: The Public of the Political Print in Eighteenth-Century England', *History* (January 1996), pp. 5–21.

Chapter One

1 For Stent's career, see Alexander Globe, *Peter Stent, London Printseller c. 1642–1665*, Vancouver, 1985; for a more general history of the print trade in the seventeenth century, see Leona Rostenberg, *English Publishers in the Graphic Arts, 1599–1700*, New York, 1963.

2 See Edward Hodnett, *Francis Barlow, First Master of English Book Illustration*, London, 1978, p. 26.

3 For an introduction into the graphic art of seventeenth-century Britain, see Richard Godfrey, *Printmaking in Britain: A General History from its Beginnings to the Present Day*, Oxford, 1978, ch. 2.

4 This has been most convincingly argued and demonstrated by Eirwen Nicholson in her unpublished 1994 doctorate at the University of Edinburgh, 'English Political Prints and Pictorial Political Argument c. 1640–c. 1832'.

5 Quoted in G. Holmes, 'The Sacheverell Riots: The Church and the Crowd in early Eighteenth-Century London', *Politics, Religion and Society in England, 1678–1742*, London, 1986, p. 225.

6 *Ibid.*

7 See N. Rogers, *Whigs and Cities: Popular Politics in the Ages of Walpole and Pitt*, Oxford, 1989.

8 The best general account of the Sacheverell affair remains G. Holmes, *The Trial of Dr. Sacheverell*, London, 1973.

9 *The Daily Courant*, 27 April 1710.

10 William Bisset, *The Modern Fanatic*, London, 1710, p. 44.

11 Daniel Defoe, *Review*, 5 January 1710.

12 *The Priest turn'd poet; or, the best way of answering Dr Sacheverell's sermon*, London, 1710, n.p.

13 *The Solicitous Citizen; or, The Devil to do about Dr. Sach———ll*, London, 1710, p. 19.

14 Defoe, *Instructions from Rome, in Favour of the Pretender*, London [1710].

15 For the Titus Oates affair, see Jane Lane, *Titus Oates*, London, 1949.

16 For the emblematic tradition in England, see Michael Bath, *Speaking Pictures: English Emblem Books and Renaissance Culture*, London, 1994, and Rosemary Freeman, *English Emblem Books*, London, 1948.

17 *The Picture of Malice; or, a True Account of Dr. Sacheverell's Enemies*, London, 1710, p. 11.

18 Bickham's involvement seems certain when one sees that he re-uses, and signs, a nearly identical allegorical format in an engraved frontispiece to Charles Snell's *The Art of Writing*, 1712.

19 My account has only touched upon the mass of fascinating satirical material, both pictorial and literary, that was issued during the Sacheverell crisis, which cries out for further research and analysis.

20 For a detailed discussion of the medley print that contains material left out of this book, see my 'The Medley Print in Early Eighteenth-Century London', *Art History*, vol. 2, no. 2 (June 1997), pp. 214–37.

21 These descriptions are from a hand-engraved list of advertisements found at the back of Sturt's illustrated edition of *The Book of Common Prayer*, London, 1717.

22 *Ibid.*, n.p.

23 C. A. du Fresnoy, *De Arte Graphica: The Art of Painting*, introduced and translated by John Dryden, London, 1695, p. xx.

24 Quoted in Jacqueline Lichtenstein, *The Eloquence of Colour: Rhetoric and Painting in the French Golden Age* (trans. Emily McVarish), Berkeley, 1993, p. 171.

25 Roger de Piles, *The Art of Painting, and the Lives of the Painters* (trans. John Savage), London, 1706, p. 60.

26 For the most interesting discussion of the Dutch letter rack paintings of the period, see Celeste Brusati, *Artifice and Illusion: The Art and Writings of Samuel van Hoogstraten*, London, 1995.

27 For a stimulating discussion of trompe l'oeil painting more generally, see Norman Bryson, *Looking at the Overlooked: Four Essays on Still Life Painting*, London, 1990, pp. 140–45.

28 For a brief but acute analysis of this image's satirical references, see Diana Donald, *The Age of Caricature: Satirical Prints in the Reign of George III*, New Haven and London, 1996, p. 12.

29 *The Medley*, 11 October 1710, n.p.

30 I discuss this print in more detail in my 1996

doctorate, 'The Spectacle of Difference: Graphic Satire and Urban Culture in London, 1700–1751', Courtauld Institute of Art, University of London, pp. 19–22.

31 *Sot's Paradise; or, the Humours of a Derby Ale-House, with a Satyr upon the Ale,* 3rd edition, London, 1700, p. 6.

32 Defoe, *Review,* quoted in Paula R. Backsheider, *Daniel Defoe, His Life,* London, 1989, p. 265. Backsheider's book was immensely helpful in researching this history.

33 That this accusation had become current is confirmed by a contemporary poem entitled 'A hue and a cry after Daniel Defoe, for denying the Queen's hereditary right', London, 1711. It is worth mentioning here that Defoe's identity in Bickham's engraving should not be confused with another famous Daniel of the period, Daniel Burgess, a dissenting minister whose meeting house was burnt down by pro-Sacheverell rioters in 1710. Burgess appears in a couple of other satirical engravings of the period, but he is always shown in a clerical collar, and wearing dark, 'Puritan's' clothing. Moreover, as a Presbyterian minister, he was never associated, however fantastically, with the figure of the Pope, and was not attacked in terms of his opposition to the monarchy. These facts, and a range of other forms of evidence, make it clear that the central portrait in *The Whig's Medly* is that of Defoe, and not of Burgess.

34 The two books I have found most useful on Defoe's early eighteenth-century career are Backsheider, *Daniel Defoe,* and James Sutherland, *Defoe,* 3rd edition, London, 1971.

35 Here, my vocabulary and my ideas are indebted to Thomas Crow's brilliant discussion of the *fête galante* in his *Painters and Public Life in Eighteenth-Century Paris,* New Haven and London, 1985, p. 57.

36 Daniel Defoe, *Jure Divino: A Satyr in Twelve Books,* London, 1706.

37 John Elsum, *Epigrams upon the Paintings of the Most Eminent Masters, Antient and Modern, with Reflections upon the Several Schools of Painting,* London, 1700, p. 101. Taylor Corse has written on Elsum's art writings, in 'The Ekphrastic Tradition: Literary and Pictorial Narrative in the *Epigrams* of John Elsum, an Eighteenth-century Connoisseur', *Word and Image,* vol. 9, no. 4 (1993), pp. 383–400.

38 See Elsum, *Epigrams,* pp. 75–6.

39 *Jure Divino, A Satyr,* London, c. 1710. The image of Defoe in the pillory in *The Whig's Medly* is also powerfully reminiscent of satires depicting Titus Oates enduring the same punishment.

40 Edward [Ned] Ward, *The Secret History of the Calves Head Club; or, the Republicans Unmask'd,* London, 1709, p. 18.

41 *The Whig and the Tory,* London, 1712, n.p.

42 The most immediate response to Bickham's print was *An Answer to the Whig's Medly,* an engraving that duplicated the first's format but reversed its political attack. See the British Museum's catalogue of satires, BM 1571.

Chapter Two

1 The seminal scholarly work on the Bubble is Peter Dickson, *The Financial Revolution in England: A Study in the Development of Public Credit, 1688–1756,* London, 1967, esp. chs 5 and 6; other works on the crisis include John Carswell, *The South Sea Bubble,* London, 1960, and Lewis Melville, *The South Sea Bubble,* London, 1921.

2 Daniel Defoe, *The Anatomy of Exchange Alley; or, A System of Stock Jobbing,* London, 1719, p. 35.

3 *Read's Weekly Journal,* 14 January 1721.

4 *The London Journal,* 3 December 1720.

5 *The Weekly Journal,* 5 November 1720.

6 *The Original Weekly Journal,* 9 July 1720.

7 *Ibid.,* 1 October 1720.

8 *Ibid.,* 22 October 1720.

9 Joseph Addison, 'The Bank of England: a Vision', *The Spectator,* no. 69, 3 March 1711, from *The Spectator,* ed. Donald F. Bond, 5 vols, Oxford, 1965, vol. 1, p. 15.

10 *Read's Weekly Journal,* 11 February 1721.

11 'A South Sea Ballad; or, Merry Remarks upon Exchange-Alley Bubbles', London, n.d. For an important discussion of the feminized imagery of Credit and Fortune, see J. G. A. Pocock, *Virtue, Commerce and History,* Cambridge, 1985, ch. 5.

12 *Exchange Alley; or, The Stock-Jobber turn'd Gentleman, A Tragi-Comical FARCE,* London, 1720, preface, n.p.; *Matter of Fact; or, the Arraignment and Tryal of the Directors of the South Sea Company,* London, 1720, p. 29.

13 *Exchange Alley,* preface, n.p; 'A South Sea Ballad', n.p.

14 *The Freeholders Plea against Stock-Jobbing elections of Parliament Men,* London, 1701, p. 10.

15 *A Catalogue of some prints and maps printed for and sold by Thomas Bowles at his shop next ye Chapter House in St. Paul's Churchyard,* London, 1720. A copy of this catalogue is available at the Paul Mellon Centre for Studies in British Art in London, along with copies of other print publishers' catalogues.

16 This remarkable volume of prints has attracted

very little scholarly attention, at least to my knowledge. An exception is Arthur H. Cole, *The Great Mirror of Folly*, Boston, 1949. Simon Schama and Katie Scott have, however, dealt with these and related prints in more recent publications: see Simon Schama, *The Embarrassment of Riches: An Interpretation of Dutch Culture in the Golden Age*, London, 1987, pp. 365–71, and Katie Scott, *The Rococo Interior: Decoration and Social Spaces in Early Eighteenth-Century Paris*, London, 1995, pp. 222–32.

17 *The Post Boy*, 28 March 1721.

18 *Enchiridion: The Life and Philosophy of Epictetus, with the Embleme of Humane Life by Cebes. Rendered into English, by John Davies of Kidwelly*, London, 1670.

19 *Ibid.*, p. 159.

20 *Applebee's Weekly Journal*, 28 January 1721.

21 *Applebee's Weekly Journal*, 21 January 1721.

22 *The Weekly Journal*, 20 May 1721.

23 See Martin Eidelberg, 'Watteau Paintings in England in the Early Eighteenth Century', *Burlington Magazine*, 107 (September 1975), pp. 576–82.

24 *The Daily Journal*, 26 December 1723.

25 Miguel Cervantes, *The History of the Valorous and Witty Knight-Errant Don Quixote of the Mancha* (trans. Thomas Shelton), London, 1725.

26 Katie Scott, '*D'un Siècle à L'autre*: History, Mythology and Decoration in Early Eighteenth-Century Paris', in Colin Bailey *et al.*, *The Loves of the Gods: Mythological Painting from Watteau to David*, New York, 1992, p. 36. See also Scott's *The Rococo Interior: Decoration and Social Spaces in Early Eighteenth-Century Paris*, London, 1995, ch. 8.

27 The most stimulating discussions of the *fête galante* in relation to its French context are Crow, *Painters and Public Life*, ch. 2, and Scott, *The Rococo Interior*, pp. 152–61.

28 Cervantes, *The History of the Valorous and Witty Knight-Errant*, vol. 1, p. 21.

29 *Ibid.*, vol. 1, p. 15.

30 Aubrey de la Mottraye, *Travels through Europe, Asia, and into Parts of Africa*, 2 vols, London, 1723–32.

31 Two of these borrowings have been noted by Ronald Paulson, *Hogarth*, vol. 1, '*The Modern Moral Subject', 1697–1732*, London, 1991, pp. 114–19, and in *Hogarth's Graphic Works*, New Haven and London, 1965, vol. 1, pp. 107–8. In both cases, Paulson's readings of the engraving are very different from mine, and make very little of these references.

32 My account of freemasonry in this period is indebted to D. Knoop and G. P. Jones, *The Genesis of Freemasonry*, Manchester, 1947, and to Margaret Jacob, *The Radical Enlightenment: Pantheists, Freemasons and Republicans*, London, 1981. A useful collection of primary sources is found in D. Knoop *et al.*, *Early Masonic Pamphlets*, Manchester, 1945.

33 *The Post Boy*, 24 June 1721.

34 James Anderson, *The Constitutions of the Masons*, London, 1723.

35 *Ibid.*, pp. 20–21.

36 *Ibid.*, pp. 42, 56, 47, 75.

37 The full advertisement is quoted in Paulson, *Hogarth, The 'Modern Moral Subject'*, pp. 117–18.

38 'The Freemasons: A Hudibrastic Poem', London, 1723.

39 *Ibid.*, pp. 3, 13.

40 *Ibid.*, p. 20.

41 *Ibid.*, p. 12 (my emphasis).

42 Paulson, while not alone, is a fair target on these counts. See his *Hogarth, The 'Modern Moral Subject'*, pp. 114–19.

Chapter Three

1 *The Fortunate Transport; or, the Secret History of the life and adventures of the celebrated Polly Haycock, alias Mrs B-, The Lady of the Gold Watch. By a Creole*. London, c. 1740, p. 6.

2 *Ibid.*, p. 4. *The Fortunate Transport* clearly recyles the plot and location of John Gay's *Polly*, 1729.

3 *Ibid.*, pp. 34–5.

4 See Ronald Paulson, *Hogarth*, vol. 1, *The 'Modern Moral Subject', 1697–1732*, London, 1991, chs 8, 9 and 10. The quotation is taken from p. 256. Other useful discussions of the series are to be found in David Bindman, *Hogarth*, London, 1981, chs 3 and 4, and in Michael Godby, 'The First Steps of Hogarth's Harlot's Progress,' *Art History*, 10 (1987), pp. 23–37.

5 John Bancks, 'To Mr Hogarth on his Modern Midnight Conversation', *Miscellaneous Works in Verse and Prose*, London, 1738, p. 90.

6 George Vertue, *Notebooks*, *The Walpole Society Journal*, 1933–34, vol. 22, p. 58.

7 As Bindman has noted, *Hogarth*, pp. 56, 53, 'Vertue tells us that *A Harlot's Progress* began originally with a single painting of an indecent nature, of a Drury Lane prostitute getting out of bed at noon . . . it is clear from Vertue's account that the initial impulse in making the series was not particularly high-minded.' Bindman also writes that Hogarth had made his studio 'something of a gathering place in its own right, by giving the impression that

something scandalous and diverting could always be seen there.'

8 Tom Brown, *The Works of Tom Brown, Serious and Comical*, 7th edition, London, 1730, vol. 1, p. 145.

9 Edward [Ned] Ward, *Hubibras Redivivus, or a Burlesque Poem on the Times, Part the Fifth*, London, 1706, (4th edition), p. 3.

10 *Ibid., Part the Seventh*, p. 25; *Part the Eighth*, p. 5.

11 John Gay, *Trivia; or, the Art of Walking the Streets of London*, London, 3rd edition, 1730, pp. 59, 60.

12 *A Trip through London, containing Observations on Men and Things*, London, 3rd edition, 1728, p. 24.

13 *Ibid.*, p. 15.

14 Christopher Bullock, *Woman's Revenge; or, A Match in Newgate*, London, 1728, p. 33.

15 *The Golden Spy*, London, 1723, a companion volume to *The New Metamorphosis*, which Hogarth illustrated in 1723, and which contains similarly satirical stories of sexual intrigue.

16 'The Kept Miss', *The Golden Spy*, pp. 336, 338, 337, 356–60.

17 *The Authentic Memoirs of the Life, Intrigues and Adventures of the Celebrated Sally Salisbury*, London, 1723, pp. 133, n.p., 28, 47, and 60.

18 Quoted in Bindman, *Hogarth*, p. 122.

19 *Authentic Memoirs*, p. 50.

20 I have not been able to find out the exact date of this satire's publication, but it may well be a work by George Bickham jnr, who was beginning to be active as an engraver in the early 1730s.

21 Here I have in mind the images of prostitutes painted by artists such as Jan Steen in seventeenth-century Holland and the pictures of royal mistresses such as Nell Gwynn painted by Peter Lely in seventeenth-century England.

22 David Solkin has discussed these paintings, including the one by Pieter Angellis that is analysed here, in *Painting for Money: The Visual Arts and the Public Sphere in Eighteenth-Century England*, New Haven and London, 1993, ch. 2. Angellis's work is investigated on pp. 54–7.

23 Brown, *Works*, 1730, vol. 3, p. 262.

24 Lynn Hunt (ed.), *The Invention of Pornography: Obscenity and the Origins of Modernity*, New York, 1993, p. 10. For a fascinating discussion of the Renaissance origins of Western pornography, see Paula Findlen's essay in the same volume, 'Humanism, Politics and Pornography in Renaissance Italy', pp. 49–108.

25 *The Universal Spectator*, London, 21 March 1730. It is worth noting that the corre-

spondent writes after having infected his wife with a venereal disease contracted from a prostitute, as he tells us himself.

26 Bernard Mandeville, *A Modest Defence of Public Stews; or, an Essay on Whoring*, London, 1725, p. 2.

27 *An Answer*, London, 1725, pp. 60 and 61.

28 Paulson, *Hogarth, The 'Modern Moral Subject'*, pp. 241–50.

29 *The Insinuating Bawd and the Repenting Harlot*, London, n.d.

30 *The Harlot's Progress, being the life of the Noted Moll Hackabout, in Six Hudibrastic Cantos*, London, 1732, p. 4.

31 See Paulson, *Hogarth, The 'Modern Moral Subject'*, pp. 273–4.

32 *The Daily Post*, 18 March 1730; *The Country Journal*, 4 April 1730; *The Daily Journal*, 28 January 1731; *The Daily Journal*, 27 February 1731.

33 *The Country Journal*, 3 January 1730.

34 The six redactions are, respectively, *The Progress of a Harlot. As she is described in Six Prints, by the Ingenious Mr Hogarth*, 1732; *The Harlot's Progress, being the Life of the Noted Moll Hackabout, in six Hudibrastic Cantos*, 1732; Joseph Gay, *The Lure of Venus; or, a Harlot's Progress, a Heroi-Comical Poem in Six Cantos*, 1733; *The Jew Decoy'd; or, the Progress of a Harlot, A New Ballad Opera of Three Acts*, 1735; *The Harlot's Progress; or, the Ridotto al Fresco, a Grotesque Pantomime Entertainment*, 1733; and the poems that accompany Elisha Kirkall's mezzotint prints of November 1732.

35 Paulson describes them as 'parasites'; *Hogarth, The 'Modern Moral Subject'*, p. 311.

36 *The Progress of a Harlot*, pp. 7 and 14.

37 *The Harlot's Progress . . . Moll Hackabout*, p. 3.

38 *Ibid.*, p. 38.

39 *Ibid.*, pp. 14, 34, 35.

40 Gay, *Lure of Venus*, pp. ii and title page.

41 Mandeville, *A Modest Defence*, p. 31.

42 Gay, *Lure of Venus*, p. 36.

43 Kirkall, sheet 6; Kirkall's prints are in the British Museum's Department of Prints and Drawings.

44 Gay, *Lure of Venus*, p. 47.

45 *The Progress of a Harlot*, p. 48.

46 *The Harlot's Progress . . . Moll Hackabout*, p. 61.

47 Kirkall, sheet 6 (my emphasis). The pantomime entertainment of 1733 offered a far more radical literary intervention than any of these texts: in this account, Moll does not die at all, is rewarded rather than punished for her sins and, caged at Bridewell in the scenario depicted in plate 4, is suddenly rescued by Harlequin, and taken to dance at Vauxhall

Gardens: 'the scene changes to the Ridotto al Fresco, illuminated with several glass lustres . . . variety of people appear in masquerade, and a grand comic ballad is perform'd by different characters to English, Irish and French tunes, which concludes the whole', *The Harlot's Progress; or, the Ridotto al Fresco*, p. 12. Here, the realms of pleasure and sensuality signified by the pantomime, and the highly codified erotics of Harlequin, are mapped onto the *Progress* and entirely redirect its narratives.

48 Harry Mount, *The Reception of Dutch Genre Painting in England, 1695–1829*, unpub. Ph.D. thesis, Cambridge University, 1991, p. 78.

49 *The Daily Journal*, 3 July 1732.

50 J. Nichols, *Biographical Anecdotes of William Hogarth*, 2nd edition, London, 1782, p. 33.

51 Quoted in David Hunter, 'Copyright Protection for Engravings and Maps in Eighteenth-Century Britain', *The Library*, 6th series, vol. 9 (1987), p. 137. This article is a particularly useful discussion of the Act and an essential source for the debates that surrounded it.

Chapter Four

1 F. G. Stephens (ed.), *Catalogue of Prints and Drawings in the British Museum, Division 1, Political and Personal Satires*, vol. 3(i), 1887, p. 182, n. 1.

2 As noted in the Preface, histories of Georgian graphic satire have often focused on the political narratives they contain, which has tended to preclude any extended discussion of such images' role within the graphic and visual cultures of the period. Historians whose works do take the visual into account include John Brewer, whose introduction to a collection of graphic satires, *The Common People and Politics 1750s–1790s*, Cambridge, 1986, raises crucial questions about how we should interpret the satirical print. Roy Porter's, 'Prinney, Boney, Boot's', in the *London Review of Books*, vol. 8, no. 5 (1986), pp. 19–20, a review of the series to which Brewer contributes, *The English Satirical Print 1600–1832*, ed. Michael Duffy, similarly calls for a revised view of the satirical print as a pictorial commodity. The most detailed exploration of the political satires of this period remains Herbert M. Atherton, *Political Prints in the Age of Hogarth: A Study in the Ideographic Representation of Politics*, Oxford, 1974. Vincent Carretta, *The Snarling Muse: Verbal and Visual Political Satire from Pope to Churchill*, Philadelphia, 1983, usefully relates graphic satire to a range of literary texts dealing with contemporary politics. For a good indication of the range of satirical images being produced in the period, see Paul Langford, *Walpole and the Robinocracy*, Cambridge, 1986. Finally, for a cautionary set of criticisms of the ways in which scholars have approached political satires, see Eirwen Nicholson, 'English Political Prints and Pictorial Political Argument c. 1640–1840: A Study in Historiography and Methodology', unpublished PH.D thesis, University of Edinburgh, 1994.

3 For a good summary of political affairs in this period, see Paul Langford, *A Polite and Commercial People: England 1727–1783*, Oxford, 1989, ch. 2.

4 Michael Harris, 'Print and Politics in the Age of Walpole', in Jeremy Black (ed.), *Britain in the Age of Walpole*, London, 1984, p. 193.

5 *Ibid.*, p. 195.

6 N. Rogers, *Whigs and Cities: Popular Politics in the Ages of Walpole and Pitt*, Oxford, 1989, pp. 196, 176.

7 Reproduced in the *Gentleman's Magazine*, vol. 7, 1737, p. 167.

8 *Ibid.*, p. 555.

9 See John Loftis, *The Politics of Drama in Augustan England*, Oxford, 1963.

10 *Pasquin. A Dramatic SATIRE on the TIMES: being the rehearsal of Two Plays, viz A COMEDY call'd THE ELECTION and a tragedy call'd The Life and Death of COMMON SENSE. As it is acted at the Theatre in the Haymarket*, London, 1736; *The Historical Register for the Year 1736. As it is acted at the New Theatre in the Haymarket*, London, 1737.

11 This image is discussed by Atherton, *Political Prints in the Age of Hogarth*, pp. 110, 200, 204, 205, 271, and is reproduced in John Brewer, *The Pleasures of the Imagination: English Culture in the Eighteenth Century*, London, 1997, p. 382.

12 *The Art of Railing at Great Men: Being a Discourse upon Political Raillery Ancient and Modern*, London, 1723, p. 11.

13 George Vertue, *Notebooks*, in *The Walpole Society Journal*, vol. 22, 1933–34, p. 131.

14 See H. Hammelmann and T. S. R. Boase, *Book Illustrators in Eighteenth-Century England*, London, 1975, p. 41.

15 John Gay, *Fables*, introduced by Vinton A. Dearing, Los Angeles, 1967 (facsimile edition), n.p.

16 Quoted in J. Bickham, *Fables, and Other Short Poems*, London, 1737, preface, n.p.

17 Gay, *Fables*, pp. 49, 53, 56, 58.

18 Quoted in Michael Snodin, 'George Bickham Junior, Master of the Rococo', in *The Victoria and Albert Museum Album*, 2, 1983, p. 359.

19 *A New Drawing Book of Modes*, London, 1732; *The Young Clerk's Assistant; or, Penmanship made Easy, Instructive and Entertaining*, London, c. 1735. As well as being sold separately, these were also bound together in single volumes with other texts and manuals.

20 See Atherton, *Political Prints in the Age of Hogarth*, p. 78, n. 47.

21 *An Enquiry into the Merits of Assassination*, London, c. 1740.

22 Henry Peacham, *Minerva Britanna 1612, English Emblem Books No. 5*, selected and edited by John Horden, London, 1973, p. 161. The connection between Bickham's print and Peacham's emblem has been noted by Vincent Carretta, *The Snarling Muse*, p. 49.

23 Quoted in Snodin, 'George Bickham Junior', p. 355.

24 For a discussion of this image and the wider narratives of Vauxhall, see David H. Solkin, *Painting For Money: The Visual Arts and the Public Sphere in Eighteenth-Century England*, New Haven and London, 1993, ch. 4.

25 *London Evening Post*, 25–27 March, 1740, quoted in Rogers, *Whigs and Cities*, p. 237.

26 *London Evening Post*, 29 March–1 April 1740, quoted in Rogers, *ibid.*, p. 237.

27 *The Life and Death of Pierce Gaveston, Earl of Cornwall* was advertised by Bickham in the *London Daily Post*, 14 November 1740.

28 Included in George Bickham, *The Oeconomy of the Arts*, London, 1747.

29 *The Daily Post*, 30 March 1742.

30 For Arthur Pond's sponsorship of caricature, see Louise Lippincott, *Selling Art in Geogian London: The Rise of Arthur Pond*, London, 1983, pp. 132–5.

31 John Brewer, *The Common People and Politics 1750–1790s*, Cambridge, 1986, p. 16.

Chapter Five

1 *The British Magazine*, London, 1747, pp. 6–10.

2 It has proved impossible, so far, to find out exactly when Walker's print was published. It was certainly produced some time between late 1747 and 1753, when it is listed in John Bowles's print catalogue; I incline to a time soon after the earlier date, i.e. 1748–49.

3 Walker's image is reproduced and briefly discussed in Jurgen Doring, *Eine Kunstgeschicte der fruhen englischen Karikatur*, Hanover, 1991.

4 *The Enormous Abomination of the Hoop-Petticoat*, London, 1745, pp. 7, 2, 17.

5 H. Phillips, *Mid-Georgian London*, London, 1964, esp. pp. 166–87.

6 I have written about these 'optical pillar machines' in the context of Canaletto's designs for engravings, in 'Framing the Modern City: Canaletto's Images of London', in Michael Liversidge and Jane Farrington (eds), *Canaletto and England*, London, 1993.

7 *A New Drawing Book of Modes, By Mons. B. Picart*, London, 1732.

8 John Bowles, *A Catalogue of Maps, Prints, Copybooks, etc*, London, 1749, p. 56.

9 For modern editions of these writer's works, see Tom Brown, *Amusements Serious and Comical, and Other Works* (1700), ed. Arthur L. Hayward, London, 1927, and Ned Ward, *The London Spy* (1709 edition), ed. Paul Hyland, Michigan, 1993.

10 Brown, *Amusements*, pp. 11–12.

11 *Ibid.*, p. 119.

12 *Ibid.*, pp. 13, 23.

13 John Gay, *Trivia; or, the Art of Walking the Streets of London* (1716), ed. W. H. Williams, London, 1922, p. 29.

14 *A Trip through the Town*, London, [c. 1730], p. 15.

15 Brown, *Amusements*, p. 85.

16 Ward, *London Spy*, p. 295.

17 Gay, *Trivia*, p. 17.

18 Brown, *Amusements*, p. 56.

19 *Ibid.*, p. 76.

20 Gay, *Trivia*, p. 21.

21 *The Spectator*, no. 454, 11 August 1712, from *The Spectator*, ed. Donald F. Bond, 5 vols, Oxford, 1965, vol. 4, p. 98.

22 David Garrick, *Miss in her Teens; or, the Medley of Lovers*, 2nd edition, London, 1747, p. 19.

23 *Ibid.*, p. 14.

24 *Gentleman's Magazine*, London, vol. 18, 1748, p. 325.

25 Robert Campbell, *The London Tradesman*, London, 1747, p. 141.

26 *Gentleman's Magazine*, London, vol. 18, 1748, p. 225.

27 *Gentleman's Magazine*, London, vol. 17, 1747, p. 338.

28 *The Female Rake; or, Modern Fine Lady. A Ballad Comedy*, London, 1736, preface, n.p.

29 See Robert Latham (ed.), *The Illustrated Pepys*, London, 1978, p. 18.

30 Hardly any work has been done on Walker's art and career. An exception is the discussion on the artist as a book illustrator in H. Hammelmann and T. S. R. Boase, *Book Illustrators in Eighteenth-Century England*, London,

1975, pp. 96–101. See also Doring, *Eine Kunstgeschichte*, n. 3 above.

Chapter Six

1 *The London Magazine*, 1751, vol. 20, pp. 44, 112, 137, 88.

2 *The Morning Walk; or, City Encompassed*, W. H. Draper, London, 1751, pp. 42–3.

3 The image has been most extensively discussed by Ronald Paulson, *Hogarth*, vol. 3, *Art and Politics, 1750–1764*, Cambridge, 1993, pp. 17–26.

4 William Hogarth, 'Autobiographical Notes', in *The Analysis of Beauty*, ed. Joseph Burke, Oxford, 1955, p. 226.

5 I have summarised some of my findings and arguments in 'Framed: William Hogarth' in *tate: the art magazine*, no. 12, summer 1997, pp. 16–17.

6 For Hogarth's advertisement, see the *London Evening Post*, 14–16 February 1751.

7 See the title page to *A Dissertation on Mr Hogarth's Six Prints*, London, 1751.

8 *Ibid.*, p. 29.

9 *A Dissertation upon Drunkenness*, London, 1727, pp. 8–9.

10 Peter Clark, *The English Alehouse: A Social History, 1200–1830*, London, 1983, see esp. ch. 9.

11 *A Dissertation on Mr Hogarth's Six Prints*, pp. 30, 29.

12 Charles Labelye, *A Short Account of the methods made use of in laying the foundations of the piers of Westminster Bridge*, London, 1739, p. 82.

13 I have dealt with the representation of Westminster Bridge in more detail in 'Framing the Modern City: Canaletto's Images of London', in Michael Liversidge and Jane Farrington (eds), *Canaletto and England*, London, 1993, pp. 46–54.

14 Henry Fielding, *An Enquiry into the Causes of the Late Increase in Robberies, etc*, London, 1751, p. 2.

15 Corbyn Morris, *Observations on the past growth and present state of the City of London*, London, 1751, preface, n.p.

16 Fielding, *An Enquiry*, p. 18.

17 Morris, *Observations*, p. 3.

18 *General Advertiser*, London, 14 March 1751.

19 *Ibid.*, n.p.

20 Fielding, *An Enquiry*, p. 20.

21 *A Dissertation upon Drunkenness*, London, 1727, p. 15.

22 Fielding, *An Enquiry*, pp. 91–2.

23 *The British Magazine*, 1747, vol. 2, p. 347.

24 *A Present for Women addicted to Drinking*, London, 1750, p. 5.

25 *The Vices of the Cities of London and Westminster*, London, 2nd edition, 1751, p. 27.

26 *A Present for Women*, p. 35.

27 Robert Campbell, *The London Tradesman*, London, 1747, pp. 153, 261, 226, 280.

28 *The Vices*, p. 4.

29 *The Daily Journal*, 29 September 1736; *ibid.*, 30 September 1736.

30 *London Evening Post*, 14–16 February 1751.

31 Donna T. Andrew, *Philanthropy and Police: London Charity in the Eighteenth Century*, Princeton, 1985.

32 Quoted in *ibid.*, p. 19.

33 *A Dissertation on Mr Hogarth's Six Prints*, 1751, p. 20.

34 For an extended discussion of the relationship between charity and pictorial production in the period, see David H. Solkin, *Painting for Money: The Visual Arts and the Public Sphere in Eighteenth-Century England*, New Haven and London, 1993, ch. 5.

35 My notion of abjection is indebted to Julia Kristeva's theoretical formulation of the term in *Powers of Horror: An Essay on Abjection* (trans. Leon S. Rouiez), New York, 1980.

36 *A Dissertation*, p. 9.

37 *Ibid.*, pp. 11, 15, 16 (my emphasis).

38 Peter Linebaugh, 'The Tyburn Riot Against the Surgeons', in Douglas Hay *et al.*, *Albion's Fatal Tree: Crime and Society in Eighteenth-Century England*, London, 1975.

39 *The Daily Advertiser*, 13 July 1748; *General Advertiser*, 28 October 1748.

40 This topic demands further research; a number of such images are reproduced in Lincoln B. Faller, *Turned to Account: The Forms and Functions of Criminal Biography in Late Seventeenth- and Early Eighteenth-Century England*, Cambridge, 1987.

41 *The Daily Advertiser*, 11 February 1749.

42 *Characteristics of Men, Manners, Opinions . . . by the right Hon. Anthony, Earl of Shaftesbury*, 5th edition, 1732, vol. 3, pp. 388–9.

Conclusion

1 *The Universal Magazine*, October 1748, p. 182.

2 For Pond, see Louise Lippincott, *Selling Art in Georgian London: The Rise of Arthur Pond*, New Haven and London, 1983.

Select Bibliography

NEWSPAPERS

In my research for this book, I have consulted a wide range of London newspapers published during the first half of the eighteenth century. For an extensive listing of these publications, see the catalogue for the Burney Collection of newspapers held at the British Museum in London.

PRE-1800 PUBLICATIONS

Anderson, James, *The Constitutions of the Masons*, London, 1723

Atkinson, Thomas, *A Conference between a Painter and an Engraver; Containing some Useful Hints and Necessary Instructions, Proper for the Young Artist*, London, 1736

The Authentic Memoirs of the Life, Intrigues and Adventures of the Celebrated of Sally Salisbury, London, 1723

Bancks, John, *Miscellaneous Works, in Verse and Prose*, London, 1738

Barrow, John, *Dictionarium Polygraphicum: The Whole Body of the Arts Regularly Digested*, London, 1735

Bickham, George, snr, *The British Monarchy; or, a new Chorographical Description of all the Dominions Subject to the King of Great Britain*, London, 1743

 Round Text: A New Copy Book, London, n.d.

 The Universal Penman, London, 1733–41

Bickham, George, jnr, *A New Drawing Book of Modes, by Mons. B. Picart*, London, 1732

 The Musical Entertainer, London, 1738

 A New Introduction to the Art of Drawing, Collected from ye Most Free and Easy Designs of the Best Masters, London, 1743

Bickham, John, *Fables, and Other Short Poems; Collected from the Most Celebrated English Authors*, London, 1737

Bisset, William, *The Modern Fanatic*, London, 1710

Bolingbroke, Henry St John, Viscount, *A Dissertation Upon Parties, in Several Letters to Caleb D'Anvers, Esq.*, 8th edition, London, 1754

Bribery in Perfection; or, a Nation Sold, London, 1721

Brown, Tom, *The Works of Tom Brown, Serious and Comical*, 7th edition, London, 1730

 Amusement Serious and Comical, and other Works, edited with notes by Arthur L. Hayward, London, 1927

[Le Brun, Charles], *Conference of Monsieur Le Brun, Chief Painter of the French King . . . Upon Expression, General and Particular*, London, 1701

Bullock, Christopher, *Woman's Revenge; or, A Match in Newgate*, London, 1728

Butler, Samuel, *Hudibras* (1662–77), edited and introduced by John Wilders, Oxford, 1975

Campbell, Robert, *The London Tradesman*, London, 1747

Cervantes, Miguel, *The History of the Valorious and Witty Knight Errant Don Quixote* (trans. Thomas Shelton), London, 1725

Characterism; or, the Modern Age display'd, London, 1748

Clarendon, Edward, Earl of, *The History of the Rebellion and Civil Wars in England, begun in the year 1641*, Oxford, 1702

Cleland, John, *Memoirs of a Woman of Pleasure*, London, 1748, 1749

The Country Spy; or, a Ramble thro' London, London, n.d.

[Davies, John], *Enchiridion: The Life and Philosophy of Epictetus, with the Embleme of Humane Life, by Cebes, Rendered into English, by John Davies of Kidwelly*, London, 1670

Defoe, Daniel, *The Anatomy of Exchange Alley; or, A System of Stock-Jobbing*, London, 1719

 The Complete English Tradesman, 2 vols, London, 1732

 A Hymn to the Pillory, 2nd edition, London, 1703

A Dissertation on Hogarth's Six Prints, London, 1751

A Dissertation upon Drunkenness, London, 1727

Draper, W. H., *The Morning Walk; or, City Encompass'd*, London, 1751

Dunton, John, *The Bull Baiting; or, Dr Sach—ll dress'd up in Fire-works*, London, 1709

Elsum, John, *The Art of Painting after the Italian Manner*, London, 1703

 A Description of the Celebrated Pieces of Paintings; of the most Eminent Masters Antient and Modern, with reflections upon the Several Foreign Schools of Painting, London, 1704

 Epigrams upon the Paintings of the Most Eminent Masters, Antient and Modern, London, 1700

The Enormous Abomination of the Hoop-Petticoat, London, 1745

Evelyn, John, *Sculptura; or, the History and Art of Chalcography and Engraving in Copper*, London, 1662

Exchange Alley; or, the Stock Jobber turn'd Gentleman, London, 1720

Faithorne, William, *The Art of Graving and Etching*, 2nd edition, London, 1702

Fashion: An Epistolary Satire to a Friend, London, 1742

The Female Rake; or, Modern Fine Lady, London, 1736

Fielding, Henry, *An Enquiry into the Causes of the Late Increase in Robberies, etc.*, London, 1751

 The Historical Register for the Year 1736, London, 1737

 The History of the Adventures of Joseph Andrews, London, 1742

 The Opposition: A Vision, London, 1742

 Pasquin: A Dramatic Satire on the Times, London, 1736

The Forced Virgin; or, the Unnatural Mother. A True Secret History, London, 1730

The Foreigner's Guide; or, a necessary and instructive Companion both for the Foreigner and Native, in their tour through the cities of London and Westminster, London, 1730

The Fortunate Transport; or, the Secret History of the life and adventures of the celebrated Polly Haycock, alias Mrs B—, The Lady of the Gold Watch, London, [c. 1740]

The Freeholders Plea against Stock-Jobbing elections of Parliament Men, London, 1701

The Freemasons: An Hudibrastic Poem, London, 1723

Fresnoy, C. A., du, *De Arte Graphica, The Art of Painting* (trans. John Dryden), London, 1695

[Garrick, David], *Miss in her Teens; or, the Medley of Lovers*, 2nd edition, London, 1747

Gay, John, *Fables by the late Mr Gay, Volume the First*, 5th edition, London, 1737

 Fables by the late Mr Gay, Volume the Second, London, 1738

 Polly: An Opera, London, 1729

Trivia; or, the Art of Walking the Streets of London, London, 1716, and the edition with introduction and notes by W. H. Williams, London, 1922

Gay, Joseph, *The Lure of Venus; or, a Harlot's Progress, a Heroi-Comical Poem in Six Cantos*, London, 1733

The Harlot's Progress; or, the Ridotto al Fresco, a Grotesque Pantomime Entertainment, London, 1733

The Harlot's Progress, being the Life of the Noted Moll Hackabout, in six Hudibrastic Cantos, London, 1732

Hell Upon Earth; or, The Town in an Uproar, London, 1729

Hogarth, William, *The Analysis of Beauty*, ed. Joseph Burke, Oxford, 1955

The Hoop-Petticoat Vindicated, London, 1745

The Humours of a Coffee-House, A Comedy, London, 1707

The Insinuating Bawd and the Repenting Harlot, n.d.

The Jew Decoy'd; or, the Progress of a Harlot, A New Ballad Opera of Three Acts, London, 1735

Tom King's; or, the Paphian Grove, with the various humours of Covent Garden, London, 1738

The Man of Manners; or, Plebian Polish'd, London, 1737

Man Superior to Woman; or, the Natural Right of the Men to Sovereign Authority over the Women, London, 1744

Mandeville, Bernard, *The Fable of the Bees*, London, 1723, 1729

A Modest Defence of Public Stews; or, an Essay on Whoring, London, 1725

Miller, James, *The Art of Life, in Two Epistles*, London, 1739

The Life of Mother Gin, by an Impartial Hand, London, 1736

Matter of Fact; or, the Arraignment and Tryal of the Directors of the South Sea Company, London, 1720

La Mottraye, Aubrey de, *Travels through Europe, Asia, and into Parts of Africa*, 2 vols, London, 1723

A New Guide to London, London, 1726

The New Metamorphosis, London, 1723

Morris, Corbyn, *Observations on the Past Growth and Present Status of the City of London*, London, 1751

Nivelon, F., *The Rudiments of Genteel Behaviour*, London, 1737

Perrault, Claude, *A Treatise of the Five Orders of Columns in Architecture* (trans. John James), London, 1708

The Picture of Malice; or, a True Account of Dr Sacheverell's Enemies, London, 1710

Piles, Roger de, *The Art of Painting, and the Lives of the Painters* (trans. John Savage), London, 1706

Pope, Alexander, *The Dunciad, in four books*, London 1743, and the edition edited by John Sutherland, New Haven and London, 1963

A Present for Women addicted to Drinking, London, 1750

The Progress of a Harlot. As she is described in Six Prints, by the Ingenious Mr Hogarth, 2nd edition, London, 1732

A Proposal for the Relief and Punishment of Vagrants, London, 1748

The Rake of Taste. A Poem, London, n.d.

Ralph, James, *A Critical Review of the Publick Buildings, Statues and Ornaments of London and Westminster*, London, 1734

The Touchstone, London, 1728

A Ramble through London, London, 1738

The Ramble; or, A View of Several Amorous and Diverting Intrigues lately passed between some Ladies of Drury, London, n.d.

Remarks on the Common Topicks of Conversation in Town at the meeting of the Parliament, London, 1735

Richardson, Jonathan, *The Theory of Painting*, 2nd edition, London, 1725

Ripa, Caesar, *Iconologia, or Moral Emblems*, London, 1709

Rouquet, M., *The Present State of the Arts in England*, London, 1755

The Rump; or, an Exact Collection of the Choycest Poems and Songs Relating to the Late Times, London, 1662

Salmon, William, *Polygraphice, or The Arts of Drawing, Limning, Painting, etc*, 8th edition, London, 1701

Sanderson, William, *Graphice: The Use of the Pen and Pencil*, London, 1658

Shaftesbury, Anthony, Earl of, *Characteristics of Men, Manners, Opinions*, 5th edition, London, 1732

The Solicitous Citizen; or, the Devil to do about Dr Sach–ll, London, 1710

A South Sea Ballad; or, Merry Remarks upon Exchange-Alley Bubbles, London, n.d.

Spiritual Fornication: A Burlesque Poem, London, 1732

The St. James Beauties; or, the new Toast. A Poem, London, 1744

The Stock-Jobbers; or, the Humours of Exchange Alley, London, n.d.

The Town Spy; or, a view of London and Westminster, London, 1729

A Trip from St James to the Royal Exchange, London, 1744

A Trip through London, containing Observations on Men and Things, 3rd edition, London, 1728

A Trip through the Town, London, c. 1730

A Trip to the Moon, London, 1728

Venus in the Cloister; or, the Nun in her Smock, London, 1725

Vertue, George, *Notebooks*, 6 vols, *The Walpole Society Journal*, 18, 20, 22, 24, 26, 30 (1930–55)

The Vices of the Cities of London and Westminster, London, 2nd edition, 1751

The Virgin Muse; or, Select Poems on Several Occasions Moral and Divine, London, n.d.

Walpole, Horace, *Anecdotes of Painting in England*, ed. Ralph Worthum, London, 1876

Ward, Edward, *Hudibras Redivivus; or, a Burlesque Poem on the Times*, London, 1706

 The London Spy, 4th edition, London, 1709, and the edition edited by Paul Hyland, East Lansing, 1993

 The Secret History of the Calve's Head Club, London, 1709

 Sot's Paradise; or, the Humours of a Derby Ale-House, 2nd edition, London, 1700

 Vulgus Brittanicus; or, the British Hudibras, 3rd edition, London, 1711

The Whig and the Tory, London, 1712

Woman's Superior Excellence over Man, London, 1743

POST-1800 PUBLICATIONS

Allen, Brian, *Francis Hayman*, New Haven and London, 1987

 ed., *Towards a Modern Art World*, New Haven and London, 1995

Andrew, Donna T., *Philanthropy and Police: London Charity in the Eighteenth Century*, Princeton, 1985

Atherton, Herbert M., *Political Prints in the Age of Hogarth: A Study in the Ideographic Representation of Politics*, Oxford, 1974

Backsheider, Paula R., *Daniel Defoe: His Life*, London, 1989

Barrell, John, ed., *Painting and the Politics of Culture: New Essays on British Art 1700–1750*, Oxford, 1992

The Political Theory of Painting from Reynolds to Hazlitt, London, 1986

Berry, Christopher J., *The Idea of Luxury: A Conceptual and Historical Investigation*, Cambridge, 1994

Bindman, David, *Hogarth*, London, 1981

Hogarth and his Times: Serious Comedy, London, 1997

Black, Jeremy, ed., *Britain in the Age of Walpole*, London, 1984

ed., *Robert Walpole and the Nature of Politics in Early Eighteenth-Century England*, London, 1990

Breward, Christopher, *The Culture of Fashion: A New History of Fashionable Dress*, Manchester, 1995

Brewer, John, *The Common People and Politics, 1750–1790s*, Cambridge, 1986

The Pleasures of the Imagination: English Culture in the Eighteenth Century, London, 1997

Brusati, Celeste, *Artifice and Illusion: The Art and Writings of Samuel van Hoogstraten*, London, 1995

Carretta, Vincent, *The Snarling Muse: Verbal and Visual Political Satire from Pope to Churchill*, Philadelphia, 1983

Carswell, John, *The South Sea Bubble*, London, 1960

Clark, Peter, *The English Alehouse: A Social History, 1200–1830*, London, 1983

Clayton, Timothy, *The English Print 1688–1802*, New Haven and London, 1997

Close, Anthony, *The Romantic Approach to 'Don Quixote'*, Cambridge, 1978

Cole, Arthur H., *'The Great Mirror of Folly' (Het Groote Tafereel der Dwarsheid): An Economic–Bibliographical Study*, Cambridge, Mass., 1949

Colley, Linda, *Britons*, London, 1992

Corse, Taylor, 'The Ekphrastic Tradition: Literary and Pictorial Narrative in the Epigrams of John Elsum, an Eighteenth-Century Connoisseur', *Word & Image*, vol. 9, no. 4 (October–December 1993), pp. 383–400

Cropper, Elizabeth, *Pietro Testa, 1612–1650*, Philadelphia, 1988

Crow, Thomas E., *Painters and Public Life in Eighteenth-Century Paris*, New Haven and London, 1985

Curtis, Laura Ann, *The Versatile Defoe*, London, 1979

Dabydeen, David, *Hogarth, Walpole and Commercial Britain*, London, 1987

Dickson, Peter, *The Financial Revolution in England: A Study in the Development of Public Credit, 1688–1756*, London, 1967

Donald, Diana, *The Age of Caricature: Satirical Prints in the Reign of George III*, New Haven and London, 1996

Duffy, Michael, *The Englishman and the Foreigner*, Cambridge, 1986

Elkin, P. R., *The Augustan Defence of Satire*, Oxford, 1973

Faller, Lincoln B., *Turned to Account: The Forms and Functions of Criminal Biography in Late Seventeenth- and Early Eighteenth-Century England*, Cambridge, 1987

Fletcher, John, and Benjamin, Andrew, eds., *Abjection, Melancholia, and Love: The Work of Julia Kristeva*, London, 1990

Foxon, David, *Libertine Literature in England, 1660–1745*, New York, 1965

George, M. Dorothy, *English Political Caricature to 1792: A Study of Opinion and Propaganda*, Oxford, 1959

Ginzburg, Carlo, *Myths, Emblems, Clues*, London, 1990

Globe, Alexander, *Peter Stent, London Printseller c. 1642–1665*, Vancouver, 1985

Godby, Michael, 'The First Steps of Hogarth's "Harlot's Progress"', *Art History*, vol. 10, no. 1 (March 1987), pp. 23–37

Goldgar, Betrand A., *Walpole and the Wits: The Relation of Politics to Literature 1722–1742*, London, 1976

Gombrich, E. H., 'A Classical "Rake's Progress"', *Journal of the Warburg and Courtauld Institutes*, 15 (1952), 254–56

Habermas, Jurgen, *The Structural Transformation of the Public Sphere: An Inquiry into a Category of Bourgeois Society* (trans. Thomas Burger with the assistance of Frederick Lawrence), Cambridge, Mass., 1989

Hallett, Mark, 'Framing the Modern City: Canaletto's Images of London', in Michael Liversidge and Jane Farrington, eds, *Canaletto and England*, London, 1993, pp. 46–54
 'The Medley Print in early Eighteenth-Century London', *Art History*, vol. 20, no. 2 (June 1997), pp. 214–37

Hammelmann, Hans, and Boase, T. S. R., *Book Illustrators in Eighteenth-Century England*, London, 1975

Harris, Tim, *Politics under the Later Stuarts: Party Conflict in a Divided Society, 1660–1715*, London, 1993

Hay, Douglas, ed., *Albion's Fatal Tree: Crime and Society in Eighteenth-Century England*, New York and London, 1975

Heal, Ambrose, *The English Writing Master, 1570–1800*, London, 1962

Hodnett, Edward, *Francis Barlow: First Master of English Book Illustration*, London, 1978

Holmes, Geoffrey, *The Trial of Dr. Sacheverell*, London, 1973
 Politics, Religion and Society in England, 1679–1742, London, 1986

Horne, Thomas A., *The Social Thought of Bernard Mandeville*, London, 1978

Hunt, Lynn, ed., *The Invention of Pornography: Obscenity and the Origins of Modernity*, New York, 1993

Jacob, Margaret C., *The Radical Enlightenment: Pantheists, Freemasons and Republicans*, London, 1981

Jenner, Mark, *Scatology, Coprophagia and Political Cannibalism: The Rump and the Body Politic in Restoration England* [forthcoming]

Kahr, Madlyn, 'Danae: Virtuous, Voluptuous, Venal Women', *Art Bulletin*, no. 43 (1978), pp. 43–55

Knoop, Douglas, and Jones, G. P., *The Genesis of Freemasonry*, Manchester, 1947

Krey, Gary Stuart de, *A Fractured Society: The Politics of London in the First Age of Party, 1688–1715*, Oxford, 1985

Kristeva, Julia, *Powers of Horror: An Essay on Abjection* (trans. Leon S. Rouiez), New York, 1980

Lambert, Susan, *The Image Multiplied: Five Centuries of Printed Reproductions of Paintings and Drawings*, London, 1987

Langford, Paul, *Walpole and the Robinocracy*, Cambridge, 1986
 A Polite and Commercial People: England 1727–1783, Oxford, 1989

Laqueur, Thomas, *Making Sex: Body and Gender from the Greeks to Freud*, Cambridge, Mass., 1990

Lefebvre, Henri, *The Production of Space* (trans. Donald Nicholson-Smith), Oxford, 1991

Lichtenstein, Jacqueline, *The Eloquence of Colour: Rhetoric and Painting in the French Golden Age* (trans. Emily McVarish), Berkeley, 1993

Lippincott, Louise, *Selling Art in Georgian London: The Rise of Arthur Pond*, London, 1983

Loftis, John, *The Politics of Drama in Augustan England*, Oxford, 1963

Lynebaugh, Peter, *The London Hanged: Crime and Civil Society in the Eighteenth Century*, London, 1991

McKendrick, Neil, John Brewer and J. H. Plumb, *The Birth of a Consumer Society: The Commercialization of Eighteenth-Century England*, London, 1982

Mount, Harry, 'The Reception of Dutch Genre Painting in England, 1695–1829', unpublished PH.D thesis, Cambridge, 1991

Mullen, John, *Sentiment and Sociability: The Language of Feeling in the Eighteenth Century*, Oxford, 1988

Nicholson, Eirwen, 'English Political Prints and Pictorial Political Argument c. 1640–c. 1832: A Study in Historiography and Methodology', unpublished PH.D thesis, University of Edinburgh, 1994

Nokes, David, *Raillery and Rage: A Study of Eighteenth-Century Satire*, London, 1987

Pacteau, Francette, *The Symptom of Beauty*, London, 1994

Paulson, Ronald, *Popular and Polite Art in the Age of Hogarth and Fielding*, Notre Dame and London, 1979

 Book and Painting: Literary Texts and the Emergence of English Painting, Knoxville, 1982

 Hogarth, vol. 1, *The "Modern Moral Subject', 1697–1732*, London, 1991

 Hogarth, vol. 2, *High Art and Low, 1732–1750*, Cambridge, 1992

 Hogarth, vol. 3, *Art and Politics, 1750–1764*, Cambridge, 1993

Pears, Iain, *The Discovery of Panting: The Growth of Interest in the Arts in England, 1680–1768*, New Haven and London, 1988

Phillips, Hugh, *Mid-Georgian London*, London, 1964

Plumb, J. H., *England in the Eighteenth Century*, London, 1963

Porter, Roy, *English Society in the Eighteenth Century*, London, 1982

 London: A Social History, London, 1994

Rogers, Nicholas, 'The Urban Opposition to Whig Oligarchy, 1720–60', in J. Jacob and M. Jacob, eds, *The Orgins of Anglo-American Radicalism*, London, 1984

 Whigs and Cities: Popular Politics in the Ages of Walpole and Pitt, Oxford, 1989

Rogers, Pat, *Grub Street: Studies in a Subculture*, London, 1972

Rostenberg, Leona, *English Publishers in the Graphic Arts, 1599–1700*, New York, 1963

Scott, Katie, 'D'un Siècle à l'Autre: History, Mythology, and Decoration in Early Eighteenth-Century Paris', in Colin Bailey *et al.*, *The Loves of the Gods: Mythological Painting from Watteau to David*, New York, 1992

 The Rococo Interior: Decoration and Social Spaces in Early Eighteenth-Century Paris, New Haven and London, 1995

Sharpe, J. A., *Crime and the Law in English Satirical Prints 1600–1832*, Cambridge, 1986

Shesgreen, Sean, *The Cries and Hawkers of London: Engravings and Drawings by Marcellus Laroon*, Stanford, 1990

Snodin, Michael, 'George Bickham Junior, Master of the Rococo', in the *Victoria and Albert Museum Album*, 2, 1983

 ed., *Rococo: Art and Design in Hogarth's England* (exh. cat.), London, 1984

Solkin, David H., *Painting for Money: The Visual Arts and the Public Sphere in Eighteenth-Century England*, New Haven and London, 1993

Stallybrass, Peter, and White, Allon, *The Poetics and Politics of Transgression*, London, 1986

Staves, Susan, 'A Few Kind Words for the Fop', *Studies in English Literature*, no. 22, (Summer 1982), pp. 413–28

Stephens, F. G., Hawkins, E., and George, M. D., *British Museum Catalogue of Political and Personal Satires, London,* 1870–1954

Stevenson, John, *Popular Disturbances in England, 1700–1870,* London, 1979

Thomas, Donald, *Fielding,* London, 1990

Trumbach, Randolph, 'The Birth of the Queen: Sodomy and the Emergence of Gender Equality in Modern Culture, 1660–1750', in M. Duberman *et al., Hidden from History: Reclaiming the Gay and Lesbian Past,* London, 1991

Uglow, Jenny, *Hogarth: A Life and a World,* London, 1997

Wagner, Peter, *Eros Revived: Erotica of the Enlightenment in England and America,* London, 1988

 Reading Iconotexts: From Swift to the French Revolution, London, 1995

West, Shearer, *The Image of the Actor: Verbal and Visual Representation in the Age of Garrick and Kemble,* London, 1991

Williams, Aubrey, *Pope's 'Dunciad',* Oxford, 1955

Wright, T. H., *A History of Caricature and the Grotesque in Literature and Art,* London, 1865

Index

Numbers in *italic* refer to illustrations

Addison, Joseph, 60
Aesop's *Fables*, 146, 161, *161*
'Albinus's Anatomical Tables', 226
alcoholism, 197–222
anatomical engravings, 226–7
Anderson, James, 83–4, 86
Andrew, Donna, 217
Angellis, Pieter, *A Company at Table*, 108, *109*;
 Covent Garden Market, 12, 13, *13*, 14, 20
An Answer to the Whig's Medly, 240n
Applebee's Weekly Journal, 68
Argyll, Duke of, 160–61
Arlequyn Actionist, frontispiece, 67, *67*, 82
Atherton, Herbert M., *Political Prints in the Age of
 Hogarth*, ix, 243n
The Authentic Memoirs of Sally Salisbury, 105, 106,
 108, *110*

Bakewell, Thomas, 235; *Yae-ough*, 6, *7*
Bancks, John, 100
Barlow, Francis, 28, 43; *The Happy Instruments of
 England's Preservation*, 28, *28*
Baron, Bernard, after Picart, *A Monument
 Dedicated to Posterity*, 58, *63*, 64–8, 69, 71–2,
 82, 88
The Baudy House, in Tom Brown's *Works*, 108,
 110
Bedlam (madhouse), 172, 177
Bell, John, 227; after Hogarth, *Cruelty in
 Perfection*, 227, *229*
'Bella in Vista, Dentro Trista' (from *Choice
 Emblems* . . .), 7–8, *8*
Bickham, George, Sr, 30, 45, 82, 151, 160, 239n;
 self-portrait, *54*; *Sot's Paradise*, 43, *44*, 45, 54;
 *To the Unknown Author of the High Church
 Champion* . . . , 35, *36*; *The Whig's Medly*, 46,
 47, 48–55, 57, 91, 240n; 'The Three False
 Brethren', 46, 50, 52, 54
Bickham, George, Jr, 17, 18, 20, 21, 24, 25, 26,
 100, 151–67, 233, 235, 236; after Gravelot,
 headpiece for 'The Adieu to the Spring-

Gardens', *155*; after Oliver, *Sleeping Venus and
 Charteris*, 106, *107*; after Picart, *A New Drawing
 Book of Modes*, 151, 180–81, *181*, 182; *An Ass
 loaded with Preferments*, 164, *166*; *The Cardinal in
 the Dumps*, 154–6, *157*, 158–9, 161; *The
 Champion*, 159–62, *160*, 166; *A Courier just
 Setting out*, 162, *162*, 164, 166; *The Conduct of
 the Two Brothers*, 228–30, *231*, 232; *An Enquiry
 into the Merits of Assassination*, 151; *The
 Fortunate Transport*, 92, 94–5, 96–9, 100;
 frontispiece to *The Life and Death of Pierce
 Gaveston*, 156, *158*; *The late P-m-r M-n-r* (*Great
 Britain and Ireland's Yawn*), 2, *3*, 5, 6, *7*, 8, 10–
 11, 15, 16, 20, 21, *22*, 24, 25, 26, 131–2, 151;
 The Musical Entertainer, 154, *155*; *The Stature of
 a Great Man*, 151–4, *152*, 156, 158; *The Young
 Clerk's Assistant*, 151
Bisset, William, 30
Bockman, Gerard, after Gibson, *Sir Robert
 Walpole*, 153, *153*
Boitard, Louise Phillipe, 177, 233, 235; *Taste à la
 Mode*, vi, 173, *173*, 174
Bosc, Claude du, 144
Boucher, François, 154
Bowles, print publishers, 15, 18, 61
Bowles, John, 15, 211; fashion engravings, 181;
 frontispiece to Print Catalogue, *161*
Bowles, Thomas, Sr, 15
Bowles, Thomas, Jr, 15, 57, 61–2, 64, 67, 68,
 71–2, 73, 78, 89, 123
Brewer, John, 166, 243n; *The Pleasures of the
 Imagination*, 9
Bridewell jail, 96, 97, 101, 102, 103, 104, 105,
 124
British Magazine, 169, 208
Brown, Tom, 7; *Amusements Serious and
 Comical* . . . , 183–4, 185, 187; *Works*, 102, 108,
 110, 112
Browne, Dan, 226
The Bubbler's Medley, or a Sketch of the Times, 56,
 57, 58, 61, 62, 64
Bullock, Christopher, *Woman's Revenge*, 104
Bunyan, John, *The Pilgrim's Progress*, 100

Burgess, Daniel, 240n
Burning of the Rumps (1660), 190, *191*, 192
Burton, John, trade card, 117, *118*
Butcher's Row, 169, 173, 177, 182, 184, 189,
 190, 192, 193, 194, 195
Butler, Samuel, 'Hudibras', 190

Callot, Jacques, 38, 43
Calves Head Club, 52
Campbell, Robert, 188; *The London Tradesman*,
 209
Canaletto, 203
caricature drawings, 159, 162–4
Caroline, Queen, 132, 134, 136
Carracci brothers, 163, 164
Carretta, Vincent, 243n
Carteret, Lord, 164
catalogues, print, 15, 18, 159–60, *161*, 181, 238n
Cervantes, Miguel, *Don Quixote*, 72, 80–81, *81*,
 116
Champaigne, Philippe de, *Self-Portrait*, 43, *45*
The Champion, periodical, 6, 19
charity, 217–19, 245n
Charles I, King, 40, 46, 52, 53
Charteris, Lord Francis, 96, 101, 104, 106, 108,
 114, 120, 124
Cibber, Gabriel Caius, 216; *Allegory of the Great
 Fire of London*, 210, *211*
Clark, Peter, 202
Cock's Auction House, Covent Garden, 16
coffee houses, 1, 5, 16, 18–19, 58, 133, 142–3;
 print auctions, 16
Cole, Benjamin, 180
Collyer, Edwaert, 40; *Letter Rack*, 40–41, *41*
commedia dell'arte prints, 43, 74, 82
Common Sense, journal, 134, 135
Complete History of the Holy Bible, 37
'conversations', painted, 108
Cooper, John, *The Right Hon.ble Sir Robert
 Walpole*, 10, *11*, 12
Cooper, Thomas, 19
Cotton, Sir John Hynde, 164
Covent Garden, 2, 6, 8, *8*, 12–14, *13*, 16, 20, *21*,
 104; Cock's Auction House, 16; St Paul's
 Church, 2, 6, 13
Coypel, Charles Antoine, *Don Quixote* series
 (Vandergucht's engravings after), 72–8, 80–81,
 82, 88, 89, 116; *The Afflicted Matron . . .* , *77*,
 78, 80; *Don Quixote defends Basilus . . .* , 73, *75*,
 80; *Don Quixote knighted in the Inn*, 76, 76–8,
 80; *Don Quixote takes the Puppets to be
 Turks . . .* , 80–81, *81*; *The Entry of
 Shepherds . . .* , 74, *75*
The Craftsman, 133, 150
crime levels, 207
Cromwell, Oliver, 46, 49, 50, 51, 53, 54
cruelty *see* Hogarth, *The Four Stages of Cruelty*

The Cully Flaug'd (after Laroon), 108, 110–12,
 111

Daily Advertiser, 226
Daily Courant, 16, 17, 30
Daily Gazetteer, 150
Daily Journal 72, *210–12*
Daily Post, 78–9, 86, 108, 113
d'Anvers, Caleb, 150
Davies, John, 65
Defoe, Daniel, 27, 30, 46, 48, 49, 50, 51, 53,
 240n; *A Hymn to the Pillory*, 46, 48; *Instructions
 from Rome*, 30; *Jure Divino*, 49, 50, 52; *The
 Kingdom of Exchange Alley*, 58; *The Shortest
 Way with Dissenters*, 46
Desplaces, Louis, after Titian, *Danaë with
 Nursemaid*, 107
The Devil, Titus Oates, and the Pope, *33*, 34
dissection, anatomical, 223, 226
A Dissertation on Mr Hogarth's Six Prints, 201,
 202, 217, 220–21, 222, 227, 233
A Dissertation upon Drunkenness, 202
Donald, Diana, *The Age of Caricature*, x
Drake, James, *Anthropologia Nova*, 226, 227
Draper, W. H., *The Morning Walk*, 197
Dryden, John, 38, 146
Dutch satires (South Sea satires), 61–72, 78, 79,
 81, 82, 89, 108, 137, 159

Edelink, Gerard, after Philippe de Champaigne,
 Self-Portrait, 43, *45*
Elsum, John, *Epigrams . . .* , 51
emblematic satires, emblems, 34–5, 40, 41, 154,
 185
engraver/print entrepreneurs, 16, 17–18, 19, 27,
 29, 37, 116, 128, 163, 167, 178
Engraving Copyright Act (1735), 128
The Enormous Abomination of the Hoop-Petticoat,
 173–4
Enquiry into the Merits of Assassination, 24
'Epitaph upon a Gin Drinker' (poem), 219
Evening Post, 30
Exchange Alley ('Change Alley'), London, 57–61,
 64, 65, 71, 170
Exchange Alley (farce), 60–61

Faber, John, 9; after Sir Godfrey Kneller, *Sir
 Robert Walpole*, 10, 11, *11*
Faction Display'd, 48, *49*
fashion engravings, 180–82
The Female Rake, 189
'The Festival of the Golden Rump', 134–5, 136
fête galante, 72, 73, 74
Fielding, Henry, ix, 135; *Enquiry into the Causes
 of the Late Increase in Robberies*, 297–8; *Historical
 Register for the Year 1736*, 136; *Pasquin*, 136
financial disasters/speculation, 57–72

Fleury, Cardinal, 149, 154, 156, 160, 161
fop, notion of the, 188–90, 194, 205
The Fortunate Transport, 93–4, 95
Foundling Hospital, 217, *218*
Fourdrinier, Paul, trade card, 117, *118*
'The Freemasons, A Hudibrastic Poem', 86–7
freemasonry, 78, 82, 83–91; *Constitutions*, 83–4, *85*, 88; Grand Lodge, 83
French art/engraving, 72–8, 89, 108, 144–51, 180, 195, 222
Fresnoy, du, *The Art of Painting*, 38
The Funeral Procession of Madam Geneva, 211–12, *212*, 214

Gamble, Ellis, 79
Garrick, David, 187–8
Gaveston, Pierce, 151, *156*
Gay, John, *Fables*, 146, 150: 'The Squire and his Cur', 146–7, *147*; *Trivia*, 103, 184, 185–6, 187
Gay, Joseph, 124; *The Lure of Venus; or, A Harlot's Progress*, 120–21, *122*
General Advertiser, 207, 208, 219
Gentleman's Magazine, 10, 188
George I, King, 29
George II, King, 132, 134, 136, 160, 228, 230
George, M. Dorothy, *English Political Caricatures*, ix
Gheyn, Jacob de, (after), *The Anatomical Theatre at Leiden*, 226, 226–7
Ghezzi, Pier Leone, 'Dr James Hay as Bear-Leader', *163*, 163–4
Gibson, Archbishop, 136
Gibson, Thomas, *Henricus Sacheverell*, 30, *31*, 34; *Sir Robert Walpole*, 153, *153*
Giffard, Henry, playhouse in Goodman's Fields of, 135
Gildon, Charles, 5
gin-drinking, 197, *198*, 200, 201, 206, 207–22
Giorgione, *Sleeping Venus*, 106, *107*
Golden Spy, 104
Goldsmith, Oliver, 5
Goltzius, Hendrik, *Farnese Hercules*, 141, *141*; *The Visitation*, 115, *115*
Gonson, Justice Sir John, 96, 101–2, 104, 113, 114, 120
Goodnight, Nicholas, after Cibber, *Allegory of the Great Fire of London*, 210, *213*
Goupy, Joseph, 128
Gravelot, Hubert-François, 144–51, 154, 156, 158, 162, 167, 195, 236; *The European Race*, *148*, 149, 154; fashion plates, *181*, 181–2; *Fee Fau Fum*, *148*, 149, 156, 158; *The First Day of Term*, 142, *143*, 144; illustration for 'The Toast', 146; illustrations for Dryden's *Works*, 146; illustrations for John Gay's *Fables*, 146–7, *147*, 150; *The Itinerant Handy-Craftsman*, *149*, 150, 154, 156, 158, 167; trade card for John

Lhuilliet, 144–6, *145*
Great Fire of London (1666), 83, 90, 190, 210, *211*
The Great Mirror of Folly, 61, 62, 68, 71, 72, 78, 81, 89
Grignion, Charles, after Samuel Wale, *A Perspective View of the Foundling Hospital*, *218*

Habermas, Jurgen, 237n
Harvey, Moll, 113
Henry VIII, King, 42
Hennekin, Michael, 72
Het Groote Tafereel der Dwaarheid see *The Great Mirror of Folly*
The High Church Champion and his two Seconds, 31, *32*, 34, 35, 37, 45, 48
history painting, 138, 139
Hogarth, William, ix, x, 1, 15, 17, 18, 20, 23, 24, 25, 26, 84, 128, 159, 177, 190, 195, 217, 235; *Beer Street*, 1, 195, 200, 201–6, 207, 210, 214, 216, 222, 223, 236: first state, 204–5, *205*; third state, *199*; *Boys Peeping at Nature*, 117, 117–18; *Burning the Rumps at Temple Bar*, 190, *191*, 192: detail: frontispiece; *Evening*, 20, 25; *The Four Stages of Cruelty*, 195, 201, 216, 222–33, 236; *Cruelty in Perfection*, 222–3, *224*, 227–8, *229*, 230; *The Reward of Cruelty*, 222–3, *225*, 226–7, *234*; *Four Times a Day*, series 14, 171; *Gin Lane*, 195, 197, *198*, 200–01, 206–7, 208, 209–22, 223, 233, 236; *A Harlot's Progress*, 1, 95–106, 108, 112, 113–29, 131, 132, 170, 182: Plate 1: *94*, 95–6, 104, 123, 124, *126*; Plate 2: 95, 96, 105, 123, 124; Plate 3: 96, *96*, 101, 123, 124; Plate 4: 96–7, *97*, 123, 124; Plate 5: 97, *98*, 123, 124; Plate 6: 98, *99*, 108, 122, 123, 124; King's engraving after, 125–6, *126*; *Marriage A-la-Mode*, 21; *Morning*, 2, 4, 5, 6, 7, 8, 12–14, 15, 20, 21, *23*, 24, 25, 26; *The Mystery of Masonry brought to light by the Gormagons*, 58, 78–82, *79*, 87–91, 159; detail, *viii*; *Night*, 20, 25; *Noon*, 20, 25, *170*, 170–71; *Procession through the Hippodrome, Constantinople*, 79–80, *80*; *The Punishment inflicted on Lemuel Gulliver*, 137, 138, *138*; *The Rake's Progress*, Plate 8: *172*, 172–3; *The South Sea Scheme*, 89, 90, *90*; *Strolling Actresses in a Barn*, 24
Holland, Mr, publisher, 91
Hollar, Wenceslaus, 28, 38
Homer, 146
Hooghe, Romeyn de, *Tabula Cebetis*, 65, 66, *66*
hooped petticoats, 173, 174, 204
Humblot, A., *Rue Quinquempoix*, 62, *62*
Hunt, Lynn, 112

The Jew Decoy'd; or the Progress of a Harlot (ballad opera), 119
Jonathan's coffee house, 58, 59, 64

Jones, Inigo, 12
June, John, 233, 236; *The Lady's Disaster*, 174–7, *175*, 178, 179–80, 182, 192, 194, 195, 222

King, Giles, 125; after Hogarth, *A Harlot's Progress*, Plate 1, 125–6, *126*
Kirkall, Elisha, 116, 121, 122, 242n; *Covent Garden*, 8
Kit-Cat club, 9, 10
Knapton, John and Paul, 146, 226, 235
Kneller, Sir Godfrey, 9, 10; *Sir Robert Walpole*, 10, *11*
Knight, Robert, 69

Lambert, George, 128
The Lamentable Fall of Madame Geneva, 213, 214
Langford, Paul, 238n, 243n
Laroon the Elder, Marcellus, *Cries of London*, 164, *166*; *The Cully Flaug'd*, 108, 110–12, *111*
Law, John, 68, 69, 82
Law als een tweede Don Quichot, 68, 69, 82
Le Clerc, Sebastien, 38, 43
Lely, Peter, 242n
Leonardo da Vinci, 42, 163
Lhuillier, John, trade card for, 144–6, *145*, 150
Linebaugh, Peter, 223
literary satires, 6, 104, 182–7, 194
Little Theatre, Haymarket, 135
London Daily Post and General Advertiser, 25; advertisement pages, 21, *22–3*, 24
London Evening Post, 155
London Journal, 59
London Magazine, 197
London Spy, 6–7, 17
Lucifer's Row Barge (*Weekly Journal*), 68–9, *70*, 71

Mandeville, Bernard, 121; *A Modest Defence of Public Stews*, 113
Maurer, John, *A Perspective View of St Mary's Church in the Strand*, 178, 178–9, 180
medley prints, 5, 37–56, 57, 62–4, 71, 82, 159–62, 239n
Mercier, Philip, 72, 73
Miss in her Teens (farce), 187–8
Moll Hackabout (*The Harlot's Progress*: poem), 119–20, 121, 122
Montague, Duke of, 83, 84
'The Morning Walk' (poem), 219
Morris, Corbyn, *Observations on . . . the City of London*, 207
To the Mortal Memory of Madam Geneva, 214, *215*
mortality rates, 207
Mosley, Charles, after Gravelot, *The First Day of Term*, 142, *143*, 144
The Motion, 164, *165*
Mottraye, Aubrey de la, *Travels through, Europe, Asia, . . .* , 79–80, *80*

Mount, Harry, 125
murder prints, 222, 227–32

A Narrative of the Murder of Mr John Hayes, 227, 228
Nebot, Balthasar, *Covent Garden Market*, 175, *176*
Needham, Mother, 96, 101, 114
Newcastle, Duke of, 228–9
Nicholls, Sutton, *Covent Garden*, 21
Nicholson, Eirwen, 'English Political Prints and Pictorial Political Argument', x, 239n, 243n
Nutting, J., 30

Oates, Titus, 34
Oliver, John, Bickham Jr's (?) engraving of *Sleeping Venus and Charteris* after, 106, *107*
'On seeing a painting of Sir Robert Walpole' (*Gentleman's Magazine*), 10
optical pillar machines (zograscope), 179
Original Weekly Journal, 59
Overton print publishers, 15, 18, 123
Overton, Henry, 15
Overton, John, 27
Overton, Philip, 15, 30

'pantines' (paper puppets), 188
Passe, Crispijn de, (the elder), *Aurora*, 14, *14*
Paulson, Ronald, x, 241n; *Hogarth*, x, 99–100, 113, 115
Peacham, Henry, *Minerva Brittana*, *153*, 154
Pelham, Henry, 164, 228–9
penman, penbooks, 37
Pepys, Samuel, 190
Perrault, Claude, *Treatise on the Five Orders of Columns in Architecture*, 37
perspective views, 178–80
Phillips, Hugh, 176
Picart, Bernard: illustrations to *Ceremonies and Customs of the World*, 140, 144; *La Divinité qui selon les Chingulais*, *140*; *Monument Consacrée à la Postéritée*, 58, *63*, 64, 65–8, 69, 71–2, 82, 88; *A New Drawing Book of Modes*, 151, 180–81, *181*, 182
The Picture of Malice (pamphlet), 35
Piles, Roger de, 38, 40
Pine, John, 116, 128; frontispiece to Freemasons' *Constitution*, 84, *85*, 88
politeness, polite culture, and graphic satire, 2, 5, 9–15, 147, 187, 217, 235–6, 237n
political satire/prints, ix, 2, 5–6, 10–11, 27, 28–55, 57, 82, 131–67, 195, 222, 243n
The Political Vomit for the Ease of Britain, 19
Pond, Arthur, 163–4, 235; after Ghezzi, 'Dr James Hay as Bear-Leader', *163*
Pope, Alexander, ix, 5–6; *The Dunciad*, 6, 21, *22*, 237n

pornography, 93, 104, 112, 119, 120, 127, 151, 242n
Porter, Roy, 243n
Portobello, battle of (1739), 154
portraiture, 48–54, 160, 162, 163
Post Boy, 61, 83
Poussin, Nicolas, 72, 151; *Venus presenting Arms to Aeneas*, 65, *65*
Pozzo, Andrea, *Rules and Examples of Perspective*, 37
A Present for Women addicted to Drinking, 208, 209
The Priest turn'd Poet (pamphlet), 30
print auctions, 16, 128
print publishers, 15, 18, 19, 128
print shops, 1, 16–17, 19, 143, 238n
The Progress of a Harlot (pamphlet), 119, 120, 121, 122
prostitutes/prostitution, 83–129, 131, 173, 174, 176, 177, 192, 194
Pulteney, William, 164
Purcas, William, 227, *228*

Raphael, *The Blinding of Elymas*, 138, *139*; *Cartoons*, 18, 71, 116, 138
Read's Weekly Journal, 59, 60
Regnier, James, 17
religious art/engravings, 6–7, 27, 29–37, 48, 115
Review, journal, 48
Ribera, Jusepe de (after), physiognomic studies, 6, *7*
Richardson, Jonathan, *An Essay on the Theory of Painting*, 18
Ripa, Cesar, *Iconologia*, 100
rococo, 78, 94, 144, 145, 154, 158, 163, 222
Rogers, Nicholas, 29, 133
The Rudiments of Genteel Behaviour, 24
The Rump, frontispiece to, *191*

Sacheverell, Dr Henry, 27, 29–31, 35, 45, 46, 48; Gibson's portrait of, 30, *31*, 34; trial of, 29, 47
St Giles, 197, 200, 201, 206, 208, 211, 212, 214, 216
St James's Park, 173, 177
Sally Salisbury, 105, 106, 108, *110*
A Satire Unexplained, *130*, 131
satiric 'tours'/walk across London, 182–7
Schenk, Pieter, after Thomas Gibson, *Henricus Sacheverell*, 30, 31, *31*, 34
Scotin, Gerard, 146
Scott, Katie, 73
Scott, Samuel, *An Arch of Westminster Bridge*, *203*, 203–4
Secker, Thomas, 217
Shaftesbury, third Earl of, 232
Shakespeare, William, *Julius Caesar*, 153, 158
Shelton, Thomas, 72, 73, 76–7
Shepherd, Jack, 108

Shesgreen, Sean, 14
Sinking Fund, 149, 153
social satire, 2, 13–14, 169–95
Solkin, David, *Painting for Money*, 237n, 242n, 244n, 245n
'A South Sea Ballad', 60
South Sea Bubble crisis (South Sea satires), 57, 59, 60, 61, 64, 66, 67, 68, 69, 71, 73, 78, 79, 81, 83, 89, 90, *90*, 137, 170
Spectator, 9, 12, 60, 146, 186
spectatorship, 99, 101, 102, 105, 111, 123, 124–5, 142, 194–5, 220
Steen, Jan, 242n
Stent, Peter, 27
Stephens, Frederick, x
Strand, 174, 176–7, 178, 192, 193; St Mary's Church, *178*, 178–9, 180
'Strip Naked, or Royal Gin forever' (poem), 219–20, 222
Sturt, John, 37, 82; *The May Day Country Mirth*, 37–40, *39*, 41–2, 43, 54
subscriptions, subscription tickets, 116–18, *117*
Swift, Jonathan, ix; *Gulliver's Travels*, 137

Tasso, Torquato, *Jerusalem*, 24
The Tears of the Muses, 24
Tempest, P., after Laroon, *The Cries of the City of London*, *166*
Temple Bar, 16, 169, 176, 177, 180, 183–4, 190, 192, 193
Temple Change Coffee House, 16
Testa, Pietro, *The Martyrdom of St Erasmus*, 230–32, *230*
theatres, closing of unlicensed, 135
Thornhill, Sir James, 114–15
Tinney, John, 195
Titian, 115, *Danaë with Nursemaid*, 106, *107*
'The Toast' (poem), Gravelot's illustration for, 146
topographical prints, 178–80, 202, 206
Tories, 29, 46, 53, 133; Radical, 133, 151
trade cards, 37, 117, *118*, 147; for John Lhuillier, 144–6, *145*
A Trip Through London, . . . , 103
A Trip through the Town, 184
trompe l'oeil satires, 38, 40, 46, 57, 239n
Truchy, Louis, after Gravelot, fashion plates, *181*, 181–2

Universal Magazine, 235
Universal Spectator, 113

Vandergucht, Gerard, *50*, 51, 89, 128, 167; *Don Quixote* engravings after Coypel, 72–8, 80–81, 82, 88, 89, 116: *The Afflicted Matron*, 77, 78, 80; *Don Quixote defends Basilus* . . . , 73, *75*, 80; *Don Quixote knighted in the Inn*, 76, 76–8, 80; *Don Quixote takes the Puppets to be Turks*,

80–81, *81*; *The Entry of Shepherds at Camacho's Wedding*, 74, *75*; engravings after Raphael's *Cartoons*, 138; *The Festival of the Golden Rump*, 136–42, *137*, 143

Vandergucht, Michael, *Daniel Defoe*, 49; illustration from Drake's *Anthropologia Nova*, *226*, 227

Vernon, Admiral, 154–5, 158–9, 160

Vertue, George, 17, 18, 30, 199–2, 116, 120, 128, 144, 241n

The Vices of the Cities of London and Westminster, 209

Virgil, 146

virginity, feminine virtue, 114

voyeurism, 13, 93, 99, 100, 102, 105, 124, 194, 220, 222

Wale, Samuel, 219; *A Perspective View of the Foundling Hospital*, 217–18, *218*

Walker, Anthony, 200, 233, 236, 244n; *The Beaux Disaster*, 169, *170*, 171, 172–3, 174, 177, 180, 182, 183, 184, 185, 187, 188, 189–90, 192–5, 204, 206; details, *168*, *193*

Walker, Robert, 51; *Cromwell*, *50*

Walmoden, Sophia, 160

Walpole, Horace, 106

Walpole, Horatio, 136, 139

Walpole, Sir Robert, 2, 5, 6, 10–11, 20, 24, 131–2, 135, 136, 146, 149, 151–9, 160–61, 162,

164; Cooper's mezzotint of, 10, *11*, 12; Gibson's painting of, 153, *153*; Kneller's portrait of, 10, 11, *11*

Ward, Ned, 6, 17, 19, 103; *Hudibras Redevivus*, 103; *London Spy*, 183, 184; *The Secret History of the Calves Head Club*, 52, 52–3; *Sot's Paradise*, 43

Ware, Isaac, 128

Ware, Richard, *A New Drawing Book of Modes*, 180–81, *181*

Watteau, Jean-Antoine, 72, 73; *The Shepherds*, *74*

Weekly Journal, 59, *68–9*, *70*, *71*

Westminster Bridge, *203*, 203–4, 245n

Westminster Hall, 142–3

Wharton, Duke of, 84, 86

'A Whig and Tory a Wrestling' (poem), 53

The Whig and the Tory (songs), 53

Whigs, 6, 29, 46, 47, 53, 86, 132–6, 150, 151, 158

Wild, Jonathan, 108

Winstanley, Hamlet, 116

'The Wofull Lamentation of William Purcas', 227, *228*

women: gin-drinkers, 197, *198*, 200, 206, 208–17, 218–22; investors, 60–61; spectatorship, 99, 124

Woolston, Thomas, 100

Wren, Sir Christopher, 177, 190

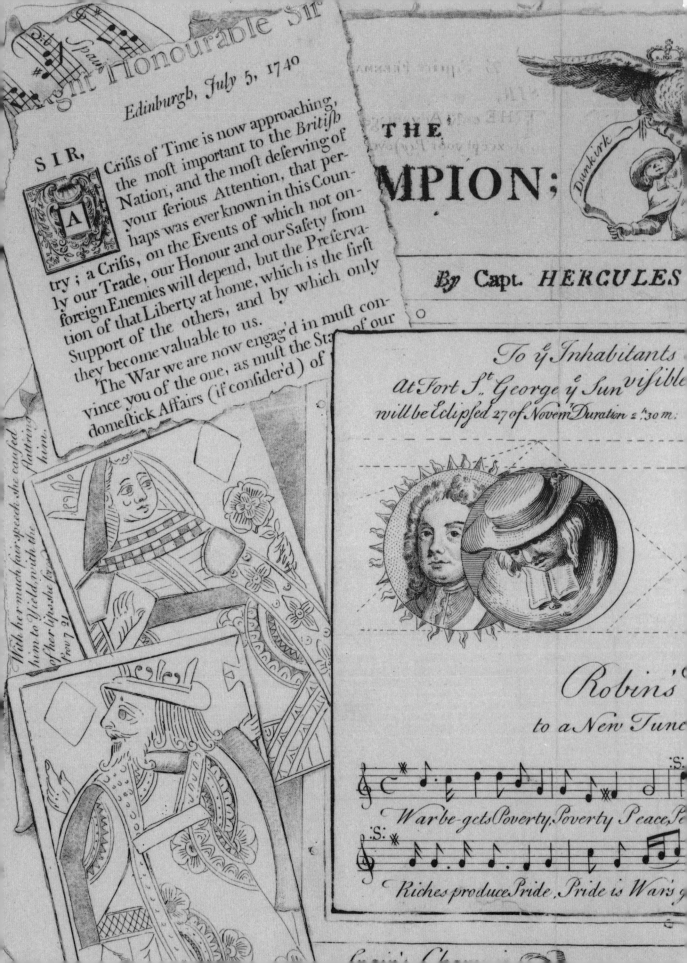